RETAIL DESIGN

RODNEY FITCH · LANCE KNOBEL

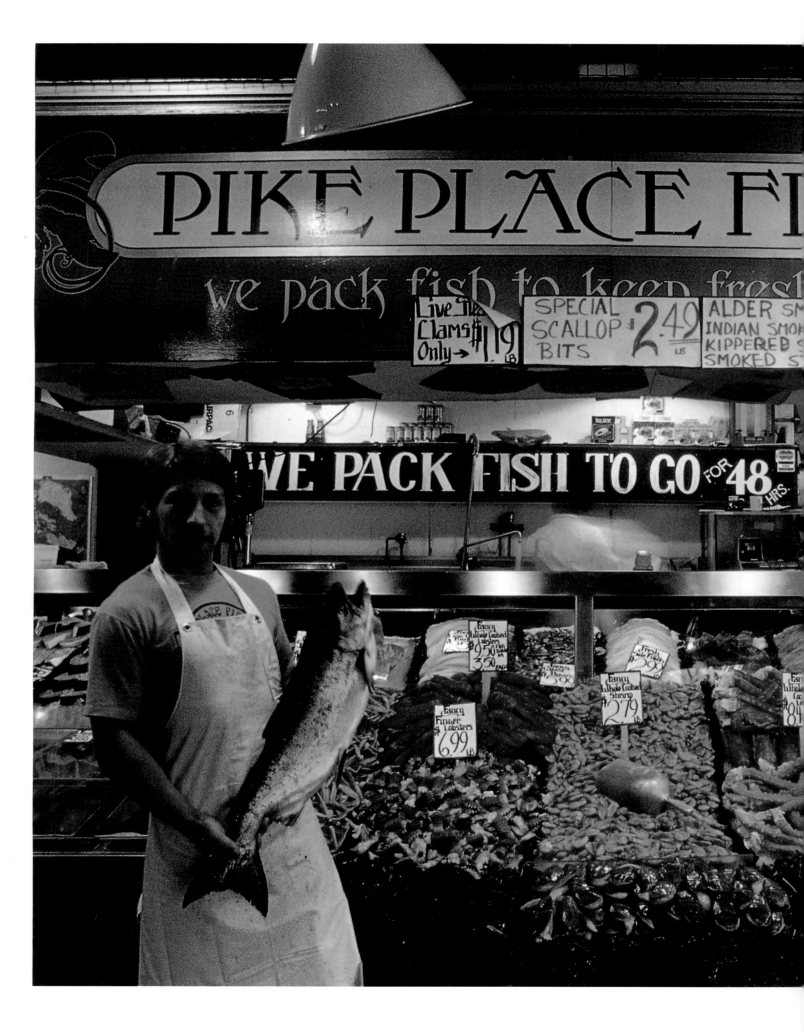

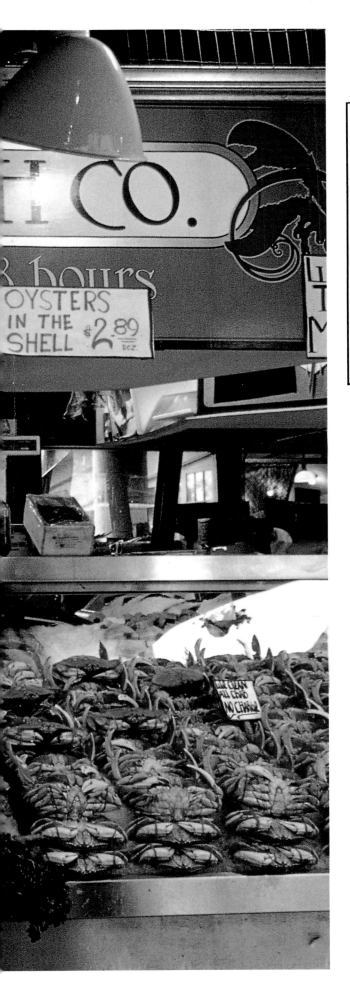

RETAIL DESIGN

RODNEY FITCH · LANCE KNOBEL

WHITNEY LIBRARY OF DESIGN

an imprint of Watson-Guptill Publications/New York

To good designers everywhere – **nil desperandum**

Title page Pike Place Market (see p. 98): *below* Gran Ciclismo,
Milan, designed by Franco Raggi and Daniella Ruppa.
(*Photo* Miro Zagnoli)

Library of Congress Cataloging in Publication Data
Fitch, Rodney.
 Retail design/Rodney Fitch and Lance Knobel.
 p: cm.
 ISBN 0-8230-4550-1
 1. Stores, Retail—Themes, motives. I. Knobel, Lance.
 I. Title
 NA6220.F58 1990 89–22659
 725'.21—dc20 CIP

This book was designed and produced by
JOHN CALMANN AND KING LTD, LONDON

Designer Robert Updegraff
Typeset by Rowland Phototypesetting Ltd,
Bury St Edmunds, Suffolk
Originated in Singapore by Toppan Printing Co. Ltd.
Printed in Italy by Graphicom
1 2 3 4 5 6 / 95 94 93 92 91 90

CONTENTS

Acknowledgements

When I set out to write this book on retail design, I thought, with the arrogance that transfixes all first-time authors, that I would find the task infinitely easier than actually working! I have not, and without the support and guidance of a great many people, the unworthy thoughts contained in this publication could never have come to fruition. With the deepest humility, therefore, I should like to thank our editors, Paula Iley and Elizabeth Thussu, whose good-humoured prodding and wheedling kept us more or less on track. The picture research was coordinated by Lucy Bullivant, with the assistance of Junko Popham in Japan and Lisa Davies in the United States, to whom many thanks for their persistence and remarkable fund of sources. Thanks are also due to designer, Robert Updegraff, who has assembled the whole clearly and creatively.

I owe a substantial vote of thanks to a group of splendid people from my firm who contributed with ideas and references on a variety of occasions including James Woudhuysen, Michael Howard, Mark Landini, Carlos Virgile, Giles Marking, Rune Gustafson, Charles Dunnett. Working with these fellows made me appreciate more and more why Fitch RichardsonSmith is a successful design business.

There were many other contributors as well: Graham Vickers, who helped with the Introduction and Postscript, together with Professor Ross Davies of Templeton College, Oxford; Bob Tyrell from the Henley Centre for Forecasting; John Richards, Senior Retail Analyst at Woodmac, London. These last undoubtedly have the best perspective on retailing outside of retailers themselves and I'm very grateful that they could spare time from their busy schedule. Also to be thanked, is Neil Burton from English Heritage.

Since the book's subject is a highly visual one, the image conveyed in photography is important and I would extend the warmest thanks and gratitude to those retailers, designers and photographers who have given us access to their archives and records.

To my collaborator Lance Knobel what can I say but "thanks and well done." Lance recorded many conversations and assembled and edited them all into coherent text.

Lastly, not just thanks but also congratulations are due to those people who really made this book possible: the designers whose splendid work has not only given their clients good value but left behind a rich heritage of invention and creativity which will be a hard act for others to follow.

FOREWORD

As a boy growing up in a surburban postwar Britain, my abiding recollection of retailing is of mean, dull shops: a recollection only occasionally leavened by visits to the big stores – Whiteleys, Selfridges, Bourne & Hollingsworth – in London's West End. The disparity between these West End stores with their seemingly huge spaces, glamorous displays and vivid presentations and what was to be found outside the metropolis was most marked.

All this has changed. Virtually all the shops and stores I came to know as a young man have gone: bought out, bankrupted, merged, or rebuilt, together with much of the suburban and city centers where they once stood.

Colossal social change has been wrought in most of the industrialized nations over the past couple of decades and this has been reflected in patterns of shopping. Indeed, the retailing landscape has undergone a total transformation. The traditional amateurism of management culture has been replaced by a more dynamic professionalism; changing ownership structures have swept away founding families, and retailing dynasties have been replaced by corporations; competition for market share has driven the process of mergers and acquisitions; while new technologies have made customer and stock information instantly available.

There is an old Chinese curse which says "may you live in interesting times." Well, retail design, at one time a minor discipline of architecture and principally the domain of the shopfitting and construction industries, has recently lived in interesting times, yet has been one of the lanterns of the period, and designers have been major beneficiaries. And it surely cannot be denied that some very fine work has been done in the name of "retail design." Yet it remains fashionable in some quarters to espouse the view that this design discipline is in some way inferior to "fine" architecture, a view possibly, but mistakenly, based on the notion that the quality of any design is established by the nobility of its purpose. Notwithstanding this, however, a burgeoning design discipline has grown up to service the needs of a retail industry which, while becoming increasingly more competitive, has also become better managed and very much more conscious of design as a powerful resource. Customers, themselves better off, more mobile, and more idiosyncratic, have paralleled this design consciousness. Indeed, in today's "telemedia-visual" world, consumers have learned to anticipate and respond to good design.

Reflecting on retailing and design in the 1950s, Nicholas Pevsner, a much respected British architectural historian, could write ". . . apart from perhaps the plate glass window, nothing much has changed in the design of shops since Roman times . . ." Forty years on, Pevsner simply could not have made the same observation.

I hope, then, that this book about good retail design is timely. I hope it will find some readers among professional designers and architects, students, and retailers themselves. Perhaps some members of the public who, after all, make the whole process possible, may also find the phenomenon of retail design interesting.

I first fell in love with store design back in the mid-1960s when Terence Conran asked me to work with him on creating the first Habitat shop. This project presented me as an impressionable young man, not only with the chance to work on the design of what, at the time, was a seminal retail concept, but to help choose merchandise, visit suppliers, and ultimately work behind the counter, face to face with customers. Habitat opened to great acclaim in 1964 and the experience set me on my life's work but, incidentally, convinced me I would rather design shops than work in them!

Several hundred retail projects later, for many of the best retail businesses in the land, I still experience that same tingle of excitement at the opening of a new Fitch-designed enterprise. Parallels are often drawn between retail and theater design. Certainly, something of this theatricality is present when anticipating the equivalent of a store's "opening night." The sheer intensity of the shopping experience or of visiting for the first time a genuine new shopping concept with the pleasure of knowing that, as a designer, one can contribute something to the quality of customers' lives, continues to sustain me.

Being able to work directly with suppliers, landlords, owners, and statutory authorities has given me an insight into both the retailing process and the shopping experience, and I firmly believe that at whatever scale and in whatever location, good retailing always recognizes the paramountcy of the customer.

That said, this book is not about retailing. It does not attempt to tell retailers how to do their job and I hope its tone is not that of the preacher or bigot. The wonderful thing about retailing and about design is that both are dynamic. No one has the exclusive right to judge what is right and what is wrong, and in the retailing experience one constantly finds examples that completely overturn conventional wisdom.

Change is an important aspect of retail design. So is speed. This was never more manifest to me than during the eighteen-months gestation period of this book. Several examples we wanted to use had closed or moved, and new examples were popping up all the time, but could not be included. Hence, no book on retail design can ever be fully up to date but can at best be a window onto the scene at a moment in time. But this book is not about contemporary design fashions. Neither is it my personal selection of the best shops and stores, yet alone the best designed stores (whatever that means!). What the reader will find between these pages are my own thoughts on the role of design in successful retailing.

There are rules it is wise to acknowledge and I explain some of them. Some thoughts I hold dear and I try to share them. I offer some practical criteria to follow, many illustrated by examples from the world's most successful retailers and designers. I emphasize that the examples are chosen because they are good design solutions to retail problems, not because they are award-winning designs, although in some cases they are both and serve to underscore my belief that good design and success often go hand in hand.

The good retailer is an impresario. He balances his various acts – location, merchandise, service, productivity, price, and so on – to create a show that will, hopefully, run and run. The art of good retail design is to complement these ingredients and to give physical expression to the retailers' culture and aspirations. Retail design, no matter how innovative or visionary, cannot work as a solo act. It is not "high art" and must constantly balance, compromise and strive to match realities with customer and client expectations.

At this point then, it is perhaps appropriate, in the context of this book, to attempt a definition of what is retailing and what is retail design. For our purposes, retailing means the sale of goods (clothes, food, books, etc.) or services (travel, banking, equities, etc.) in a built environment (shopping center, high street, department store, etc.). Retail design is the physical expression of this interaction in an architectural, graphic, and engineering context. And in this book are examples from some of the best professionals in the business.

That said, not all good retail design is conscious nor is it always the work of these professionals. Some of the best retail experiences around – street markets, "mom and pop" stores, the local baker shop or food store, are successful yet charmingly unconscious. But most retailers have to work much harder than this so the book concerns itself with the more conscious, professional approach to designed retailing.

In accepting design as only one part, albeit an important part, of successful retailing, what is the retail designer's role and what claims can retail designers justifiably make? How do retailers and consumers measure the designer's input and what are the criteria for their success? I have attempted answers to those questions in the book but, essentially, retail design operates on two levels: firstly, in creating the atmosphere, the identity, the ambience for the client which, in complementing the merchandise offer, instinctively tells customers they are in the right place. Secondly, there are the practical, problem-solving issues of better planning, better space productivity, innovative presentation methods, better merchandising facilities, better customer flow. When these image and problem-solving attributes meld well with the retailers' management and merchandise philosophies, the result can be phenomenally successful in both financial and human terms.

Design is an important dimension in imbuing a store with premium values. When the store looks and works well, by association, the very products seem to become better and customers feel rewarded. Through good retail design, the store can become more relevant, more enduring and often more profitable.

Equally, the business of retail design has become more complex. It is no longer a singular matter of just being a good professional. It is no longer a simple matter of a good idea followed by sound budgeting, quotations, materials selection, technical information, and project control. It must of course be all of these things, but there is now the added dimension of information both to and from the consumer. Retail design arises no longer from an empirical creative act but is a conscious, targeted response to particular customer preferences and expectations. Stores are a collection of symbols that can be rearranged in a limitless fashion. In the language of design, today's stores often say as much to the customers they wish to keep out as to the customers they wish to attract. So, the retail designer may well be involved in demographics, psychographics, and market research, making a meaningful contribution, not only in design terms, but also in identifying and understanding the customer.

It has always been the designer's task to see, understand, translate, and assimilate historical and existing references in order better to reinvent and reassemble them so that they have a contemporary quality that is relevant at this moment of time and space. For as George Nelson once noted of designers ". . . as he inherits, so he also bequeaths." It is this very need to remain contemporary that makes retail design a transient, experimental activity. However, the retail designer's role goes beyond this, since the genre is in a field that is highly competitive in a commercial sense, and, as the customers of good retail design extend beyond national boundaries, so do the opportunities and the references. This is no less true for consumers. Increasingly, shoppers have access to world products and world brands through travel, through published and transmitted media, through the commonality of information and references. Thus, future consumers will become more internationalized. But despite this inevitable proliferation of references, designers will need to find a way of expressing, valuing, indeed championing things both local and of the community. Designers have the unique opportunity to "think globally, design locally!"

So, in a complicated, unclear, and shrinking world, existing retailers are merging and combining, new retail concepts are appearing, and all are working like crazy to build their market share. At the same time, we have customers who are more discerning, better informed, and more widely travelled and products that are increasingly homogenized and marginalized. To this complex environment, the retail designer brings innovative yet practical skills. The process of innovation and invention is infinite, and as long as there are products, customers to buy them and shopkeepers to sell them, so retail designers will find opportunities to improve both the quality of retail service and the quality of our customers' lives. Long may it continue.

Rodney Fitch

A HISTORICAL INTRODUCTION

In establishing the history of retail design, we may be disappointed if we expect to find documentation of conscious retail design development through the ages. However, it is not that retail design did not exist: indeed there is overwhelming evidence to prove the opposite. However, "retail design" was frequently an intuitive and unselfconscious expression of commercial acumen and not, until recently, considered to be a discipline in its own right. Accordingly, the existing documentation frequently focuses upon the broad sweep of retailing, upon the architecture which housed it, upon its significance as a mirror of shifting social values or upon some of its more colourful characters.

If our perspective on the details and motives of retail design over the past two hundred years is occasionally uncertain, it is for good reason: for the large part of that period retail design has been essentially another dynamic selling tool, not a static art form. Perhaps it was inevitable that retail design would eventually become a highly sophisticated skill in its own right, worthy of special study and, of course, demanding a history. That history developed through the bazaars, arcades, and department stores of the nineteenth century, and, although we are afforded very many glimpses of conscious and inventive retail design – from Eric Gill's fascia lettering for W. H. Smith, first seen in the rue de Rivoli, Paris, or Gordon Selfridge's revolutionary London window displays of 1909, to Marshall Field's Chicago store, or Biba's radical 1960s adventure in Kensington – we should remember that the great retailers of the nineteenth and early twentieth centuries were primarily commercial adventurers. For them, design, in all its forms, usually worked as unforcedly as it did for many of their admired contemporaries, the great engineers, architects, and craftsmen.

Bazaars and arcades

Until the changes of the Industrial Revolution, stores were an integral part of the domestic architecture, usually situated on the ground floor of domestic buildings and sharing their character and scale. For centuries, the manufacture and selling of goods had taken place in the home. Craftsmen, such as tailors, cobblers, and metalworkers made and sold their products where they lived, often with workshops opening onto the streets. Products made by craftsmen were generally unique and custom-made or commissioned for a specific purpose or patron. Not until the Industrial Revolution and the replacement of craft with mass-production were there the necessary preconditions for retailing to develop and expand, so that shops could become the natural outlet to distribute manufactured goods.

Among the earliest bids to structure retail environments were the bazaars that appeared in England in the late eighteenth century. While open markets had existed for centuries, authorized by charters and accepted as part of the fabric of everyday life, the bazaars introduced a conscious design to selling goods, providing a dedicated space and a corresponding sense of occasion. These bazaars echoed their eastern prototypes, which, for those Western travellers who had experienced them, must have seemed exotic places, embodying trading at its most exciting and vigorous. However, it must be remembered that the English bazaars arose simply to gather together a wide variety of goods for the mutual convenience of customer and retailer. The bazaar was usually a structure of more than one story, managed by a single proprietor. It might feature exhibitions as well as shopping stalls that were rented out to a variety of tradesmen. This 1807 account of Exeter Change, located on the north side of the Strand from about 1773, suggests something of the colourful atmosphere of the bazaar.

Exeter Change is precisely a Bazaar, a sort of street under cover or large long room, with a row of shops on either hand, and a thoroughfare between them; the shops being furnished with such articles as might tempt an idler, or remind a passenger of his wants. At the further end was a man in a splendid costume who proved to belong to a menagerie above stairs. A macaw was swinging on a perch above him . . .

Although it is unlikely that such bazaars were originally contrived with any motive other than the basic one of convenience, the commercial benefits of a specialized retail environment did not go unnoticed, and the subsequent development of arcades throughout Europe was essentially a more sophisticated architectural expression of the same idea.

As well as the "carriage class" of the developing middle classes, another important factor in the history of retail development is that, well into the nineteenth century, much shopping in Britain and much of Europe was done by servants. Many of the commodities for sale would have been foodstuffs, with other goods being commissioned direct from the maker. In visual terms, the first arcades were of architectural interest: as public spaces they were often well-designed, linking streets, acting as thoroughfares, and providing an early model for today's urban shopping center. The goods sold in the arcade stores were not particularly expensive – haberdashery, trinkets, and suchlike, reflecting the fact that servants were the most likely customers.

London's Burlington Arcade, built in 1818–19 and designed by Samuel Ware, represents a more prestigious form, whereas most arcades, many of which existed in provincial towns in Britain even as late as the 1950s, mainly sold cheap utilitarian goods. However, it was the aspirational Burlington Arcade and others such as Paris' Galerie d'Orléans which defined the early form. Towards the end of the nineteenth century and after, larger and grander arcades flourished, such as the Galleria Vittorio Emanuele II in Milan and the Galleria Umberto I in Naples, inspiring many others all over the world, from Cleveland to Sydney. Today, the influence of the arcade in retail design can be seen in the many "atrium" shopping centers, based unashamedly on Milan's Galleria.

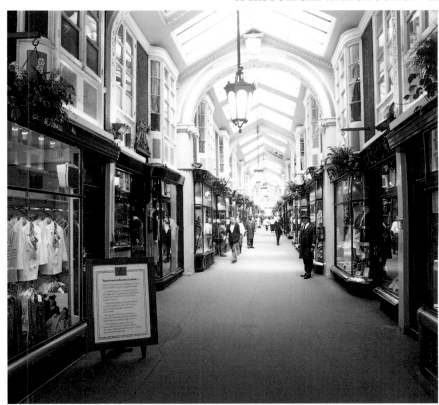

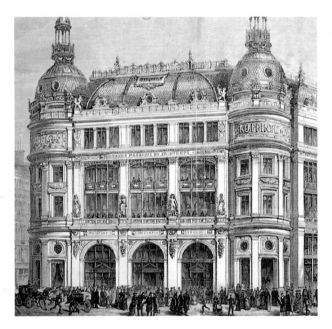

Department stores

The great social changes in nineteenth-century Europe and America, brought about by industrialization and urbanization, created a new mass market in the towns and cities. The move to factory production meant a wider range of goods was available in much greater quantities, which led to a huge increase in demand for retailing space where the needs of the new urban population could be met.

Designs for a purpose-built department store can be found as early as the 1820s, with the architect Karl Friedrich Schinkel's plans for a store with a façade of glass divided by masonry pillars. However, this prototype was not realized, and the dynamic retailing duo of Madame and Monsieur Bouçicaut are credited with the establishment of the first department store in Paris in 1852.

Beginning with a drapery store, by 1860 their Bon Marché store had separate departments selling dresses, coats, millinery, underwear, and shoes. But what was so innovatory was their attitude to their customers. The Bouçicauts encouraged total freedom of access, tempting people in with specially created displays and offers, with clearly marked prices on the goods. They pioneered the idea of the store as purposely designed for fashionable public assembly rather than just a means of supply. The success of the store was reflected in the opening of rival stores, such as Le Printemps in 1865 and La Belle Jardinière in 1866.

The Burlington Arcade, above, is still a prestigious shopping area in the London of today. (*Photo:* Burlington Arcade)

The impressive and elaborate façade of Printemps in Paris is shown left in a contemporary print. (*Photo:* Printemps)

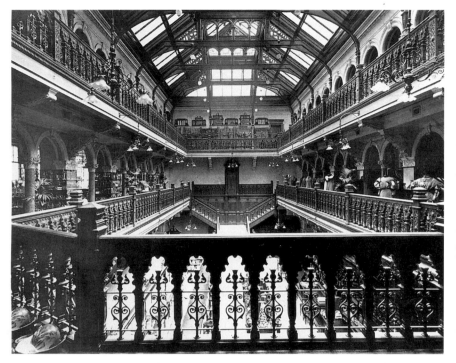

The upper floor of the grand hall at Jenner's department store in Edinburgh exhibits features that have influenced modern shopping malls, such as the glass atrium and galleries. (*Photo:* The Royal Commission on the Ancient and Historical Monuments of Scotland)

took over the role of basic, "convenience" retailing. Even so, it would be true to say that coherent interior design or even imaginative display was the exception rather than the rule.

Despite the occasional department store building of architectural character and merit, notably Louis Sullivan's Chicago store for Schlesinger & Mayer (1899–1904), early attempts at imaginative retail environments seem to have been largely limited to Selfridge's and a handful of others such as Harrod's, Whiteley's, and the Liverpool store Lewis's – and Selfridge's alone managed the trick of making middle-class goods look luxurious by means of the store environment. However, it is worth remembering that even the least inventive department store would have impressed its customers with the sheer scale of the operation and the novelty of putting so many departments under a single roof. It is not fanciful to suggest that this sort of scale and vision was in itself an early form of "retail design," at first more than sufficient to stimulate and sustain customer interest. Retailing had arrived in the highly visible form of the vast emporia at a time when great buildings were synonymous with importance and power.

Chain stores

The arrival of the chain store established a quite different route for the development of how shops might look and, it could be argued, set the pattern for retail design as we know it today. Frank Winfield Woolworth opened his first store in Utica, New York in 1879 on the seductive "five and dime" principle – that is to say items were priced at either five or ten cents. By 1919 there were 1,081 Woolworth stores in existence, firmly establishing the chain-store principle both in the United States and in Europe as retail outlets appealing primarily to the working classes by accessibility, cheapness and familiarity.

Although Woolworth specialized in miscellaneous goods, the chain-store principle was most avidly taken up by retailers of single commodities, and this perhaps suggests that it was not so much the nature of the merchandise as the reassuringly familiar identity of the chain store that quickly found favour with the customer. The advantages to the retailer – a centralized supply system and a single shopfitting formula – are clear, and yet for the customer, the early chain stores represented the very antithesis of what an aspirational store like Selfridge's or Marshall Field's was offering at about the same time.

In place of a designed environment, personal assistance, and the trappings of luxury, most early chain stores were rather basically appointed and architecturally undistinguished. Their sole concession to visual identity was usually a bold fascia, in which typestyle and colour scheme combined to create often

Bon Marché, which was designed by M. A. Laplanche and later extended by Louis-Charles Boileau to fill an entire city block, caught the imagination of American visitors to Paris and formed the basis for many of North America's early department stores. In fact, a number of provincial British stores, usually drapery-based and including Kendal Milne & Faulkner of Manchester and Bainbridge's of Newcastle, had pre-dated Bon Marché by several years. Kendal Milne & Faulkner's department store was acquired incrementally from 1837, and within ten years could list a comprehensive range of departments, all housed in a building furnished with a well-designed shopfront featuring recessed windows for maximum window display. Bainbridge's followed a similar pattern, and, by the last decades of the nineteenth century, the true origin of the department store had become largely an academic question. Launched internationally from Paris' Left Bank, the phenomenon was now to be found everywhere – Marshall & Snelgrove, Selfridges, and Swan & Edgar in London; Belle Jardinière, Printemps, and Samaritaine in Paris; Macy's, Bloomingdale's, and Lord & Taylor in New York; Marshall Field's and Schlesinger & Mayer in Chicago.

Customers of the department stores were often drawn from the new middle and lower-middle classes and, in the case of Selfridge's, were wooed with sophisticated window dressing, interior displays, colour-coordinated carpeting, wrapping paper and string, delivery vans, and notepaper. This process was to become more widespread later, so that, eventually, the department store came to be seen as the "quality" shopping environment, defined by its respectable ambience, courteous assistants, generous delivery services, and customer loyalty, while the chain store

powerful images, some of which grew into popular icons. Anyone growing up in town or city in postwar Britain also grew up believing that the shopfronts of Boot's The Chemist, W. H. Smith, and F. W. Woolworth formed an inevitable part of the urban landscape. Similarly the United States quickly embraced the chain-store fascia notion, sometimes with highly imaginative variations. For example, the White Tower hamburger franchise of the 1930s and 1940s used its eponymous image (each store was tricked out with a full-size square tower shape) in every conceivable street and highway location. The object here was simply to reassure the customers of a standarized quality of service, wherever they might be. In Britain, fascias were most probably an unconscious extension of a historical tradition in which craftsmen and suppliers naturally favoured highly individual shopfront signatures. But the ultimate effect of the ubiquitous shopfront however, was to establish feelings of loyalty, reassurance, and stability within the customer. It is difficult to prove, but tempting to believe, that the highly distinctive chain-store frontage laid the psychological basis for many of today's tenets about the importance of retail identity and image as expressed in retail design.

Shopping centers

One of the most significant postwar retailing innovations is the rise of the shopping center. This originally came in two basic types: the town-center precinct and the out-of-town center. The precinct type was first seen in Rotterdam in the early 1950s where shopkeepers joined together to form the Lijnbaan, a pedestrian-only shopping area. The out-of-town center found its origins in the first fully enclosed shopping center, built in 1956 at Southdale, near Minneapolis, by Victor Gruen and Associates. The broad pattern was soon established: precincts tended to become focal points for town centers, often linking streets and regenerating, or at least enlivening, depressed areas. Large out-of-town centers, attracting major department and chain stores, were conceived as self-contained buildings and were invariably surrounded by huge car parks. Given the geographical differences – and the much later mass car-ownership in Britain – it followed that the out-of-town center originally thrived in the United States, while the city-center precinct was more popular in Europe where in the postwar years it was an important part of rebuilding the devastated city centers.

Covent Garden, a busy fruit and vegetable market in the center of London until the 1970s, is now a popular shopping center with a variety of fashion and specialty units, including small craft stalls that echo its original function. (*Photos: inset* – Radio Times Hulton Picture Library; *main picture* – © Julian Nieman/Susan Griggs Agency Ltd.)

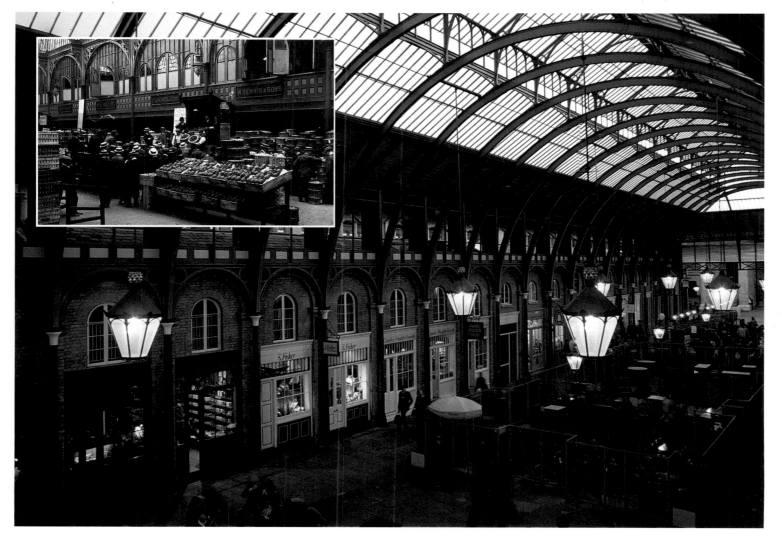

Interestingly, more recent trends show a reversal of this process, as America looks to rebuild some of its decaying inner cities by means of retail complexes, and Britain builds more out-of-town shopping centers and leisure complexes of a scale to rival the early American giants.

The impact of the shopping center upon retail design has been gradual but powerful, and it brings us right up to the present day. The shopping center story is essentially an American one; it may be worth reflecting that, had there been no United States, there would still have been department stores, but without America, there would be no shopping centers as we know them today. The United States had created its own form of the British "High Street", initially in the form of open-strip malls on the West Coast, where fine weather made enclosure unnecessary. In the East, climates meant that enclosure soon became essential, and, as the early out-of-town centers expanded into large regional ones, a whole new style of shopping environment emerged. The security of an overall enclosure meant that traditional shopfront designs were no longer appropriate – wider access and different sorts of window display soon resulted. With the advent of air conditioning, no shopfronts at all were needed, and this affected the positioning of checkouts and eventually the entire layout of the stores. Today, it is not unusual for the barriers between stores to be broken down completely, as one store leads directly into another and designers are required once more to reassess the impact of the shop environment on the newly liberated customer.

The past fifty years have seen many notable examples of individual retail design, from the work of Raymond Loewy and Walter Dorwin Teague in the United States, to Terence Conran's mold-breaking Habitat shop and the new British design awareness it embodied in the 1960s, to Japan in the 1980s. They, and numerous others, helped to inspire their contemporaries, and their contributions to the history of retail design deserve serious study elsewhere. Meanwhile, this brief, historical outline is intended simply to set the scene for what follows: Finally, it is worth suggesting that the gulf that may appear to separate the primitive appearance of the early bazaars from the elaborate environments of today's shopping center and leisure complexes, perhaps has rather more to do with a changing world than with any fundamental shift in the motives and aspirations of the retailer. Retailing remains a vigorous and dynamic commercial area that ultimately depends not upon any applied values or aesthetics, but upon people and their appetites. Correspondingly, with today's greater emphasis upon the quality of life, retail design has become an indivisible part of the retailing experience. Today the customer has come to expect stimulating retail environments – indeed it is often the quality of the surroundings as much as the goods on offer that attracts leisure shoppers. And if the medium has not quite become the message, it does at least now form a significant part of that message. The exciting task that confronts tomorrow's retail designers is to prepare themselves for future expressions of that continuing process.

PART ONE

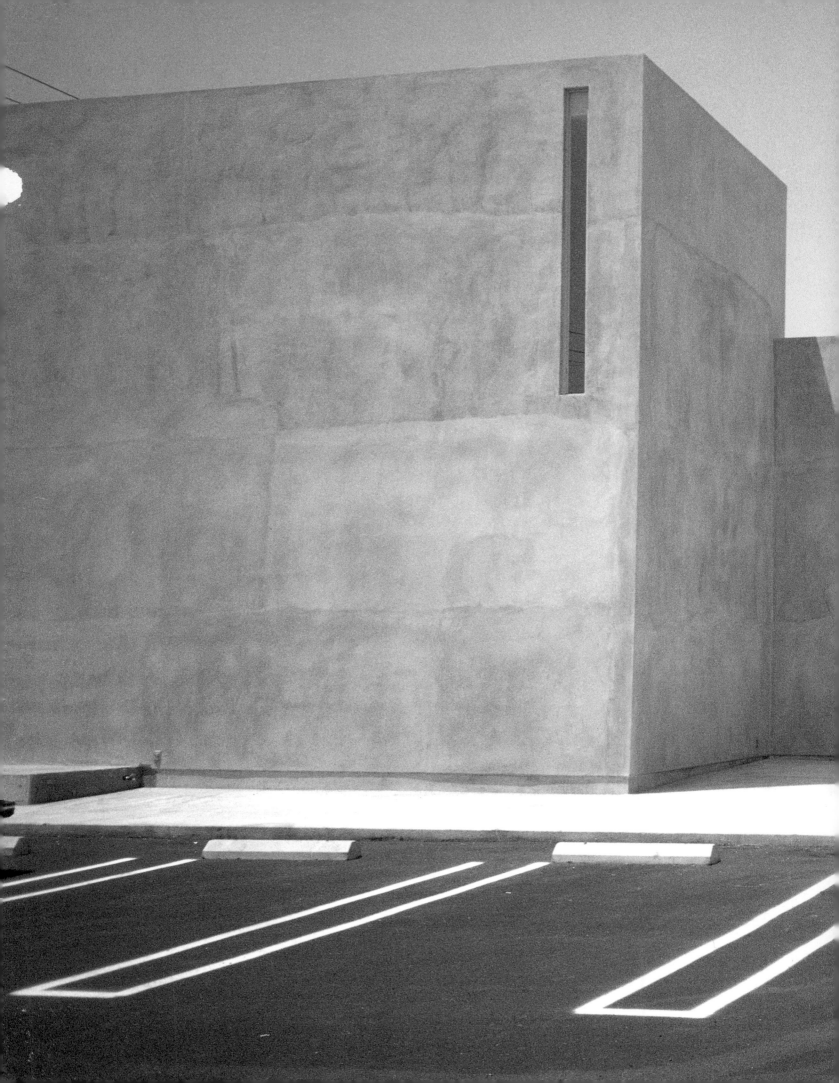

STOREFRONTS AND ENTRANCES

The first impression of any store design is critical: the storefront and entrance are a condensed version of everything the design is trying to communicate. The first aim is obviously to attract customers into the store. But an effective exterior design should do more than this. It must communicate to customers that this particular store is the one for them – or not, as the case may be. This means that, in general, discordance between the exterior message and the interior is likely to fail as a retail solution. (Even today, there are always significant exceptions to the rule – SITE's showroom fronts for BEST, Sacramento, say little about the merchandise within, and yet are exciting pieces of architecture and design whose images are revered among retail designers.) Generally, there can be useful improvements to storefront presentation with better windows or lighting, or even the installation of a better sign, but there are a great many examples of the cynical application of "designer" graphics on the exterior, substituting for meaningful retail design or any genuine identity. Customers may be initially attracted, but if they discover that the store is not what it seems, they are likely to leave, seldom to return. Equally important, the store exterior can even turn away shoppers who *would* be attracted to the merchandise inside, if the storefront itself was not offputting.

FAÇADES

The exterior communicates its message through many elements: the windows and the character of the window displays, the nature of the entrance, views to the interior, signs, and the materials from which the entrance itself is constructed. Each of these elements needs to be consistent and harmonious with the others. A luxury jewelry store may appropriately have a marble storefront, but if crudely lettered signs are

used in the windows, few shoppers will believe the refinement implied by the marble. But how does a designer go about deciding what an appropriate storefront might be? To avoid a disjunction between interior and exterior, the design of the outside cannot be considered in isolation. Without a coherent notion of the store's merchandising policy, and a considered approach to the interior, the designer cannot develop the exterior. But if the design has reached the stage where these things are known, there are some specific considerations that generally apply to the outside.

First, designers need to take account of the surroundings of the store (or stores, in a chain). Indeed, it could be said that location is the most important aspect of retailing. Since this book is about retail design, and not retailing, a detailed discussion on choosing a site for a store is not appropriate, although it remains one of the most crucially important commercial decisions for any retailer. But designers should be conscious of the store's local environment, and what is likely to be suitable and acceptable – or unacceptable. Designers will need to be aware of local issues, pressure groups, regional and architectural characteristics, and any relevant planning laws. The number of locational factors that go into a design means that good retail designers should "think globally, but design locally." No design should be offensive in its visual relationship to its neighbours, or to the building within which the store sits, but, equally, every retailer wants to be noticed – indeed, this is the essence of retail design. The exterior design needs to fit somewhere between these two demands. For the single store, this task is challenging, but for the chain store it poses particular difficulties. A chain store will inevitably have sites in many different contexts, yet it needs to have a common identity in all of these surroundings. It does not necessarily follow, however, that the storefronts should be identical. In order to cope with different situations – a shopping

The entrances to some stores are effective because they violate convention. At Maxfield, Los Angeles, shown previous page, which was designed by Larry Totah, the forbidding blankness of the exterior suggests exclusivity: "If you don't know what the store holds, you shouldn't enter." In fact the avant-garde clothing store is reached across the concrete patio and entered through stark steel entrance doors. (*Photo:* © Anne-Marie Dubois-Dumeé)

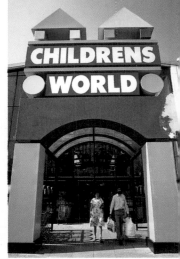

A very different approach is taken at Childrens World (above), designed by FitchRS. At its out-of-town sites, the grand, ceremonial arch acts as an entrance signal to motorists. The overscaled child's building blocks that make up the arch clearly communicate what might be found inside.

At Tokyo's No Brand store (left), designed by Takashi Sugimoto of Superpotato, the generic merchandise can be seen through the full-height display windows. The glass front and simple illuminated sign are consistent with the store's direct, "no-brand" image.

On a featureless and disorderly street in Tokyo, the clothing store Gallery of Lanerossi, shown opposite, demanded a striking exterior to attract attention. Designer Yasuo Kondo has created an H-framed entrance, with a sculpture of steel girders, plates, and red-painted pipes, projecting outwards into the street and inwards into the store (*Photo: Hiroyaki Hirai*)

mall, a traditional main street, or a modern development – some chains develop a family of exterior solutions, used for each case as appropriate, with perhaps only the lettering on the sign remaining the same from the outside. If, however, the choice for a chain is to keep one storefront for every situation, a versatile, adaptable exterior solution is essential – although this risks the result being less distinctive.

The design of the exterior starts with two basic decisions: first, how open or closed should the design be, and second, should the storefront project or recess? The extreme of the totally open design can be seen in many enclosed shopping malls, where stores may literally have no front (see the Eaton Centre, Toronto, page 186). Instead, the store is completely open to potential shoppers. With no barriers such as windows, walls, or doors, this type of storefront should, in the abstract, be the most inviting form of design. But it is also the most anonymous: other than the sign above, and the character of the fully exposed interior, it becomes difficult to imprint an image on such a completely open space. At the opposite extreme, the closed design such as that at Maxfield, Los Angeles, can have tremendous character. But it clearly signals to shoppers that unless they have the confidence to shop there, they should not enter. A closed storefront can deter browsing, though it may encourage window-shopping if the displays are good.

The choice of a recessed or projecting storefront is equally basic. A recessed storefront offers protection from the weather and acts as a funnel, drawing shoppers into the store (see Görtz, Kiel, page 127). A projecting storefront intrudes into the street or mall, announcing the presence of the store directly to shoppers. The choice of projecting or recessing obeys no formula; what is more important is that a design

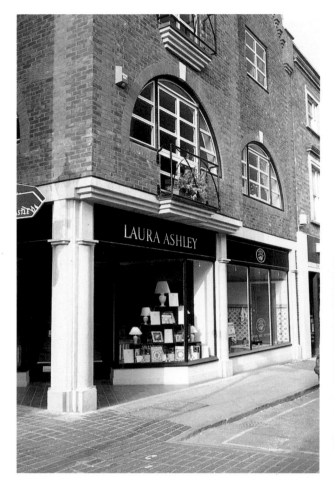

Laura Ashley implements a common identity at its sites worldwide by using its distinctive dark green hardwood fascia and classical serif lettering. Designed by Northwest Design Associates, both the Farnham (below) and Winchester (above) stores in the UK have been sensitively integrated into older buildings, without becoming unnoticeable.

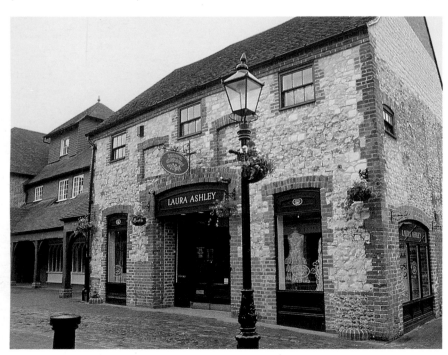

should differentiate itself from its surroundings. Hence, if every other store on a street has a recessed front, a projecting front will differentiate the store in question. There are of course variations. A retailer can have a recessed store at sidewalk level while the fascia juts out above the shopper to provide contrast, weather protection, and a projecting sign (see Top Man, London, page 95), or the storefront can be open, with a projecting fascia. In some Japanese shopping centers and department stores there are no storefronts, no fascias, no doors, no security screens. The only demarcation is provided by a line drawn on the floor, a change of material at the operative point, or perhaps a step. But this approach is only possible in cultures where customers are extremely honest.

A store's identity can be projected into the street or mall in other ways too. Since most stores are approached at an angle and seen in perspective, a projecting sign is an effective device to advertise the store. When done well and sparingly used, such signs are useful to the customer and add articulation to the general scene. Erected in a haphazard, irregular fashion, however, these signs are self-defeating and become the principal ingredient of visual pollution. Projecting signs come in a variety of forms. They can be standard, pressed box signs of metal or plastic, internally illuminated; alternatively, neon can be used to great effect, while carved and painted wood panels

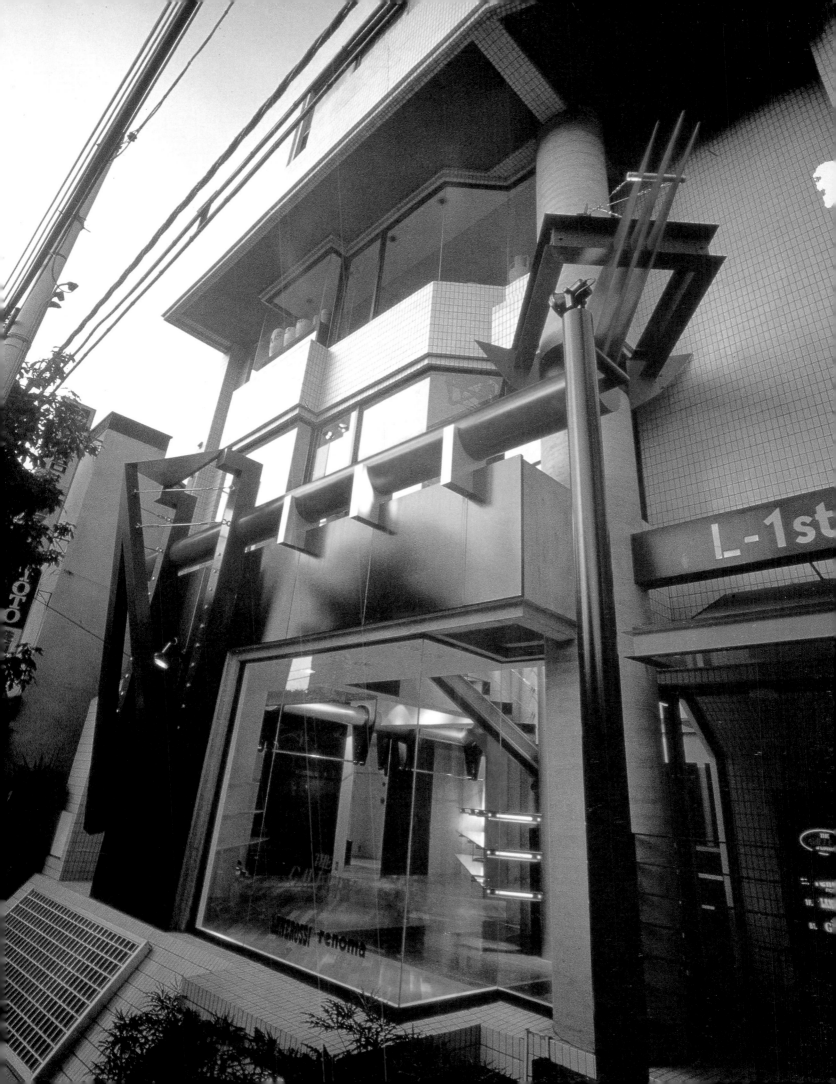

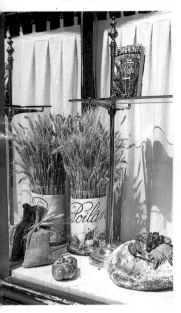

The most traditional of window displays, shown above, is appropriate for Poilâne, the "grandest" bread store in Paris. The marble base and glass shelf, which were installed in the early 1960s, are backed by a simple white curtain, allowing for easy access to the displays from inside the store. (*Photo:* J. C. Martel)

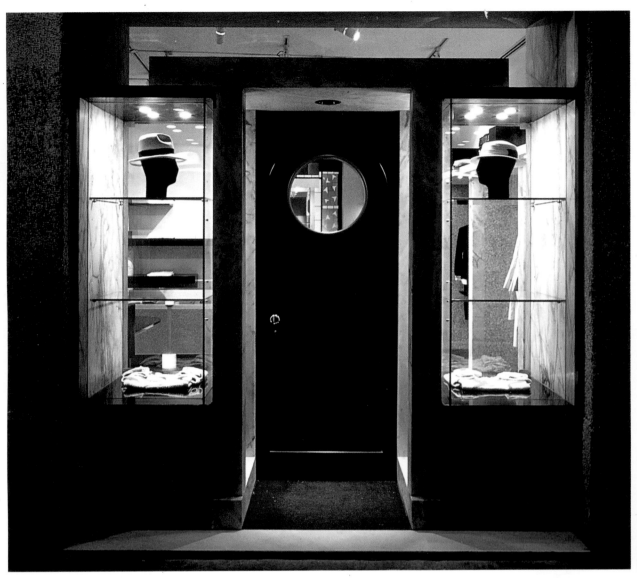

The open-back display windows and glass display shelves at Marisa Lombardi, Milan, Italy (above right), designed by Sottsass Associati, allow some views into the store. The porthole window in the door is not only an unusual feature but also makes the approach more tantalizing. (*Photo:* Santi Caleca)

Shown below right, Oliver, in South Molton Street, London, designed by David Davies Associates, is fronted with an awning, which, though projecting into the street, is nevertheless discreet. The completely open-backed windows make the views into the store an important feature of the design. The metal-studded solid timber door is flanked by the display window, which has sculptured torsos on twisted steel bases to serve as mannequins. (*Photo:* David Davies Associates)

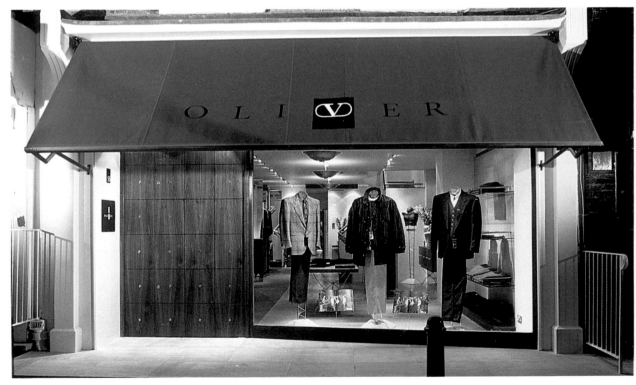

can be decorative, and, in the right context, very appropriate. Historically, pictorial signs arose from the storekeeper's need to identify his location and trade in the times before universal literacy. So a carved mortar bowl and pestle indicated a pharmacist, a sheaf of corn a baker, and so on. Today, such signs can be distinctive in a long street, or aid recognition at a distance. Awnings and canopies can also help with identity, as they traditionally carry the store's name, as well as protecting shoppers from the weather and shielding store windows from the glare of direct sunlight. These are often made from canvas, but wood, metal, glass, and plastic are also increasingly used, particularly in northern climates. The façade of the supermarket Grand Union, Wayne, New Jersey (see page 225), has adapted the look of an awning, to great effect.

The display windows are the main element of most storefronts. No matter how open or closed a storefront is, the windows are the primary means of giving passersby an idea of what they can find inside. The windows act as the stage sets and "menu" of the store, and they will generally be changed more frequently than other displays. There are two basic choices for display windows: closed- and open-back. Closed-back windows create their own display environment, where the setting can be rigidly controlled (see Poilâne, Paris, opposite). In addition, a closed back will usually allow for some additional stock or display space inside the store, on the reverse of the window enclosure itself. These windows require a high level of display expertise, and designers should be aware that window display teams are expensive. Equally, displays are not always appropriate for smaller stores or chains. But when windows are well dressed they can be an entire attraction in themselves – Selfridges in London, for example, is famous for its Christmas windows. Such displays improve not only the store, but very often the streetscape too. And for department stores, window displays can play an essential part by showing what different types of merchandise are available. But closed backs also conceal what could well be the best attraction of a store: views to the inside. Since the open back allows the store itself to create interest, some designers and retailers prefer its use. An open back has the advantage of allowing glimpses, in the interior of the store, of a far wider range of merchandise than a window alone can display; also, space taken up by window displays is often better used for merchandise. Real, live product, merchandised right up to the glass line, creates a sense of immediacy as well as providing selling footage. And the sight of people participating in the buying process is a great incentive to potential customers. In fashion stores it is sometimes possible to get the best of both worlds – display mannequins in the window are often replaced today by mechanical or stylized devices that enable merchandise to be hung or laid flat, occupying less of the valuable space, that are much easier to maintain, and also allow views through to the store beyond.

ENTRANCES

All the devices of the façade are preludes to the entrance itself. Except where the openness of a store is a design feature, there should be some sense of transition from the public world outside to the special world of the retailer inside. A good designer not only makes an entrance as noticeable as possible (shoppers should not be confused about how to get into the store), but also an event in itself. In many situations stores can function without doors, and designers should consider carefully whether a door is actually needed, since it creates a definite, visible barrier to entry, even if its opening is electronically controlled. If the decision is made to use one, it needs to be appropriate: a massive, solid wood door might be right for a select fashion store, for example (however, the needs of the disabled and infirm must be remembered: the weight of a door, both real and imagined, can be a big deterrent to entry). Some storefronts question the relationship between outside and inside: the door of the BEST "Notch" showroom in Sacramento, California, is a sliding corner of the brickwork itself. In fact, in many cases there is a direct relationship between the need for a door and the level of "spend" in a store: the more exclusive the store, the more a door is needed to communicate that exclusivity rather than for security. And there are many types. Swinging doors are side-hinged, usually made of glass, with a frame of wood or metal (although clear tempered glass allows swinging doors to be made without a frame). Side-sliding doors usually open automatically and slide into a side recess. But the side recess can use up valuable space around the entrance. Pivoting doors are a space-saving alternative (see Domain, Massachusetts, page 143). Revolving doors are excellent for keeping out the weather, but they have the disadvantage of being extremely expensive, and present a problem for those in wheelchairs. In addition, in most places revolving doors are not allowed as fire exits, so an adjacent manually operated door is also necessary. Heated entrances are really doors without doors: a wall of heated air is blown over the entrance, keeping cold weather out of the store. While this is often much appreciated by customers, heated entrances are inefficient in energy terms, although the hot air can be recirculated back into the store if necessary. Finally, both the type and the positioning of door handle or door push should be thoughtfully considered – again, especially where the disabled, and those with armfuls of shopping bags, are concerned.

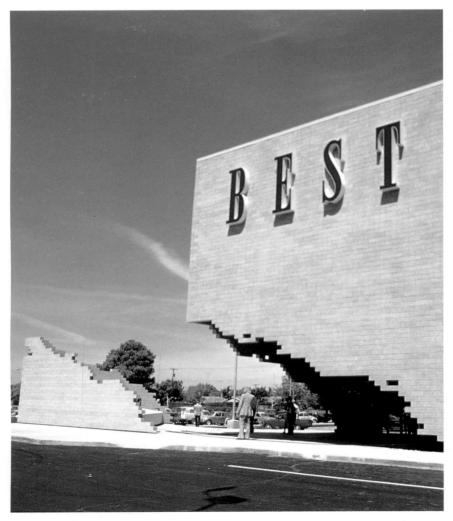

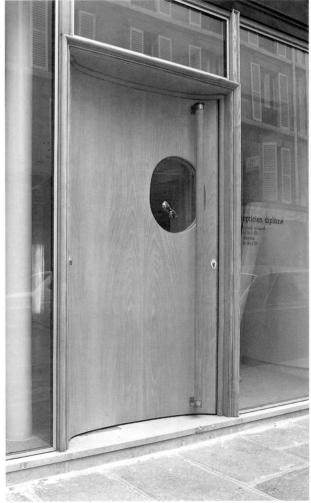

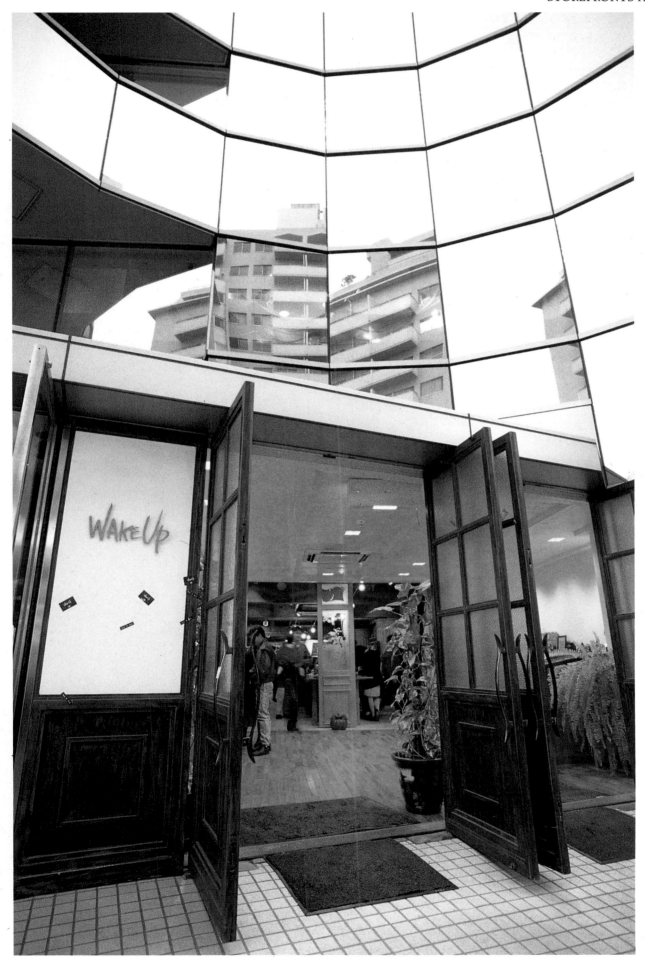

Wake Up, Tokyo, designed by Kinnue Kondoh, has an entrance that conflicts visually with its context: the modern, anonymous mirror-glass building is entered by traditional, glass-paned, bronze-painted aluminum doors. But tradition does not necessarily suggest exclusivity – the ability to fix the doors open invites customers to enter and browse. (*Photo:* Benjamin Lee)

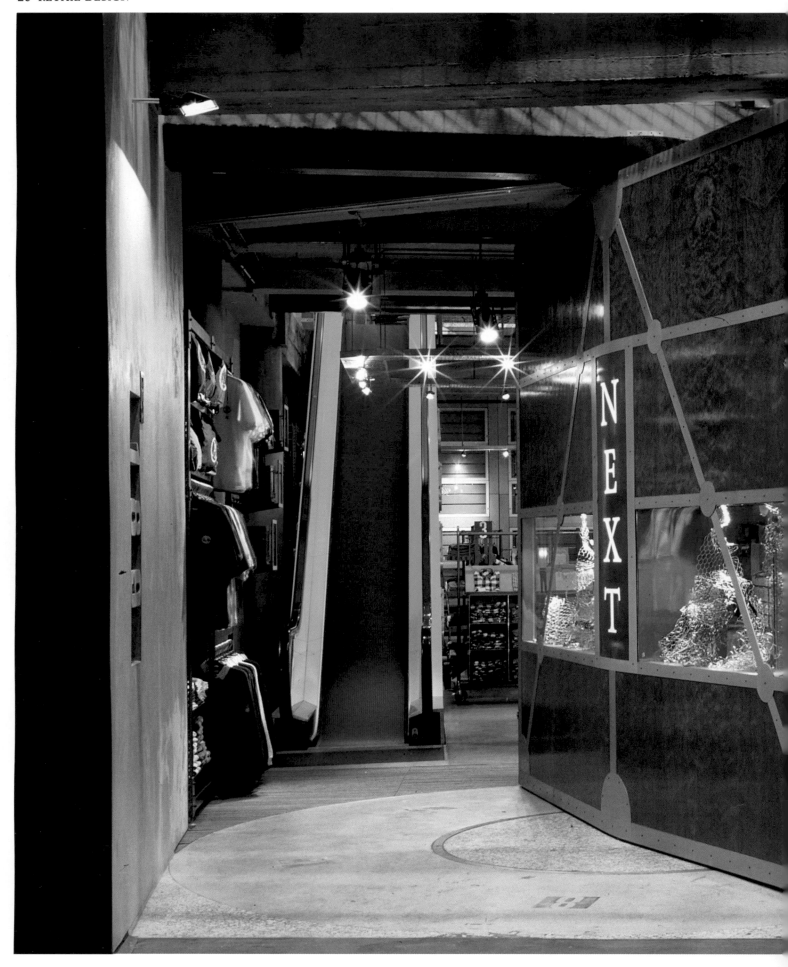

The door itself can become a major feature of the design. At Department X, in London, designed by Din Associates, a vast aerofoil-shaped pivoting door, with integral display windows, promises an unusual experience inside. (*Photo:* Din Associates)

In 1987, the Conran Shop (opposite), designed by Conran Design Group, moved to premises in the landmark Michelin Building, in the Fulham Road, London, after extensive renovation and restoration of its unique façade of Art Nouveau tiles and mosaics. The entrance from the Michelin Building has been designed to be in keeping with the setting to preserve its original character, with clean rectangular lines and floriated decorative panels. (*Photo:* Conran Design Group)

An innovative use of materials is key to the design of clothing store Giada, New York, developed by architect Steven Holl. The door and surround – the work of three metal craftsmen – are of ⅛-inch thick (3mm) brass plate, with a specially created patina. The pushplate resembles a peeled back sheet of the brass. This costly but unusual feature is illuminated for display at night. (*Photo:* Mark C. Darley)

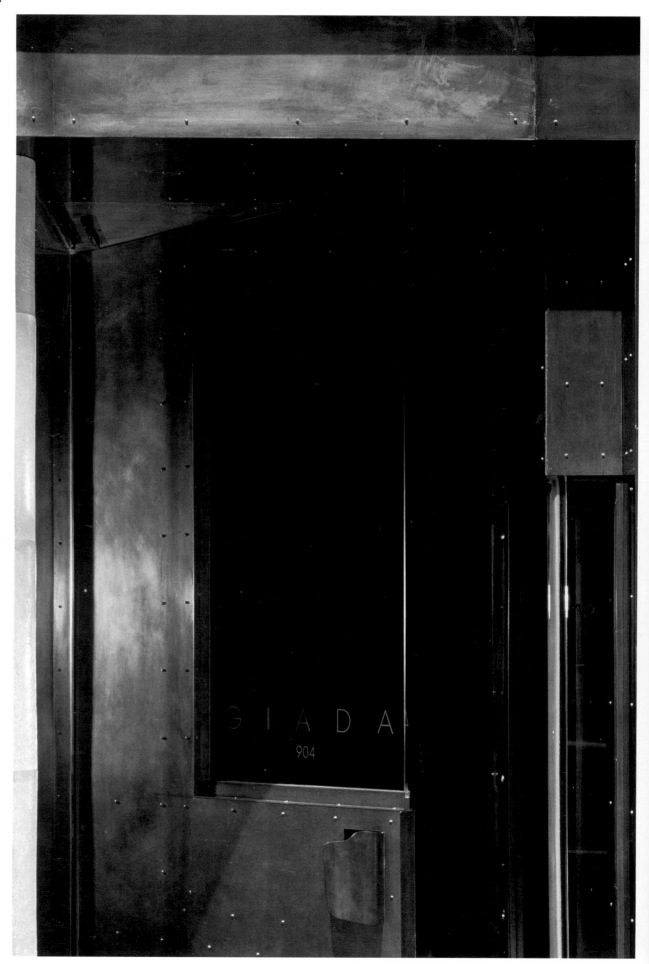

MATERIALS

The choice of materials for the storefront conveys much about the image of a store. Although materials can be used in such a way as to defy their associations, for the most part they are a clear signal of design intentions. The use of stone, marble, or granite, for example, suggests a solid and enduring quality for the store; in contrast, stainless steel offers an image of contemporary, mechanistic, and perhaps transitory style. Wood, traditionally a much-used material, has been a less frequent choice for storefronts in recent years; however, it is now regaining popularity. Its many varieties and adaptability in construction allow wood to serve many ends – it is very versatile and can be shaped to suit any design. Most woods, however, need fairly consistent maintenance such as painting and polishing to prevent unsightly weathering. Metal storefronts require less maintenance, and aluminum in particular is extremely cost-effective. But the widespread use of metal, which generally consists of standard parts, means that one store can look pretty much like another. More expensive metals, such as bronze, brass, or stainless steel, convey an image of excellent quality, but the initial capital investment is very high. However, no materials are maintenance free. Glass is the other main material used for storefronts. Transparent glass is unparalleled for allowing views of merchandise and store interior, and virtually all storefronts use it; however, other forms of glass, such as glass blocks or opaque or translucent glass, can be considered as possible design alternatives, perhaps to introduce an element of surprise, or striking discordance with the rest of the design.

The creation of a memorable experience for the customer must be a prime objective for the retail designer – a storefront that not only serves the retailer's culture appropriately, but is the starting point in differentiation. Yet to do this within the strictures of planning and zoning legislation, good architectural manners, and efficient economics, is not always the simple task it may seem at first.

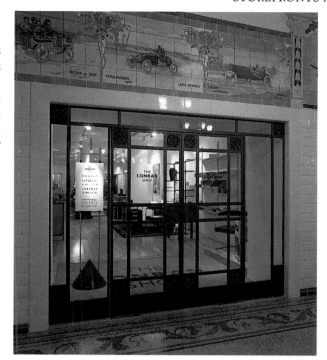

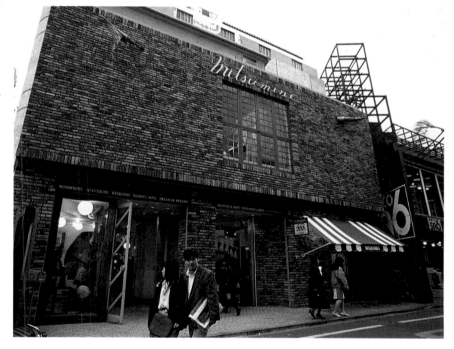

At Tokyo clothing store Mitsumine (below), designed by Kinne Kondoh, discordance creates interest, with the use of brick, unexpected in Tokyo, and the meaningless English phrases above the entrance. The imitation lead-paned window on the upper story adds further reference to English culture, while the "meaning" of the strange metal projections (furled flags?) is not so clear. (*Photo:* Benjamin Lee)

In the entrance hall at Mitsubishi Bank, Tokyo, designed by Fumihiko Maki, a traditional Japanese screen is created from modern materials: glass blocks, a sealed window unit, and plaster walls. The green, leafy landscape surrounded by the opaque and anonymous front creates an intriguing focal point. (*Photo:* Monma Kaneaki)

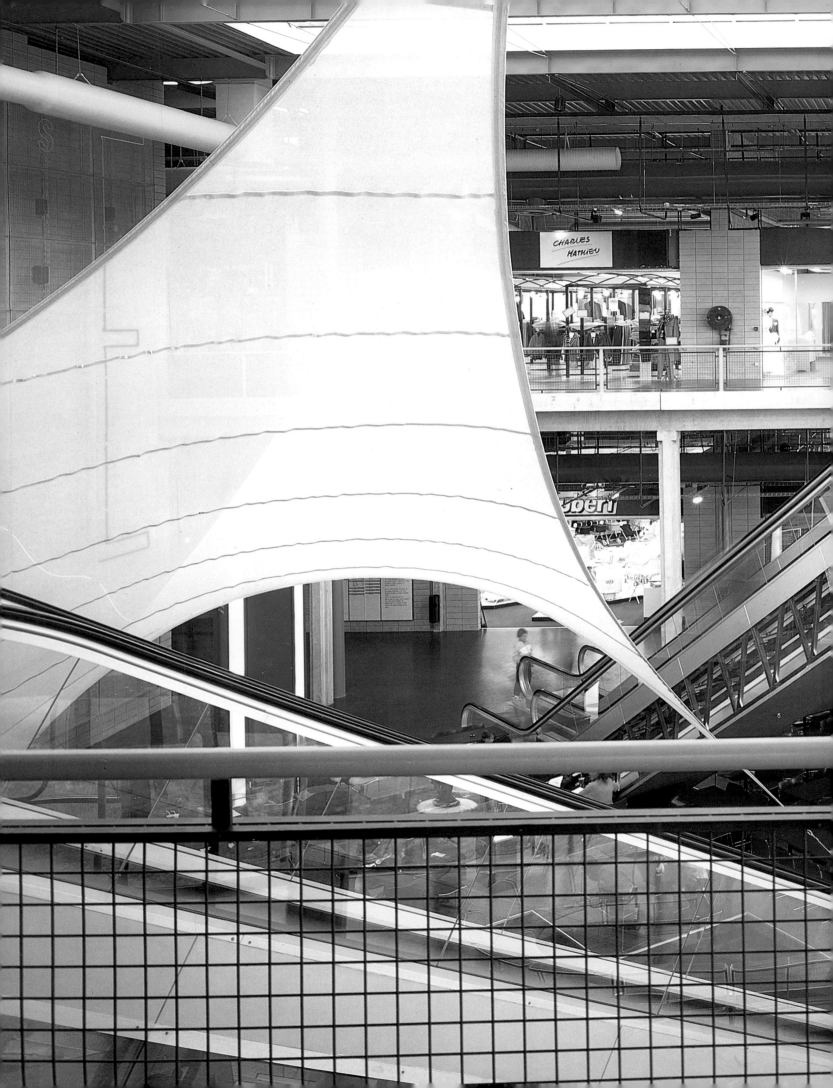

PLANNING AND CIRCULATION

Planning and circulation are possibly the most essential aspects of the retail designer's job. But their importance is concealed by the nature of the task: when done properly, the planning and circulation should, in effect, be seamless and invisible to the shopper. The planning should have a transparency that allows the store to work well, guiding and helping the shopper through the space naturally, without confusion. For the retailer, appropriate planning will help the store to run and operate effectively, without the design "getting in the way." The designer's task in circulation is largely functional: moving people through and around the retail environment. In crude terms, the purpose of circulation is delivering people to the merchandise in the store. Again, good circulation will work unobtrusively – no shopper likes the feeling of being herded around the store, but shoppers do appreciate being helped by logic, convenience, and visual recommendation.

Store planning and layout are influenced by a wide range of factors, among them, size, type of store, variety of merchandise, building regulations, number of staff, and expected flow of customers. Most designers start with an architectural assessment of the store infrastructure: the entrances, stock and service areas, staircases, fire exits, and so on. Onto this, they overlay the client's first thoughts on the ideal sequence and relationships between different departments and areas – the "adjacencies" and positional hierarchies. Many of these factors will be specifically considered in Part Two. But there are a number of points that apply no matter what the retailing situation. The aim of planning can be simply stated: to use space effectively and efficiently. Planning is about achieving function; other aspects of design concentrate on form or aesthetics, which is why design and planning are sometimes seen as separate functions. In fact, of course, no part of the design processes should occur in isolation – planning is not a dry exercise, divorced from considerations of retail identity. But in a well-planned store, it should be possible to strip away the imagery and still be left with a coherent basis for the design – good planning should always work well, regardless of surface identity.

BRIEFING

Before a designer can embark on planning a store, a planning and design brief is essential. The brief provides the essential information, the framework on which the design will be built. Briefs are necessarily of widely varying complexity: from the concise outline of cost, concept, and anticipated program, to extensive documentation, detailing numerous retailing and operational requirements. A brief is best formulated by both the designer and the retailer working together – the designer's job is to ask the right questions, the retailer's to let the designer know as much as possible about the business and the merchandise. Honesty and openness in these discussions are crucial in order for both designer and retailer to be able to assess and evaluate the work involved. The first step in formulating the brief is to ask, "What do you want to achieve and how can success be measured?". The brief should continue by defining the customers: their age range, sex, income level, geographical mix. This information is vital, because every step of a retail design must be taken with the customer in mind – appealing to the appropriate, targeted customer is the overriding goal. In addition, any brief will need to consider what merchandise will be sold, the character or style of the merchandise, how it breaks down into product groups, what percentage of the store area needs to be devoted to each group, what the expected sales per unit area are for each category, type of service to be offered, and so on. Information in itself will not guarantee a successful design, but lack of it may lead to failure.

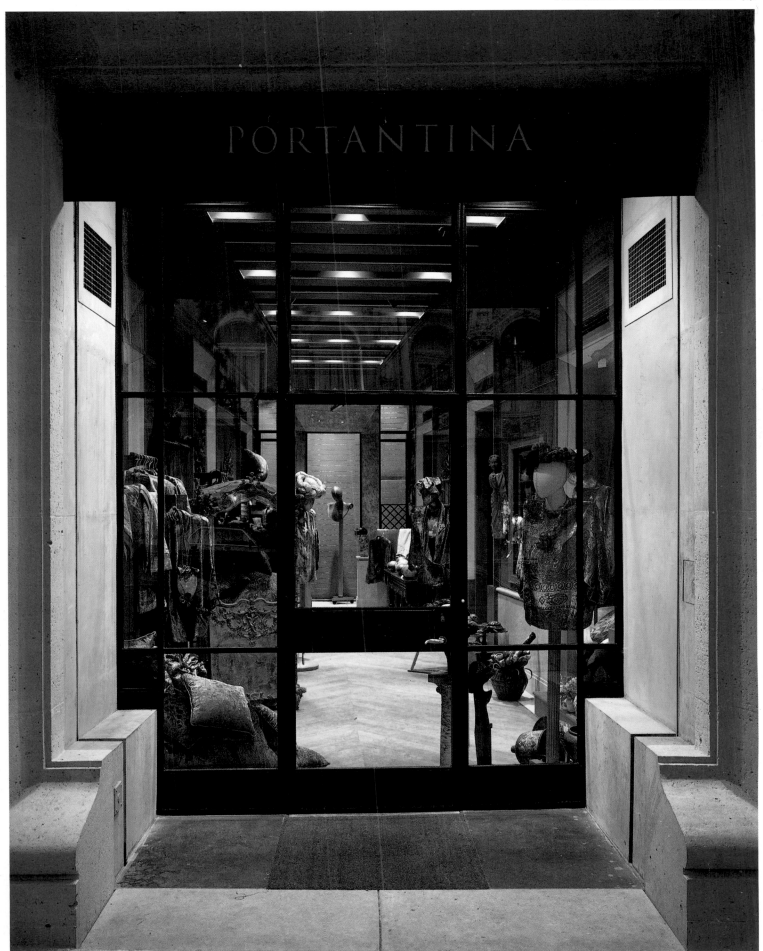

Vessel Port ETD ETA Contents

From the entrance at Crate and Barrel, San Francisco, the double-height space allows views around the store. The use of pine and white formica is instantly recognizable as "Crate and Barrel". The store is planned around merchandise rather than merchandising. Crate's policy is "to put the stockroom in the showroom and light everything with spotlights." (*Photo:* © 1986 Bob Swanson/ Swanson Images)

PLANNING

With this logistical data in hand, together with a knowledge of the store's cultural context, the retailer's philosophy, and the identity that needs to be projected, the designer can begin to plan the store. The store plan itself is based on six principal requirements: interior traffic flow (circulation), placement of merchandise, visual merchandising and display, lighting, security, and storage. In large stores, consideration also has to be given to location and adjacency of departments. All of these topics are dealt with in detail later, but a few basic points can be made here.

The placement of merchandise needs to be determined by the retailer's priorities, which almost certainly will change with time. There needs to be a specific "attitude" to merchandise so that adjacencies of stock and the presentation of merchandise are carefully planned and consistent with the store's merchandising policy – whether products are grouped by category, or as coordinated packages, or by size, and so on. A design should provide appropriate areas for merchandise. In larger floor plans (such as department stores), the relationship of the circulation routes to the size of the departments themselves is particularly important. For example, there are optimum depths to departments when they are approached from a walkway. If they are too deep, customers are intimidated. If they are too shallow, customers will ignore the front merchandise and go straight to the back, or worse, will see the department "at a glance" from the walkway and simply keep going. What is needed are good-sized square blocks of merchandise with sufficient frontage to appear as a department and sufficient depth to encourage people off the walkway. This is not always possible, and sometimes subsidiary methods of circulation are required, acting as "feeder" routes from the main walkways. Designers should ensure that these subsidiary routes are not choked off by bad planning or encroachment of merchandise.

Within the merchandising areas, the planning will have to provide space for visual merchandising and display. Depending on the product, this might involve an area that requires special presentation facilities: additional lighting or other services, a higher ceiling, or particular security systems, for example.

It is at the planning stage that the most important contribution to security can be made. The design should ensure, wherever possible, that sales staff have unobstructed views in the store (without creating too oppressive an atmosphere). Where views are necessarily blocked, mirrors, facilities for additional staff, and, of course, the paraphernalia of modern security equipment, can all be integrated effectively with the design. As regards lighting, it is important to note that because of both the importance of lighting itself and the practical difficulties of incorporating lighting fixtures in an interior, a lighting plan should generally be devised at the same stage as the floor plan. It is also at this time that any storage requirement should be taken into account. This is to some extent a negative task: the space not needed for storage (and other ancillary facilities) is what is left for the public area of the store. In determining this balance, the incentive to think creatively about the hidden parts of the design, such as storage, may become clear. In small sites, in particular, the designer's most valuable contribution may be in finding a way to reduce the space taken up by storage, or develop "off-site" stock-holding facilities, without hampering the store's operations. In these situations it may be best to follow the maxim "stock on the floor is stock for sale," reducing extra storage to an absolute minimum and finding ways of concentrating merchandise in the selling area.

Small stores pose particular problems in planning and design. The general rule to follow in smaller spaces is the KISS principle: Keep It Simple, Stupid! There is no room for complication of circulation or merchandising. So the most effective small schemes will use a basic layout, organized around the perimeter or with some central focus of attention. In a small store, in fact, the importance of this focus is increased. Without the apparent variety of a larger store, customers must be attracted by emphasis on the particular niche of the retailer.

Constricted spaces can make the planning of services especially difficult. Again, simplicity is the key: a complex arrangement of merchandise might necessitate expensive and space-consuming routing of wiring and force an excess of light fittings to cope with display. Small spaces suffer, too, from problems of heat build-up. Any electronic equipment, lights, and, above all, people, will generate considerable heat in a small space. Thus adequate ventilation will need to be considered in the design.

Some aspects of planning and design are of course simplified in the smaller store. Lack of space will

eliminate many design decisions: there may virtually be only one way to plan a particularly small store. But designers must be conscious of the dangers of cramming too much into a small space. A balance must be struck between the delight of abundance and the distinctly unpleasant experience of lack of room created by retailers in the mistaken view that an overstocked store says "merchandise authority" but is rather the result of a lack of confidence. Neither customers nor staff will enjoy feeling crowded out of a store by constricted circulation areas or overflowing merchandise.

It is easy, however, to view small stores as special cases, requiring solutions and viewpoints considerably different from larger stores. But the design guidance in this book can apply throughout the spectrum of retailing. Scale and ambition may have to be modified, but the principles generally remain the same.

One aspect of planning and circulation that needs proper consideration right from the start is access for the disabled and infirm. Other groups also need special thought, such as the elderly, parents with young children or babies in strollers. Much criticism can be levelled at architects and designers for an unthinking attitude in this regard. It need not spoil a design, nor add substantial costs to a project, to include reasonable and effective circulation and access for these groups, enabling them to enjoy the shopping experience, too. One solution is to use steps with permanent alternative ramps, or slopes in place of shallow steps. An elevator in an accessible position should be provided as an alternative to stairs and escalators, except for short vertical journeys. Steps between the circulation routes or the stores and departments themselves should be discouraged. After all, there is no point in providing easy access to a shopping mall only to make access within the stores themselves difficult. A final point: in considering disabled access and circulation, access from the parking lot is as important as it is inside the store itself.

Fizzazz, New York, uses the unusual circulation device of an entrance-level walkway, with most merchandise on the level below. But it does conform to a basic rule of circulation, in allowing shoppers a readily understood view of products and general layout.

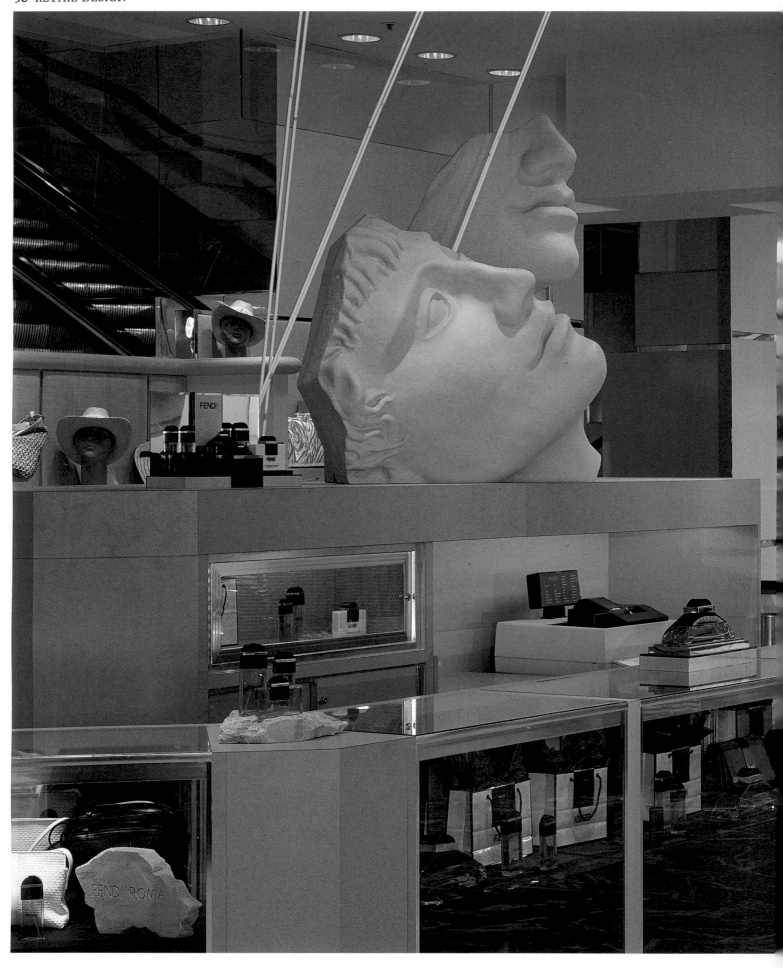

The circulation system at Bloomingdale's, Boca Raton, Florida, designed by the Walker Group, brings the customer from the entrances directly to the central atrium, where escalators link into the vertical plan: on the main floor the circulation pattern is defined by the marble floor around central counters. The merchandise areas are further differentiated by the ceiling bulkheads following the articulation of the display counters. (*Photo:* John Wadsworth Photography)

CIRCULATION PLANS

Within the store, there is a limited number of ways for shoppers to move: front to back, diagonally across, and from side to side (and, in multilevel stores, up and down). Planning the circulation of a store involves both catering to and determining these movements, based on the expected pattern of customer behaviour. Circulation must be made simple: a retail environment in itself contains enough challenge and interest for the shopper, with merchandise, displays, and people, without a complex circulation path that only distracts and confuses the customer. Simplicity also demands a certain generosity; narrow aisles create congestion in the store, forcing the shopper to worry about moving through without bumping into people or merchandise. And designers should always remember that the paramount purpose of achieving good circulation is to deliver the shopper to the merchandise. Just as seasoned scriptwriters may wearily state that there are only half-a-dozen plots that are endlessly recycled, so it can sometimes seem as though only a small number of basic circulation patterns exist for retailing. In practice, of course, circulation can be endlessly varied. But it may be helpful to consider a few basic approaches.

The **straight plan**, as the name implies, provides for the shoppers to "shop the store" with direct access from front to back. Walls are used for stock, as are floorstanding units. This most basic of plans can be enlivened by projecting walls, or the placement of display units to divert circulation. Straightforwardness has its retailing virtues: the simplicity of the straight plan encourages shoppers to move to the back of the store, particularly if they are lured by signs or special promotions or features.

Sweet Factory, London, designed by Michael Peters Retail, uses the straight plan effectively. Perimeter units carry most of the "pick and mix" candy, but an attractive concentration of red units on the back wall draws shoppers through the store.

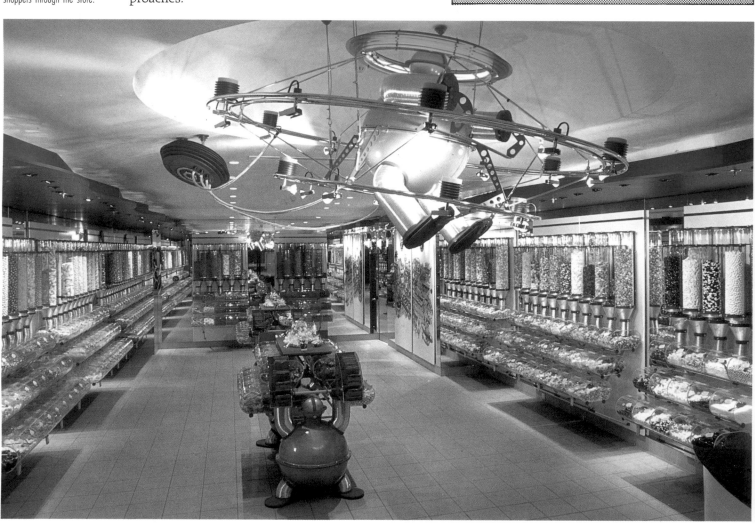

The "racetrack," walkway, or **pathway plan**, common in larger stores, consists of a distinct circulation path that moves shoppers through the store. The pathway may be defined by differing floor materials, changes in the ceiling treatment, or even just a clearing of display units. In department stores pathways are a frequent circulation device. Shoppers travel along a well-defined route, passing the merchandise-intensive areas until they see something that attracts their attention.

The **diagonal plan** immediately creates movement by defying the normal rectilinear grid of a store. The converging lines of a diagonal plan make it useful in situations where a focal point can be particularly helpful – for example, a cash-taking, service, or information desk in a central location, or a special display or feature.

Curved plans also encourage circulation, since curved walls suggest more movement than straight ones. But constructing curved surfaces can be expensive.

Vertical circulation is a further aspect that needs discussion. This is considered more fully in Part Two. But, generally, vertical circulation should be treated in the same way as horizontal: clarity and generosity of space being crucial. In a retail environment that functions on a number of levels, there is an additional factor of particular importance: the design must find ways of encouraging shoppers to move up or down from the entrance level, in order to support the business in these less popular parts of the store. So the means of vertical circulation should not be hidden, be they stairway, escalator, or elevator, but should be celebrated and planned in a prime position where they cannot be missed. And they should also be designed in such a way as to lure the customer to another floor. Thus a grand staircase, with views of the other levels, is better than a merely functional one. The same advice applies for an escalator or elevator. These are expensive, both initially and in terms of maintenance, but in most large modern stores, the escalator is used more commonly than stairs. The elevator is inefficient as a tool for moving large numbers of shoppers unless the store has many floors; however, it can be useful in more limited ways. It can be essential, as mentioned earlier, for anyone using a wheelchair, for older people, or for those with children, strollers, and/or heavy shopping bags, and is often preferred by elderly people.

CIRCULATION GRAPHICS

However careful the planning and circulation of a store may be, it is likely, particularly in large stores, that graphics will have an important part to play. Store directories will be necessary, strategically placed by entrances, escalators, and other vertical circulation routes. Customers will need to know exactly where they are in a store, and what floor they are on. Graphics should be used as a directional tool at every point of decision along the circulatory route, to help shoppers on to the next experience or opportunity. There, department or concession signage should tell customers that they have arrived. The *Graphics* chapter considers this subject in more detail.

Good planning and circulation within a store or shopping center is paramount. It is worth both designer and client spending a considerable time at the commencement of a project to get the first essential design task right. However, this is not always achieved at the outset. It is therefore important that retail space is planned with flexibility. The only truly fixed elements should be those that are part of the structure – escalators, elevators, staircases, and so on. But time taken in planning the likely developments of the retail space will obviate the necessity for much change at a later stage.

Diagrams based on Barr and Brovidy, *Designing to Sell*, 1986.

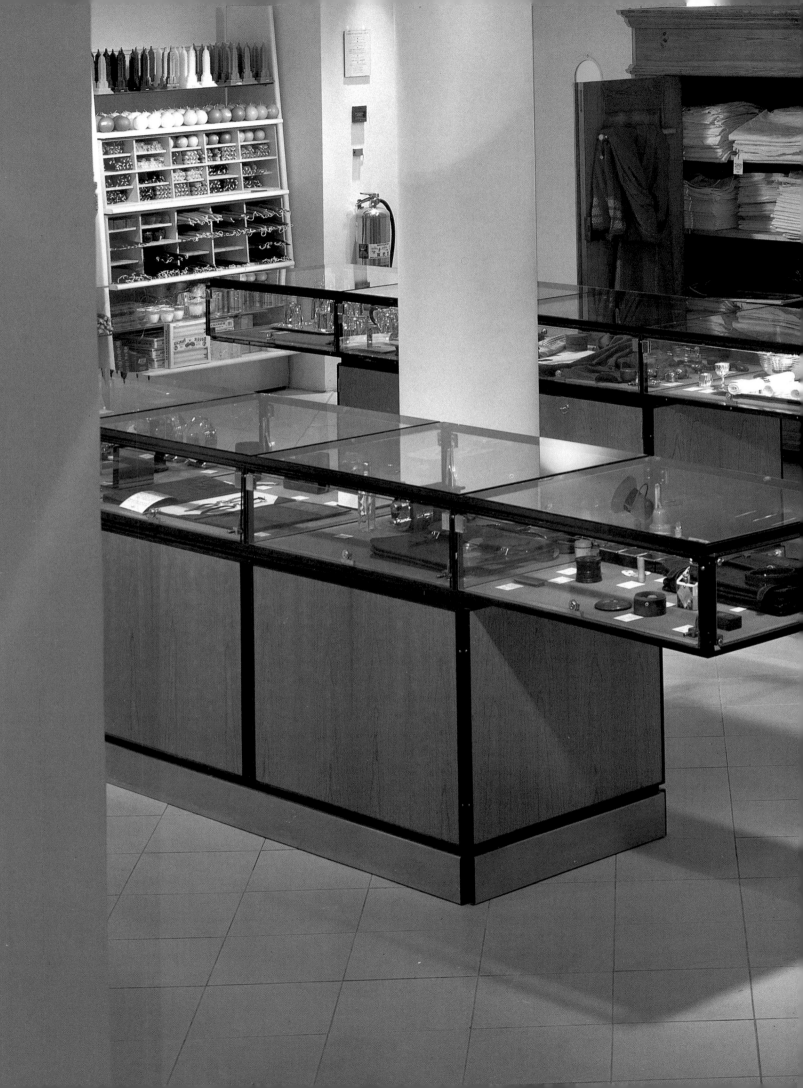

MERCHANDISING

Without merchandising, retailing cannot exist. Despite this, designers frequently neglect merchandising, concentrating attention on the many other (and sometimes easier) aspects of retail design, and leaving the merchandising largely in the hands of the retailer. But, having created an appropriate environment for the merchandise, the designer must also invent ways to display, present, and encourage the sale of the retailer's products, while coming to terms (in a design sense) with the realities of stock densities, equipment, and merchandise organization.

Given the many thousands of different products sold by retailers, generalizations about merchandising can seem somewhat futile. In later sections of this book, details of the best approaches for merchandising specific categories of product are discussed. But there are a number of considerations that apply to merchandising in all types of retailing. Since the merchandise is the *raison d'être* for any store, how it is presented is of prime importance in determining the character of any design. Designers should not treat lightly the choice of a merchandising system, or other forms of fixturing. The starting point is the product: what will make it appeal to the customers, how can it best be presented, what are the dimensional considerations, how many of the product are needed, will customers be able to handle it or does it need to be protected because of fragility or security, and how much flexibility is required? Some of these questions may seem obvious, but details such as knowing the physical dimensions and characteristics of the product are essential in order to design or specify appropriate fixturing. And it must be reiterated that the product is the key – fixturing does not have to be anonymous, but neither should it overwhelm the merchandise.

FIXTURING CHOICE

A basic choice will confront designers in merchandising: off-the-rack or stock fixturing (see Dean & Deluca, page 234), or custom-designed fixturing (a possible third category is product-specific fixturing, which is created by manufacturers for their own products). Most designers, given the chance, will opt for custom-designed fixturing. When done properly, this approach offers the advantages of uniqueness to the individual store and complete suitability for the merchandise. It can create a difference where, for example, a product range is similar to that of other stores; and, of course, it may also be designed to be more efficient than stock fittings: British retailer Burton's midfloor ziggurat fixtures were more space-to-density-efficient than any other standard fittings when first designed in 1977, and since then have been adopted for use in many stores.

Sometimes, special fixturing can itself be a major part of a store's identity: the neat fixtures for compact disks and records in W H Smith, Southampton, the bizarre elements in One Off, London (see page 145), and the colonial-style packing-crate displays and bamboo-surrounded fixtures in Banana Republic, San Antonio, are all good, if very different, examples. But it will also mean additional cost and time for the design, and, more importantly, some sense of "re-designing the wheel" for each project.

The use of stock fixturing, where the range of types and alternatives produced by manufacturers can be bewildering, will provide an appropriate and proven solution for many projects. With stock fixturing, some degree of customization is usually possible: changing finishes or materials, incorporating additional features, and "making to measure" some parts. Whether the fixturing is custom-designed or stock, care should be taken to keep the design as simple as possible. Stores must be able to respond to changes in the market, sales, and seasons. Inevitably the fixturing will be adjusted, moved to a different part of the store, or disassembled for later use. Thus it should be designed for easy use by untrained staff: if something is too complicated, it will not be used; if it requires precise adjustment, it will remain unadjusted. Similarly, flexibility can usefully be limited: a hanging rail will only ever be used in perhaps three positions, so an accompanying slotted bar that allows clothes to be hung six inches off the ground is a waste of design effort and money. Another aspect of simplicity is to

Sand-blasted glass shelves with integral low-voltage spotlights specially designed by ORMS, give Le Set, London, (above left) distinctive fixtures. The effect is to heighten the uniqueness of each product, emphasizing the visual strengths of the objects. (*Photo:* Padraig Boyle/ARCAID)

Effective merchandising need not be expensive. At Zabar's, New York (above), a visual cacophony of pots and pans hangs from butcher's hooks on rails. The stress is on quantity, with no design pretensions. A similar attitude is conveyed at the No Brand Store, Tokyo (left), although the designer's influence is far more evident. Long wooden shelves allow for simple arrangements of merchandise, and simple tables suffice for aisle display. (*Photo:* Peter Cook)

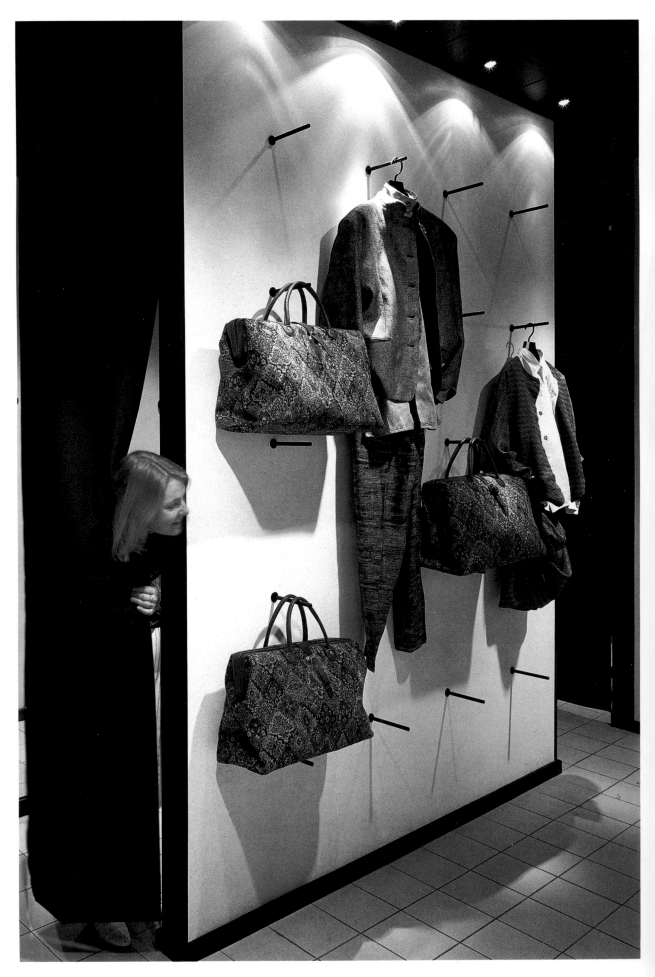

In a well-run store, simplicity in fixturing can be an opportunity for creative merchandising. At Joseph Pour La Maison, London, designed by Eva Jiricna, a wall between changing rooms has slots for twenty removable steel rods which can be used for hanging displays. (*Photo:* Peter Cook)

limit strictly the number of parts needed in any fixturing. Parts tend to get lost or misplaced in stores. The injunction of simplicity means that the much-lauded concept of versatility should be treated with caution. Versatility is often gained at the expense of simplicity (and at considerable monetary cost). The beautifully engineered units for Harrods' Way In, in London, for example, are "flexible" but could, if used wrongly, lead to confused merchandising. Thus, a system that can supposedly display clothes, household gadgets, and books is probably a system that will prove unworkable in a real retail environment. But versatility to some degree should not be ignored: see, for example, the comparable units in Cinderella 12, Tokyo (overleaf). Market responsiveness requires the flexibility to reflect both changing products and customer needs. Few retailers will find much use for a fixture that serves a single, narrow purpose, however well.

At Harrods' Way In, London, designed by Eva Jiricna and Future Systems, complex aluminum display units offer a wide range of construction options, as well as integral lighting. But the wheel-mounted units, which can carry several varieties of shelves, and other accessories, require alert, well-briefed store staff to avoid chaotic, unplanned merchandising. (*Photo:* Martin Charles)

Straightforward fixturing can be enlivened by using panels for illustrations and other graphics. W H Smith, Southampton, UK, designed by Peter Leonard Associates, uses similar units for compact discs, records, books and stationery. But illustrations and colours change with the different departments. Shelves can be slotted in at any point on the aluminum uprights. (*Photo:* Richard Bryant/ARCAID)

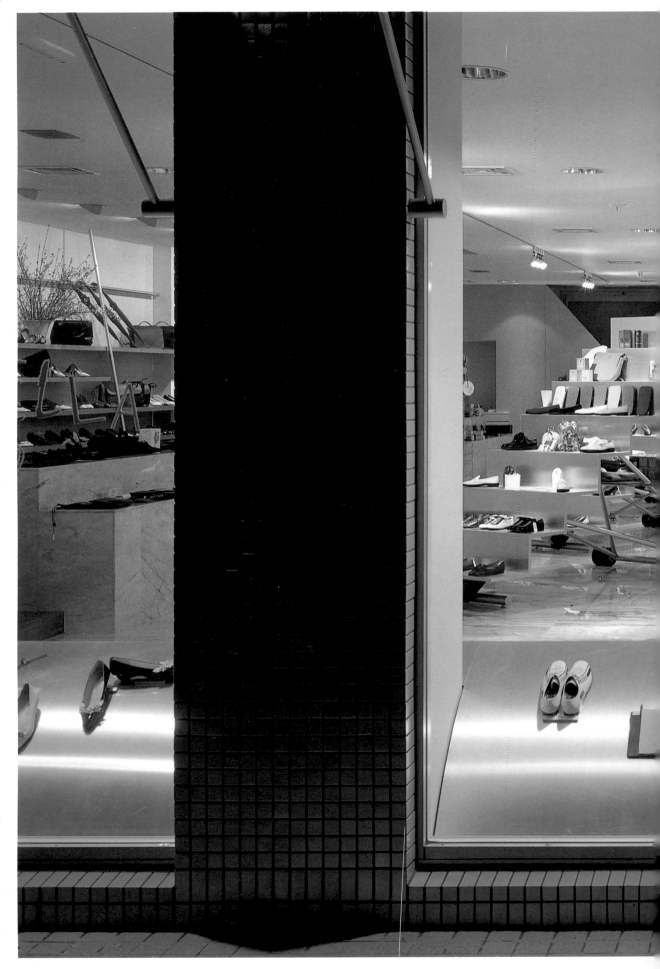

Cinderella 12, Tokyo, designed by Katsuhiko Togashi, has unusual but highly versatile units for displaying its shoes and accessories. A flight of eight steps is mounted on a wheeled structure, with a table fixed behind. Shoes and a small number of other items are displayed on the steps, while radios and other packaged products are arranged on the table.

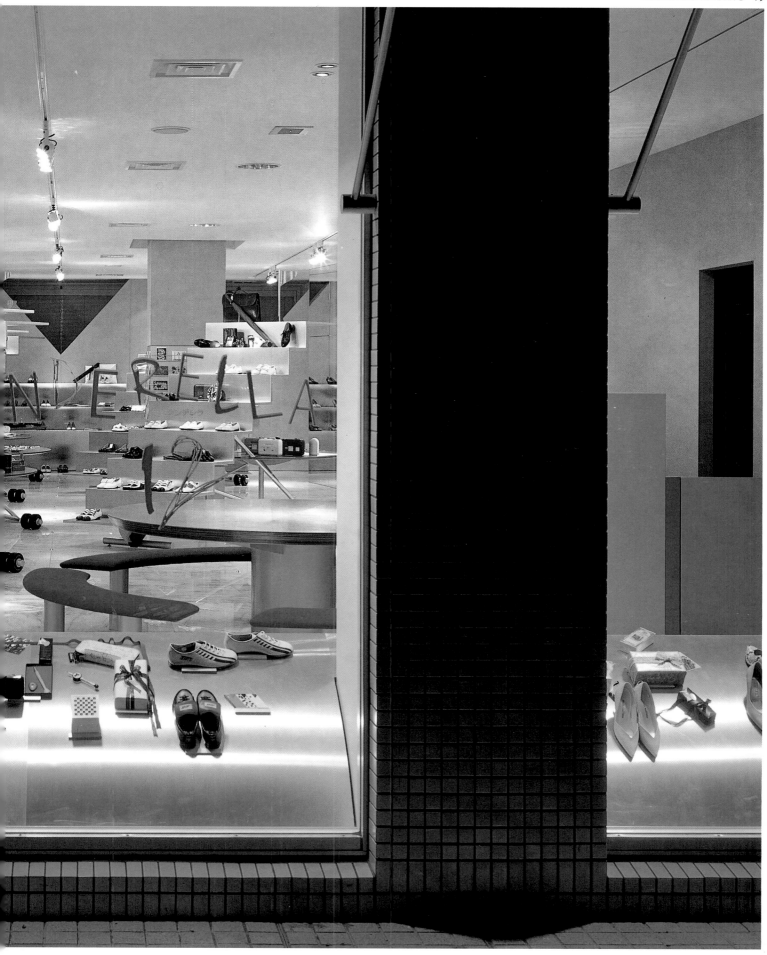

The costume jewelry at Törq, London, is not very valuable, but the glass display cases aid security as well as convey an aura of luxury and expense. The store, designed by Michael Peters Retail, however, also uses other fixtures where customers can handle and try on the jewelry without staff assistance.

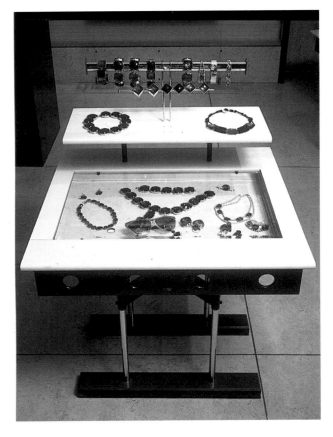

Interesting features can be made from otherwise standard equipment. At Yamamoto (right) in Sloane St, London, designed by Munkenbeck & Marshall, the rail itself is standard, but the visual interest is created with the almost sculptural web of black steel wire that holds the rail. (*Photo:* Dennis Gilbert)

At Top Shop, London (opposite), designed by Michael Peters Retail, perimeter fixturing can use three different levels of display, with graphics panels and two levels of both side- and front-display hanging. (*Photo:* Padraig Boyle/ARCAID)

POSITIONING OF MERCHANDISE

One of the first choices in fixturing is whether the merchandise is to be accessible or inaccessible to the customer. There may be a range of reasons why the merchandise should be inaccessible: security, danger, fragility. Security is the most obvious consideration. Small objects that are particularly valuable will have to be kept behind glass, or under constant sales-staff supervision to prevent shoplifting. Dangerous merchandise, such as weapons, certain tools, or, indeed, animals, similarly need to be kept out of reach. Fragile merchandise, such as rare books, china, or artwork, may need protection as well. But there is a further category that needs the same attention. Inaccessibility implies a certain exclusivity or desirability, so valuable wines, for example (hardly fragile, dangerous, or easily pocketed), may be kept behind lock and key. Many fixtures enable some form of access control. Display cabinets, which can be locked, are the most common. The display cases in the Conran Shop, London, provide security and also convey the idea that the objects are rare and precious. But inaccessibility can also be created by placing fixturing in a position where assistance from the sales staff is essential. Conversely, the height and ease of removal of merchandise where inaccessibility is not essential must be carefully planned, and in particular – where possible – the disabled shopper (especially those in wheelchairs) borne in mind.

For all the many permutations of fixturing, merchandise will generally be supported, in some way, from either above or below; from above with a hook, arm, pin, rod, or clip; from below with a shelf, bin, box, rack, platform, or pedestal. A further choice in fixturing is between wall-mounted or perimeter units and floorstanding units. Most stores will need some combination of the two. The ratio between them will be determined by the size of the store, and consideration of circulation needs and stock densities. In some fashion stores, for example, perimeter wall units will permit three levels of stock (triple hanging). This high perimeter density can then allow a less dense midfloor presentation. Often with perimeter systems, there is some space between the top of the fixture and the ceiling. This can sometimes be filled with display photography or merchandise, or even just with lighting, all of which can be altered to allow for variety. Britain's Top Shop, a mass-market young fashion store, cleverly maximizes the clothes on display through these techniques.

Some perimeter fixturing may need to be back-illuminated for products such as china or glass. As a result of the construction this requires, the area behind the perimeter fixturing can sometimes be used for back-up stock, provided it is easily accessible. The movable partitions at Harrods' Way In create the perimeter, with storage behind. A note of caution on back-lighting, however, should be sounded: whether used in cabinets or wall fixtures, proper ventilation is essential to avoid creating fire hazards and to prevent products spoiling, or photographs curling.

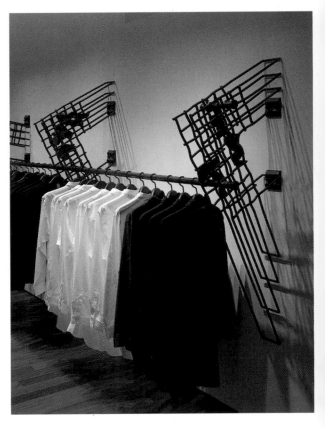

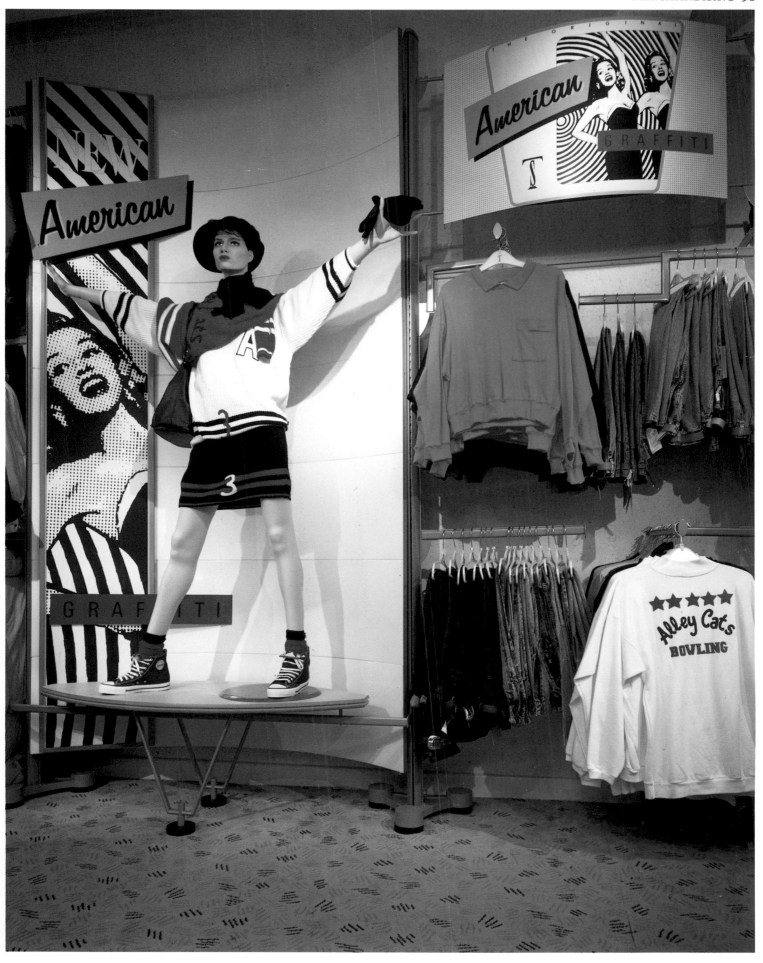

The furniture corner at Loft, Tokyo, designed by Nomura-Kogeisha, uses a stage-set-like wall to create display space and shelves for flat-packed merchandise. The "Hibino Dept Store" resembles a primitive store, perhaps found in some Third World village, and provides a foil for the avant-garde furniture on show.

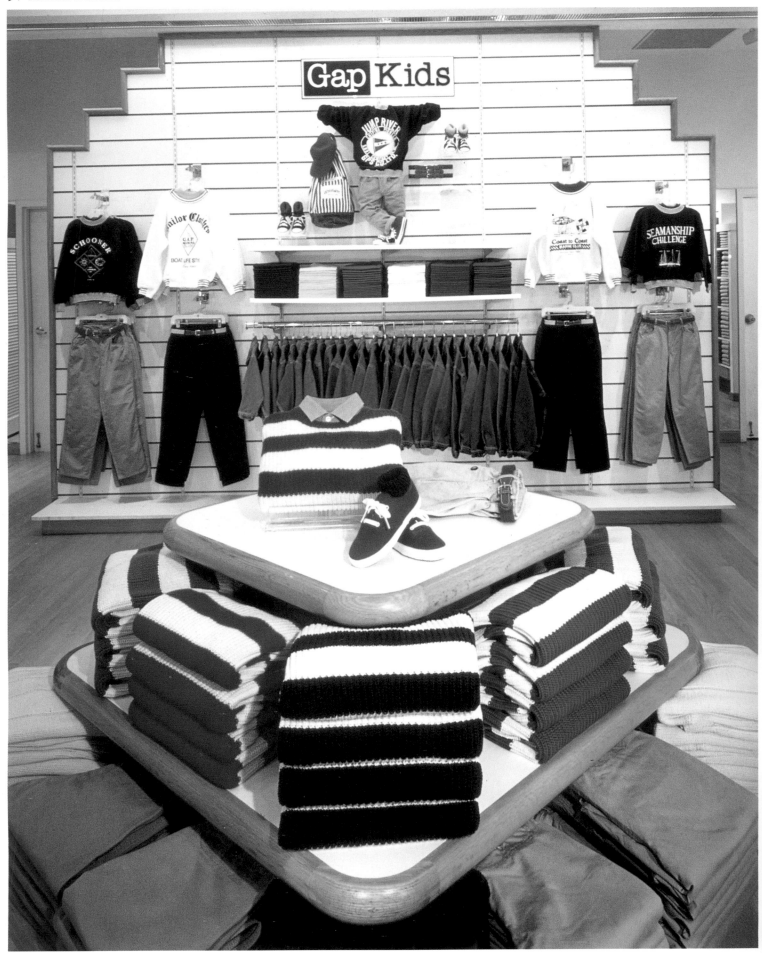

FORMS OF FIXTURING

Of the scores of different types of fixturing, slatted walls, or "slatwalls," are one of the most common, used both along wall surfaces and as part of a floor-standing unit. Slatwalls have horizontal channels into which brackets can slot. The brackets can support shelves, or may be designed for more specific tasks, such as displaying shoes or hanging clothes. One virtue of slatwalls is simplicity: no great skill is needed to slot a bracket in at an appropriate height. But they can be monotonous. Varying the walls with different textures or colours, and varying the slats themselves into angles or curves, does mitigate this problem. In Gap Kids, San Francisco and elsewhere, slatwall fixtures become almost monumental features. Systems based around poles and slotted channels are also prevalent, in virtually every conceivable variation. For shopfitting manufacturers, the expense of setting up a production line for such systems is considerable, so the amount of change possible in a standard range may be limited. However, with pole-based perimeter systems, the space between the poles can either be a decorated shell wall or a slotted-in panel that itself can make use of timber, paint, or graphics for decoration. Such dry-construction techniques allow a great deal of variation, customizing, and flexibility. Overall, these systems have a versatility, for both perimeter and floorstanding units, that makes them very popular.

Poles and slotted channels have been exploited well at Top Shop, London (left). Adjustable hanging rails, graphic panels, and display rails can all be slotted into channels in the upright poles, giving the flexibility to update fashion promotions. (*Photo:* Padraig Boyle/ARCAID)

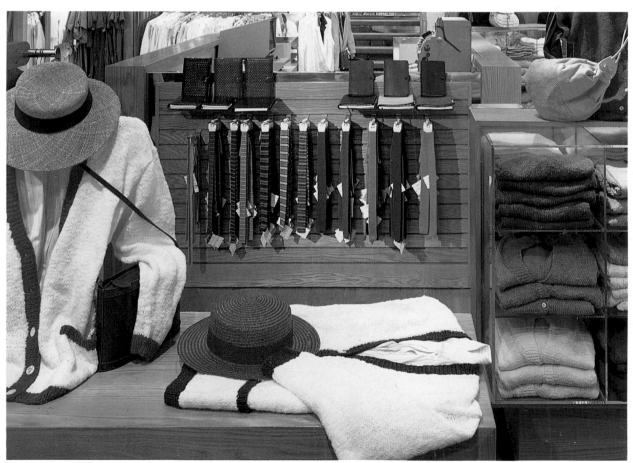

At Ann Taylor, New York (left), designed by Charles E. Broudy Associates, a mixture of different fixture types has been custom built. But the adaptability of the wooden "slatted wall" is shown in the foreground with its shelves for personal organizers and hooks for ties. The use of wood, contrasted with the white laminate at The Gap, demonstrates how materials can vastly alter the character of a fixture.

The versatility of the slatted wall, shown opposite, can clearly be seen in the Gap Kids display at The Gap, San Francisco. Hanging rails for both front and side display are combined with shelves and shoe stands to create a mixture of display and selectable merchandise. The wall also has the advantage of serving to divide one area of the store from another. The three-level table in the foreground is used for midfloor display. (*Photo:* © 1988 Karant and Associates, Inc.)

Shelving, another standard form of fixturing, can be low or high, fixed or adjustable. Shelving is used for general merchandise, books, groceries, and packaged goods. It is also increasingly used for flat-packed merchandise in home furnishings or fashion. Benetton throughout Europe and Next in Britain are often associated with their intensive use of shelves with neatly stacked sweaters and shirts (see page 71). But this does require an attentive staff constantly to refold clothes and tidy the shelves. Gondolas are popular, as centerfloor or aisle units (see Asda, Watford, page 232, and A&P Supermarkets, page 224). Gondolas can have adjustable shelves and integral lighting. Some gondolas are fitted with canopy lighting, while others use shelf lighting. The lower levels of both gondola and shelving units are often less popular for open display but can provide useful storage space in the form of cupboards or drawers. Tables, generally used midfloor, are useful for flat display of fashion merchandise such as shirts, woollens, or ties. Tables are equally good for books or home merchandise. In men's fashion, stores such as Paul Smith, Kanasawa, and Polo, New York, use the look of antique tables to lend substance to their displays of ties and accessories. Counters are used in virtually every form of retailing and are extremely adaptable. They can be solid, shelved, glass-fronted, or internally lit; glass-topped counters allow storage below and display of goods above, while half-depth counters can display merchandise in front and contain stock behind. Counters are particularly useful for jewelry, cosmetics, and some fashion products. Freestanding display units such as T-bars or cross-shaped systems are also popular, and are often essential for short hung clothes, accessories, and all sorts of other hanging merchandise.

Whether considering tables or cabinets, wall systems or midfloor units – whatever the merchandising equipment or method – the criterion should be "controlled flexibility" and the aim, that the equipment must not be allowed to dominate the product.

At Paul Smith, London, fixtures cannibalized from old stores and the wooden flooring create an atmosphere of tradition and venerableness. The genuinely old units are combined with dark wood display cases that have been designed to look old. (*Photo*: Dennis Gilbert)

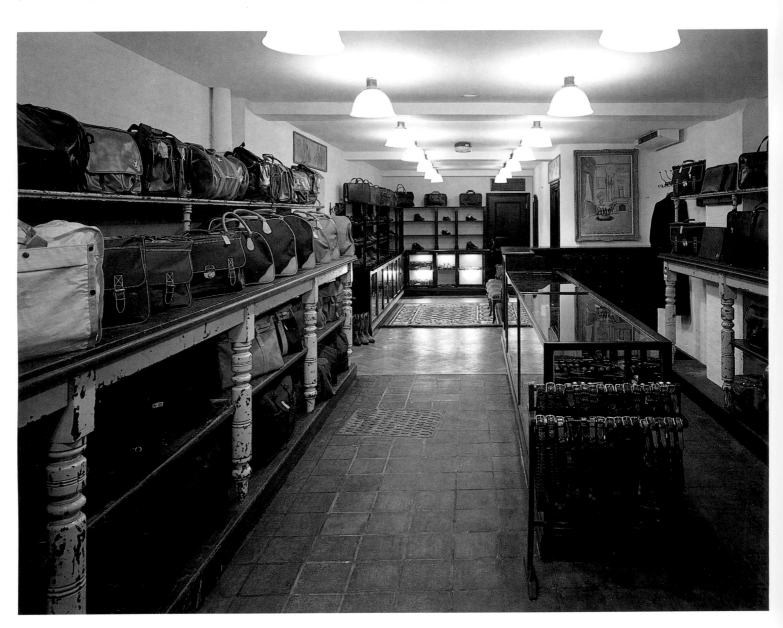

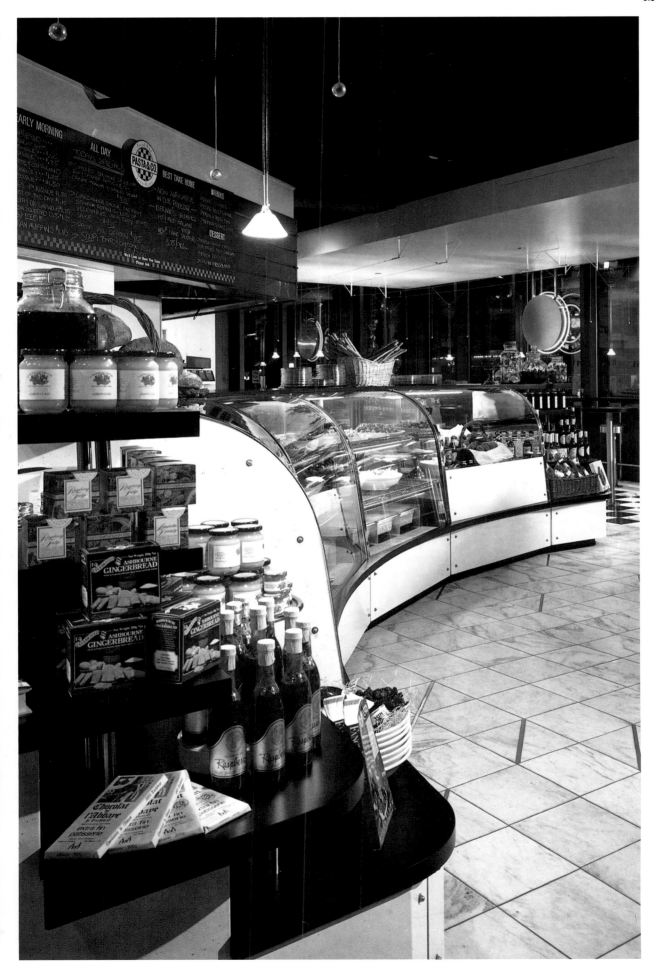

Food stores often present particular difficulties with fixturing, because of the size of refrigerated units and the need to comply with health and hygiene regulations. At Fasta & Co, designed by Retail Concepts, the custom-built counters become a major organizing element, with the curve adding to the slightly art deco ambience. (*Photo:* Paul Warchol 1987)

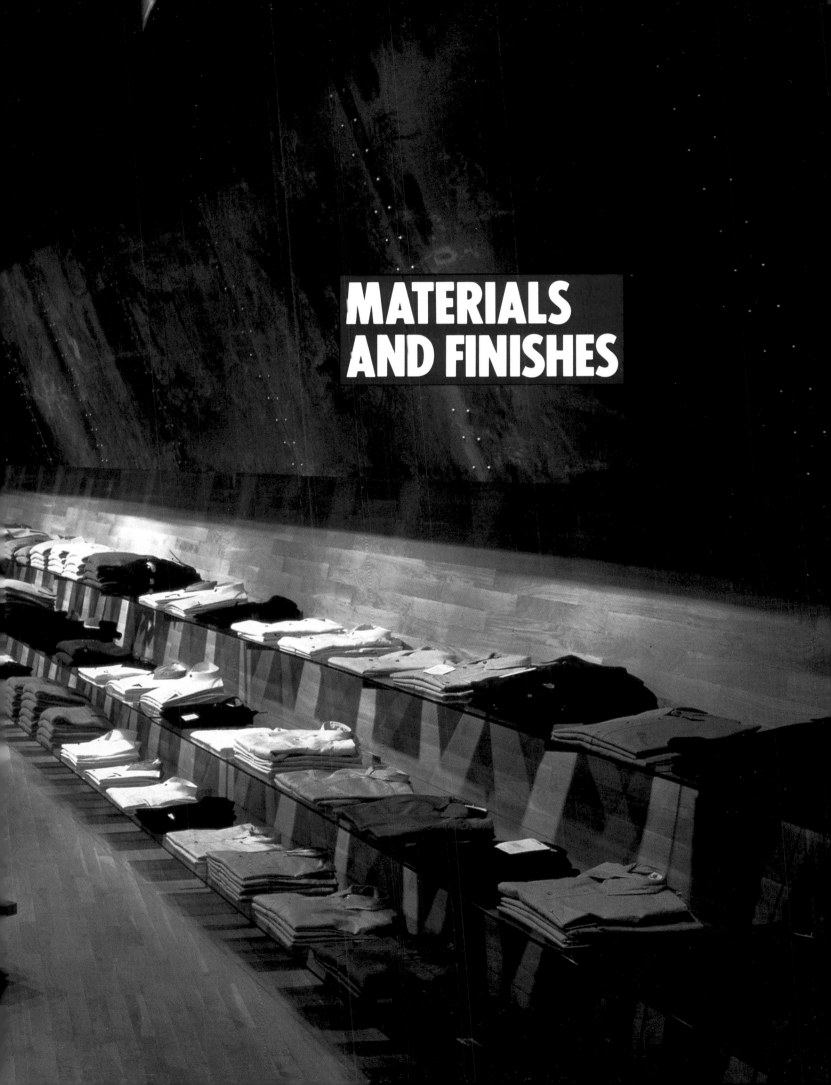

MATERIALS AND FINISHES

As most materials used in retail design are for interiors, and, as such, unaffected by the elements, the choice available to the designer is bewildering. Which materials and finishes to use is generally determined by three factors: the image they convey, the practical considerations, and cost. Image is a complex issue where materials and finishes are concerned – a wood floor, for example, could signal both a high-class retailer or a bargain, no-frills environment. Banana Republic uses a wooden floor to promote its "primitive" identity, while the smoothly polished floor of Marisa Lombardi in Milan denotes elegance. An image cannot be simply determined without regard to the surrounding context, and, most crucially, to the other materials used. Practical considerations include availability, durability, fire-resistance, and ease of replacement. Legislation plays a considerable part in the choice of finishes. Paint might have to be fire-retardant and therefore could be restrictive of colour or texture; steelwork might need to be concrete-clad and, as a result, could look harsh; doors might have to be solid rather than framed or open; staircases might need to be in steel rather than wood. Also, since all materials do eventually reach the end of their useful life, it is as well to choose those that age respectably, acquiring something like the patina on well-used bronze or antique furniture, rather than giving the appearance of wearing out. But designers should be wary of choosing materials on the basis of an anticipated short life. A carpet with a "three-year life" can look awful after one year. Cost is a less obvious consideration than it first seems: to arrive at a "true" cost, both initial and lifecycle costs must be considered. Paint, for example, is inexpensive as a finish, but usually requires frequent repainting that may disrupt the retailer's business. And choosing materials that can easily be replaced can sometimes be a false economy – it may be difficult later to match paint colours or carpet tiles, for instance, if original batches go out of stock.

The original Zas Two in Barcelona, designed by Fernando Salas (previous page), confounds contemporary expectations of a fashionable clothing store through its use of dark, sombre materials. The dark hardwood floor and wall is brooded over by the presence of the rusted and rivetted steel plates. (*Photo:* Hisao Suzuki)

Designers will always have to consider when choosing materials the balance of effect versus capital cost and maintenance. But any attempt to solve this equation is complicated by the question of flexibility. Nothing in retailing is permanent – modification is inevitable and often desirable, ranging from constant small changes over several years as the identity evolves, to a complete redesign every so often. Materials must be chosen that allow retailers to be flexible, without compromising the design.

Although choice of materials and finishes will enter every aspect of retail design, particular attention should be paid to three of the basic elements of any interior – the floor, walls, and ceiling.

FLOORS

The choice of floor can do much to determine the visual character of a store. Different floor finishes will help to create different atmospheres, zones, walkways, and even departments. In larger stores, a design may use a wide range of floor finishes. Such variety both contributes to and restricts flexibility. Variations in surface, for example, can present problems where they abut, making some sort of masking or parting strip essential. Other problems can occur during maintenance: polishing wood might spoil an adjacent carpet; washing tiles might stain them. Careful thought needs to be given to floor colour. Generally speaking, the floor should be neutral, a passive element whose colour should not dominate the interior. Designers also need to consider the particular characteristics of the floor surface: marble, for example, although it looks luxurious and is hard-wearing, can create a noisy environment. Some surfaces need to be more durable than others: because stairs are very heavily used, stair carpeting should generally be of a high quality and will probably need replacing more often than other floor areas. Local legislation may insist on

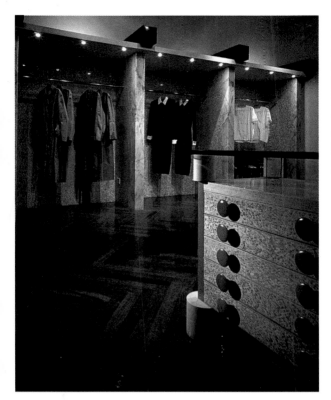

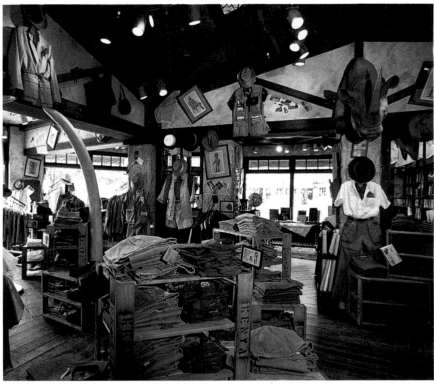

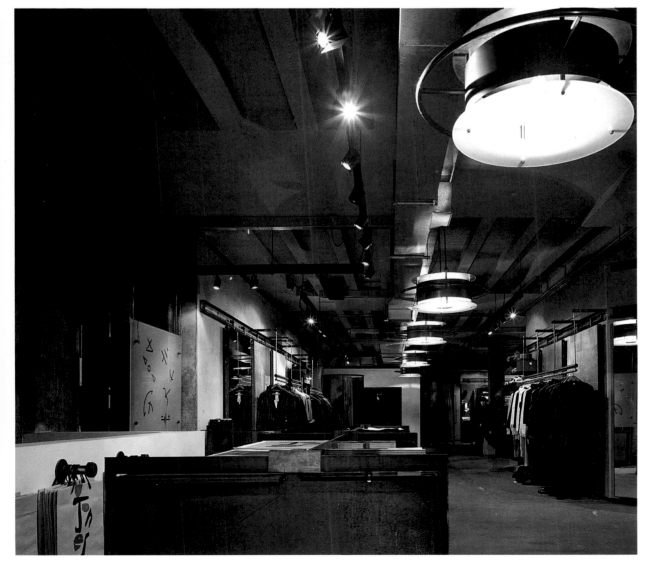

Contrasts of materials are central to the design of Marisa Lombardi, Milan, by Sottsass Associati (above left). The bird's-eye maple drawers contrast with the dark wood floor, which in turn contrasts with the marble columns separating display areas and dense terrazzo walls. (*Photo:* Santi Caleca)

Materials at the US chain store Banana Republic (above right) are a key part of the identity: worn wooden floors, suggesting a tropical encampment; torn-apart packing crates for display, and roughly plastered, half-timbered walls. (*Photo:* John Bildahl)

Hard, industrial materials are favored at Jones, London (left), designed by Peter Mullins and Jake Morton. But all the materials have been finished with a care and attention that reflects the designers' admitted debt to minimalist artists such as Richard Serra. The concrete screed floor has been varnished, and has insets of leather and Belgian fossilized granite. The walls have a rough rendered finish. The service counter is made of sheets of 1 inch (25 mm) thick solid plate steel, propped together. (*Photo:* Peter Cook)

The original Zas Two, Barcelona, designed by Fernando Salas, used concrete stairs in cast metal, with the name of the shop to act as a striking entrance, as well as to imprint the store's identity. (*Photo:* Richard Bristow)

nosings of fiber, rubber, or aluminum. These are useful in any case for defining the tread and for nonslip purposes, as well as for preventing wear. At entrances, special matting is essential to clean customers' shoes on entry. Coir matting, rubber matting, fiber carpets, or combinations of metal, rubber, and fiber are all useful.

Carpet, or "soft flooring," is popular with many retailers, and it is easy to see why. With modern carpetmaking technology, specially designed carpets are easy to create at relatively low cost. This can aid the establishment of a store's identity, helping to differentiate one retailer from another, even though the basic woven construction of the carpet is identical. Carpet design and colour can be coordinated with fixtures and other elements of the overall store design (see below). Additionally, the feel of carpet underfoot is welcome to weary shoppers, and the noise reduction caused by carpets is often advantageous. Cleaning is also easy – usually this is a simple vacuum-cleaning task. The different types of carpet fiber used need some consideration. A wool/nylon blend is highly durable, but tends towards the more costly range of carpets. Nylon or other synthetic carpets, once associated with a "cheap" look, have improved enormously in the last few years through the introduction of new fibers that allow better colours, avoid shininess, and have the wear and soiling properties of more expensive natural-fiber carpets. It is worth bearing in mind, however, that manmade carpet used in conjunction with metal equipment in a dry atmosphere will almost certainly give rise to static electricity. However, there are special coatings and new fibers now available, designed to minimize this effect. For all types of carpet, a proper padding or underlay will extend the carpet life, as well as improve the feel underfoot.

When choosing carpet, some particular aspects should be borne in mind. If, during the life of the carpet, the store is going to be rearranged – during sales, for example, or when moving displays – unworn areas of carpet may be exposed (as bad are sections of carpet damaged by heavy counters or display equipment). Hence it may be necessary to confine carpeting to areas of the store where the planning rules out significant change. Carpet can be laid over a hard floor, a solution which may appeal to the retailer who wants more flexibility. In whatever situation, if carpet is used, its laying is of paramount importance, since this will have a significant effect on its life and wear. Some carpet is, of course, designed and laid broadloom (the full width of the manufacturer's loom), but more expensive carpets are laid as body carpet (one meter – thirty nine inches – wide), which requires stitching. The stitching is likely to be the weakest point when it comes to maintenance, so designers often arrange with carpet contractors for what is known as a "make, lay, and maintain contract." Alternatively, carpet tiles

At Rizzoli, New York, the patterned carpet is consistent with the use of traditional materials throughout. The carpeted floor adds an appropriate "library" hush to the atmosphere. The plasterwork of the original Sohmer Piano Showroom has been retained and the chandeliers and carved casework were brought from the Fifth Avenue store. These original features have been integrated with new custom-built cabinetry, fabric wallcoverings, glazed finishes, and muted colours, giving a gracious ambience that is distinctly Rizzoli. (*Photo:* © Norman McGrath (1985)

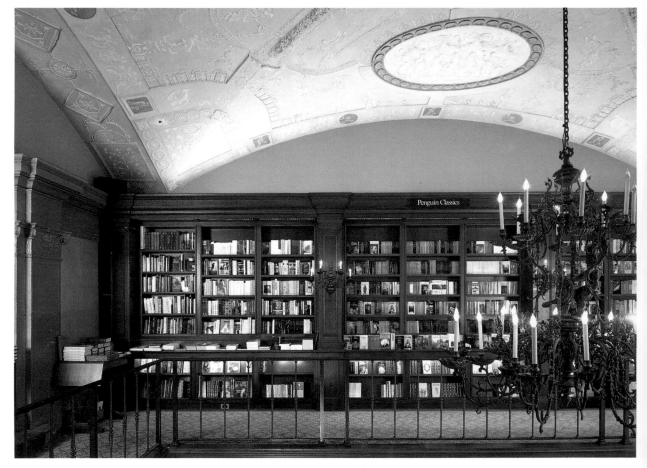

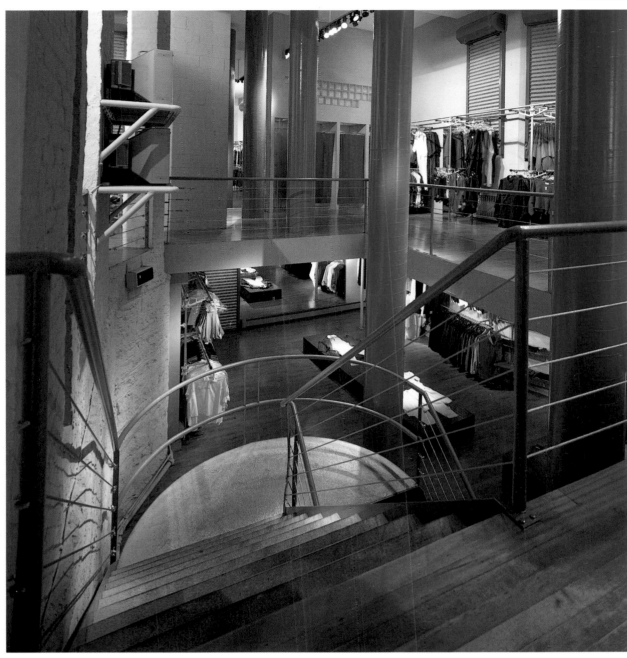

The original design of Parachute, New York, by Harry Parnass, shown here, has influenced store design from Tokyo and Paris to London. The design artfully used a variety of basic materials. Rough concrete steps and plaster walls provided a foil for the smooth maple-wood floors, while the cast-iron columns were part of the original cast-iron construction of this building in the historic SoHo district. In 1986 this was redesigned with poured concrete floors and concrete display platforms but nevertheless retaining the original character.
(*Photo:* © Paul Warchol 1984)

may be used; these have the advantage of flexibility and are easy to replace, although there can be problems matching the colours of old and new tiles. Some retailers arrange for their carpet tiles to be moved around periodically to give even wear across the whole installation.

Wood floors are seemingly more durable than carpet, but, as many well-worn wooden floors attest, levels of wear, and particularly soiling, need to be considered with this material as well. The best wooden floors look even better after some usage, because they take on a coloration and patina that are entirely natural and that stop scratches, bumps, and variations in colour from hurting the overall look. Some wooden floors come with prefinish, and are relatively maintenance-free. Wood can also be stained so that it has a colour of its own, impregnated into the grain, rather than just a surface finish like paint. But wood can be expensive – as a rough guide, an average quality wood floor will cost as much as an expensive carpet. Wood floors are available as single boards, sections of boards, or parquet. Because of the wear on floors, hardwoods are naturally preferable in most instances: beech, maple, and oak are common. Strip floors, which form parallel, herringbone, basket-weave, or other patterns, are the most expensive, and expensive-looking, of wood floors. In general, timber strip floors should be laid with the line of traffic rather than across it. Feet moving across the grain tend to pull the fibers out of the wood and destroy the surface. The rich patterns, and the quality of the wood itself, are well suited to particularly traditional, more exclusive environments. Straight boards create a more old-fashioned feel. They can be especially effective in a

Himmel Bonner Architects were asked by clothes designer Ralph Lauren to design a store environment in keeping with the fine classic garments to be displayed. Shown right, the herringbone pattern of the wood-strip floor at Polo, Chicago, could have been borrowed from the fabric of one of Lauren's suits. The appropriateness is strengthened by the use of oriental rugs and a leather sofa to add a touch of "clubby" comfort to the design. (*Photo:* Karant and Associates, Inc.)

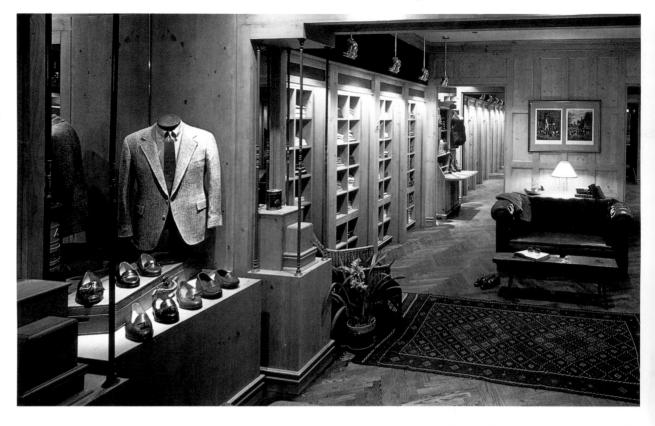

Shown opposite, the enormous expanse of polished concrete screed at the former Katharine Hamnett store, London, designed by Foster Associates, matched the formerly industrial setting of the store. The effect of the predominantly white finishes and well-lit space, evocative of a dance or art studio, was to focus the attention on the clothes displayed and provided a timeless quality for the setting. (*Photo:* Alastair Hunter)

The change in floorcovering from broadloom carpet to woodstrip announces a change in character at Liberty's London. The carpeted path distinguishes circulation areas from the principal clothing displays.

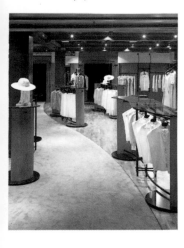

department within a larger store, to set off a carpeted area. The least expensive means of using wood is probably modern parquet tile flooring, which comes in fixed geometric modules, secured to a particle board or canvas backing which is then glued down to a concrete subfloor. The traditional and much more expensive version, "parquet royale," comes in herringbone pattern and is laid in tar or bitumen. In the former example, it is important that the subfloor screed is of first quality. Upkeep of timber flooring is equally important. Regular polishing, waxing, or occasional washing of pre-finished boards will help to maintain a good, fresh appearance. After years of wear, wood floors can always be sanded, resealed and polished to start a new life.

Although carpet and wood are likely to be the most common choices for flooring, so-called "nonresilient" materials such as marble, terrazzo, mosaic, granite, and ceramic tile also have important uses in retailing. All nonresilient floorings are extremely durable and easy to clean, but they have a tiring, hard feeling underfoot, and contribute to a noisy acoustic in a store. However, for many circumstances, such hard floorings are desirable. In aisles and other heavy-traffic areas of a store, the hard-wearing qualities can justify the additional initial cost. And the image of some of these materials can also be valuable in a design. Even concrete can be used: in Katharine Hamnett, London, polished concrete is practical and conveys an image of modernity. Marble is always the most luxurious of materials (and the cost reflects this) – for public spaces in an exclusive shopping center it

conveys an unmistakably elegant atmosphere. Marble and stone veneers mounted on fiberboard or honeycomb cores are a more recent development. These veneers have the advantages of lightness, low cost, and easy availability. But not all marbles or stones lend themselves to this construction. Terrazzo, consisting of marble chips mixed with cement, is another slightly less expensive alternative to marble. Various types of ceramic tiles are often used for aisles and other circulation spaces. In wet areas, such as those used for food preparation, or areas where spillage or hygiene is a concern, tiles may be the only sensible choice for a design. Mosaic is another traditional form of flooring, as effective today as in the ancient Roman town of Pompeii (see Jean Paul Gaultier, Paris, page 136).

In addition to the various natural forms of flooring, there is a wide variety of resilient surfaces, such as vinyl and linoleum, which are now very fashionable. These are available in many versions, including imitation wood, marble, or terracotta. However, while these imitations can look very good, the cost of the best surfaces may begin to approach that of the real thing. Cut and inset multicoloured linoleum and vinyl floors are also being reintroduced and can be very decorative and practical. In sheet form, they are the traditional, inexpensive, "homogeneous" flooring finish for stockrooms, wash areas, and the like. In this context, they are very durable, and easily cleaned and maintained. This type of flooring now comes with an integral skirting if necessary, which can be "welded" to floor vinyl. Composite floor tiles are also popular

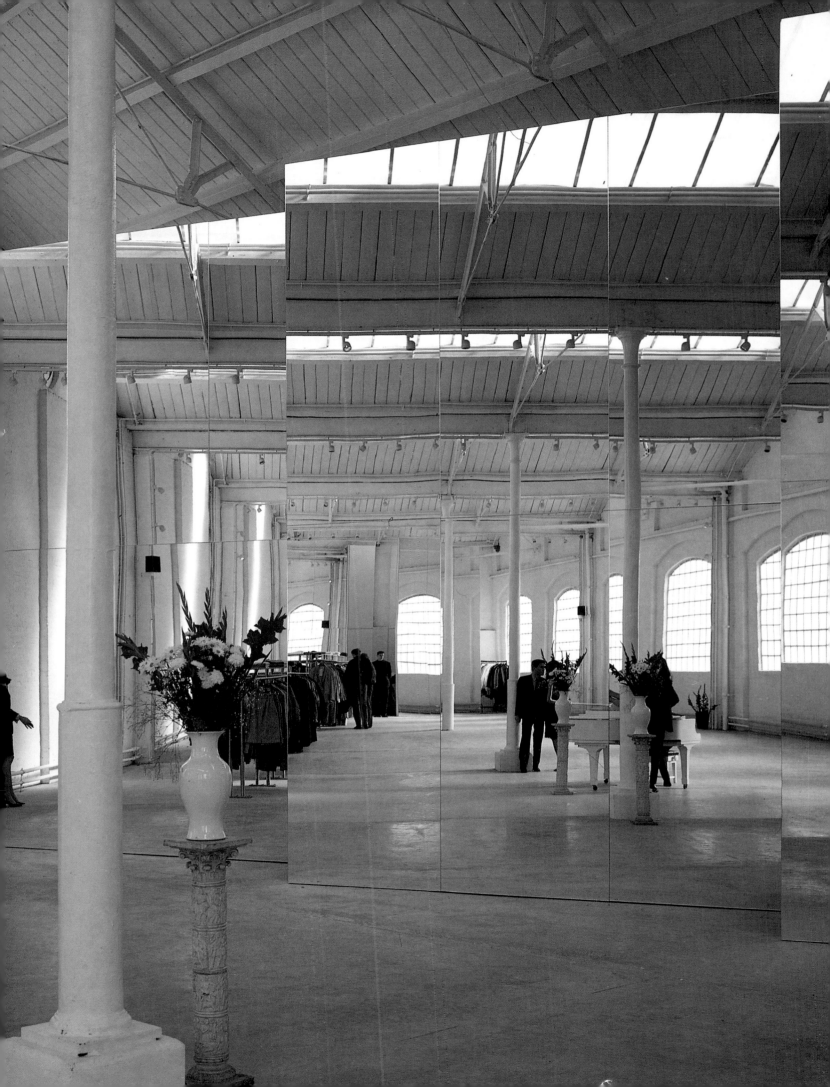

Designers Schwartz/Silver use the walls in Domain, Chestnut Hill Mall, Massachusetts, to create a number of theatrical effects. The tilted wall is of yellow *fresco secco* plaster, and acts as a screen for a sequence of display rooms, which the designers compare to a street in an eastern bazaar. Throughout the interior, steel and silk floor-to-ceiling panels move on a track, like stage flats, for flexibility of arrangement. (*Photo:* © Steve Rosenthal)

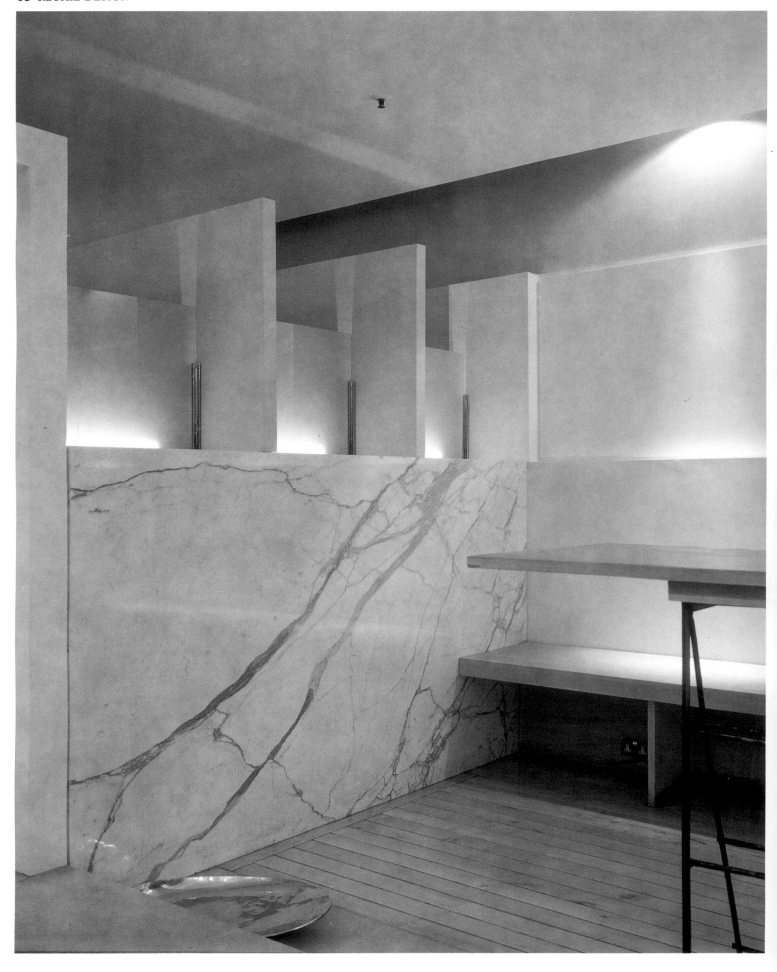

throughout the retail business in many patterns and colours, and with considerable variations in quality and price. Colour and pattern can be used to reinforce a store's identity or to confirm circulation routes.

There is an increasing tendency for designers and clients to use natural materials, reflecting the general concern about the environment and "green" issues, and the search for a more narrative style. However, paradoxically, this has also led to concern about the use of hardwoods due to their scarcity.

INTERIOR WALLS

There is a bewildering diversity of possible finishes and materials for walls, but before a designer struggles to find something new, it is worth considering first how much of the wall will be visible in the finished design. In many stores, merchandising systems, graphic displays, or a concentration of attention on what is happening in the central space rather than the perimeter may result in the walls taking a subsidiary role in the design.

Paint is undoubtedly the lowest-cost and most flexible of finishes for walls. While the qualities of paint are well known, and the range of colours almost infinite, designers should bear in mind that many painted finishes are easily marked and, in a well-maintained store, will require frequent repainting. Some more modern paints, however, are very durable, comparing well with plastic or natural finishes. Decorative paint effects are increasingly popular. The marble-effect walls of Domain, Chestnut Mill, Massachusetts, are a good example. Marbling, stencilling, scrumbling, and ragging are all methods of using paint in more interesting ways, and the craft skills necessary for these techniques have enjoyed a recent revival.

The other principal wall finish is plaster. Plaster is a much underrated material. A combination of plaster and paint, for example, can give walls a sculptural, three-dimensional quality. This combination also permits hues and variations which can then allow the wall to be left very attractively raw. Another way to exploit the properties of plaster is to polish it – a technique rediscovered from ancient Greece. As the plaster dries, it produces a finish similar to natural marble. Plaster has the additional advantage of a high fire rating. Fibrous plaster, still relatively uncommon in the United States, can be molded and cast into almost any decorative shape, allowing for relatively inexpensive cornices, column capitals, and other ornamental or sculptural devices. Plaster can also be mixed with fiberglass, glass, concrete, and different resins to improve its structural or weathering qualities.

Beyond the two basic wall finishes of paint and plaster, the choice seems endless – brick, marble, concrete, wood, plastic laminate, mirror, fabric, paper, and others, depending entirely on how the wall is to be used. If it is to be covered in merchandise, then a simple plastic laminate may suffice. In other cases the designer will need to assess the practicalities of different surfaces with regard to maintenance, use of graphics, and other considerations.

A contrast of materials for walls can both define separate areas within a store and create visual interest. At Issey Miyake (opposite), in London, designed by Armstrong Chipperfield, marble abutts smooth plaster and wood.

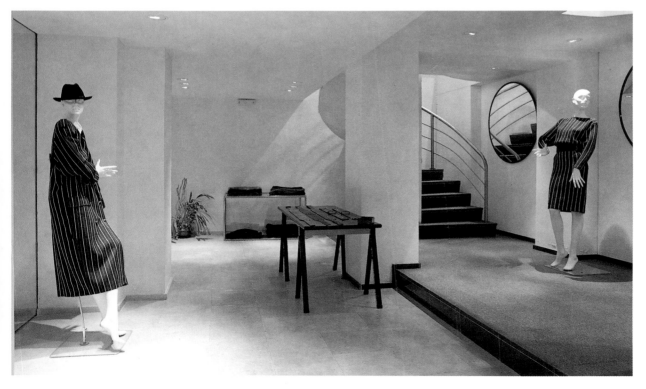

An extremely restrained use of materials is common in the most exclusive of fashion stores. At Junko Shimada, Paris, white walls and ceilings are barely contrasted by the main floor of white granite and raised platform of black granite. (*Photo:* Stephane Couturier)

CEILINGS

Ceilings are often the last considered and the least favoured part of a design. But the ceiling is one of the most complex parts of any store, usually carrying and concealing vital services such as lighting, electrical wiring, air conditioning, security equipment, and fire protection devices. When not handled skillfully, the ceiling can become a dominant visual element, distracting the shopper's eyes from the merchandise below. For this reason, the ceiling should generally be treated simply by the designer.

Many larger stores need a suspended ceiling, often with some form of acoustic construction. These often use a metal grid suspended from the structural slab above as a supporting framework for the visible "ceiling". As the name implies, acoustic ceilings provide good sound control, but one of the additional attractions for many retailers is that they require no further finishing. There are two main types: exposed grid and concealed spline systems. In an exposed grid system, the lines of the grid are visible, and can tend towards the monotonous, "airport-runway'-style ceiling that detracts from a good design. Concealed spline systems have an invisible grid, so they resemble the smooth, monolithic surface of a plaster or gypsum-board ceiling. The supporting systems themselves are generally made of mild steel or aluminum, while the ceiling tiles are normally of fiberboard, plaster, or metal panels and can be faced with a variety of materials providing they meet fire regulations. However, concealed spline systems are more expensive than exposed grid, and access to the void above the ceiling can be difficult. With exposed grid systems,

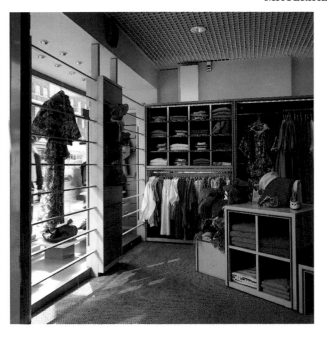

The open-cell ceiling used in Next for Women, London, designed by Conran Design Group, allows irregularities above the ceiling to be easily hidden, as well as making integration of sprinkler heads, air conditioning and lighting simple. (*Photo:* Peter Cook)

modular tiles or panels fit into the grid. These removable panels offer easy access to concealed mechanical and electrical systems. Manufacturers have developed acoustic ceilings into complex structures, integrating facilities such as lighting, air-conditioning, and security devices, making the necessary servicing a simple package. With tiles or panels available in a wide range of textures, colours, finishes, and patterns, acoustic ceilings are a fairly common yet versatile design choice.

While a plaster or gypsum-board ceiling generally lacks the sound-controlling properties of an acoustic ceiling, it offers a more finished, higher quality, and expensive appearance. In the United States, plaster ceilings are relatively rare except in department stores because of cost; in Europe, the wider availability of plastering skills – and the use of fibrous plaster – makes them more common. Existing decorative and molded plaster ceilings, in older buildings, can of course be exploited: Ralph Lauren's Polo store on Madison Avenue in New York benefits from beautiful original and restored plaster ceilings. For special ceiling features, such as vaults, coffers or domes, plaster is often the best material. Both plaster and gypsum board provide the quality of surface necessary if "uplighters" (upwardly directed light sources) are to be used in the design.

The other main type of ceiling used in retail design is the open-cell or, informally, "eggcrate" ceiling. Open-cell ceilings consist of square or hexagonal sections, generally of formed aluminum or wood fiber (less commonly of wood or plastic), which are manufactured in panels and assembled in an open grid. As with acoustic ceilings, the monotony of the regular grid needs to be considered by the designer. The popularity of eggcrate ceilings in retail design, as well as their visual characteristics, is due to the ease with

Changing both height and ceiling treatment helps to define different areas within a store. At Dollar Drydock Bank, New York (left), designed by Turner Design, principal service areas are located under a concealed spline bulkhead carrying air conditioning and lighting, with acoustic tiles to dampen sound transmission. But in the circulation and information areas, the ceiling has been left high and plastered. (*Photo:* Peter Cook)

Shown opposite, a standard exposed-grid suspended ceiling is perhaps the most common of store ceilings. At W H Smith, Southampton, designed by Peter Leonard Associates, the monotony of the conventional ceiling is disguised by planning the store on a different grid, with display towers and counters running at a 45-degree angle to the ceiling. (*Photo:* Richard Bryant/ARCAID)

At English Eccentrics (opposite) in the Fulham Road, London, designed by Corstophine and Wright Design, twisted steel reinforcing bars and sheet metal panels have been given a patina of rust and age. The toughened glass supported by the metal fixings contrasts with the product to create tension. (*Photo:* Peter Cook)

which sprinkler heads, air-conditioning diffusers and returns, and lighting fixtures can be hidden in or integrated with the grid; in fact, they can be bought as complete systems with their own custom-made modular light fixtures, HVAC grilles, and graphics-carrying possibilities. One caveat with eggcrate ceilings: to ensure that they effectively hide the clutter above, the structural slab and as many elements as possible above the ceiling should be painted a dark colour.

FITTINGS AND EQUIPMENT

While the appearance of walls, floors, and ceilings is obviously crucial, finishes to fittings and equipment should also be considered, since they need to be not only appropriate to their function but also to the overall scheme. Although it is currently fashionable, for instance, to construct fashion-hanging systems from timber, these are not always strong enough and the finish is often inadequate. It may be better to use timber in conjunction with chrome, finished steel, or brass. Timber paneling can be combined with an all-metal system to create a piece of equipment that shows a complete range or fashion story, allowing the

retailer to coordinate as he or she wants. By using timber and other materials together the designer will have the benefit of both practical and natural materials. Timber equipment with inset metal fixtures can be entirely durable, and, in light-usage areas, can be painted, stained, or lacquered. A popular and durable alternative to paint and lacquer is chromium plate, but the mechanistic feeling this creates often leads designers to opt for brass, or for the cheaper and less-effective lacquered brass. Metalwork can be painted, and fitted with coloured plastic ferrules and detail pieces for effect and practicality. Baked, epoxy, and plastic-coated finishes are often very effective. It is also fashionable these days to use metal in its natural finished state, such as brushed aluminum or steel, or acid-treated for a "distressed" or "found" look. As with all finishes, the designer's aim should be to use equipment and fixtures that age gracefully, and do not appear to be wearing out. At the same time, since the retailer's overriding objective must be to be different, the designer's choice of materials and finishes will make a major contribution. The watchwords should be uniqueness and experimentation combined with practicality, good value, and appropriateness.

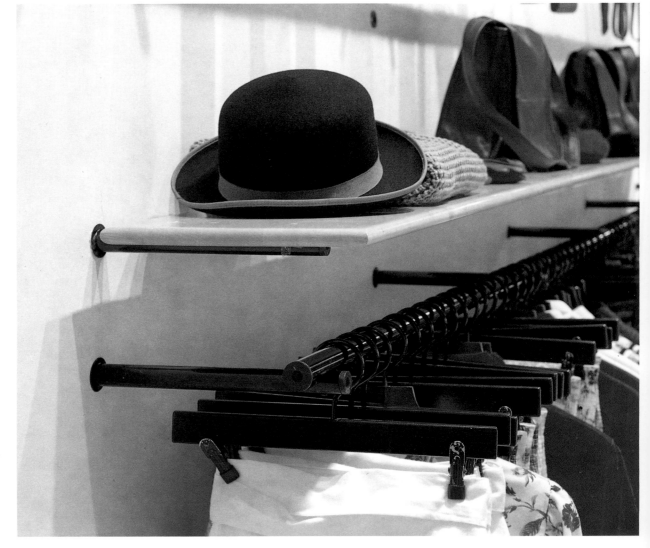

Materials for fixtures and fittings must also be consistent with the overall effect desired in the store. Kenzo, London, designed by Eva Jiricna, has smoothly plastered white walls, and the fixtures are equally simple. Black coated-metal tubing supports ash shelves. The tightly constrained palette of materials allows the boldly coloured merchandise to stand out. (*Photo:* Richard Bryant/ARCAID)

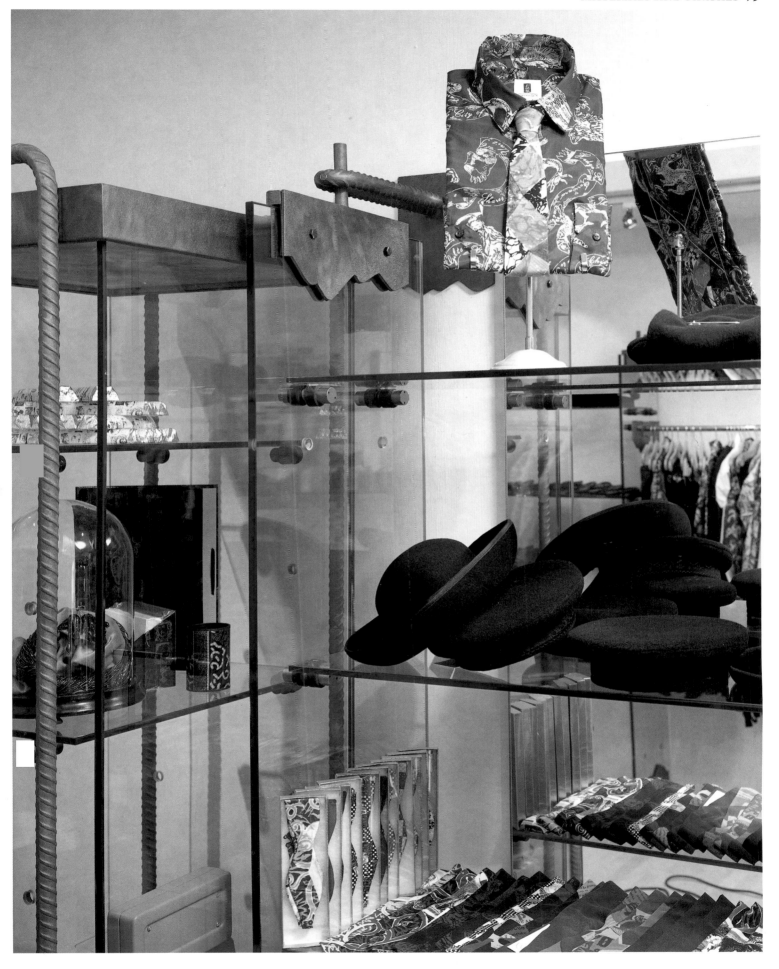

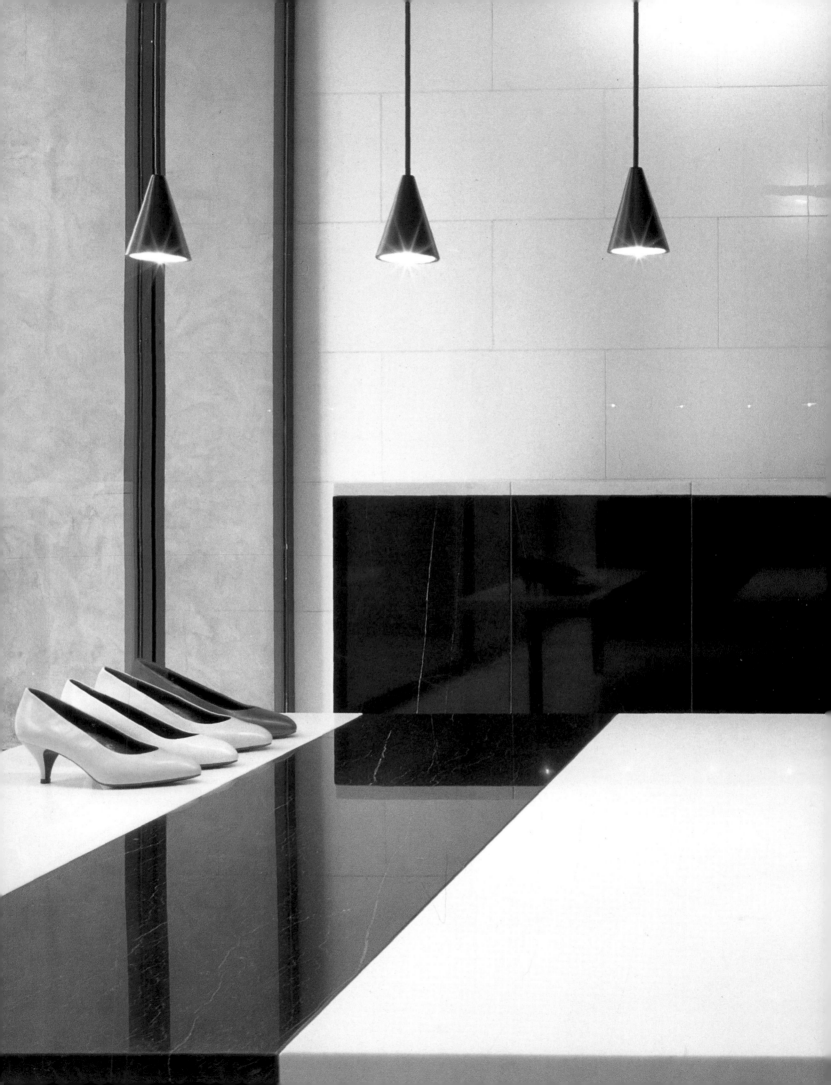

LIGHTING

Merchandise apart, good store lighting rates above all else as an essential ingredient in retail design. Lighting not only performs an essential function, illuminating both the store and the merchandise, but is the element most singly able to give a store its atmosphere. Without good lighting, any retail design is condemned to failure. In fact, skillful use of lighting can often rescue mediocre designs; in the best schemes, lighting is the factor that raises them above the ordinary. Lighting is about the contrast between light and shade, and the handling of that contrast is the key to successful lighting design. It involves understanding that what the designer chooses *not* to light is as important as what *is* lit and that the lighting of the retail space may be different from the lighting of the merchandise. And in addition to the art of lighting design, any responsible designer must consider the practicalities: the initial cost, the energy costs (lighting consumes most of the electricity bills for retailers), the flexibility of the design, and the ease of maintenance. There is a tendency for light sources and fittings to be chosen as interesting designs in themselves, rather than for their efficiency. This is wrong. From the start designers should select the most competent and effective form of lighting, irrespective of the design of the fitting.

Most stores fit into one of two broad categories for lighting: the ambient-lit, such as supermarkets, do-it-yourself stores, or drugstores, where an overall level of illumination is necessary; and the theatrically lit, usually preferred for fashion stores or jewelers. Many retail designs fail from the point of view of lighting because they fall between the two types: their ambient lighting is too bright to allow much to be made of the highlighting, or else so much "dramatic" highlighting is installed that it begins to approach an ambient solution. Yet good lighting design helps store efficiency and leads to improved staff and customer

wellbeing: people generally feel happier and more at ease in well-lit surroundings.

However, lighting must be considered in the context of the floor plan and the merchandising strategy for the store. In many respects, the lighting plan will reflect the ideas of the floor plan. Circulation areas, for example, should be differentiated in lighting, as in floor treatment. The lighting in each instance should reinforce the design approach. And since retail design is ultimately about the selling of merchandise, the product must not be neglected by the lighting design. In simple terms, merchandise has to be seen, otherwise it will not sell. An effective contrast in lighting is needed between the merchandise and its surroundings: generally, the merchandise needs to be brighter than anything around it (in occasional exceptions, backlighting can be effective). Whatever the situation, merchandise is rarely fixed in its position in a store. Thus a good lighting design will have sufficient flexibility to allow for adjustment as products and departments move and change within the store.

Spotlighting is generally chosen to provide this flexibility, as well as to highlight merchandise. Provided that the basic infrastructure for spotlighting has been designed into the store, there is a near-infinite facility to reposition lights or merchandise. But designers should be aware that often this does not happen. Track, seemingly so useful, can be placed in the wrong position, making access difficult, or any real flexibility of positioning illusory. And, equally, spotlights are frequently either kept in a permanent position because they are too difficult to adjust, or asked to do a job they were simply not designed to do.

There are many ways to light merchandise, but some basic rules should apply. It is important to understand what part of the merchandise needs to be illuminated: for most items, the front matters more than the top. For products that have shiny surfaces, or

Striking, low-hanging pendant lights (previous page), which focus attention on the table for display, are used primarily for visual impact at Santini and Dominici, Florence, designed by Antonio Citterio. Most of the ambient light in the store comes from the wall-mounted tungsten halogen fittings. (*Photo:* Gabriele Basilico)

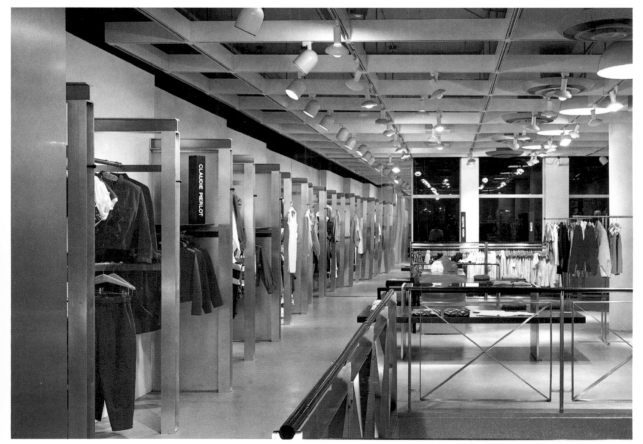

The lighting level of the ground floor of Vinçon, Barcelona (above), designed by Fernando Amat, is low compared to many stores, to great dramatic effect. In the darkness, the track-mounted spotlights produce pools of light to attract attention to the arrangements of merchandise, which is displayed on "islands" in the middle of the floor. Where lights themselves are for sale, they provide their own lighting. (*Photo:* Richard Bristow)

The designer floor at Coop Barneys, New York (left), uses large downlighters to provide ambient light, while track-mounted spotlights pick out displays. The comfortable level of the general lighting helps eliminate shadows created by the brighter spotlights. (*Photo:* © Paul Warchol 1988)

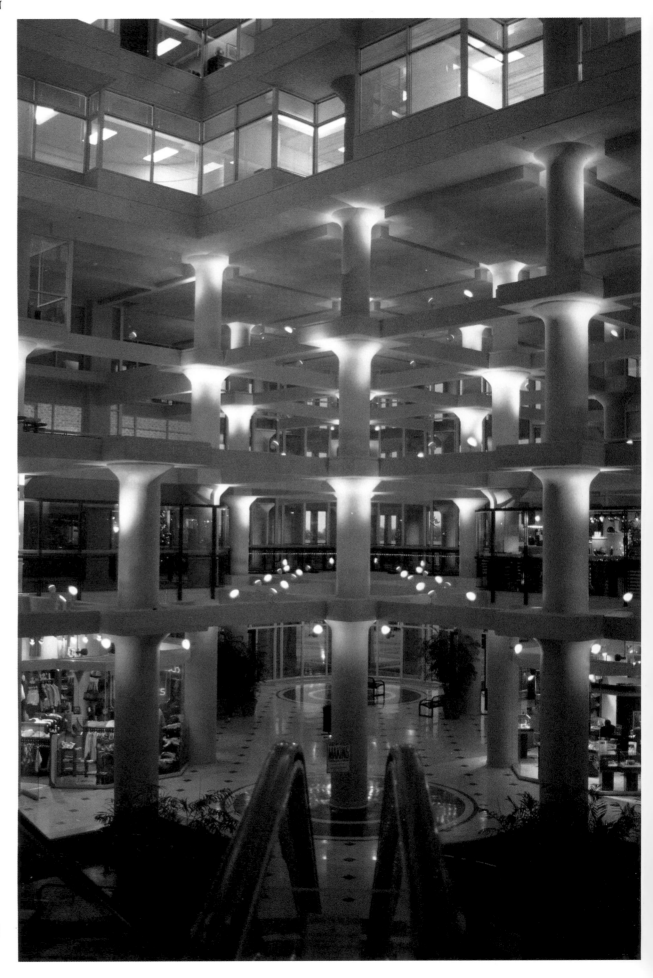

The spectacular concrete structure of the Queen's Quay shopping center, Toronto, is accentuated by the upwardly directed spotlights arranged around the column bases. Such dramatic lighting effects demand overall light levels lower than the highlights.

are displayed in glass showcases, glare must be eliminated or at least minimized. With the latter, this problem can be resolved by designing the lighting within the case (see Törq, London, page 50). Lighting can sometimes be featured in the plinths of counters, gondolas, and other floor units. This technique can be used to lighten the apparent heaviness of bulky sales counters, and can help give cosmetics or jewelry counters a "floating" appearance, making them look more exquisite. Designers also need to understand the technical qualities of light sources, in order to keep colour rendition accurate. Some light sources, notably fluorescent, metal halide, and sodium, have relatively poor colour rendition, distorting the colour of merchandise. For many products, particularly in the fashion arena, such distortions are unacceptable, and more accurate light sources need to be used.

But lighting is employed for more than merchandise. It can be a potent tool for establishing space. Circulation paths can be distinguished through lighting; in general, they require a lower level of light than display areas. The actual pattern of lighting can help determine circulation. This can be done simply by using a light track that follows the circulation path. In the de Bijenkorf department store in Holland, a neon stripe traces the walkways, indicating primary and secondary routes by its colour and intensity (see page 89). In some stores, a dropped bulkhead provides

housing for the light fixtures, while defining the walkway and allowing sidelighting to spill out over the rest of the store. In other situations, small lights, including "pea lights," regularly placed to trace the walkway at floor or ceiling level might be more suitable. And although walkways can remain marginally underlit, brightly lit focal points can be used to intrigue customers and draw them onwards. In this way, lighting design can reinforce the circulation pattern for a store.

To help create a sense of space within a store, or to emphasize its spatial qualities, designers should not neglect the effect of using lighting on the walls. Strong, positive perimeter lighting can help define the total space. Particularly in stores on several floors, it is comforting for shoppers to get some idea of the shape and scale of the floor they have arrived at when they step off the escalator or elevator. Perimeter lighting can add both interest and reassurance. If the walls have an unusual texture – for example, timber or brick – this can be enhanced by a wash of light along the surface. But even with more prosaic finishes, lighting thrown onto the walls will brighten the space generally, helping to convey the feeling that the space is bigger than it actually is. Conversely, keeping the walls in relative darkness, with spots of light picking out merchandise, creates an aura of intimacy, making a space appear smaller. Hidden light sources are often useful, drawing the eye while creating ambient lighting. Fixtures can be placed behind panels offset from the walls perimeter pelmets, or dropped bulkheads, or even from behind feature displays.

Creeks, Paris (above), designed by Philippe Starck, is a store that revolves around one bold design idea – the long, grand staircase. Square lights, fixed in brass in a regular series on the stairs, emphasize the straight, upward line. Ceiling-recessed low-voltage downlighters create a bright sparkle of light on the balustrade. (*Photo:* Stephane Couturier)

In the café at Fooks (left), in Amsterdam, designed by David Davies Associates, downlighters wash the stylized wall graphics depicting the city. (*Photo:* David Davies Associates)

The large atrium space at Debenham's London, designed by FitchRS, is defined by strings of "Tivoli" lights and small washes of uplight. The lighting at Debenham's is programmed to change as the amount of natural light entering through the rooflight alters.

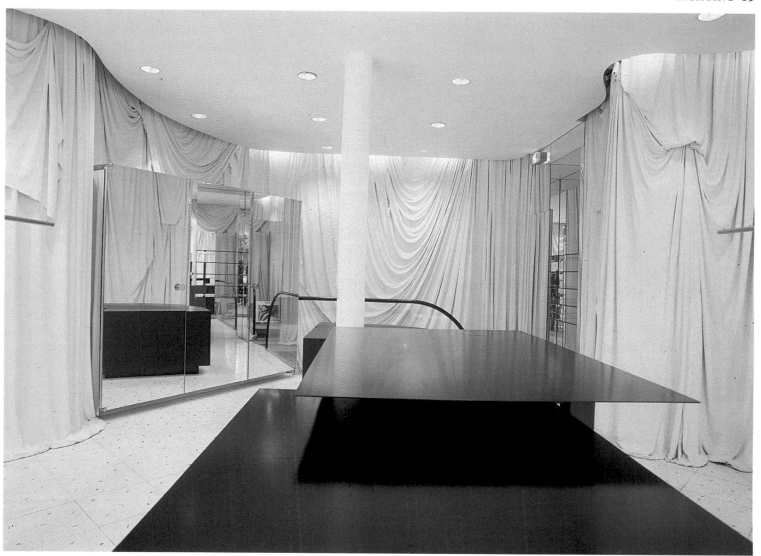

Lighting can also affect the feeling of height in a store. Using light vertically often helps to articulate the space. The designer may want to emphasize that the store contains several floors, or that there is a mezzanine, staircase, or elevator. Debenham's department store in London uses vertical lighting to emphasize the interior to good effect. If the ceiling is particularly interesting, as it might be in a restored building, uplighting washing the ceiling will reveal the features and add to the sensation of height and interest. To conceal a ceiling, or to make a space seem lower, pendant lighting fixtures can be used to keep light off the ceiling surface. But however the lighting design treats the ceiling, designers should not forget that the merchandise is the important focus: the customer's attention should always be drawn to the product, not up to the ceiling.

There are two other main areas in which lighting design plays an important part in a store: the display windows and the exterior. Lighting in display windows must be highly controllable, since displays here will change even more frequently than in the rest of the store. The window display can be treated as pure theater lighting by the designer. Track lighting, mounted both overhead and as footlights, provides considerable flexibility. For more dramatic effects, some designers use actual theatrical lighting fixtures, such as Klieg lights or large spotlights with barn-door louvers For smaller merchandise, high-power pin spots or fiber optics will pick out individual items.

Lighting of the exterior starts with the signage carrying the store's name. This signage may be self-illuminating (see Graphics), but if other lighting is required, the designer should make certain the sign stands out, though always consistent with local building regulations, good taste, and architectural manners. With the main signage as a focal point, it is important to consider how other exterior lighting can best convey the store's image. If the building itself is interesting, lighting of particular features with spotlights, washes, or Tivoli lights (strings of individual light sources) can effectively help define the store's identity (see Harrods, London, page 160).

The high level of illumination in the mostly white interior of Shiro Kuramata's design for Issey Miyake in Paris (above), does not contribute much visual interest and drama. Without the contrasts offered by lighting, the drapes of fabric along the wall seem comparatively flat.

Specially designed by Piero Castiglioni, the wall-mounted tungsten-halogen fittings at Santini and Dominici, Florence (opposite), make the most of the vaulted ceilings. Store designer Antonio Citterio also takes advantage of the light spilling through the open metal walkway to create striped reflections on the ceiling. (*Photo:* Gabriele Basilico)

Low-voltage tungsten-halogen spotlights provide sharp, white light on merchandise and wall graphics at Coles, London, designed by David Davies Associates. The new lighting system carries through the circular shapes of the interior, starting with a suspended central cartwheel light in satin chrome, and taken up by the snake lights in an S-shape on the perimeter. (*Photo:* David Davies Associates)

Most supermarkets use fluorescent lighting to provide a blanket, overall level of illumination. But at Grand Union, designer Milton Glaser wanted to alleviate the boredom of unrelenting aisles by using lighting to create a variety of areas, giving each part of the store a different character. Here incandescent fittings give an air of domesticity while overall lighting is provided by ceiling recessed downlighters. (*Photo: Milton Glaser Studio*)

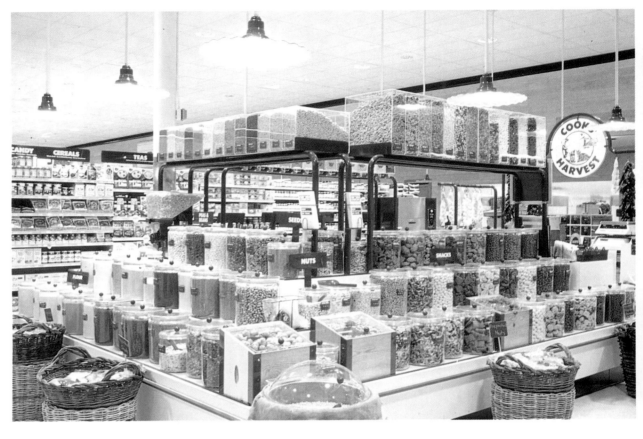

of fluorescent more elusive. Still, there are many areas of retail design where fluorescent sources can be of use – in nonselling areas, the colour disadvantages may not matter, for example. And fluorescent sources, with their long life, are handy to use in relatively inaccessible places, such as coves or valances. Equally, their very harshness can help create an image of low price, and functionality, essential for many kinds of store, such as supermarkets, discount warehouses, and others.

The various types of discharge lamps—metal halide, mercury vapour and high- and low-pressure sodium—are extremely efficacious, and have relatively long lives. But their colour rendition is not good and fixtures are generally expensive. On the other hand, the high wattages of many discharge lamps, and their efficacy, make them very useful in high-ceilinged, warehouse-type spaces.

Neon is an interesting light source for special effects or highlighting. It can come in virtually any colour, and can be an art form in itself. But neon also requires high voltage and, if not properly installed and maintained, can be very dangerous. Transformers and installations have become safer, but old or damaged neon is still one of the primary sources of fire in stores.

The newest type of light source is the multireflector, usually a low-voltage dichroic tungsten lamp. These have the advantage of extremely white light – providing accurate colour rendition. But designers who have been attracted to these versatile sources for virtually every situation should remember that some

Neon can create some of the most surprising lighting effects in stores. At De Bijenkorf (opposite), designed by FitchRS, a double track of coloured neon snakes around the store defining the principal circulation route. It is vital that neon be properly installed and maintained, otherwise it poses a fire hazard.

retail areas benefit from a warmer ambience, rather than accurate colour rendition. There is little flattery in the light from low-voltage dichroic lamps. But these lamps do have advantages beyond colour rendition: they are reasonably efficacious, generate very little heat (reducing the load on an air-conditioning system), and have a fairly long life. Fixtures for multi-reflectors are, however, generally expensive. Low-voltage fixtures also require a transformer. Some fixtures come with transformers attached, others with a remote transformer. The remote transformer is generally preferable since it can be hidden and serviced independently. However, transformers do get very hot, and require good insulation and ventilation. Another advantage of these newer fittings is that they are often well-designed products in their own right and can be used to enhance the interior.

Designers should not neglect the oldest light source. Natural light, most designers would agree, is the best light in many ways: it is free, absolutely accurate in colour rendition, and gives unparalleled spatial interest to the interior of a store. Natural light can be introduced through skylights or windows (see the Mitsubishi Bank, Tokyo, page 30, and the atria on pages 183 and 187). But natural light is not perfect. It can be difficult to control, is unpredictable (particularly in northern climates), and can introduce considerable heat to an interior; also, its ultraviolet rays (which are not blocked by ordinary glass) fade fabrics. But it is a rare design that could not benefit from the judicious use of this prime light source.

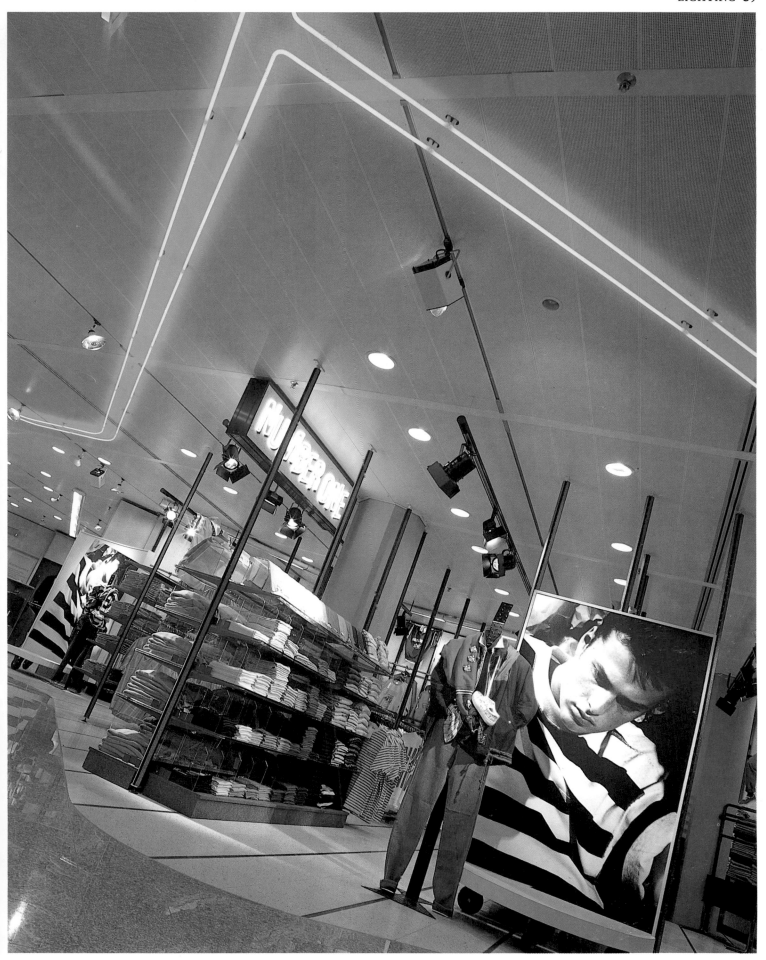

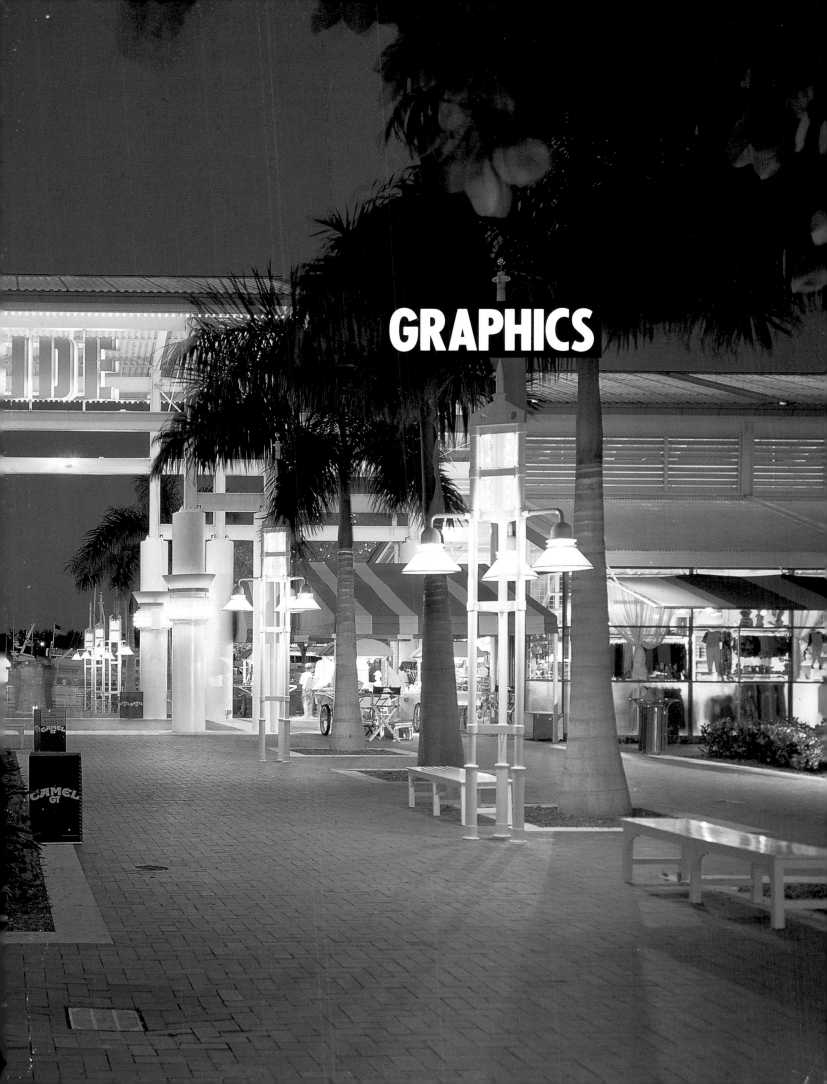

GRAPHICS

Good graphics can "make or break" a store interior: graphics are a key design resource in communicating a store's identity to the customer, both outside and inside. Underplaying the graphics element can prevent a store from achieving its full potential, although graphics alone cannot create a successful retail design. But graphics can be changed more frequently than architecture and can therefore help a store's identity to stay contemporary. Retail graphics embraces a wide range of tasks for the designer and presents a stimulating challenge: exterior and interior signage, merchandise ticketing, special information displays, and packaging. Every designer approaching the task of designing a store's graphics should be aware, however, of the specific skills and perceptions needed – it is generally better to use a specialist graphic designer who will think in environmental and spatial terms. The importance of such an attitude should not be underestimated when relating the trading identity to the overall corporate presence that the retailer wishes to express. Indeed, considerations about corporate and trading identity are not only inseparable, but should also be linked to policy on media advertising. The result should then be a powerful underpinning of the trading stance.

Unfortunately, all too often retail graphic packages will be conceived by quite separate designers from those who develop a store and its retail philosophy. Designers who lack the particular skills required for graphics will need to call in a specialist, but the work should always be done in close coordination, otherwise a disconnected design results. But coordination does not always mean "high" design. Zabar's, New York, is a prime instance of a store where "rough" graphics are not only consistent with an image but also help to shape it. The importance of tying the graphic approach to the wider design is one of the principal reasons for the growth of retail design as a specialist skill. At a number of specialist retail design consultancies, the various teams involved in research, retail planning and design, and graphic design are all part of the project personnel – thus producing the most dynamically integrated results.

EXTERIOR SIGNAGE

The first impression most shoppers get of a store is often that given by the exterior signage, whether it is glimpsed when passing by in a car, walking along the sidewalk, from across the street, or sitting in a shopping mall's eating area. The exterior signage must therefore act as a compelling advertisement for the store, clearly and concisely communicating the name as well as its retail character. The choice of name (sometimes part of the designer's brief), the typographic style, and the physical qualities of the sign itself will all say something about the store. The traditional method of naming stores after their owners, such as Marks and Spencer or Tiffany and Co., is now giving way to creating names from scratch – Polo, Next, The Gap, and Esprit are all examples where names suggest style and identity. Clearly, the graphics used should seek to enhance and underpin any stylistic implications.

Exterior signage is often an extremely sensitive area of retail design, governed by local ordinances or planning regulations. Neon, illuminated, or projecting signs, for example, may be ruled out in many communities. But even when such constraints do not apply, designers should try to strike a balance between what is unnoticeable discretion and offensive overexuberance: a successful retail design, signage included, should be a good neighbour to its surroundings. Sometimes the sign itself can be a major attraction,

The effectiveness of the Bayside entrance gateway in Miami (previous page) is increased by the close match between the architectural and graphic style. Designers Communication Arts developed a graphic language in happy accord with the casual, semi-tropical style of buildings.

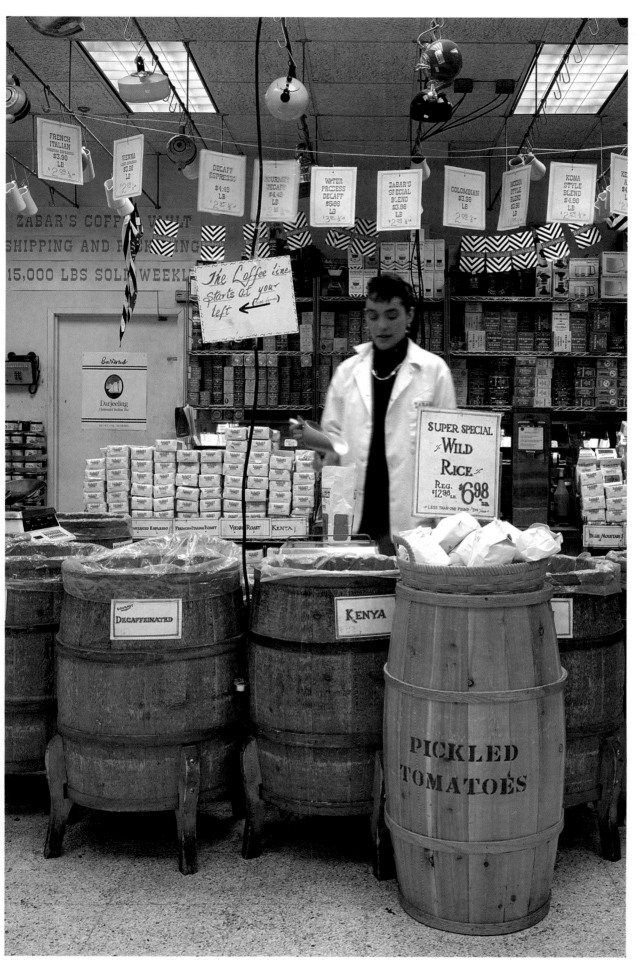

The large, blank architecture of the Macy's store (above), in Hamilton Mall, New Jersey, designed by Macy's Corporate Store Design with Hambrecht International, requires an equally bold sign. Fixing the individual letters slightly proud of the wall creates an attractive shadowing effect and enables the sign to be back-lit at night. (*Photo:* John Wadsworth Photography)

The rough, thoroughly "non-professional" graphics at Zabar's, New York (left), suggest a freshness and exuberance in keeping with the lively atmosphere of the delicatessen and the ad-hoc appearance of the product displays, such as the coffee barrels. Hand-lettered or, increasingly, computer printout signs are unmatched for merchandise where availability, price and freshness change rapidly. (*Photo:* Peter Cook)

A sign can become an event in itself. At Loft, Tokyo, the sign is a kinetic sculpture that constantly breaks apart and reassembles.

Box signs are probably the most common example of exterior store signage. At the Automobile Association, Southampton, designed by FitchRS, shown left, the bright yellow illuminated sign stands out clearly from the more subdued fascia, and is angled for greater visibility from both directions.

At Top Man, Watford, UK (below), the complex, three-dimensional sign was fabricated from aluminium. With such a profusion of graphic ideas in one sign, there is a danger that the message projected lacks clarity. (*Photo:* Peter Cook)

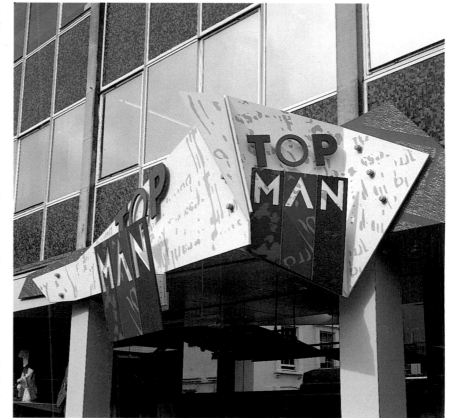

without causing offense: the dynamic "performance" of the Loft sign in Tokyo, for instance, is a focus of attention.

As many different types of exterior sign exist as typographical styles. There are advantages and disadvantages to each. But as with typography, the importance of clarity cannot be overstressed: as a result, highly reflective surfaces that distort the sign or restrict visibility should be avoided. For preference, exterior signs should always be illuminated, either from within or by using external lanterns, tubes, or spotlights. In many situations, particularly with large buildings such as department stores or supermarkets, signage will be wall-mounted: individual pinned letters, rear-illuminated letters in silhouette, front-illuminated signs, or box signs with lighting behind the plastic face in a metal box. Individual letters, given the right typographical treatment, provide the most "sophisticated" exterior graphics; a box sign is probably the most ubiquitous. If rear illumination is used, the wall surface must look good in the light halo. Whatever method is chosen, the designer should not underestimate the power of signage presentation. The combination of name, lettering, style, and sign construction will say much about the store and its aims.

Esprit du Vin (above), an upmarket wine store in London designed by FitchRS, uses paint effects and bronze to produce a "coat of arms," against a textured background, creating a symbol which is as much of interest in itself as for what it represents.

Princes Square (above right), designed by Hugh Martin and Partners, is a conversion of historic listed buildings, dating from 1841, into a new speciality shopping center in the heart of Glasgow, Scotland. The wrought steelwork of the projecting entrance is in keeping with the original style of the architecture.

In the main street, or in the shopping mall, exterior signs are more likely to be fascia-mounted. The internally illuminated box sign is the most commonly used type in this situation, but it can look ordinary. On the other hand, when constructed in the corporate logo style, this is a relatively inexpensive and flexible way of creating instant external recognition, and is appropriate for the less expensive types of retailer. However, a problem with this type of sign is that the usual fluorescent tubes used for illumination tend to fail over time (and before maintenance), so the output goes down without anyone really noticing. Neon is a more reliable and better source of internal illumination. Nonilluminated signs can, in certain circumstances, be more appropriate than lit ones. Hanging signs are more traditional, echoing the origin of store signs: a boot for the shoemaker, golden balls for the pawnshop, an anvil for the blacksmith. More conventionally, a hanging sign in carved wood or wrought iron can simply carry lettering. And in the right context, hanging signs may still be a good design solution. For a craft store, or for stores in a conservation area, painted or crafted hanging signs can provide an enjoyable test for designer ingenuity, adapting new symbols to an old style of signage.

The simplest method of exterior signage is glue-on or rub-on letters on the plate glass of the store windows. As the principal external statement, such an approach can be too retiring. It is better to use this technique dramatically, for signage announcing a sale or a special event. It does convey an instant quality that may impress on passersby, for instance, that the fish-store owner or vegetable-seller adjusts prices daily. Another alternative – if a somewhat overzealous one – is provided by Oddbins in Britain, where offers are advertised directly on the window. Water-based paint is easily removed and therefore provides an infinitely flexible solution. Eye-level lettering on the glass may also be the only way a consumer can identify the store, given the narrowness of many pedestrian sidewalks. Some understated stores, such as the Japanese fashion retailers Comme des Garçons, use discreet lettering on glass as the only statement. Very decorative signs can be made by reverse signwriting on glass. Acid-etching and gilding are both techniques available to the signwriter. Although in some areas signwriting is a dying skill, it generally can be found, and will prove quite appropriate for some retail ideas. At the other end of the scale, designers should consider embracing the sign as both art and architecture. The Hollywood scale of Communication Arts' work at Bayside, Miami, can transform the sign into the primary medium of identity in retailing.

Bravado and wit are combined here (right) at the entrance to Bayside, Miami, conceived by Communication Arts as a sculpture rather than a sign. The large individual letters (12 feet high), illuminated by neon lights at night, are deliberately reminiscent of the famous Hollywood Hills sign, making a similar announcement that Bayside is something important and exciting.

The illuminated sign (opposite) announcing the Trainshed – part of a hotel and shopping complex housed in the original Union Station in St Louis, designed by Communication Arts – identifies what shoppers will find and provides a clear directional sign. The materials and design of the sign echo the functional metal structures of the original building. (*Photo:* R. Greg Hursley/Communication Arts Incorporated)

FISH CO.

fresh 48 hours

ALDER SMOKED
INDIAN SMOKED-LOX
KIPPERED SALMON
SMOKED STRIPS

OYSTERS
IN THE
SHELL $2.89
DOZ.

WE DELIVER
TO ALL
MAJOR HOTELS

FOR 48 HRS.

In Seattle's Pike Place Market, stalls have maintained the best traditions of marketplace graphics. The fish stall combines skilled signwriting with handwritten notices publicizing the day's freshest fish and best prices. (*Photo:* © 1988 Rick Morley/West Stock)

In Sainsbury's supermarkets (above), price is an important message to convey. But these signs are combined with others reinforcing the store's corporate marketing – "Selected for Quality and Freshness" – which is carried through in a consistent graphic style. (*Photo:* Ian Cook)

In Dillon's bookstore (right), London, designed by FitchRS, the main staircase has a discreet but informative sign providing information on the basic breakdown of departments on the floors. For shoppers wanting a more detailed directory, there is a large signboard placed in a slightly less busy and central position, allowing for unjostled scrutiny.

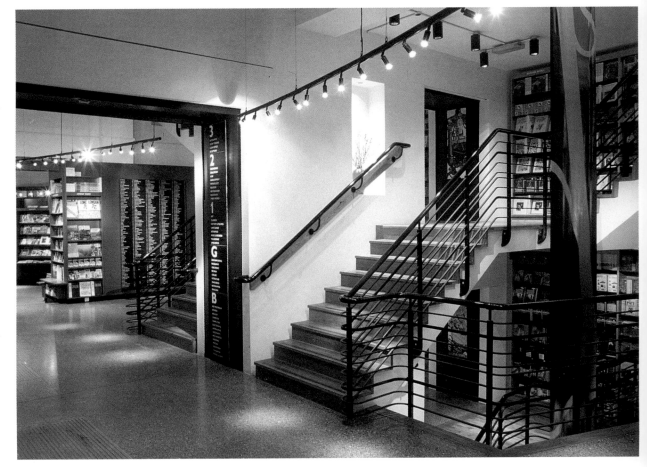

INTERIOR SIGNAGE

In combination with good planning, retail graphics should help to make the store intelligible to the customer. At the same time, these graphics have some very specific roles: selling merchandise (price ticketing, descriptive tags), giving information (statutory signs, such as "fire exit" or "no unaccompanied children"), and providing direction inside the store. And in some stores there is a further level of signing which is more emotive: photographs and transparencies for fashion stores or cosmetics departments, for instance. The hierarchy of these separate graphic groups will vary from store to store, but overall a single corporate personality should be projected. Different tasks may often be performed by different signs, but the purposes should not be in conflict: disoriented shoppers, unable to find what they are looking for, are going to be unhappy. In the British supermarket chain Sainsbury's, graphics are used largely to project price; at Dillons bookstore in London, department identity and location is perhaps the most important informa-

tion. Signs that provide direction need to be simple, and quickly comprehensible – arrows that point in indeterminate directions are no help. And even the best directional signs will only be of use if the destination is clearly signed upon arrival. Signs that help the selling process are more complex. They can range from the simple, such as the designer label in a fashion store, to the intricate, providing museum-level detail to give historical information or explain a curious gadget. The level of graphic information needs to be adjusted to fit the store and merchandise. The graphic design will then be considered accordingly. In general, the more sparse the information, the bolder and more studied the graphics. Where information is copious, the graphics will need to be scaled down in order to be useful. And designers should not neglect the potency of the seemingly undesigned: chalked-up or temporary-looking prices, for example, suggest a market freshness that is new every day. The overall watchword must be simplicity. Signs that try to convey too much are certain to confuse the customer and be self-defeating.

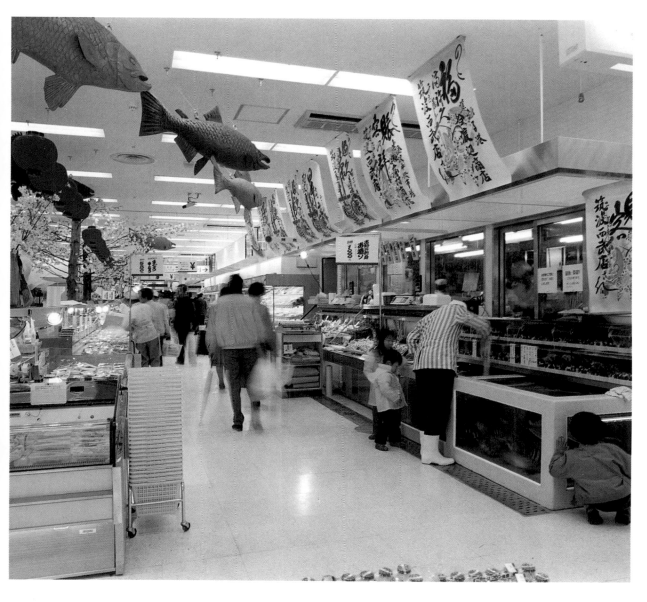

The food section at Seibu, Tsukuba, uses hanging banners designed by Yasuhiko Kida, which employ colourful calligraphy to announce special offers and items. The hanging fish models are also an effective, immediately understood graphic device.

Vinçon, Barcelona, designed by
Fernando Amat, uses a simple
stencilled typography, but bags
convey the personal style and
humour of the store, with
caricatures of the two owners.
(*Photo:* Richard Bristow)

TICKETING AND PACKAGING

Ticketing and packaging are part of the total trading identity and should be part of the designer's brief. Although price tags, clothes labels, boxes, and shopping bags may seem to have little to do with the environmental aspects of retail design, they are important components of the overall "total retail identity" of the store. Carrier bags, in some stores, have become such a powerful means of identity that they are virtually collectable objects: the US store Bloomingdale's started the trend of commissioning artists to design seasonal carrier bags, which added to the lure of the store, and the Victoria & Albert Museum in London even held an exhibition to demonstrate the qualities of the simple bag. In many stores, own-brand, house-brand, or own-label packaging has become an important way not only to introduce new trading lines but to convey the retailer's position. This is particularly prevalent in European foodstores such as Marks and Spencer, Carrefour, and Asda, but is also a feature of nonfood stores such as Britain's Body Shop.

Although ticketing and packaging graphics should become an enjoyable design exercise – conveying identity and information concisely – it is easy to get carried away. The product must remain the principal object of attention. Scale is important with ticketing: it should not be so large that it dominates the product, but nor should it be so small that it is difficult to find. In fashion store presentation of several items assembled on one mannequin, an efficient way of ticketing is to list prices of individual items on a single price stand. Many different systems of ticketing and price-tagging now exist, varying from handwritten to pre-printed, and including slot-in systems, such as those designed by Pentagram, or friction/pressed-down systems, as used by Wallis (both in Britain); it is a question of finding the one most appropriate to the merchandise. It is worth remembering that the requirement for ticketing in the window is likely to differ from that of the rest of the store. Ticketing should link with other aspects of the design; sometimes merely using corporate colours on ticketing will be enough to do this.

The graphic content of a store – the importance of the written and printed word – cannot be over-emphasized. Too much will obscure the objective, too little will fail to release a store's full potential. Yet again, this graphic dimension must be woven into the overall identity of the retail surroundings. It must be sympathetic to both merchandise and built environment, while at the same time both expressing the personality of the store and helping to shape it.

The shopping bags (right) at
Janet Fitch, London, designed by
FitchRS, are of a marbled paper
that cleverly matches the
marbling effects on the store's
plaster walls.

The handwritten labels for the ice creams at Gran Gelato, above left, designed by Dinah Casson and Roger Mann, echo the unusual shape of the counter shelf.

The packaging for Club Monaco, above right, imaginatively imitates the products being merchandised.

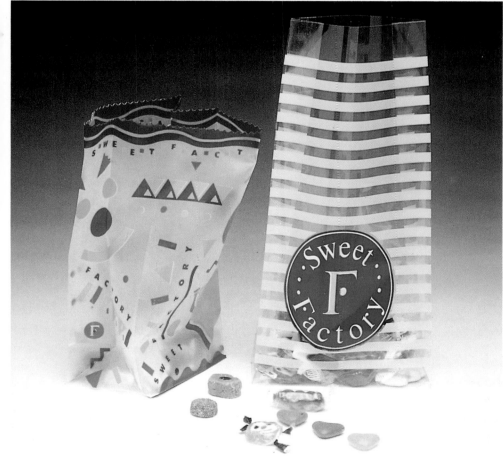

The design of these bags for confectionery, left, reflects the transparency and colourfulness of the store design by Michael Peters Retail for Sweet Factory.

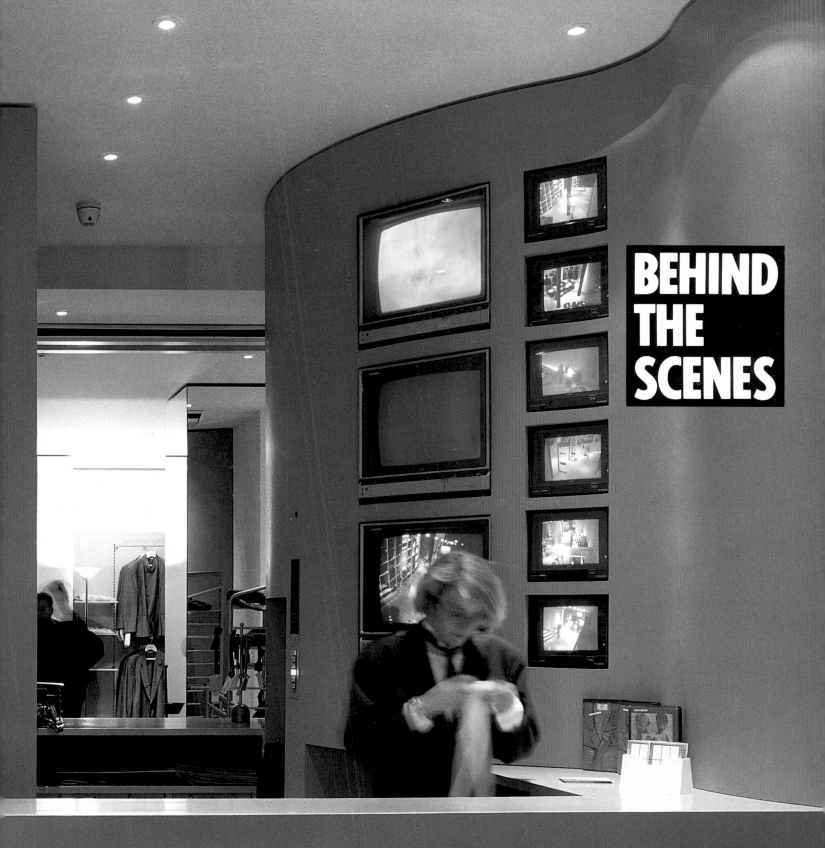

BEHIND
THE
SCENES

The Trainshed at Union Station, St Louis (opposite), designed by Hellmuth Obata and Kassabaum, uses brightly painted, exposed ductwork to handle the large ventilation load. In such a big space, the ductwork can be exposed without becoming an intrusive element of the design. (*Photo*: R. Greg Hursley/ Communication Arts Incorporated)

At Martine and François Girbaud, Paris (previous page), a large service desk allows for easy handling of cash-taking, wrapping, and information. Monitor screens for security are made a feature of the design: shoppers seeing security precautions aids effectiveness. (*Photo*: Stephane Couturier)

The successful retail environment is most likely to be one where the customers' needs are the first consideration, yet many parts of this environment are usually never seen by the ordinary customer. In the best designs, these areas will have been given just as much attention as the more prominent, obvious selling spaces. A number of different areas of design are involved: "behind the scenes" essential services, such as air conditioning, fire precautions and security, that will usually be unseen by the customer; spaces intended for the sole use of the staff; and ancillary spaces such as restrooms and storage. (There is further coverage of concealed services such as electricity in Chapter 5.) Any discussion of services depends to a large extent on local regulations and environment – air conditioning, for example, may be essential in some locations, unusual in others; medical provision is required by statute in some countries, and is particularly necessary in large stores, both for customers and staff. But a number of important considerations should apply as a matter of course in the design of services for retailing. Most critical, and the fact that often diverts designers' attention from the subject of services, is that they be unseen and unheard. Further, given the large capital and running costs of most services, careful scrutiny should be given to the allocated budget. Finally, as with visible aspects of retail design, the goal should be to create the environment most pleasing to both customer and staff – and elaborate technical calculations will be useless without satisfying this aim.

FIRE PROTECTION

Generalizing about fire protection in retail design is difficult; much will depend on the size and age of the building, together with local building and fire regulations. The prevention, containment, and management of the fire hazard is increasingly legislated for in retail design. As fire-management techniques become ever more complex and sophisticated, it is often wise to employ specialist fire and smoke management consultants. Research shows that most fires are started either through carelessness or through electrical failure. The former category includes instances of cigarettes dropped into wastepaper baskets made of plastic, wood, or some other combustible material; cigarettes left in changing rooms or staff areas; and cigarettes dropped into plant or machinery. In the second category, main causes are appliances left on in stores overnight, overheating low-voltage lighting, badly vented showcases or display windows, and electrical failure in the overdoor heating systems. From the very earliest stages of a project, designers must take fire risk into account and design in a number of preventive measures, notably the choice of inflammable materials and finishes, and planning clearly understood escape routes, particularly for buildings of several floors or those that contain large open spaces such as atria. In shopping centers and larger stores, the positioning of main, ancillary, and escape stairways is conditioned by the assumed travel distance from the source of the fire, and there is frequently a minimum width requirement for shopping malls. In many places, some form of sprinkler system may be required. The design of these systems is usually strictly regulated, and designers are confronted with the problem of integrating the plumbing and control systems for sprinklers into the design. Similarly, smoke and heat detectors may be necessary in many places. Whatever fire conditions are imposed, designers should treat them with respect, and should try to design imaginatively within them.

A variable air volume (VAV) system of air conditioning uses locally positioned boxes, mounted above the ceiling, to provide air extract and supply. VAV systems have the advantage of local control and flexibility.

HEATING, VENTILATION, AND AIR CONDITIONING (HVAC)

The subject of heating, ventilating, and air conditioning is highly technical, and an area of retail design where it will be wise to consult an expert – in this case a services engineer. Many factors determine the correct HVAC design for any space: the size of the store, the opening hours, local climatic conditions, the number of customers at peak times, the type of merchandise sold, and so on. An electrical store, for example, selling televisions, computers, and audio equipment, will generate a considerable amount of heat, so that even in winter, cooling may be essential. For a small clothes store that expects only a few customers at a time, heating will be needed during cold spells. But a busy store might need cooling even in cold weather, since people and lighting can generate great heat. The kind of points for consideration that apply in so many areas of retail design are also relevant here: how good will the retailer be at maintenance, and how much money would be a sensible expenditure? Any thought about HVAC should be informed by the realization that many stores are overheated, because of inadequate air conditioning or even air movement. The trade-off between an unpleasant atmosphere and low capital expenditure is a false economy, and one practiced more usually in Europe than in the United States.

Designers should start with some form of air-conditioning system in the budget, rather than adding it in if the fixtures and fittings costs allow.

Whether the designer or retailer deals with HVAC, or consults a specialist, some knowledge of the basic types of systems is useful. The most versatile is generally a variable air volume (VAV) system, used for ventilation and cooling. With such a system a terminal or VAV box is mounted above the ceiling and draws warmed air from the ceiling return-air plenum (the space above the ceiling), or from separate return ducts. Warmed air is produced initially by the people, equipment, and – particularly important – the lighting in the store. Once extracted, the warmed return air is mixed with the conditioned supply air and delivered into the store. VAV systems can, in winter, supply heated air into the store if necessary. VAV systems have the advantage of relatively low capital cost, local control, and flexibility, but they require a local plant for the supply air.

The other main type of HVAC system is a combined heating and cooling rooftop system. A plant on the roof does all the conditioning of the air, either heating or cooling, which is then delivered anywhere in the building through ducts. But rooftop systems are

A rooftop system, using a central plant room which distributes a constant volume of air around a building through ducts, has the disadvantage of poor flexibility and high operating costs, but older retail developments may still use a constant volume system.

generally more expensive to maintain and lack the flexibility of VAV systems. Rooftop systems may also create an unacceptable roofscape, bringing problems with building volume and local planning controls. The importance of maintenance has been made clear in recent years with the highly publicized incidences of Legionnaires disease caused by inadequately maintained, water-cooled air-conditioning systems.

Although in most instances the rule applies that HVAC should not be seen or heard, there are some exceptions. In some stores, the "high-tech" device of exposing ductwork in its natural metal finish or painting it in bright, noticeable colours can be effective: in a children's store, a sporting goods store, or a hardware store, perhaps. This "designer ductwork" also works well in bringing new services into older buildings, such as refurbished market halls. In any situation where ductwork is to be exposed, designers and services engineers will need to work particularly closely. Designers can also take advantage of the problem of concealing ducts and vents by choosing to celebrate them instead – an elaborate vent grille can become a decorative element in a store (see Magasin d'Usine, Nantes, page 186). A word of caution about

exposed ductwork, however – it is difficult to keep clean and the retailer will probably need to hire a specialist cleaning contractor.

Whatever system is chosen (and it should not be forgotten that for many small stores, being able to open the windows may be sufficient as an HVAC system), an important consideration is control. If any system is too complicated for the day-to-day staff of a store, it is likely to be misused and will fall, eventually, into disuse. And given the energy cost of HVAC systems, designers should find some way to ensure that controls cannot be adjusted whimsically: it is very easy to lose a store's narrow profit margin by a casual lowering of the air temperature a few degrees. Different stores require different ambient temperatures: the optimum for fresh food is 55/60° Fahrenheit; groceries require a temperature of 60/65° Fahrenheit; while nonfood stores should be around 65/75° Fahrenheit. One of the problems of cooling fresh food stores or areas is that as the cool air falls, it creates a very cold layer at floor level – uncomfortable for feet, and, particularly, for small children. This air will need to be "stirred" around or sucked out beneath equipment and recirculated.

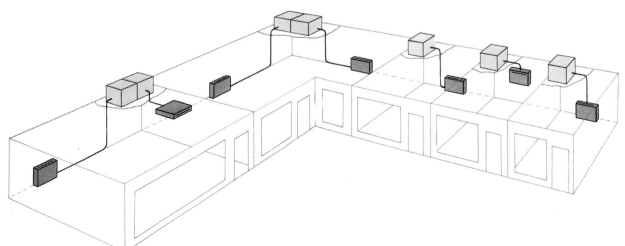

For small groups of stores, a simple split air conditioning system may be the most effective solution. It has the advantage of much smaller plant than a VAV system. (All from *Air Conditioning Systems for Commercial Buildings*, Carrier Distribution Ltd.)

DATA SUPPLY

A relatively new consideration in the provision of services is data. Increasingly, retailers rely on sophisticated information systems to track inventory, sales trends, and even electronic payment. Generally, the planning of data supply meshes with the placement of sales points or cash desks. Wiring (or occasionally optic fiber) can be carried in trunking in ducts beneath the floor, along the perimeter trunking, or in the ceiling void. But data require a number of considerations that do not apply to electrical wiring. Data supplies must be shielded from electrical wiring and other data sources to prevent interference (optic fiber does not have this problem). Many types of trunking now have an integral channel for data supply that provides the necessary shielding.

SECURITY

Security is a major consideration in retail design almost everywhere. There are increasingly two kinds of security that designers need to take into account: the obvious one of merchandise "shrinkage" or shoplifting, and the less apparent one of shoppers' personal security – a number of shopping malls have become easy targets for pickpockets or muggers, a fact that is unlikely to encourage a pleasant shopping experience. Without doubt, the most effective form of security is aware, observant sales staff. But the cost of staff often means that numbers are well below those required effectively to stop pilfering. In many stores, uniformed security personnel provide a visible reminder to shoplifters of the risks they face – and, of course, the concept of the plainclothes store detective has long been familiar in retailing. At the most basic level, security is provided in the planning of the store, but there are also a number of means available to the designer to improve store security. Blind spots or concealed entrances and exits can and should be avoided. A careful compromise has to be reached by both designer and retailer, however, for while customers need to feel confident about personal security, no-one relishes an environment where they feel under constant surveillance.

There are some areas of the store where security is particularly important. Fitting rooms in a fashion store are perhaps the most vital security consideration, and sales staff must be able to control and monitor access. Floor-to-ceiling partitions between fitting rooms prevent shoplifters who work in teams from passing garments to one another (see Department X, London, page 127). An uncluttered fitting room, with few hiding places, reduces the opportunity to secrete an electronic security tag illegally removed from a garment. For expensive merchandise that can easily be pocketed, such as jewelry or small gadgets, lockable display cases such as those shown above help prevent bold thieves from grabbing and running. Impact-resistant glazing on showcases has eliminated the threat of smash-and-grab crime.

Many stores now use some form of closed-circuit television as an effective way to increase surveillance. The cost of such systems has been greatly reduced in recent years, and many have recording facilities (to aid prosecution of shoplifters). Fortunately, too, progressive miniaturization has made closed-circuit systems less oppressive and more visually acceptable. Designers should remember, however, that too much discretion in locating a security system is a mistake: to act as a deterrent, the system must be clearly visible and identifiable. Another major advance in store security in recent years has been the development of electronic security tags. Although there are a number of systems in use, they all work on similar principles. An electronic signal is set up at the store exit between a pair of pedestals or columns. If the tag passes between the pedestals, the signal is interrupted, setting off an alarm. The tagging itself falls outside the designer's brief, but the hardware at the exits will need to be integrated into the overall design.

The jewelry department (above) at Next in Kensington, London, designed by Rashied Din Associates, uses specially made lockable display cases to deter shoplifters. The metal panels and studs of the display cases give an impression of toughness and impenetrableness, heightening the sense that the merchandise is valuable and rare – although much of it is in fact reasonably priced and massproduced. (*Photo:* Din Associates)

Security at Le Set, London (opposite), designed by ORMS, is aided by the open lines of vision between fixturing. Floorstanding fixtures need a measure of transparency, or reduced height, to prevent views from being obstructed – an encouragement to shoplifters – while the closed-circuit security television camera is mounted in an effective yet discreet position. (*Photo:* Padraig Boyle/ARCAID)

The Café des Artistes at the Heal's department store, London, designed by the Conran Design Group, is exclusively for the staff. Providing a well-designed, attractive staff restaurant gives workers a refuge from the pressures of the store, as well as a tangible non-pay benefit. Although the ductwork is exposed here, it does not detract from the overall café ambience. (*Photo:* Conran Design Group)

Designers should not forget to consider the security of stockroom or delivery areas that may not normally be open to the public. Again, electronic surveillance methods may be used, or locked areas with limited staff access may be needed to segregate higher-priced merchandise. Planning, however, is the most important security step in these areas: potential thieves should not be able to gain access to stockrooms without being seen. So an access door hidden from view, or a side stairway, should be avoided. Designers should also take into account the security of shoppers outside the store. If a parking lot is used by shoppers, it should be well lit and devoid of hiding places that might conceal a mugger. Similarly, in the public areas of a shopping center, lines of vision should be kept clear and lighting should be ample to prevent crime. Staircases and elevator foyers are similarly areas where safety of shoppers should be considered. No shoppers will want to come to a place where they feel insecure.

STAFF AREAS

Good customer service is an essential ingredient in successful retailing and so the staff who are crucial to this should be well treated, and the design should take as much account of their needs as those of the shoppers. The areas restricted to a store's staff – locker rooms, offices, cafeteria, lounge, training rooms, and restrooms – are part of the retail design too. However, these spaces are not intended for selling. Therefore, while the design of staff rooms can be consistent with the retail identity of the store, designers should remember that a lounge or cafeteria should often be a useful escape for the staff from the constraints of the store. Pleasant working surroundings in the store itself are important too, and it should be recognized that the stress encountered in public areas may not always lead to an environment amenable to good customer service. All too often pressure on the salesfloor space reduces staff facilities to a minimum. This can be a false economy that designers should resist. Good examples of staff facilities are provided by Marks and Spencers and Heal's in Britain, and Nordstern in the United States. This attention to staff wellbeing encourages loyal, contented staff, which makes good business sense. Smaller specialty outlets probably cannot follow such leads entirely, but they can usually go some way in the right direction. Provision for staff should include at least a rest area, kitchen facilities, and a changing space with secure personal lockers or cupboards, all of which should be generously designed and well maintained.

Some stores and retailers have a staff uniforms policy. This can range from requiring the staff to wear the designer clothes of the store itself, to a standard, low-budget overall at the other extreme. While a uniforms policy can be helpful in identifying staff to customers, the clothes themselves can be demeaning and irritating if not well designed and comfortable. Britain's Midland Bank has a policy of providing a "wardrobe," or several items of clothing that can be mixed and matched. The themes carry through without everyone looking the same. This system is popular with staff as well as helpful to customers.

CUSTOMER SERVICE AREAS

Many designs neglect customer service areas, such as the checkout counter, service counters, fitting rooms repair facilities, and restrooms, even though they may be more visible to customers than staff spaces. Yet these areas can condition a shopper's impressions of a store just as effectively as the entrance or the main selling arena and money spent on the store interior is wasted if customer service points are not well planned or designed.

Seen from the customer's angle, the checkout counter is just another fixture in the store. But in many stores, it fills an intricate, varied role that makes careful design particularly important. In addition to being the critical point where the sale is finally completed (necessitating the wiring, communications, and data links needed for modern cash registers and credit-card validators), it may have to contain storage space for shoppings bags, merchandise for collection and returns, catalogues, boxes, and so on. At the same time, staff will be expected to take money, check credit cards, carefully wrap merchandise, and answer shoppers' questions. Because of the complex transactions that might need to be performed, it is best, if space permits, to create a number of distinct areas for these different service tasks, and to consider each function carefully from a practical point of view. So,

for example, the design of a checkout counter will need to take into account the particular requirements of the individual store.

The designer should remember that checkout counters, like service counters, are working areas and not display points. Therefore, ergonomics and human factors are important considerations. The counter should not be too high, too low, or too wide, nor so far from the back fittings that sales staff will need to take extra steps to reach the products. Everything should be designed to be within reach. Those fractions of a second saved at each transaction during the course of a day build up to hours of extra sales and hundreds of customers served more quickly and efficiently – and the sales staff will appreciate efforts made on their behalf to lessen their work-load. The checkout counter or cash register desk needs to be an efficient machine, and it is one that will increasingly be linked electronically to computers for direct stock and merchandise information. And, so that it can act as a focal point for information as well as for paying, it should have a highly visible position in the store, often signalled by its own sign. In the Worcester branch of the hardware megastore chain, Homebase, the information desk is placed at the entrance, handy for both entering customers and the adjacent registers. Congestion around checkout counters is often a likelihood, and shoppers will appreciate space that allows

At Wakefield Fortune Travel, Twickenham, UK, designed by Pentagram, the heavy information demands of the travel business are incorporated into the design. Staff working areas have ample space for airline and hotel directories, and specially designed turntables to allow ease of use with the computer terminals. (*Photo:* Martin Charles)

Hardware and Do-It-Yourself stores have particular problems at checkout counters. Homebase, Worcester, UK, provides robust counters with roomy aisles between to allow shoppers to maneuver large pieces of timber and other building materials through.

for shopping bags, children, and orderly queues. All in all, designers should generally err on the side of generosity in planning customer sales and service points.

Many stores will need some sort of public pick-up area, where ordered goods, or merchandise that has been altered or packed, can be transferred to the customer. For stores that deal in bulky merchandise, such as furniture or appliances, the pick-up point will be a loading bay, so that cars can drive straight up. For others, it may just be a desk or small areas to hand over packages. But in either case, the identity that has been established by other parts of the design should be carried through consistently – after all, it's the last memory of the store! Practical considerations also apply: secure storage, and facilities for cash handling, packaging and wrapping may be needed.

Public toilets are a troublesome area in retail design. Local practice and building codes may require them, but few retailers are willing to spend money to make toilets anything other than ordinary. But, like so many other ancillary spaces, they can be an important part of the shopper's experience of the store; they should have the same attention to detail, as well as a sense of identity, and should be subject to the same standards of maintenance as the more public areas of the store. And in many cases, this sort of provision can become a major part of the store's personality: a retailer catering for children, for example, should include a nursing mothers' and baby-changing room as an essential service. The designer's attitude should be that if the store is to have these facilities, they should be done well. Cost dictates that public toilets are planned near the building's plumbing supply.

Designers should be unconcerned if they are somewhat out of the way (although they should not be impossible to find). But inside the toilets consideration should be given to ways of adding identity at relatively low cost. Instead of tiling in a uniform colour, for example, some play can be made with patterns and colours. It may be possible to use a store's own products, such as soap and towels, or to put store posters and advertisements on the walls, or even to promote the store itself, with floorplan or storeguide, opening hours, and other information.

Some mainline stores also provide so-called "ancillary" services for their customers such as cafés, travel agents, and hairdressers; however, as far as the designer is concerned, there is no such thing as an ancillary or subsidiary service. All these services should be well designed and well planned, so that they make both a financial and an emotional contribution to the store service culture. For example, a bank that follows bank opening hours is an irritation in a store where the opening hours are different. A café where the menu or level of comfort is worse than outside the store provides no encouragement to linger.

Plainly, the level of services requirements in a store will vary, depending on the store's nature and size. A small specialty store with a modest and efficient staff room, carrying its stock on the floor, is a far cry from London's Harrods, which is reputed to have miles of "behind the scenes" stockrooms, corridors, and staff facilities. But all services facilities must be efficient and well planned, and should contribute to the sales-floor activity rather than be a hindrance. Whatever scale the services operate on, the designer must plan them into the scheme from the beginning.

All too often, public toilets are neglected in store design, even though they may significantly condition a shopper's experience in the store. At Loft, Tokyo, fresh flowers and granite fixtures and walls bring the toilets up to the design standards of the other parts of the store.

PART TWO

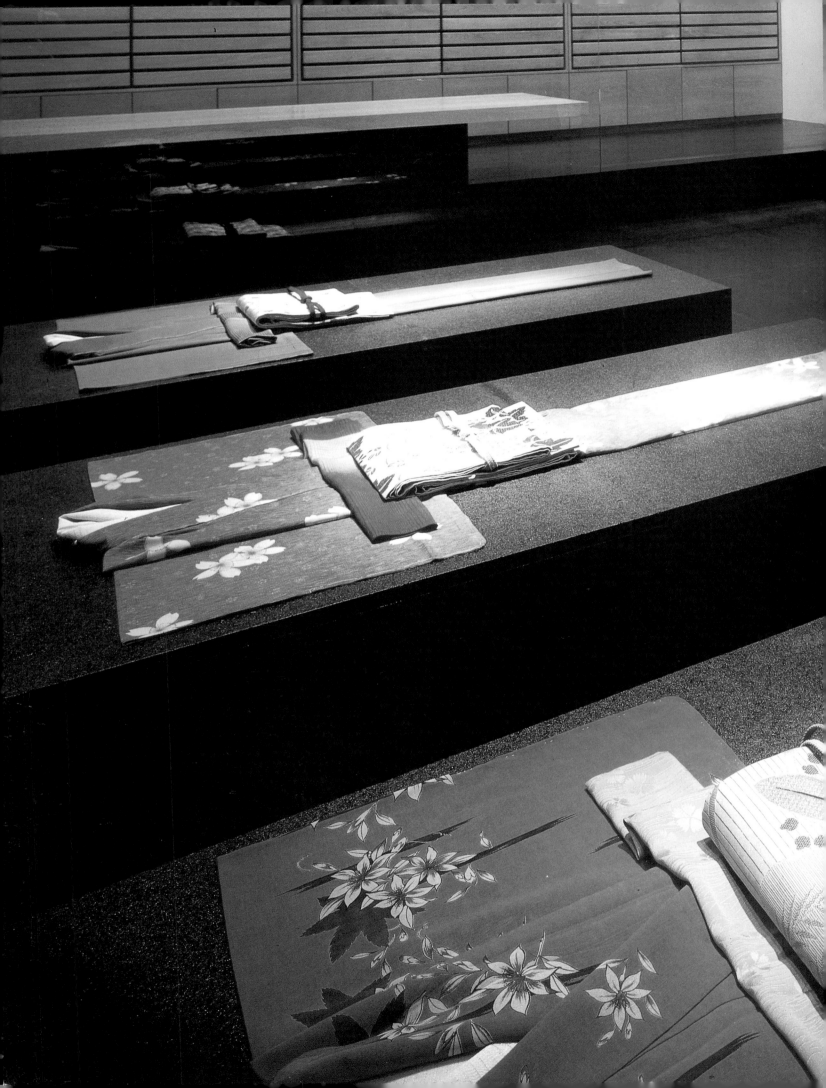

FASHION STORES

By the very nature of the product, fashion stores have for long been a prime source of retail creativity. As mass fashion has become more visible and accessible, so retail outlets have mirrored this trend. Today, fashion stores are one of the most common territories for retail designers, and one sector in which the power of good retail design was recognized very early on by retailers themselves. The arguments for design in fashion stores are powerful: with so much competition, with the constant change in merchandise, and with the importance of image above all, design can play a key role in differentiating one retailer from another. In fashion more than in any other type of store, the life expectancy of a design is particularly brief: as a rough rule in the mass market, a face lift in design is necessary every five years or so. This is not entirely because fashions change, although that certainly is one reason. More important is the overwhelmingly specialist and "niche" nature of fashion retailers. A store that aims at 18- to 24-year-old women, for example, is trying to appeal to a group that is itself constantly shifting and changing its demands, attitudes, and expectations. This should not, however, be seen as a negative aspect of retail design: in the best fashion stores, design helps to keep the store contemporary, so that it is both of its time stylistically and relevant to its particular audience.

SERVICES AND PLANNING

The shortened lifespan of a fashion store's design therefore requires a heightened level of originality and flexibility from the designer. Flexibility can ensure that change does not mean inevitable obsolescence or substantial capital reinvestment: for example, by re-colouring and reconfiguring merchandising fixtures, and changing the carpet, the graphic design, and altering lighting, the design can evolve with the changing market and at relatively low cost. However, while these changes can be influential, designers should be aware that customers are not gullible – superficial changes will never prove decisive or fundamental in the success of a design. What many designers fail to recognize is that this demand for flexibility means that the "hidden" aspects of the design – services and planning – become of even more fundamental importance. Services such as lighting, air conditioning, power, and data supply, are the starting point and basis of any design: if they have been properly designed, subsequent cosmetic change can take place without the retailer tearing the store apart and spending a fortune. Similarly, the basic planning of the store – positioning the entrance, major circulation space and storage areas – is difficult and expensive to alter. Few retailers can afford completely to redesign a store every five years: planning must be right first time. Inevitably, there comes a time when the "life" of both presentation and services expires and a completely fresh approach is necessary. Retailers should not be resistant to change – the time to change is at the "top," rather than too little, too late.

If services and planning, and other aspects of the infrastructure are correct, other less expensive changes can take place. Designers can think of the services as the walls of a room, and the fixtures and finishes as the furniture and decorations. In this context a good subfloor is of prime importance, so that different types of floor finish can be used. If a suspended ceiling is used it should be of a quality to outlast changes within the store, because if the void above carries overhead services such as air conditioning, lighting, and power, it will probably have to be retained during alterations. In contrast, walls can often be left in a rough state, to be dry-paneled over. Occasionally, and particularly in the fashion arena, the starkness of unfinished walls and ceilings is considered not only acceptable but original and stylish, creating a kind of inverted snobbery (see also *Materials and Finishes*). Generally, though, it is most important for walls to have good fixing points top and bottom, so that an interior wall system can be independent of the shape or condition of the structural wall.

Bushôan in Tokyo (previous page), designed by Ikuyo Mitsuhashi of Studio 80, highlights the early origins of the Japanese minimalist style of display. The traditional, dramatic simplicity in the presentation of these kimonos is a style now widely applied by designers. (*Photo*: T. Nacása & Partners)

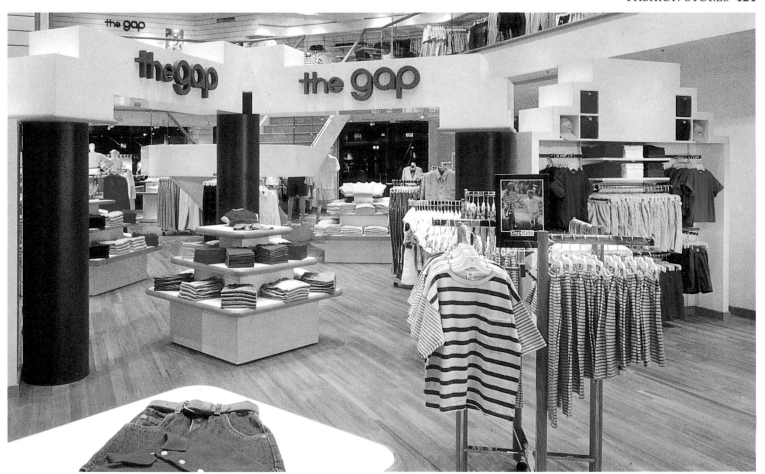

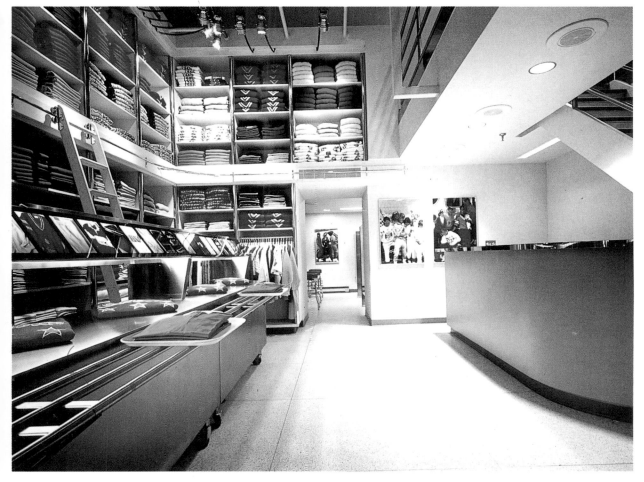

The now international chain The Gap (above) is deliberately classic and understated, albeit in a youthful idiom, to allow for maximum flexibility in accommodating the changing tastes of the younger shopper. Neutrally coloured units with a wooden trim enable hanging, folded and table display. In this San Francisco branch, designed by Gensler and Associates, the wood-plank flooring enforces the informal, warehouse atmosphere. (*Photo:* Karant and Associates Inc.)

Aiming for a market similar to The Gap's, and despite a far smaller space, Fizzazz (left) makes shopping at its store on Columbus Ave, New York, rather more of an event. The visual references are to a canteen or fast-food store. Most of the clothes on display are folded tightly in blocks of colour, many accessible only by ladder; shoppers collect purchases on canteen-style trays. The wheeled displays in the foreground can be used as island units, and are styled like cold cabinets in a supermarket.

Steven Hall's design for Giada, on Madison Avenue, New York, uses ceiling lighting almost as sculpture, like his asymmetrical floor mannequins. Meshed screens of different depths over light sources express with sophisticated humor the sense of compression the designer claims to have felt at working in a cell-shape only 14 by 30 feet (4.2 by 9 metres). (*Photo:* © Paul Warchol, 1987)

LIGHTING

Lighting is another area of prime importance in fashion stores. Because of the key role of the merchandising units in this area of retailing, lighting design must take particular account of the need for flexibility around them: as merchandising displays change, the store must be easily able to increase, decrease, or change the lighting on the merchandising. Lighting should not necessarily emulate the environment the clothes may be worn in, although that is one option for designers. Instead, as on a film set, the lighting should be designed to make the clothes look good. The old retailing adage that lighting levels should be "50 percent brighter than you think" has some validity, as long as it is understood that there must also be contrasting darker areas to show off the merchandise (although dark areas must never be allowed to become dull). If lighting levels are uniform, nothing will stand out: contrasts of light can be used to create atmosphere and drama.

One area of the store where there must be ample light is at the entrance: few customers will be attracted into gloomy spaces. Natural light, if it is available, can be an advantage both at the entrance and perhaps as a lure to a deeper, interior part of the store; however, designers must always be careful that merchandise does not end up in silhouette, particularly to bright sunshine. Direct sunlight, although good for colour rendition, can also fade the colours on some fabrics. Considering colour rendition under artificial light is important in the design of fashion stores (see also Lighting). Accurate colour rendition is easier to achieve with tungsten-based sources than with fluorescent ones, although some of the newer-technology fluorescent sources represent a major step forward in this area. While colour accuracy is desirable, designers often need to make some compromise among the competing interests of accurate rendition, servicing of lighting fixtures, seeing circulation routes, and energy consumption. It may seem a trivial consideration, but generally if a bulb lasts longer, even if it is more expensive, it will prove a good investment: as mentioned earlier, for most stores, the expense and nuisance of changing bulbs is best avoided. Nothing makes a design – and store – look shabbier than lights that have burnt out and have not been replaced. The long life, as well as the very white, low-energy sources of low-voltage tungsten bulbs, have been a tremendous spur to their popularity in retail design. But in choosing any light source or light fixture, the decision should be based on appropriateness and performance – never on how good the fixtures look. The design is there to sell the merchandise, not the lights.

At Joseph in Draycott Avenue, London, pinpoints of light create a filmic sparkle above the clothes on display and are reflected in both mirrors and polished surfaces. Nonetheless, the lighting does not dominate the style of the garments or distort impressions of their colour. (*Photo:* Alastair Hunter)

At the original Katharine Hamnett store (opposite) in the Brompton Road, London, designed by Foster Associates, a conscious decision was taken to violate expectations of the entrance. All that could be seen by the approaching shopper was a meandering, arched glass bridge, lit from below, leading to the interior. The dramatic approach suggested exclusivity. (*Photo: Richard Bryant/ARCAID*)

Unfinished looking surfaces and primitive materials can, perversely, convey an image of high style and originality, particularly in fashion stores. In the original Parachute (below), designed by Harry Parnass, the use of simple wire hangers and of discarded envelopes for display is at once humorous and ostentatiously inexpensive. (*Photo: © Paul Warchol, 1984*)

PRESENTATION

Part of the challenge of designing a fashion store is that the customer should be offered ideas – what some retailers call their "story:" it is not enough merely to be efficient and well-ordered. The story should first be presented in the windows, to introduce customers to the retailer's particular "menu," and again in the front part of the store. But it must also be told consistently throughout. The story will, of course, vary according to the market that the store is targeting. In the mass market, where retailers are selling a wider range of items, the story may have many parts: the design will have to accommodate displays that construct ideas, perhaps on mannequins or on hanging systems. For the high-fashion store, it could well be enough to display a solitary jacket on a table. The wave of Japanese minimalist fashion stores have perfected this art of display.

Another current trend is "solution retailing," where merchandise is conveniently displayed and carefully

coordinated – blouses, skirts, accessories, and so on – suggesting to the customer not only ideas, but also "solutions" for their wardrobe (see opposite). But the story is told through more than the display of clothes. Music is one ingredient: loud, popular music may attract an audience of teenagers and young adults, for example, but deter an older audience. The opposite effect can be seen in a more traditional clothing store, such as Polo, Chicago (see page 64). Thick carpets, dark wooden cabinets, and a general hush (no canned music here) create a solid, serious atmosphere that tells prospective customers that the store is not selling anything so ephemeral as fashion, it is selling tradition.

The first impression customers form of the fashion store is from the storefront: shoppers should be able to sample the "menu" the retailer is offering. This is vital to inform passersby both what the store does sell and what it does not sell – its "attitude." The traditional approach to window displays is carefully to control impressions with windowbacks, concealing views of the store's interior (see page 23). The fashion window may be a set piece, with mannequins, lighting, and full ensemble, fully priced and complete with props. At the other extreme, no garment or just one simple item and no price make an equally telling statement. Plainly, the former window will need more attention, more access, and more lighting, and, of course, more commitment of human and financial resources. In many cases it is far preferable to eliminate windowbacks and offer strategic views into the store. Such a design, however, makes it imperative that there is a coordinated policy of display both in the window and inside the store: nothing is more confusing than a disjunction in display. These fully open windowbacks are perhaps most appropriate for mass-retailers who will merchandise right up to the glass line. Most fashion stores today, however, opt for a "half-way house" where carefully harmonized window displays allow tempting views of merchandise within the store. There is an increasing tendency today to show coordination, and the merchandising equipment in the window will need to provide for this, with shelves for folded items, hanging rails, back walls for pinning and draping, and closets for folding and stacking. A conscious decision to violate expectations of a storefront can also be successful. The Görtz shoe storefront in Kiel, designed by Robert and Trix Haussmann, for example, is a vast blank wall. A window below knee height, however, uncovers a glimpse of the store's shoes (see page 127). Even more enigmatic is the Foster Associates' design for Katharine Hamnett, London, which offers to the street nothing but a glass bridge leading to an interior. There is no suggestion that Hamnett sells fashionable clothes for men and women: the store is clearly aimed only at *cognoscenti*.

KATHARINE
HAMNETT

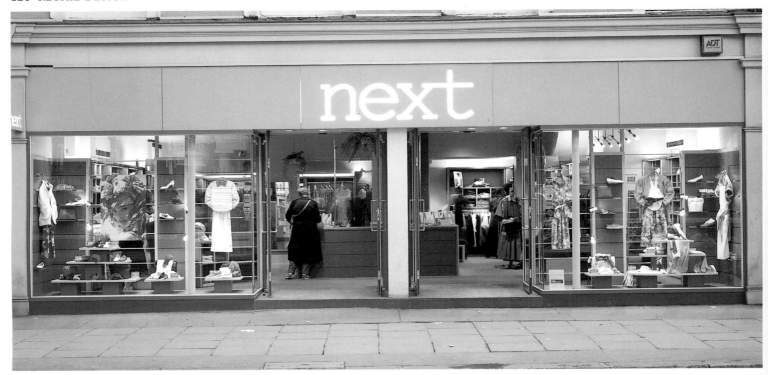

Next for Women in London (above) exemplifies the recent trend towards combination windowbacks for middle-market fashion stores. Its combination of closed and open displays in the windows, with carefully lit fashion "stories," and its wide doorways open onto the street are designed to entice passers-by into the stores with the suggestion of more, carefully coordinated fashion ideas within. (*Photo:* Peter Cook)

At Montana Femme in Paris (right), designed by CANAL, one dramatically clad mannequin, a simple, symmetrical window-lighting scheme, and a stark backing screen make a telling statement about the exclusivity of the store. (*Photo:* Stephane Couturier)

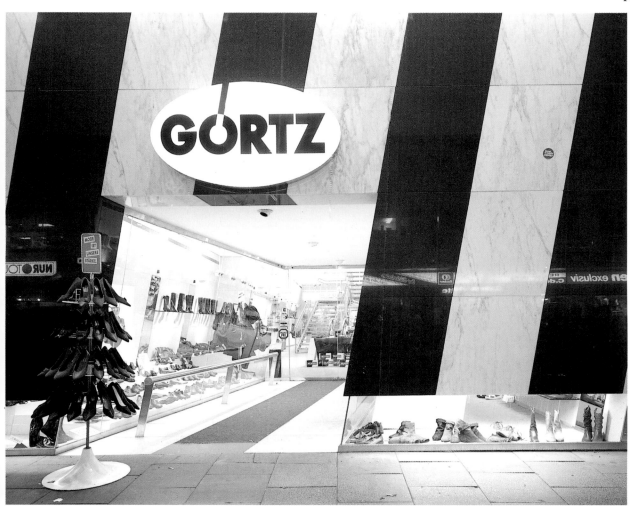

Görtz (left), the low-priced shoe store in Kiel, Germany, though appealing to a different sector of the market from that addressed by Katherine Hamnett or Montana Femme, has also benefited from a design for a largely unrevealing exterior. Robert and Trix Haussmann have used a sense of deep perspective at the entrance and a tantalizing shoe-height glimpse of the merchandise to draw shoppers into the store (*Photo:* Martin Charles)

Next's Department X, in London (below), designed by Din Associates, provides fitting rooms which combine privacy (full-length doors), and convenience (clothes hooks and some natural light) with an element of fun (feeling of being in a horse-box). They are also grouped together, to simplify security control and signposting. (*Photo:* Din Associates)

FITTING ROOMS

One area where stores are legitimately encouraged to flatter with their lighting design is the fitting room. Here, lighting has to make people feel and look good, above all other considerations. Warm sources, such as par spotlights, may therefore be preferred. Another point to remember for fitting rooms is that they should be collected together rather than scattered through the store, to simplify both their identification and security control. Inside, fitting rooms should be havens, without being superficially grand, condescending or intimidating, where customers can take personal stock. Paul Smith, New York and Next Department X, in London, provide good examples in different styles. Mirrors, generous and flattering, should enable customers to see themselves both from the front and in profile. Wide mirrors tilted back slightly show off both customers and clothes to best advantage. Where possible, doors rather than curtains should be used, and preferably should not be visible from the store entrance or sales floor. Floors should always be carpeted for stockinged feet, and provision of clothes hooks and space in which to change should be as generous as possible.

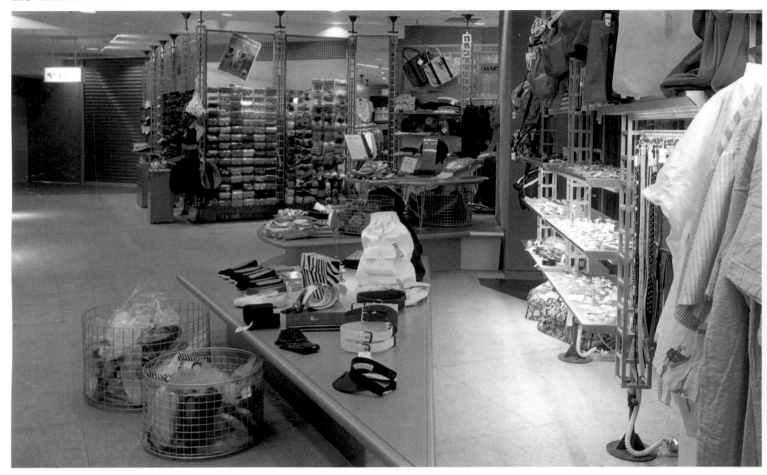

The fixturing at Seibu Seed's Young Casual Shop in Tokyo is flexible enough to allow changes in the positions of shelves and hanging devices; it also enables a permanent mixture of side and front presentation at the perimeter, and folded, table, and bin display. Its simplicity means that it is at once economical and reasonably longlasting in style.

FIXTURING

Inside the store, the prime means for telling the fashion story for designers is the fixturing – and effective fixturing is one of the principal difficulties for retail designers. In the mass market in particular, a degree of flexibility is important so the story can be changed regularly. But the more flexible the system, the more costly it will be. To offer this flexibility is often meaningless and unnecessary. A fixture does not need to hang maxicoats one day and miniskirts the next, nor to turn into a shelving fixture the day after. There should be a balance between flexibility and efficiency. A basic strategic decision needs to be made on the ratio between front presentation of merchandise, where clothes are seen straight on and usually banked at an angle, and side presentations, where the clothes are displayed in profile, hanging on a rack. In general, front presentation is used in mass-market stores, and side presentation in more exclusive ones. But front presentation does have advantages in any context: it is particularly useful for showing details such as stitching, buttons, and collars. This decision rarely results in an either/or choice, but in an appropriate mix of the two methods.

One of the principal decisions on fixturing is whether to choose standard, off-the-rack fittings or to custom-design for the project. Fixtures can be purpose-designed, even if this only means modifying a manufacturer's existing range, in more circumstances than many designers realize. Since the fixtures are a key element in any fashion store, they must be a crucial aspect of any differentiation between one store and another. In some countries, retail design has developed largely as a service of the fixturing industry. In Germany, for example, many stores rely on major manufacturers not only to supply the fixturing but also to plan its use. The result can sometimes make it difficult to distinguish one store interior from another. However important the fixturing may be, retail design should never adopt the attitude of "never mind the design, look at the quality of the fixtures." In small projects, however, off-the-rack fixtures may be dictated by budget. The better manufacturers are often willing, even on small orders, to allow some degree of customization. Alternatively, custom-made fixtures can sometimes be designed inexpensively, particularly in cases where a long life is not expected of them. Durability invariably costs money, and it can occasionally be an economic solution to decide to throw out the cheap fixtures and start again at regular intervals.

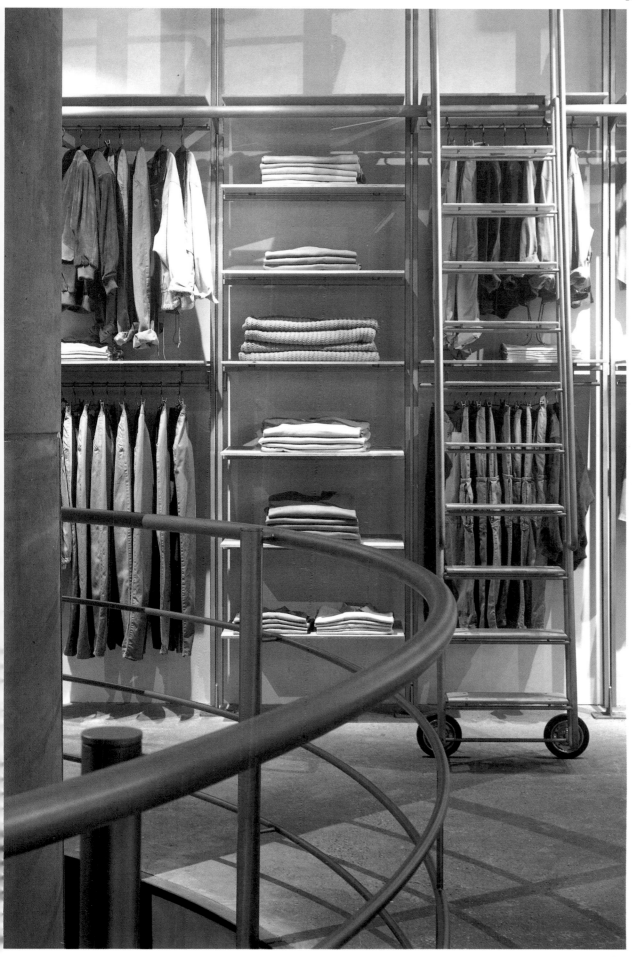

Foster Associates' display and storage systems at Esprit, Sloane Street, in London, use vertical steel support poles and light birch-faced panels. Merchandise is laid out around the perimeter of the store, whose central feature is a steel staircase with glass treads. Wheeled ladders give access to different levels of the folded and profile-hung displays. (*Photo:* Richard Bryant/ ARCAID)

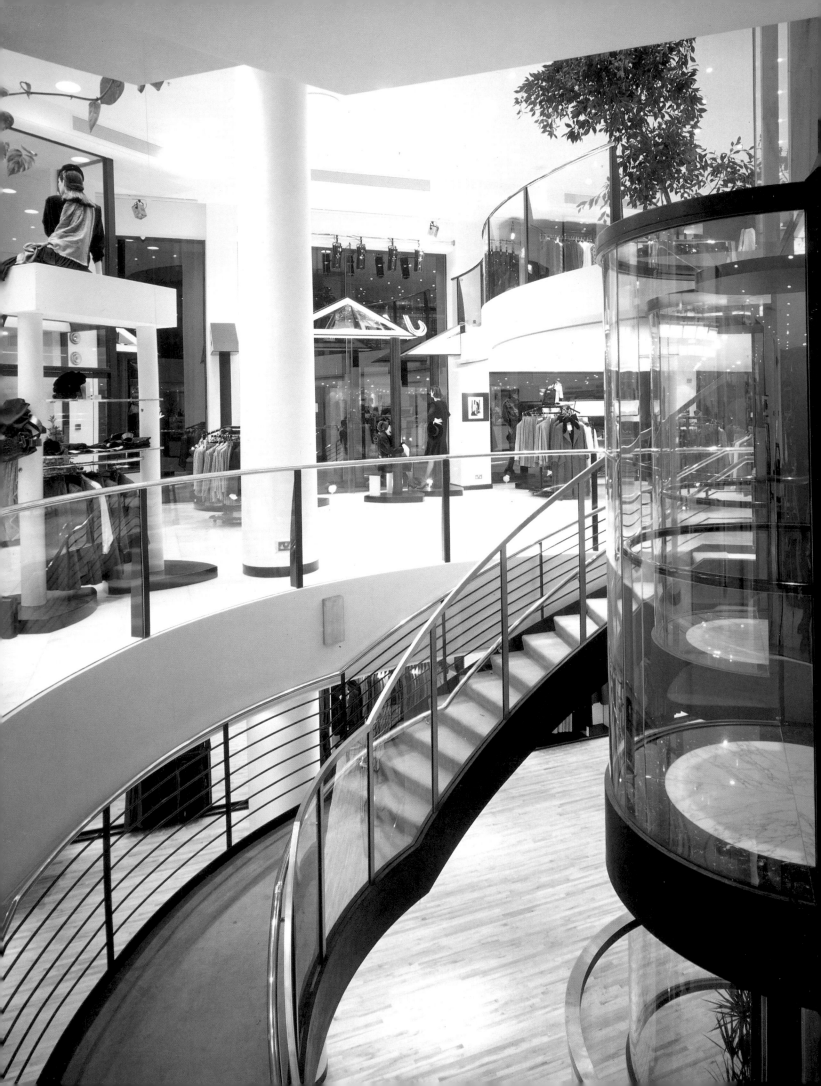

Of the various methods of presentation that can be applied in fashion stores, perimeter hanging is inevitably one of the most used, with or without adjustable rails for profile hanging or cranked bars for forward hanging. Fixtures can be manufactured with intermediary slotted support poles attached to the wall, or pressure poles fitted floor-to-ceiling. Often they provide the option of built-in shelves, feature panels for folded merchandise, or mirrors; occasionally they might even include graphics. Centerfloor hanging, consisting of freestanding units such as T-bars, ziggurats, and the ubiquitous cross-shaped hanging rails (see *Merchandising*) is generally essential. These fittings are used for short hung merchandise – suits, trousers, blouses, skirts, and accessories – but can also be used to feature fashion stories: for instance, trousers, shirt, and accessories acting as an ensemble. The top of the unit might be used as a shelf for torso displays, or simply a vase of flowers or price ticket. A more recent development is the use of the wardrobe, closed or open, and with or without doors. Wardrobes are generally used for profile-hung merchandise, but are equally appropriate for folded or flat-packed presentation or even a combination of both. Pioneered by stores such as the British Principles for Men and Next for Men (see pages 140–41), the objective is to present smaller collections of merchandise in a more exclusive setting. All these fixtures can be either bought from stock or purpose-designed; it is worth remembering, however, that noncustomized fixtures are also available to the competition, while specific custom-designed features will not only help to create separate and identifiable corporate personalities but should attract new customers.

Oliver, in South Molton Street, London, was designed by David Davies Associates to appeal to a young, fashion-conscious customer who seeks traditionalism with modern styling, so the rich look of wooden wardrobes in which to display the clothes was an appropriate choice. (*Photo:* David Davies Associates)

USE OF SPACE

One of the determining factors in designing any fixturing is the desired density of merchandise in the store. Establishing densities is one of the most emotive areas for designers and retailers: most retailers persist in believing that they need to get their stock on the floor, while designers want to preserve as uncluttered a feeling as possible. In most cases, some compromise should be achieved. Dense merchandise may not only oversaturate a design, but may be self-defeating in terms of selling power. Too much merchandise is confusing for shoppers looking for a particular item, and is difficult to control visually for the retailer; on the other hand, too little can restrict choice. Designers must consider, too, that low densities may require large storage space, which could be an unsustainable cost for the retailer. Density also has implications for both security and customer service. Good visual supervision must be possible, taking in fitting rooms, staircases, and store entrances as well as the main merchandising area. This function is normally carried out from checkout counters or customer service points, which therefore need to be carefully positioned. They also need to be clearly visible and well signposted from the customer's point of view; the temptation to hide them should be avoided. Similarly, other service facilities such as staircases, escalators, and elevators need to be clearly and easily accessible – no designer should assume that all these functions can be tucked away into secondary areas.

Although custom-made, the display fixtures at Quincy (left) in Dean Street, London, devised by Ben Kelly Design, could perhaps have been partially emulated by adapting stock items. The rails are in stainless steel, the wooden shelves and partition in solid wenge. Real sandstone tiles have been used for some wall surfaces and reconstituted marble tiles for the floor. (*Photo:* Dennis Gilbert)

At Jaeger (opposite), in Regent Street, London, Maurice Broughton Associates specially designed the glass elevator. This and the delicately articulated staircase are focal points in the store.

GRAPHIC DESIGN

Closely tied in with the method of merchandising is graphic design, a sensitive area where designers should be wary of overstepping the mark. It is all too easy for graphics to be contrived and quite out of character with the three-dimensionality of fashion stores. The design needs to consider carefully two prime areas of graphics: first, signage, and second, the various graphics linked directly to products, such as labels, price tags, and shopping bags. Signage becomes particularly important in larger stores, where customers need to be directed to different areas or levels. On the whole, graphics should be understated – an overabundance of hanging signs, information, and exhortations to buy will often defeat the fashion statement, as it will with most store types. Overly complicated signage is a mistake. Signage should be sympathetic to and supportive of the design, but above all it needs to be clear, in positioning, typography, and colour. Exterior signage is also important. On the storefront the lettering should be of the kind that can work in illuminated and nonilluminated form, since planning requirements will vary from place to place. Equally, the construction of the sign should allow for its manufacture in different materials, again in order to meet local or specific planning regulations and opportunities.

Product graphics are a considerable and challenging design task, not least because of the danger of making too strong a statement. Designers should strive to ensure that all graphics – price tags, bags, and labels – are consistent with the visual and graphic identity of the store, but they must also keep the end result simple, while still creating something that will distinguish the graphics (and by implication, the product) from that of other retailers. Photography is another way of setting the tone, and is often used in a store window, or indeed a store interior (see de Bijenkorf, Amsterdam, page 89). Good photographic images can be helpful in both setting a style and identifying a lifestyle. They should be original, and, in general, large. They can be positioned above the merchandise or on columns, or used to puncture the wall displays or hung merchandise. Sometimes they will be large transparencies set in back-lit boxes. This version is very effective, but is also expensive, and the back-lit boxes need careful ventilation. The clue here is to regard photographs as part of the decor and not part of the fixturing, hence they should be changed regularly, and not allowed to become dated or faded. (See also Seibu Seed, Tokyo, page 128.)

Overall, the graphic element for fashion stores should aim at enhancing the individual character of the store without becoming intrusive. With fashion, more than with almost any other retailing, the overriding rule for the designer is that the merchandise should be allowed to speak for itself.

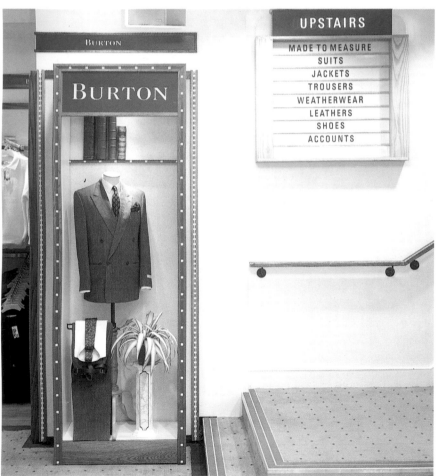

UPSTAIRS

MADE TO MEASURE
SUITS
JACKETS
TROUSERS
WEATHERWEAR
LEATHERS
SHOES
ACCOUNTS

BURTON

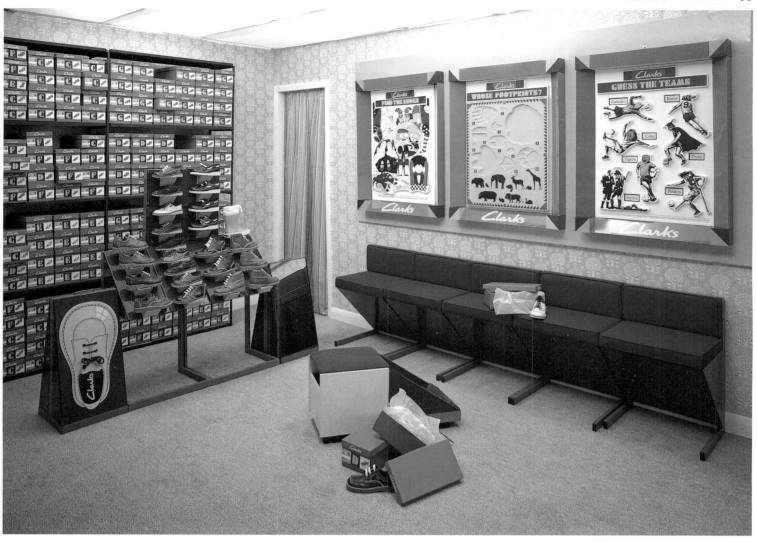

SHOE STORES: A SPECIAL CASE

Shoe retailing is one of the few businesses where, generally, service remains paramount, at almost any market level. The rite of kneeling down and taking off shoes even has religious overtones for some. Window displays are particularly important in shoe stores. A high level of purchases, up to 80 percent by some estimates, arise from window-shopping. As a result, the store's range needs to be shown in the window. And, of course, if shoes are displayed, they must be in stock.

Shoe stores present particular problems to the designer because of the display requirements, the large storage capacity needed, and the necessity of devoting a considerable amount of space to the fitting area. As with all fashion stores, the choice of style for the design will be determined by the type of retailer: a high-fashion shoe store could happily be sleek and spare, while a traditional men's shoe store might seek the reassurance of dark woods and thick carpets. An important choice needs to be made about how to handle the stock. Shoe boxes can be either in view or hidden in a stockroom. If they are on view, they must be designed to underline the store's corporate personality, which may be difficult for anyone other than the largest chain stores. But there are strong reasons for going to these lengths. For the customer, it is more comforting to see the store assistant take a pair of shoes from a box than for the assistant to disappear behind the scenes. On the other hand, there are visual advantages in keeping the merchandising area simply for display and fitting.

In exclusive shoe stores, the emphasis will be on displaying individual shoe styles with elegance and distinction (see Midas, London, p. 135), whereas mass-market and self-service stores will need concentrated display space for many styles in several colours and sizes, and customers must be able to handle the shoes easily and return them to their correct positions without difficulty. For these lower-priced stores, vertical merchandise presentation is the norm, usually with angled shelving that allows the customer to see details of style. Care must be taken always to show the outside of the shoe rather than the inside.

Shoe and fashion stores for children can present the designer with a special challenge. Pentagram's designs for the British shoe chain Clark's unabashedly transform the children's stores into playrooms, with puzzles on the walls and building-block-like fixtures in bright primary colours. (Photo: Pentagram)

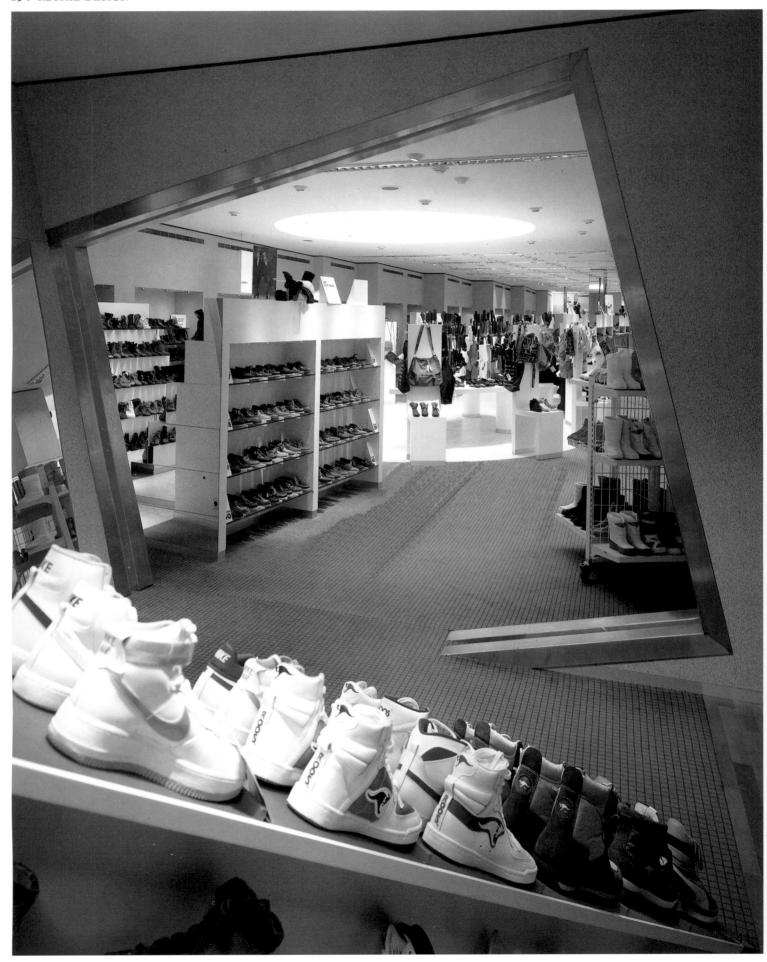

All shoe stores, regardless of price bracket, will benefit from careful lighting. Good spotlighting can be particularly effective, either from the ceiling or clipped to upper shelves. Glass shelves used with a downlighter system are another alternative, or lighting can be contained underneath solid shelves so that shelf upon shelf is illuminated. In lower-price stores, an internally illuminated back wall might suffice.

Furniture is also important in shoe retailing. Chairs, benches and sofas are all possibilities for customer seating and may well contribute to the corporate personality, but designers should remember that the store is not selling furniture. In mass-market retail stores in particular, furniture should be space efficient. Children's shoes, and indeed, children's fashions in general, may need their own solutions. Unfortunately there is not space to treat this subject in detail, but it can be stated that it is as valid to treat children as "little adults," as Harrods does, in London, with scaled down furniture, as to transform a shoe store into a playroom unabashedly for kids, as Pentagram has done with the British Clark's stores. But whatever the fashion store's identity, the design needs to account for the need to service both children and parents. Benches rather than chairs enable parents and children to sit side by side, and receive joint attention. Seating for children, if individual, needs to be lower than for adults and similarly, display shelving needs to be lowered as well, with a method of presentation that will not be totally destroyed within minutes by active small hands.

It is easy for shoe stores to overwhelm the shopper with an embarrassment of choice and a confusion of styles. One solution is to use "lifestyle" photography graphics, which will demonstrate the fashion context of various different styles as well as livening up the atmosphere and punctuating the space.

In Görtz of Kiel (opposite), various methods of vertical presentation are used. The layout of the space is given a sense of unexpectedness by the use of angles in the archways. Combined with the compelling quality of the exterior (see p.127), the whole design seems to suggest earthquake damage. (*Photo:* Martin Charles)

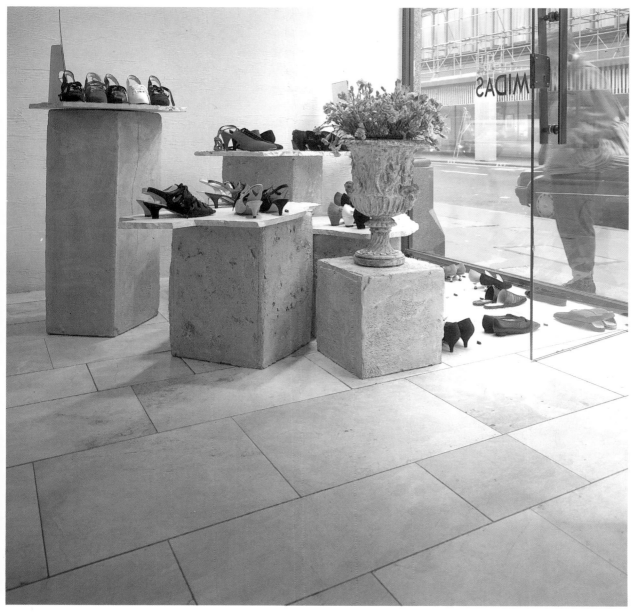

Michael Turner opted for a seemingly offhand use of expensive materials at Midas in Sloane Square, London, creating an impression of fashionable insouciance. In fact, although the shoes in the window stand on broken marble slabs, the bases are blocks of plaster-covered chipboard. The floors, however, are of solid marble. (*Photo:* Dennis Gilbert)

JEAN PAUL GAULTIER
Paris, France

At a time when so many high fashion stores tend towards the minimalist style of the Japanese, Jean Paul Gaultier, Paris, stands out as something quite different, underlining the decidedly idiosyncratic style of Gaultier himself as fashion designer and stylist. An old marionette theater has been transformed by Maurice Marty and Patrick Le Huérou into a store that is at first sight a display of witty design ideas, but is in addition a perfectly functional and appropriate space that makes for a successful shop.

The site is extremely long and narrow, but has the advantage of height (19½ feet/6 meters). From the glass wall of the entrance, with its steel frame painted a Parisian green bronze colour, the full height of the store can be seen. This height is emphasized by the large rooflight that extends the length of the store, providing a flood of natural light. The march of the rooflight down the central axis leads the eye through the store. This linearity, however, is broken by a sinuous staircase directly inside the entrance (leading to the administration offices on the first floor), and two curving staircases, extending like arms from a mezzanine level at the end of the initial vista.

But inside the store, the design detailing attracts attention, as well as the overall impression of space. Marty and Le Huérou have created the images of a Pompeian ruin within the store. Faded fragments of mosaics, created by the designers, are laid into the concrete floor. Vaguely Roman "statues" substitute for mannequins. And one wall is left roughly plastered, to suggest that the process of archaeology may still be continuing.

The design is not purely an exercise in historical retrieval: technology also has its place. Set into the concrete floor are circular video screens behind glass, reminiscent of looking into a ship's porthole. The "ancient" mosaics are directly juxtaposed to the modernity of the video screens, showing the latest Gaultier fashions. The video screens mounted in the floor also emphasize Gaultier's irreverent attitude to his own fashions: instead of giving the video display pride of place on a wall, or at the entrance, interested viewers must stand around and view an image in the floor.

A view of the store from the upper level, towards the entrance, shows the mosaic floor and in-set video screens.

Into this mix of modern and ancient, many of the details are more redolent of nineteenth-century Paris. The "faded bronze" appearance of the steel frame for the external window and door (reminiscent of the Paris metro) is repeated in much of the steel detailing. Visible bolts and rivets, in steel frames outlining niches in the wall and on merchandising units, extend the notion that the store has been uncovered from an older building.

There are other interesting design touches. Perhaps in deference to the former marionette theater, seating is provided by old theater seats, covered in red moleskin (plush). On the mezzanine level, which starts about one third of the way down the store and stretches the rest of the length of the site, a large round mechanism mounted on the wall perplexes visitors with its seemingly random generation of numbers – one of the numbers is. apparently a reading of the humidity.

But these touches do not render the store impractical. Befitting the high fashion nature of the clothes, the displays are sparing – on the "Roman" mannequins – and merchandise is hung on simple rails ranged along the walls.

In addition to the natural light from the rooflight, artificial light is provided by halogen spotlights that wash the walls. Some of the spotlights are mounted under glass, both in the floors and in the walls – a suggestion of archaeology again – but others are more conventionally fixed to the tops of the wardrobe units.

Axonometric drawing of the store interior.

Although some of the rails are on wheels, allowing for flexibility in layout and quick rearrangement, most of the merchandise is in large wardrobes with internal lighting and sliding glass doors. Changing rooms are small circular "cages" of steel: Gaultier is plainly not concerned with his customers' comfort.

A rather incongruously dressed Roman statue is posed at the foot of the stairs to the upper level, lit by the natural light from the glass atrium roof. (*Photos:* Stephane Couturier)

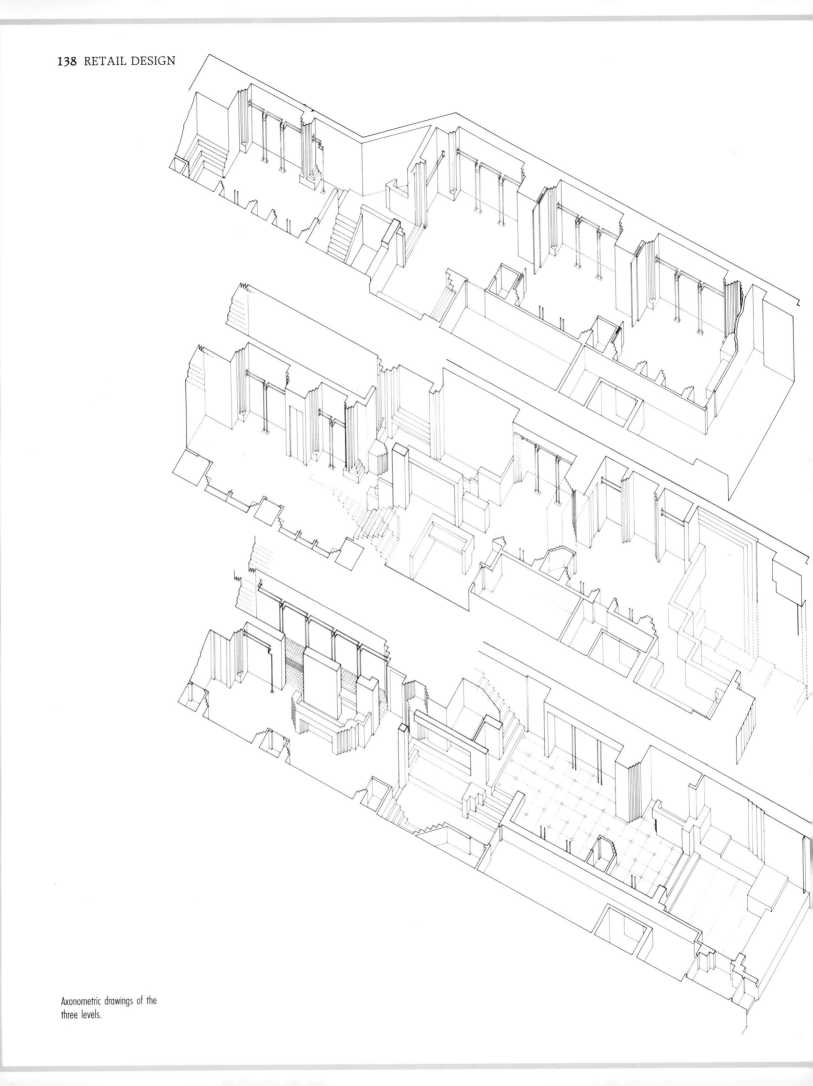

Axonometric drawings of the
three levels.

NORMA KAMALI
New York City, USA

When fashion designer Norma Kamali decided to open a new store in New York, she interviewed a number of designers well versed in the design of fashion stores. Yet P. Michael Marino Associates, the designers she ultimately chose, had never worked on a store before; however, Kamali felt that this very "newness" to the genre would enable them to approach the work with no preconceptions. According to Marino, the resulting design was very much a collaborative effort. In preparing the brief, the designer spent time in Kamali's existing store, both to understand her customers and the store dynamics, as well as to develop ideas for the new store.

The site for the store was previously an abandoned industrial loft in Manhattan, which had been damaged by fire. The resulting design of the five-story building is, externally, an enigmatic abstract in concrete: full-height windows on the ground floor are contrasted by a narrow strip window on each of the upper floors. A stepped sequence of pilasters defines one edge of the building. Concrete was chosen for both the exterior and interior because Kamali wanted a strong, neutral material that would allow the clothes to be the most important element in the store. She also felt that concrete was expressive of her New York roots – in a sense, it brought the street inside. Flying outside are four large golden lamé banners. These soft, billowing shapes act as a foil to the

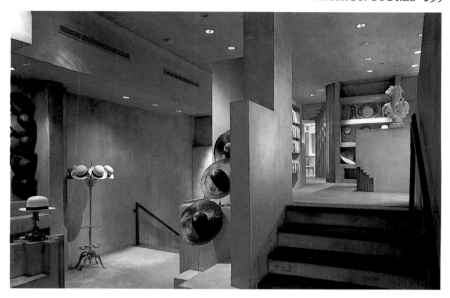

harsher concrete and identify the store better than any sign, making it a city landmark.

Instead of conventional mannequins in the ground floor display window, antique cast bronze statues symbolize the four seasons. On a bank of video monitors models display the clothes (a similar strategy to Jean-Paul Gaultier, Paris, page 136). But the dominant impression from the outside is of the tall, austere concrete interior space, with an almost Escher-like intrusion of stairs, balconies, and other structural elements.

The store is on three floors (the upper two floors are for offices and studio space), but one of the principal achievements of the design is the spatial flow through the complex sequence of areas. Marino describes the idea as creating "pieces of intimacy within the larger space" – the result is a sense of no dividing walls or rooms as such. Transitions between areas are created by steps, stepped walls, or – as on the exterior – stepped corners and pilasters.

The lighting plays an important part in the design. Recessed low-voltage lights in the ceiling provide the fairly subdued ambient light, while track-mounted spotlights highlight displays. No colours are used in the materials in the store, but colour is introduced by using coloured gels on the spotlights, creating gentle washes of blue or pink on the concrete walls.

The architecture also provides the fixtures and fittings. Steps cut into a wall niche, for example, are used to display hats or shoes. Clothing hangs from a system of nylon-coated pipes. Hat racks are raw steel with brass ends.

Interior walls and ceilings are cement plaster over metal studs and lath. Floors are poured concrete with steel inlays. Against this monolithic backdrop, the sensuous variety of Nora Kamali's designs creates dramatic contrasts.

The interconnections of the levels are seen here with surprises at every turn. (*Photos: Paul Warchol 1985*)

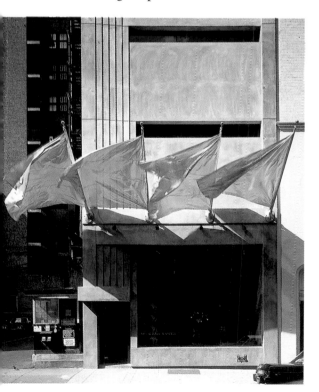

Gold lamé banners mark the entrance to the store.

NEXT FOR MEN
Bristol, UK

Next for Men was the first spinoff of Next, a successful chain of women's fashion stores first established in Britain in 1982. The formula for Next was deceptively simple: a coordinated range of moderately priced fashion, aimed at the 25-to-40 age bracket. Not only were well-designed clothes available in a well-designed environment, but the retailing idea was commercially astute – a woman buying a skirt would be led to buy a coordinated blouse, jacket, and sweater (termed "wardrobe building"). However, the idea of a similar concept for men, particularly in the conservative British menswear market, seemed far-fetched.

Next for Men was launched shortly afterwards and the skeptics were proved soundly wrong. The reasons for the success of Next for Men lies in part with the design of the stores. This design, by the Jenkins Group, suggests the ambience of a gentleman's tailor, with rich American cherry veneers and dark blue carpets with a strong border to suggest a hearth rug. The tone is set from the outside, where a dark, gunmetal-gray fascia holds the simple Next for Men logo: a lowercase "next" with an adaptation of the universal register symbol containing the "m." A riser to the front window, in contrast to the full-length glazing common in most fashion chains, emphasizes the more considered image of the store.

The doors are substantial, framed and molded in American cherry with brass door handles set diagonally across the glass. Inside, most of the display is around the perimeter, with a mixture of front- and side-hanging units, and shelves for shirts and sweaters. For the most part, this display is in a deep "wardrobe" of standard dimensions, that can be fitted out with a wide variety of display devices: rails, drawers, pigeonholes, angled brackets, and hanging rails. A central island unit also contains merchandise, and a similar unit is used as the service counter.

The display units are edged with solid and molded lippings, again in American cherry. Within these edgings is a laminate resembling an antiquarian book's marbled endpapers. The display units use a number of practical details. On the perimeter shelving units, a raked shelf is used for display; below this, a sliding shelf is used so customers and staff can unfold, see and refold garments. Ties and belts are displayed on "trombone" slide racks, with a rounded timber piece capping the end (again, American cherry).

Because the design had to be replicated in numerous building shells, with a wide variety of dimensions, quarter-round displays units are used to

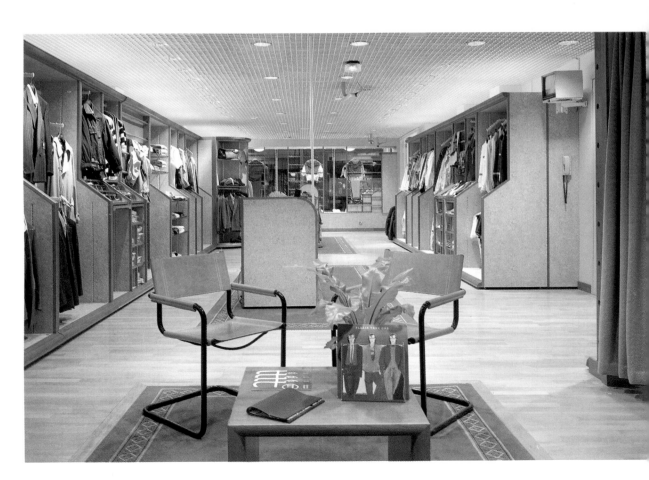

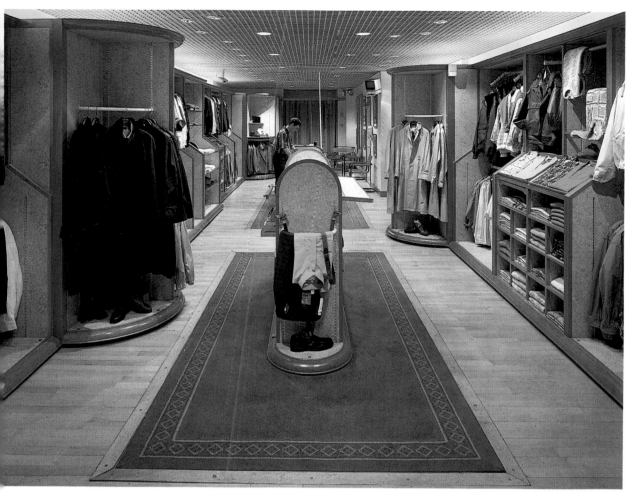

A view of the store interior shows the simple circulation plan.

mark transitions and take up dimensional differences. The suspended "egg-crate" ceiling is also a forgiving detail, concealing messy services in the void above. In keeping with the image of a gentleman's tailor, the changing rooms are well appointed: curtains are heavily lined, a full-height mirror is provided, and at least two brass double-tier clothes hooks prevent garments from being heaped on the floor.

The design concept of Next for Men has helped to propel this chain into a substantial position in the British menswear sector and has, flatteringly, spawned a number of imitators.

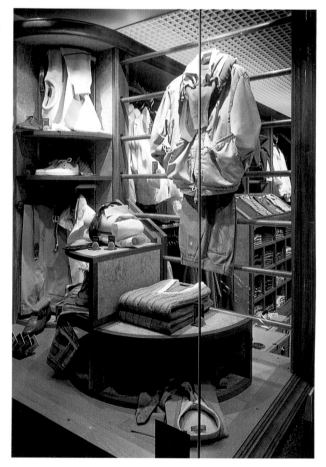

The style of presentation and fixtures in the window are in keeping with those in the store interior. (*Photos:* Peter Cook)

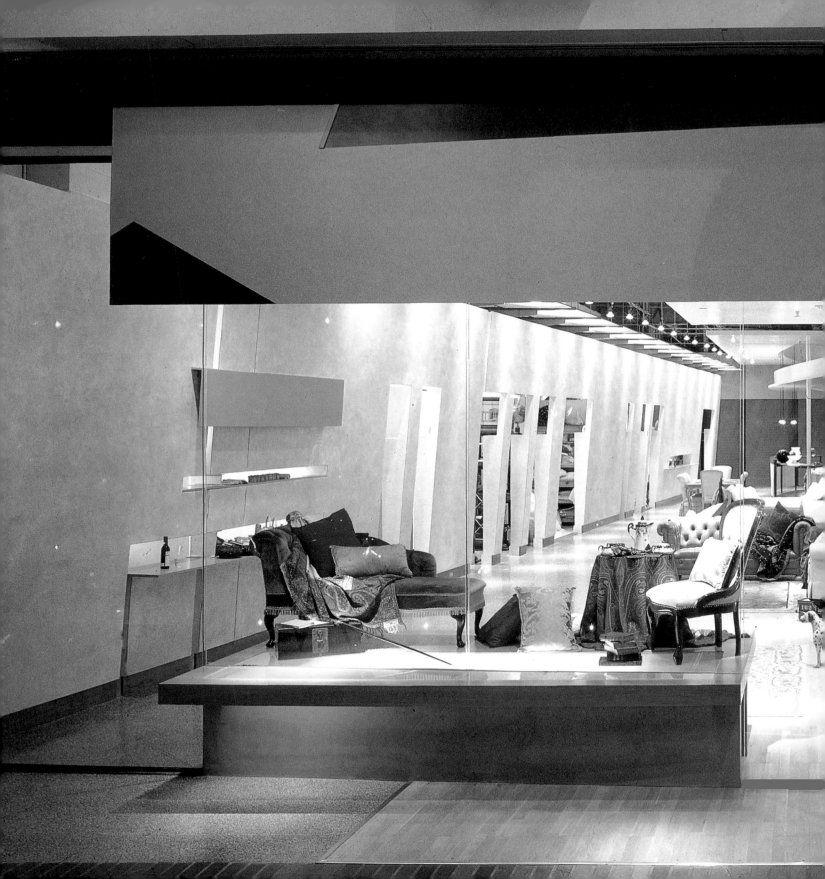

DOMAIN

HOUSEHOLD
STORES

A wide range of stores sells things for the home: furniture, carpets, cutlery and china, "do-it-yourself" (DIY) products, electrical goods, appliances, and gardening equipment and products. Several design problems are posed by the diversity of product and outlet, since the common focus on the home can often mean that many of the product categories are combined under one roof, as happens with, for example, electrical and electronic domestic products, termed "brown" goods (radios, televisions, and audio systems) and "white" goods (refrigerators, washing machines, and so on). But the design issues in stores that cater for the home are sufficiently differentiated for some of the main types to be considered separately.

FURNITURE AND HOUSEHOLD GOODS STORES

The design of a furniture store depends largely on the "position" or attitude of the retailer to the "home-making" market. A warehouse-style, discount furniture store demands one kind of approach, while a smaller, perhaps more specialist furniture retailer will try to achieve something quite different. However, most furniture retailers these days are interested in feeding customers with ideas: the stress is on "home-making" rather than home furnishing. This emphasis is not altruistic. The notion is that if a customer buys a bed, they will go on to buy the bedlinen. If they buy a nest of tables, they will take a lamp as well.

The primary problem with furniture as merchandise is often its size, which brings with it difficulty of presentation, and this is exacerbated in a discount store. A sea of beds, for example, may show range and choice, but poses an unattractive visual barrier for the customer. The most common solution to this problem is to organize furniture stores or departments around coherent room sets, as Bloomingdale's, New York, are famed for doing. But in a large discount store this can often be impractical and misleading – the coordination of related products and accessories demanded by room sets may not reflect that which the retailer is really offering, and may be outside the customer's culture. Where more appropriate, the domestic scale offered by room sets can be achieved in a larger store through segmentation of the merchandise. Segmentation can be by price, function or style. Function is the norm in furniture stores, but style may be a better choice in many cases. By grouping, for example, country, traditional, French or modern styles separately the products sit comfortably with each other. This form of segmentation groups similar products into "worlds of . . ." whereby they relate by style rather than sit as uncomfortable neighbours just because they happen to be dining tables or sofas (see Printemps, Paris, page 178).

There are other means of breaking up the monotony in a larger store, too. Fabrics, louvers, screens or even solid walls can divide one area or room set from another. A solid wall conveys a feeling of the store's commitment and permanence and can easily be re-painted or repapered. Screens, perhaps slotted into a ceiling track system, are flexible and quick to change (see Way In, London, page 47, and Domain, previous page). Often only the hint of a panel or wall will be enough to provide a whole visual break and create a satisfactory transition. This compartmentalization can also be achieved by suspending lightweight panels or grids below the ceiling itself.

One unusual consideration in furniture retailing i

Domain (previous page), at the Chestnut Hill Mall, Massachusetts, carries a wide range of styles and types of merchandise. The architects, Schwartz/Silver, have therefore treated ceilings and interior partitions rather like stage flats: steel and silk floor-to-ceiling display panels move on a track to allow maximum flexibility of arrangement, as in theater sets. The interior is finished in glass, plaster, steel, and wood; the floors are wood and black marble terrazzo. The pivoting entry door is made of hand-painted panels, echoing the presence of screens and partitions inside. (Photo: © Steve Rosenthal)

Surprisingly, the 2000 square feet (186 square metres) of Ron Arad's One Off showroom in Shelton Street, London, succeed in being more intimate than many of the light, airy, warehouse-type spaces found elsewhere. The lighting is theatrical – a combination of 12 V halogen lights and the natural light filtering through the pierced metal covering the windows, reflected onto the curved and welded sheet steel walls and plaster ceiling. In such a setting, pieces can be grouped dramatically to cast long shadows or reflections of their own. (*Photo:* Dennis Gilbert)

The Conran Shop in the old Michelin Building on the Fulham Road, London, is a site of some 22,000 square feet (2044 square metres). Apart from careful spacing of grouped merchandise, the simplest length of hanging fabric can create a clear division between one display and another, even in such a large space as this. Walls are neutral in tone and the floor shown is of cream ceramic tile. The levels of lighting – a combination of Par 38 downlighters, 2D fluorescent downlighters, track-mounted spot lamps and dichroic lamps – are computer controlled. (*Photo:* Conran Design Group)

At Next Interiors (above), in Regent Street, London, designed by David Davies Associates, segmentation of merchandise is largely by type and function, but in the corner, space for a small room set allows for the presentation of ideas on the coordination of colours and styles. (*Photo:* David Davies Associates)

The beams and other features of the original Elizabethan house in which Laura Ashley of Stratford-upon-Avon is based (right), create an almost natural domestic setting in which to display groups of merchandise in traditional and country styles. Historic features such as the fireplace and stone-flagged floor were incorporated by Northwest Design Associates, and are used to full advantage to present accessories. An open framework of solid oak was made for display; the pendant lights are wrought iron, supplemented with low-voltage spotlighting and concealed fluorescent fittings in some of the display furniture.

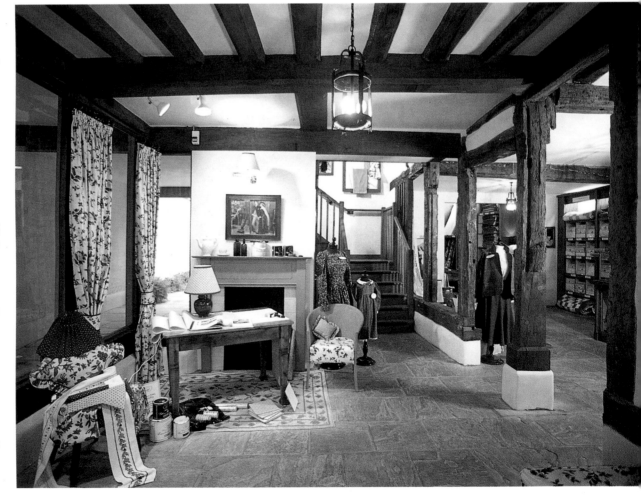

that customers will be keen to try out the merchandise. They will want to lie on the beds, sit at the dining-room chairs, and lounge on the sofas. Any design must bear this in mind and eliminate barriers between customers and the furniture as far as possible.

An equally difficult issue in the larger store is lighting. The scale of the store may demand some form of overall lighting, such as fluorescent (which may create difficulties with colour rendering – see *Lighting*) or floodlighting. The goal of making the lighting seem homelike rather than storelike is hard to attain and perhaps dubious in value. But, to some extent, varying the brightness and quality of light within the store will help create both pace and interest, whereas uniform lighting will leave the products themselves looking uniform and the store without character. In smaller stores these problems are not likely to be so great. A homelike quality can be created by room sets and by lighting that is more domestic in feel. In fact, goods and furniture can be presented so that the only lighting appears to come from within the room sets. Although these sets give customers ideas, and allow for the coordination of related products, they make the task of providing visible choice and product range more difficult. As the size of most pieces of furniture necessarily restricts this choice within a smaller store, any presentation device that displays variations of fabric, finish, or material is all the more important.

In all stores selling furniture and large household goods, a further, though welcome, problem presents itself: getting the sold product to the customer. In many situations, where items are not kept in stock, some form of delivery system will be used (although such a service should build in a design element, the subject falls outside the scope of this book). But for stores that keep at least some items in stock, other methods are necessary. Typically, the store will have some form of loading bay, delivery entrance, or depot where shoppers can park their cars to collect their purchases. Although these areas must necessarily be more utilitarian than the main body of the store, attention should be given to design as it is the customer's last impression: is there adequate lighting, is the store's identity clearly expressed, and, above all, is there easy access? In some cases the necessity of using valuable space for stockrooms can be turned to advantage. One furniture chain in Holland emphasizes the fact that they always have plenty of stock by making their stockroom the main entrance to the store itself.

Some stores have gone a step further in getting the product into the customer's hands. The Swedish furniture retailer IKEA (see pages 158–9), which now has stores throughout Europe and the United States, pioneered the use of flat-pack or knock-down design in its merchandise. Since their products pack into flat

At Au Bain Marie in Paris, the lighting is reflected in the glass and brass of the Deco display cabinets and their contents, creating an effect of warmth and sparkle. The displays have a cultivated air of profusion; the mood is one of relaxed opulence. (*Photo:* J. C. Martel)

boxes, customers in an IKEA store can collect the box while inside the store, wheel it in the store's oversized shopping carts to the checkout, and drive away. If necessary a roof-rack can be rented. Such an approach simplifies the process of furniture shopping for the customer and puts it more on a par with regular "take it home with you" stores. However, IKEA's main selling feature is not the boxes, but their well-coordinated room sets, with a wide range of finishes, colours and matching accessories, which give an air of taste and authority, and are seen as the store's hallmark. What becomes important in a store such as IKEA, which offers enormous choice, are the information points. Located strategically around the store, these areas are staffed to provide information on stock position, design advice, and colour variations, so customers do not have to wander around the store looking for help. IKEA also has a café, given a place of pride at the heart of the store. This gives shoppers the opportunity to pause and reflect on their purchases, or to decide on colours or finishes.

PLEASE PAY HERE

Designers of the British Marks and Spencer's household departments have paid careful attention to the width of aisles for ease of access, and clearly marked trolley points for heavy goods. While carpeted sectors denote the display areas, hardwearing surfaces such as wood and linoleum are used for the main circulation routes through the store.

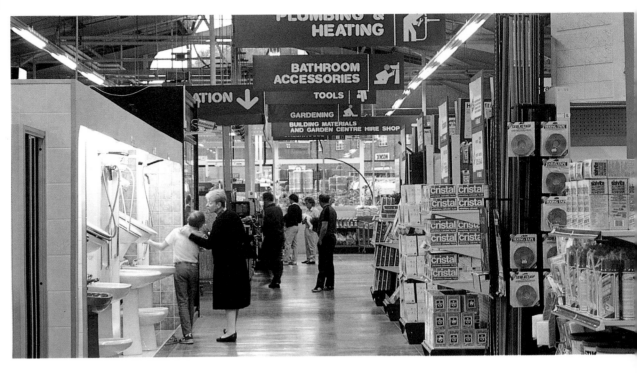

DO-IT-YOURSELF STORES

Do-it-yourself retailing grows out of the traditional hardware store, providing, at its best, a haven for serious do-it-yourself enthusiasts, relying on the expert knowledge of the retailer or sales assistant. Lines of stock in the hardware store run well into the thousands: every kind of screw and nail, a wide range of tools and fixings, and so on. Recent years, however, have seen a new development: the careful "editing" of this "professional" choice into more manageable and popular ranges augmented by a wide variety of complementary products. Thus, every tool, material, fitting and finish can be found in one single outlet, often housed in huge edge-of-town stores, offering a seemingly more comprehensive range than any corner hardware store. This reflects the current trend in do-it-yourself retailing: from a Mecca for home repair *aficionados*, the concept of the do-it-yourself store has developed into more of a focus for home improvement – in fact, for homemaking. This approach is largely a reflection of the recent shift within society of the role of women. Their growing independence and consequent home ownership means that, increasingly, purchases are made and do-it-yourself work in the home is undertaken by women: the male mystique of the more old-fashioned hardware store is no longer appropriate. But in design terms, the best qualities of those more conventional stores can often be retained. Their authority and comprehensiveness have to be allied to a new level of "user friendliness" that recognizes the new attitudes to DIY and, in particular, the new female market and social priorities.

For the designer, however, the first consideration as with most other types of store, must be good circulation. The larger the space, the more important circulation becomes, together with a logical set of adjacencies. Even in the small store, it is only through a coherent pattern that the customer will be able to untangle the large number of products on offer. Another crucial aspect of the design is information. In addition to expert staff, graphic explanation is vital. The functions of products must be made clear, descriptions of how to do a particular job must be provided, and the linking of one activity to another must be evident. And, given the growing clientele in this area of retailing, it is a good idea to emphasize the end result rather than the drudgery involved – pictures of sprouting vegetables, for example, can perhaps most effectively complement a row of spades on display. In Britain, Homebase has developed a system of basic instruction panels mounted directly above display areas: over the screwdriver section there are explanations of the uses of different types of screwdrivers; over sinks and faucets, basic instructions on how to plumb in a new sink.

One important practical consideration in do-it-yourself retailing is that the flooring has to be particularly robust. The wheeling of heavy trolleys loaded with paint cans, or wheelbarrows filled with bulky garden materials, for instance, requires the best quality underfloor. Trowelled grano finish, for example, is both strong, acid- and stain-resistant, yet good looking enough for many of these stores.

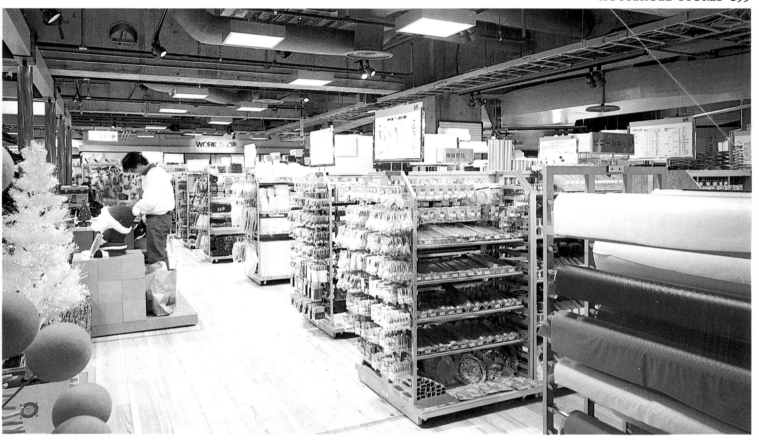

Gondola units in the hardware section of Loft, Tokyo (above) – adaptable to the display of many ranges of items – are topped by panels of written and diagrammatic instructions on the use and assembly of goods.

It is noteworthy how, with a not dissimilar space, structure and materials, Topeka Kansas (left) in Chicago (now closed) can suggest a totally different kind of market and merchandise from that associated with the Loft store shown above. Designed by Daniel Hanson in 1987, Topeka Kansas appealed to a discerning market seeking one-of-a-kind "designer" pieces. The polished wooden floor and the highly selective range of merchandise on display contributed to the image. In contrast, Loft's untreated wooden floor, serried merchandise and exposed HVAC system convey an air of functionalism and "hands-on" activity. (*Photo:* Karant & Associates © 1988 Jamie Padgett)

ELECTRICAL AND ELECTRONIC GOODS

Electrical and electronic domestic products, termed "brown" and "white" goods by retailers and manufacturers, create particular problems for designers. For both brown and white goods, the product is basically a box. The retailer, however, is selling not the box, but the screen, the face, the control panel, and the performance. Accordingly, designers must find a way to direct attention away from the volume of the product, and emphasize the features being sold, although this can be difficult if these features are internal and purely technological. On the whole, there are two types of electrical retailers: those who sell on the basis of low price, and those who sell on the principle of service. The first demands category dominance, the availability of a wider range of choice than elsewhere. The second requires a different approach, that of an edited (at its best, carefully selected) range of product. These two kinds of retailers have different design requirements from each other.

For the retailer trying to stress category dominance, repetition of the merchandise's image is a potential design tool. So a wall of switched-on televisions or lead crystal displays on audio equipment conveys the excitement of the technology and product design. To aid the customer's choice, the presentation should allow the products to be grouped vertically: by looking down a bank of televisions, for

example, a choice of roughly similarly priced products should be visible. If the shopper has to move along the shelf to see and compare prices, maintaining attention and recalling references and features become far more difficult. For the store stressing service, the design emphasis will change. Instead of a wall of televisions, only a handful might be displayed with obvious care. To convey the knowledge and authority that will give this store the edge over an undoubtedly less expensive rival, the design should use higher-quality materials and finishes, and it is essential that knowledgeable sales staff be on hand to explain the product and provide a customer service. Ample labelling may also be required: the most stylish retailers may well prefer the distinction of informative, museum-type descriptions. Detailed graphic information is, however, just as important a requirement of discount stores, where staff are less available to give advice or have less specialist product knowledge.

An electrical goods retailer – whether selling white or brown goods, or both – needs a controlled environment more than most stores. For a start, a large amount of wiring to all of the merchandise may be necessary: many of the products will need to be on demonstration, rather than sit mutely on display. Others will need to be demonstrated. Coping with the volume of wiring in a rational, designed manner is

The British Radio Rentals in Swindon, designed by FitchRS, represents one approach to the design of electronic goods stores. The store rents and sells largely on the basis of low price; a display system which stresses category dominance by grouping products vertically – as here – not only enables product prices to be compared but also expresses something of the excitement of technology. The dramatic center-piece, framed by the flooring design, enforces this sense of excitement.

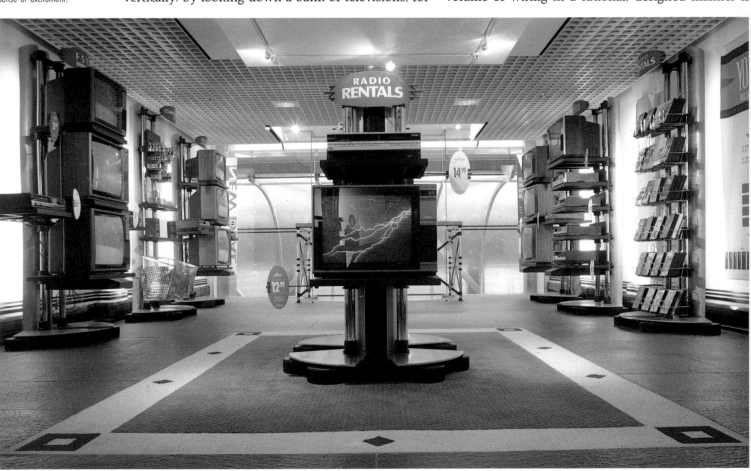

known as "wire management." Effective wire management must be simple to be functional: a complicated wiring route, no matter how beautifully detailed by the designer, will not work. If it is convoluted, it will often develop interference with audio equipment. Staff must be able to wire and rewire quickly, and trace promptly any faults that might develop. The size of wiring channels needed in any store will be determined by the number of products capable of being demonstrated, but in all but the most modest instances, the majority of working displays will probably be confined to the perimeter of the store, to avoid laying wiring to island sites. These factors need to be considered at the initial planning stages.

Wiring is not the only service that needs special attention, however. Clearly, the designer of any audio store needs to pay particular attention to acoustics. A high-quality audio store will probably need a special demonstration room for customers to "audition" the equipment: here, the design should acoustically resemble a typical domestic interior. Some stores achieve this with upholstered furniture, curtains, and carpeting. In more typical audio stores, absolute accuracy of sound reproduction may be impossible to achieve, but designers should attempt to include carpeted floors and other sound-absorbent surfaces if possible. Too much acoustic "brightness," created by hard and reflective surfaces, for example, will sound annoyingly hard-edged, as well as making life unpleasant for other customers.

Lighting for most brown goods needs to be subdued, and natural light should be screened out where possible. Ambient background or indirect lighting is usually preferable to spotlighting, particularly as a means of controlling glare. With light levels low, the aim of focusing attention on the face of the product is preserved: television screens will stand out, blinking lights on audio equipment will seem that much more alluring. For some products, however, such as personal stereos, which are designed to be bright and for use outdoors, the mood in the store will need to shift: a visually lively, bright area is more appropriate.

A word of warning: this type of product is small and desirable, and may well need to be secured. For white goods, too, low light levels are inappropriate. White goods need an air of efficiency and cleanliness around them, best created by clean, white lighting and well-polished surfaces and materials. Again, the front of the product is important, but unlike brown goods, the whole volume is of interest: customers will want to know how big the refrigerator or oven is, to see if it can be accommodated in their home. Since much of this product category is these days built into kitchens and utility rooms, it may be helpful to be able to demonstrate "built-in" appearance, using movable panels and false work-tops.

An increasingly large proportion of customers' discretionary income is spent on electronic audio products. At the same time, white goods are no longer luxury items. A bewildering number of products and technical innovations come into the stores every year. Therefore flexibility, clarity, and simplicity are essential design ingredients for these stores.

In contrast with Radio Rentals, Le Set in London, designed by ORMS, displays its goods like rare jewels in a museum. The emphasis is on quality and service, so high-quality materials and finishes are used – steel and sandblasted glass custom-made merchandising units with integral spot and uplighting and wire management. The overall effect is cool and monochrome – white walls, uplit barrel-vaulted ceiling, and a steely gray staircase. (*Photo:* Padraig Boyle/ ARCAID)

GEAR
New York City, USA

Gear, on Seventh Avenue in New York City, sells a wide range of home furnishings and accessories: fabrics, wallcoverings, furniture, lamps, framed art, tableware, dinnerware, linens, bedding, glassware, rugs, baskets, dried flowers, and so on. However, all of the merchandise and the general atmosphere of the store are consistent with an open, "country" style, which the designers further characterize as "welcoming."

Designer Raymond Waites, with architects Rosenblum/Harb faced the problem of accommodating these requirements in a standard retail space: a long rectangle 35 × 90 feet (10.5 × 27.5 meters) which had no distinguishing features or character of its own to build upon. There was the advantage, however, of a high ceiling. The store is organized in two rows of merchandise, with furniture serving a dual role as fixturing and merchandise. One wall serves to display fabrics, while the other is a warren of shelves to display glassware and tableware.

Two focal points provide movement in the long, linear space. At the back of the store, a clapboard "house" lies at a jaunty, 60-degree angle to the main axis. The house provides further display surfaces, and, inside, an area for Gear's "made-to-measure" program of customized drapes and decorating services. The other main focus is the large, central service desk. The U-shaped desk sits between two of the building's large structural columns, and is further marked by the display of baskets and dried flowers suspended above. Behind the service desk, a large table provides staff with ample room for wrapping the often fragile items.

All of the fixtures for the store have been custom-designed, or are Gear-originated furniture. Light-coloured woods are used throughout, and the "country" atmosphere is promoted by the hardwood floor. In contrast, the ceiling services are exposed, although the impact of the large air-conditioning duct is softened by its light yellow colour against the off-white ceiling. Four lighting tracks run the length of the store, and adjustable spotlights provide the lighting.

The staff facilities are in the basement, which is also used as the warehouse for the store.

Gear is a quintessentially American "theme" retail design – the designers have captured the spirit of "traditional" America within an efficient and contemporary store.

The central service desk is festooned with bouquets of dried flowers.

The entrance to Gear is direct and simple, with a combination of window displays and open views into the high-ceilinged store.

A large-scale doll house – "under occupation" by teddy bears – displays childrens clothes. (*Photos:* Jan Staller)

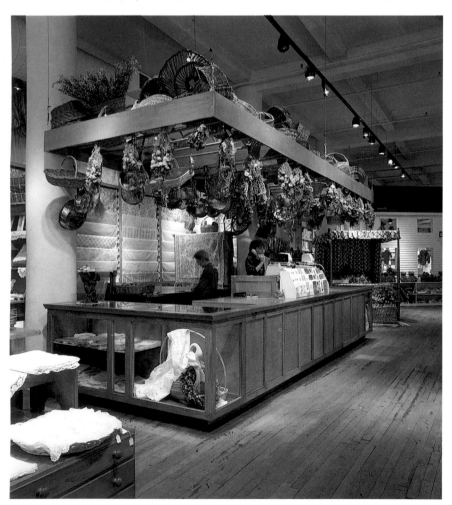

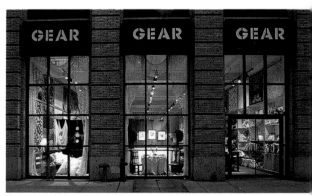

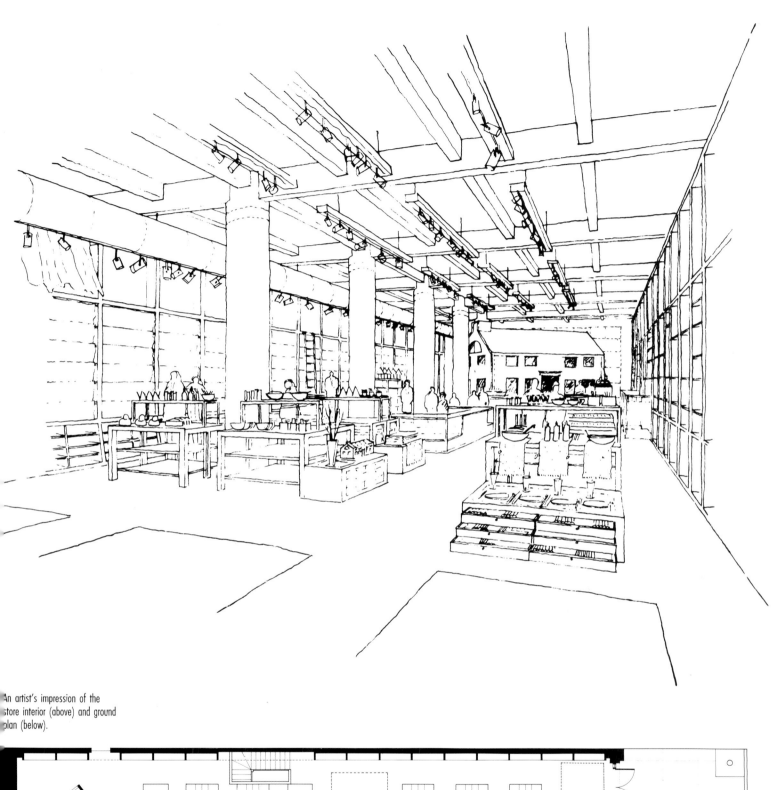

An artist's impression of the store interior (above) and ground plan (below).

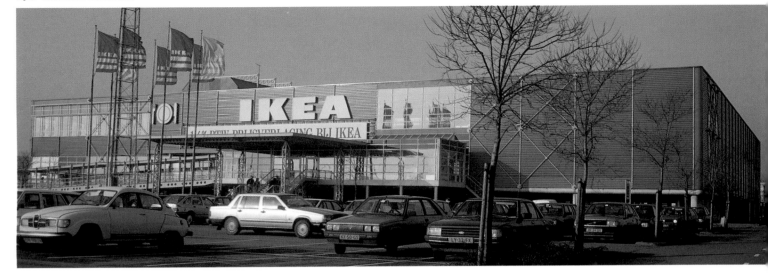

The IKEA store is a well-designed architectural "box", over which the giant lettering of the IKEA sign dominates.

The bright white and yellow finishes give an airy feel to the warehouse-type space, with a contrasting strong blue for the bold signs.

IKEA
Amsterdam, Netherlands

IKEA is of interest not only for its novel retailing concept, which has been meticulously carried through, but also because it is one of the few examples of a retail concept successfully transposed to a number of countries. The world's largest furniture retailer, IKEA has stores in Sweden (its original home) as well as the other Scandinavian countries, and in Belgium, France, Germany, Holland, Britain, Canada, and the United States. Throughout this empire, both retail design and merchandise are consistent with each other. An Ikea spokesman explains, "We do not design products to appeal worldwide. We design products that are Swedish in style and functional. That a product functions well is important regardless of

Flat-packed furniture is stacked on functional industrial shelving. (*Photos:* Paul Vos)

where you are living. Ninety-nine percent of our products will function well in every market." IKEA's store design criteria follow a similar philosophy.

Most IKEA stores are on out-of-town sites, with easy access from road networks, and ample on-site parking. The large, distinctive blue-and-yellow shed (Sweden's national colours) is identified both by colour and a bold, all capital letter "IKEA." Sign banners and flags often add a festive air. The shopping visit is well planned. At most IKEA stores the site has been designed to bring the customer to the entrance at first-floor level. Progress through this level exposes the merchandise on display; the stock is on the lower level.

Once inside the entrance, a large, efficient information desk is a focal point and provides guidance on the IKEA catalog and its products and store services. All IKEA stores have, near the entrance, a nursery area for three-to-six-year olds, filled with a sea of bouncing rubber balls. Many of the newer stores also have a video room for seven-to-ten-year olds. Both children's areas are supervised by experienced play leaders. The aim is to make a family shopping expedition enjoyable and relaxed so that it might last longer than the norm, encouraged particularly by a choice of restaurants available in most stores.

The interior of the store does not hide its functionality – the fabric of the building, ducts, and services are exposed. The warehouse/factory-like appearance is reinforced by the industrial materials used in the fixturing and for the steps and rails. The lighting is also functional, with fluorescent for general ambient use and spotlights to highlight merchandise.

Merchandise is displayed in three ways. Around 100 room sets provide customers with integrated solutions for their homes: the sets encourage them to buy not only the chair, but also the accompanying table, cabinet, and light fixture. Secondly, comparative shopping is made easier by "compact areas," which display a profusion of beds, chairs, tables, sofas, and related merchandise to show the range and choice available. Thirdly, a "marketplace" shows fabrics, tableware, prints, lighting, posters, wall and floorcoverings, and houseplants in a number of "stores" within the store.

In all of these areas, ordering desks are prominent, enabling customers to seek information or place an order. Clear, detailed information is also provided on price tickets, which describe materials, dimensions, and even the name of the designer. Most of the larger merchandise at IKEA is of knockdown (K-D) design, available in flat packs that can be loaded onto a car roofrack (which can be hired at the store). The flat packs are available from an in-

store warehouse, so most merchandise is available on the spot. Large, industrial-sized shopping carts can hold the flat packs, and encourage the purchase of greater quantities of merchandise.

The checkout area is designed around the large boxes and shopping carts. Factory-like rollers and hard, durable materials strongly convey the practical, no-nonsense aesthetic of IKEA.

Store guide to IKEA

Ground floor

A Children's paradise
B Entrance
C Exit
D Customer service
E Checkouts
F Baskets
G Indoor garden
H "Accents"
I Picture frames/posters
J Lighting
K Cook shop
L Glass and earthenware
M Self-service hall
N Trolleys
O Mirrors
P Floor coverings
Q Window dressings
R Bed linens
S Linens

First floor

A Living rooms
B Bathrooms
C DIY
D IKEA family
E Restaurant
F Hall furniture
G Dining rooms
H Children's rooms
I Bedrooms
J IKEA contract office furniture
K Kitchens

DEPARTMENT AND VARIETY STORES

The good department store can be one of the high points of the shopping experience for consumers. At the same time, it represents perhaps one of the designer's most challenging tasks, for the department store incorporates virtually every aspect of retail design, with the additional demand that the disparate elements be grouped into an understandable and balanced whole. It also poses an extra challenge for the designer, embodying as it does one of the richest traditions in retailing and often acting as the keystone that holds a main street or shopping center together. Often there exists, with the best department stores, a social role too; the store can become the fixed point in a shopper's experience, in some ways more special than an ordinary store, and remembered by customers as a treasure trove. The building itself can become an architectural or permanent landmark in an otherwise changing shopping landscape.

This larger role has practical consequences. On the whole, shoppers will be prepared to spend more time in a department store than in a single-purpose store. Consequently, designers need to be conscious, either through discussions with the retailer or direct study of shopping patterns, how much time shoppers will spend in the store, and cater for this accordingly. In effect, the store has to be an effective manager of shoppers' time, while allowing shoppers to feel in charge of events. Designers need to provide both physical and emotional refreshment in a department store; they need to create variety and choice, yet avoid confusion and frustration.

There is a further complication. The store will need to be planned and merchandised in the context of both a single-purpose visit and multipurpose visits. This presents one of the main difficulties faced by department stores. In an age of specialization, they must nevertheless continue to meet a huge variety of needs. They must compete on price while at the same time offering greater service, paying high rents and even higher property taxes or rates. Although they are the last remaining retailing generalists, they must still have great specialist authority within individual departments. For all these difficulties, department stores start with the goodwill of their customers. Most people are keen to shop in department stores and want one within easy access. Like the shopping centers that in effect they are, department stores still have the ability to capture a collective shopping imagination. Similarly, many department stores in urban areas possess a local identity and designers may be wise to retain some of its distinctive character where it is considered part of local history.

Given the size of department store buildings, designers will not always get the chance to design an entire store. Such a project requires the involvement of architects, structural and services engineers, and a host of other specialist consultants, and generally occurs only in "new build" circumstances. Total refurbishment schemes are somewhat rare. But a wide range of design projects exist nevertheless, such as the redesign of a single department, the relaying of circulation areas, the replanning of floors, or even a complete interior overhaul. Whatever the size of the scheme, designers should approach the project with a background understanding of the entire store. Doing even a single, small department in isolation is unlikely to prove a satisfactory solution over the longer term. After several "independent" projects, the store could lose its cohesion to become a collection of vignettes.

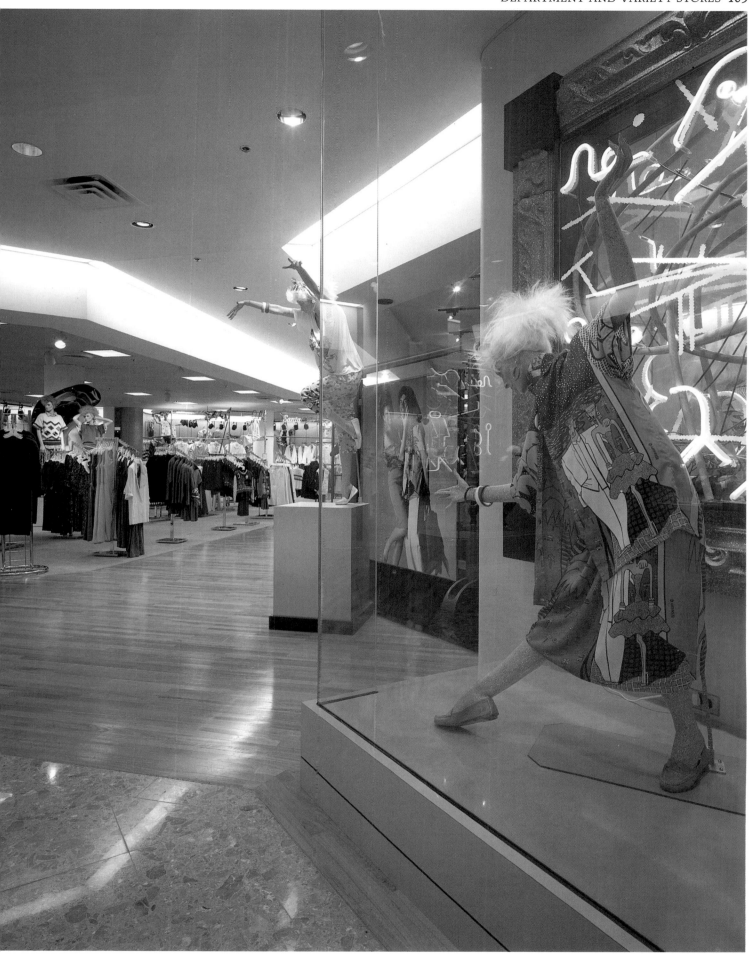

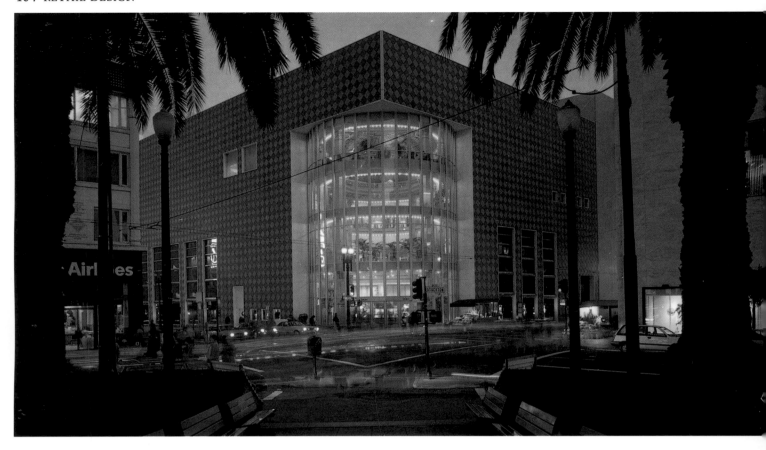

Breaking the rules followed by most competing stores, Neiman Marcus in San Francisco succeeds in drawing shoppers with its rather blank façade and full-height glass corner entrance. Especially impressive at night, this reveals circular galleries on each level and, at the top, a decorated domed ceiling. To either side, the store's frontage intrigues, with only small, slit-like windows for display.

EXTERIORS AND ENTRANCES

The first characteristic that sets department stores apart from most retail projects is the building itself. Unlike small store retailers, or a chain that uses main street or shopping center units, the department store often controls the entire building. For these stores, it is the building itself that gives identity to the store-front, as much as anything that happens at side-walk level. Thus, the building can often become the prime identity of the store. One of the most famous examples of this is Harrods, London. By daylight, it is a memorable sight; at night, a simple but interesting lighting scheme makes the fantastic Edwardian building an instantly recognizable landmark.

However, even if a store building is a well-known landmark, once close to it, prospective shoppers may well need further encouragement to venture inside; window displays can play an important part here in establishing the store's merchandising identity, "telling the story" of each different department and colouring the various displays with the store's particular character. Generally, the larger the store, the more window displays there will be. There are, of course, notable exceptions – the Neiman Marcus store in San Francisco has a relatively small entrance with a few, proportionately small, slit windows on either side, while the building itself is comparatively large. Some department stores in shopping centers may not have window displays at all, if their entrances fill the entire width at the end of a shopping mall.

The entrances to a department store present an exciting design challenge and require particular attention, especially in stores of a larger scale. In the past, the entrances were traditionally indicated by canopies and other architectural devices, often sited at the corners and centers of the façade. For modern department stores, whether in town or at an out-of-town shopping mall, the same philosophy can prevail. In general – though as usual, there are always successful exceptions – the entrance needs to be important, it needs to be proportionate to the scale of the building and it needs to be clearly defined. Yet this must be achieved with good architectural manners and propriety. A particularly grand entrance, for example, may intimidate a shopper seeking a bargain-priced department store. Equally, a mean, underprovided-for entrance may be incapable not only of signalling the store's culture, but also of handling volumes of visitors. A vital aspect of the siting of departmental store entrances is deciding which ones are the most important. Simplistically, if a store has four entrances, almost certainly two will receive 80 per cent of all visits. Deciding which two entrances these will be will have a profound effect on planning and circulation, particularly if the store is to be newly built or has entrances on different floors – in a multilevel shopping center, for instance.

The tall entrance window of
Debenham's, Bristol, designed by
FitchRS, attracts passers by
with its almost abstract pattern-
like view of criss-crossed
escalators and, at night-time, its
starry lighting.

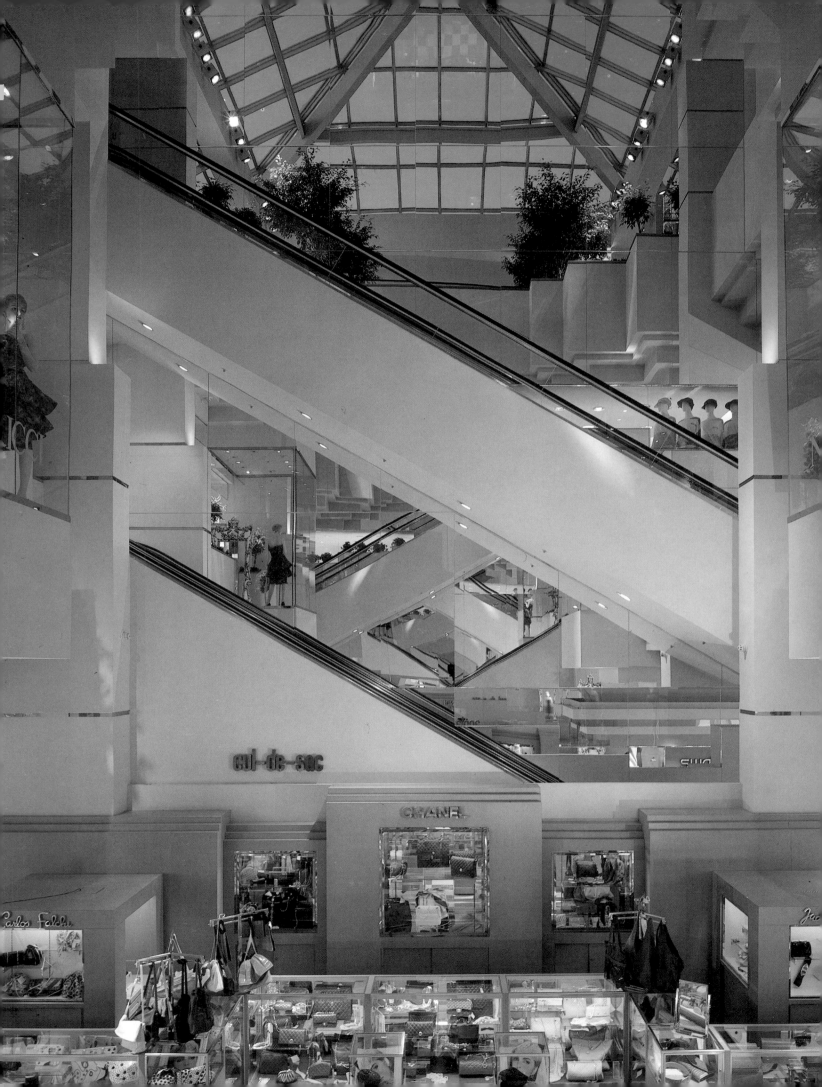

CIRCULATION AND PLANNING

Once inside, designers must confront two principal tasks in department stores: circulation and planning – the "laying" of the store. The two are, of course, interrelated. If shoppers cannot progress through a store comfortably, then the cleverest sequence of departments will fail. Similarly, an efficient circulation scheme is wasted if shoppers need to trail from one part of the store to another to find related merchandise. The designer also has to bear in mind the special adaptability required in a department store, for individual departments may need to expand, contract, or be completely relocated. And on other occasions, walkway patterns, circulation emphasis and even lighting may need to be changed. Thus, circulation design needs to build in a degree of flexibility. Two kinds of circulation are involved in most department stores: vertical and horizontal. Although various approaches to circulation are discussed more fully in *Planning and Circulation*, the particular difficulties of circulation in a department store require attention.

Vertical circulation is crucial. Most department stores find ground-floor sales easy, but selling on upper floors becomes progressively more difficult. Moving customers to upper and lower floors, so that all available retail space is maximized, is the principal planning task. With this in mind, the temptation to hide circulation space should be avoided; instead, it should be emphasized. Again, traditional department store buildings dating from the nineteenth century often had the right idea (see Printemps, Paris, pages 178–9). The escalators (at one time, the grand staircases) form the centerpiece of a design. If the vertical space can be opened up, with an internal courtyard or atrium, even better: this allows shoppers to see other levels and products, while highlighting the grandeur and excitement of a space. An atrium can also act as a visual and physical funnel, drawing people in and allowing them tantalizing views of other floors. The question then is how to get customers to these upper levels. One of the problems with escalators is that they are (and designers have to face it) generally fairly clumsy pieces of machinery. But this need not be the

Pathway routes through each level of a department store should be evident, tracing the perimeter but allowing shoppers to be diverted into individual sections of interest at the US store Burdines, Boynton Beach (here and overleaf).

At Bloomingdale's, Boca Raton (opposite), Walker Group/CNI gave the store a strong sense of the vertical structure by devising an atrium as the core of the space. Directly inside the entrances is the central escalator well and vertical circulation routes are both clear and attractive to shoppers. From the central atrium, a loop-aisle system emerges, creating a sense of individual stores which are easily visible from all directions. (*Photo:* John Wadsworth Photography)

case. The Seibu store in Tsukuba has an effective way of dealing with them: instead of being encased in rigid, opaque structures, they are freestanding, and the balustrades are of transparent glass. Other solutions also exist: designers working on a department store aiming for a younger, livelier image might want to take a lead from Richard Rogers' Lloyd's Building, London, and expose the escalator machinery to view behind glass.

Any department store will also require elevators and stairways, but because of the lesser volumes of traffic they are able to handle, they will necessarily be of secondary importance in vertical circulation. However, the question of elevators should not be ignored. As mentioned earlier, for some shoppers, particularly the disabled or infirm, elevators may be the only means of reaching upper levels. In a few cases, they can usefully form design features (see Water Tower Place, Chicago, page 191, and Jaeger, London, page 131). Wallclimber elevators are generally popular and can animate an open space (although they are far more common in a multilevel shopping center than a department store – see Riverchase Galleria, page 190). Even conventional elevators offer scope for design. The magnificent cast-iron grillework found in nineteenth-century elevator cabs should inspire a modern-day equivalent, consistent with the designed identity of the modern store.

Horizontal circulation obeys many of the laws that apply to smaller stores, but the scale of a department store gives added importance to the clarity of the circulation routes. Horizontal circulation must be designed to encourage shoppers not only to explore areas that may be quite some distance from the main access points, but also to gravitate naturally towards the vertical circulation systems. However, designers must avoid creating a circulation pattern that provokes shoppers into feeling that they have been misled through areas they did not necessarily want to visit. Circulation paths should be designed to mimic the experience of the best perambulatory streets: on the one hand, shoppers should be able to wander around without pressure, so that when something catches their eye, they can dive into the merchandise areas; on the other hand, they should, if they require, be able to get quickly and easily to their departmental destination without being sidetracked. Some form of internal perimeter is often the answer. Off this internal pathway, secondary routes penetrate through the departments to the outer perimeter (as in Bloomingdale's, Boca Raton). From the internal perimeter there needs to be constant visual contact and connection with the outer perimeter, but endless views are best avoided; the perspective has to be defined. In other words, as in smaller stores, "gloomy edges" should be banished, and shoppers given something to aim for as they journey through the store. Interesting features or focal points placed strategically along the circulation path will encourage customers from one diversion to the next, but should not impede their progress. Walkways can be created either by wide aisles, carpeted as for the rest of the store, or by "racetracks," where the flooring, whether hard or soft, is different from the surrounding floor surface. In either case, designers should not allow departments to be split by principal walkways, that leave the resultant space either too deep or too shallow for effective merchandise layout.

At Burdine's, Boynton Beach (previous page and right), the pathway is clear at first-floor level but also at ceiling level, thanks to soffits and partitions suggesting storefronts (emphasized by internally directed lighting), and to the device of a *trompe l'oeil* sky, marked here with a track of stars. Display stands provide visual focal points. (*Photo:* John Wadsworth Photography)

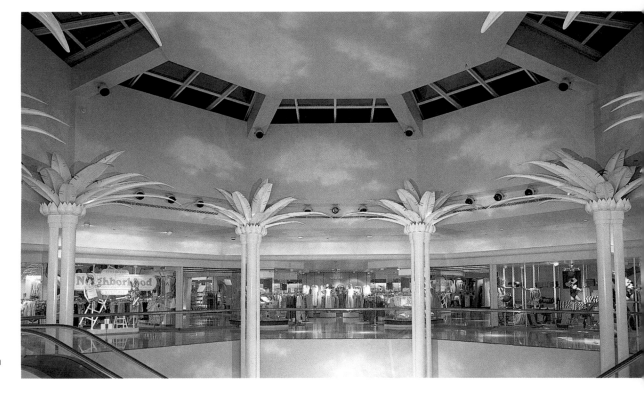

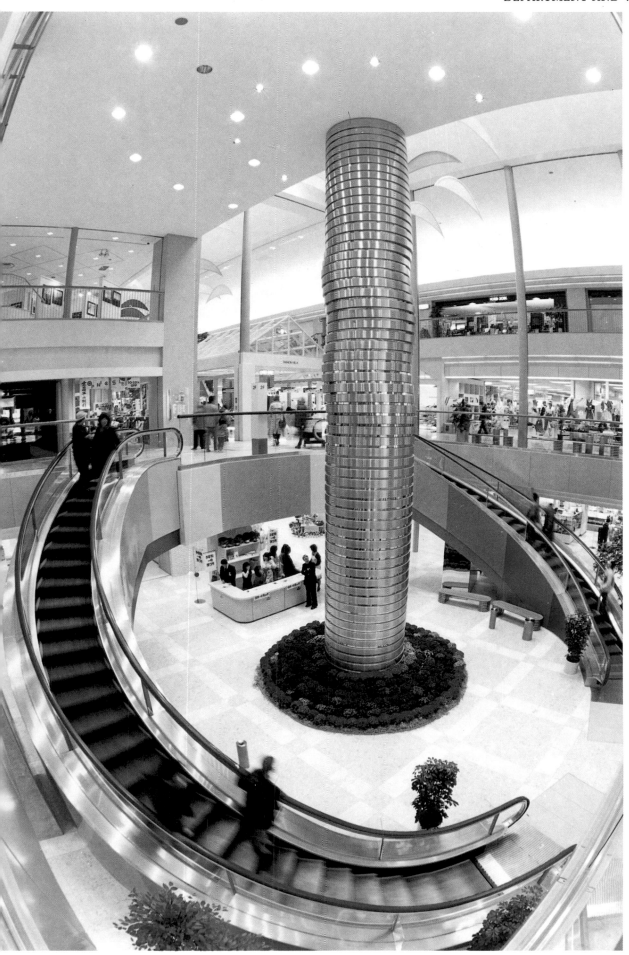

The Seibu store in Tsukuba was the first in the world to feature curved escalators. A magnificent technological achievement, they were conceived in glass by Shoichiro Uomari and Yasuhiro Kato, defying the usual clumsiness and opacity of conventional designs.

The boundaries of this retail concession in the Printemps department store in Paris are marked firstly by the flooring and then by the internal store structure with "frontage" and "window"-type displays. The eggcrate ceiling, lighting and graphics also indicate the self-sufficiency of the retail area. (*Photo:* Printemps)

In Rich's, Atlanta, designed by David Widmer and Roger Mullman, departments for children, sports activities, and fashionable shoppers are logically and stylistically grouped together. (*Photo:* © 1986 Jonathan Hillyer)

POSITIONING OF DEPARTMENTS

In this matrix of vertical and horizontal circulation paths lie the departments. Designers and retailers often debate the best departmental adjacencies for departments. But in any department store a successful solution will be achieved by agreeing on a consistent retailing philosophy as the basis for the adjacencies: they can be by lifestyle, by merchandise by age, or by attitude. For example, the departments for children, or the ones that focus on trendy shoppers, or all those that cater for the home may be grouped together. Whatever the outcome, it is the task of the design to support this essentially merchandising choice. As far as possible, adjacencies should be logical and complementary, not only between departments on the same level, but ideally also between the departments at the top and bottom of an escalator. The positioning of some departments is, as with so many aspects of department store design, traditional. The cosmetics department, for example, is generally at the entrance. This tradition has a powerful logic: cosmetics have a high turnover, use low-level units that shoppers can easily see past, and, perhaps most importantly, look and smell good, attracting customers with their glamorous appeal.

The departments themselves need distinct imagery, but that imagery needs to fall within some overall identity for the store. Each department should add to the whole; the tone, the "culture" of the store must carry through. Sometimes this can be achieved through more transient design elements. The famous promotions run by Bloomingdale's, New York, illustrate this approach: disparate departments are loosely tied together by an Italian theme one month, a Chinese theme the next. A more typical solution would be to use some form of perimeter detailing – a frieze along the wall that changes as it links departments.

CONCESSIONS

One aspect of design in department store development that needs particular attention is the role of product concessions. Concessions are sometimes frowned upon by designers because they inevitably interrupt any attempt at a seamless store identity. However, they can be an important and valuable addition to a department store because they bring variety and specialization, key factors that enable a department store (or indeed any other store in which they operate) to compete with more specialist outlets. Generally speaking, concessions will have their own identity, created by themselves and built up over several years' experience. They will not willingly forgo this identity, and indeed, it is dangerous for the designer to attempt to wipe it out completely.

FitchRS's small internal display "windows" – glass cabinets showing merchandise thematically grouped (bathroom items, fashion accessories, and so on) – help give the departments of Debenham's individual identities, and endow items for sale with special character.

However, if every concession is allowed its fullblown identity, the store's own identity will be lost. So the intelligent designer will try to develop some mutually acceptable design criteria. Guidelines might cover the choice and colour of materials, heights of fittings and showcase faces, and conditions for display and presentation. Designers might insist on a particular floor finish, or on fittings to be used for an existing ceiling. Obviously concessions will want to use their own lettering and logos, but the store may want to condition their appearance – whether illuminated or nonilluminated, on a given fascia panel, or of a certain size, for instance. The idea is to preserve some sense of the store's identity, without emasculating the concessions. Position is one of the most important factors. Plainly, the concession must be located sympathetically within a store; judicious placing of concessions can create variety in departmental adjacencies.

If concessions provide their own sales staff, as is often the case, the store may well have less influence over the way they operate, but they will need to fit the tone of the store in the same way as their directly employed colleagues. Likewise, similar cash-taking and reporting systems should be developed and used. From a design point of view, a look and style for the concessions fittings must be developed, so that they form a homogeneous whole while at the same time conveying their own identity.

Galeries Lafayette in Paris provides an example of the classic department store entrance, through the cosmetics and perfumery department. Despite the presence of several retailing concessions, the design conveys all the glamour, variety, and excitement of this store section within a unified scheme; concession names, in different typographical styles, are contained within panels of matching heights, materials, and sizes; the aisles and circulation plan are clean and generous; and the display counters form an attractive geometry of related shapes. (*Photo:* John Wadsworth Photography)

PREPARING

SIGNAGE

The multiplicity of departments and the size of department stores makes signage more important than in most stores. Signage serves a number of purposes: to aid circulation, to create departmental identity, to convey essential store information, and to promote special merchandise offers and events. Circulation graphics require clarity, simplicity, and generosity of provision. Nothing is more annoying for shoppers than having to search through a store to find an elevator, escalator, or exit. Although they are in fact common in department stores, plans and maps should generally be avoided. Designers may believe that they are a concise method of conveying information, but few shoppers will bother to work them out, and many people find them difficult to understand. Far better are simple directional signs, pointing out different departments. Another alternative is an alphabetical list of product offers followed by their floor-by-floor location. Within individual departments, graphics can be a powerful contributor to identity. As with the overall design of the department, the signage may well relate to some larger, store-wide graphic scheme, but should have a distinct character of its own. In contrast,

essential store signage, such as "No smoking" o "Thieves will be prosecuted," should be straight forward, without eccentricities, and in language an style that clearly projects the store's tone. Promotiona signage is more problematic for many designers who usually would rather avoid it. But retailers nee some way to announce and promote their offers. De signers should find a means of integrating promc tional signage with the department store's genera identity, rather than allowing promotional styles t distort the store's image. At the same time thes signs need enough distinction to highlight the tran sitory nature that is an essential element of speci promotions.

Department stores are undergoing something of revival at present, as the sector tries to come to grip with their specialty competitors. For the designer department stores represent an exciting opportunity more complex than specialty stores, more akin t shopping centers. The secret of success is to keep i mind the vision of the whole while designing th individual smaller elements or departments. Littl else in retail design can give both designer and cus tomer such satisfaction as a successfully designed an operated department store.

VARIETY STORES: A SPECIAL CASE

The variety store can be seen as a mini-department store, though without the "big ticket" merchandise or service. Another important distinction is that they are generally single-floor outlets operating at lower prices. The origin of the variety store lies in the general store, where, in the past, shoppers could find a little of everything. Over the decades, however, the growth of specialist retailers has eroded the position of the general store, reducing it to the present-day variety store. Still, however, it needs to preserve the impression that it is the store of first and last resort for a wide range of items. Indeed, in some countries, locations and markets where the culture of the specialty and the department store is not strong, variety store retailing continues to hold its own.

As the name implies, the variety store needs to demonstrate choice. The challenge for the designer is to maintain an apparent cornucopia, while imposing clarity and focus. Three features of the design task can help achieve this goal: simple planning and organization, good merchandising, and direct, legible graphics. The nature of a variety store is intended to be direct; planning should be simple when it comes to organizing the disparate merchandise. Generous aisles with direct access to "deep" departments give shoppers ease of movement within the overall space. Aisles can be supplemented by centers of identity, promoting specific categories of merchandise. Further points of interest can be provided by reviving some of the older traditions of variety stores – a soda fountain in the United States, or a tea bar in Britain, for example. Simple planning is complemented by generally high levels of illumination – part of the ambience of a basic store – and few frills. This image, and the strains put on such stores by the many customer visits, both demand hard-wearing materials for floors and fixtur-

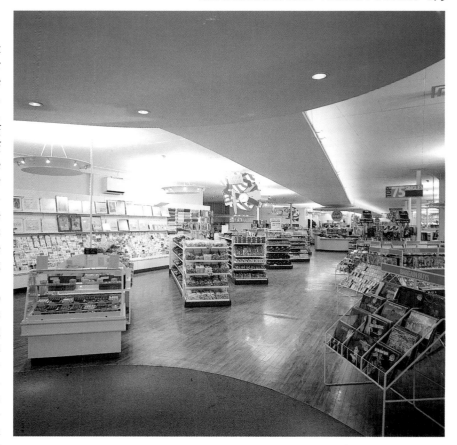

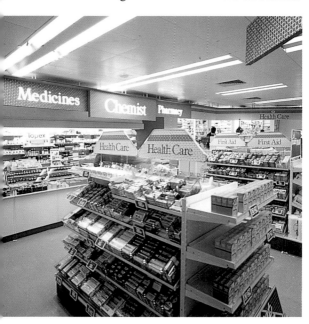

ing. But "hard-wearing" need not mean a hostile environment – features such as hardwoods, carpets, and soft colours can all have a place in the contemporary variety store. As for merchandising, although a wide range of goods will be carried, most successful variety stores are so because they have found a niche within which they can demonstrate authority and expertise: it may be as a drugstore, as a household goods store, or, as with Britain's Woolworth's, as a store selling inexpensive goods of all kinds. The merchandising style needs to emphasize the nature of the niche, but also to convey the impression that it will be worth browsing for other, unexpected items to purchase. Merchandise should be "blocked," with a higher display of goods along the walls, and lower displays midfloor. If midfloor displays creep up in height, the store will appear cluttered, and sightlines will be irremediably interrupted. As in supermarkets, merchandise should be so arranged as to allow a change of type within the field of vision – while apparent wide choice is essential, shampoos stretching beyond sight will not lure shoppers onward. To aid this variation in rhythm, designers should provide opportunities for nonshelf displays. Variety-store graphics must be easy to see and read, conveying both price and novelty; they should be flexible, because of the regular change of stock in a variety store; and they may need to give product information while performing strongly as promotional material, for promotions are an essential part of the ambience and character of the variety store.

The British Woolworths chain (above), another variety store, aims to express a sense of value for money, variety of choice, and ease of access to the busy shopper. The displays suggest abundance with economy; the graphics are again clear and straightforward.

The Cookshop department (left) in the British Boots chain store was designed to convey a clear, affordable country feel. Display tables with a wooden veneer have an adaptable shape, and are lit by low-hung pendant lights, akin to domestic lighting.

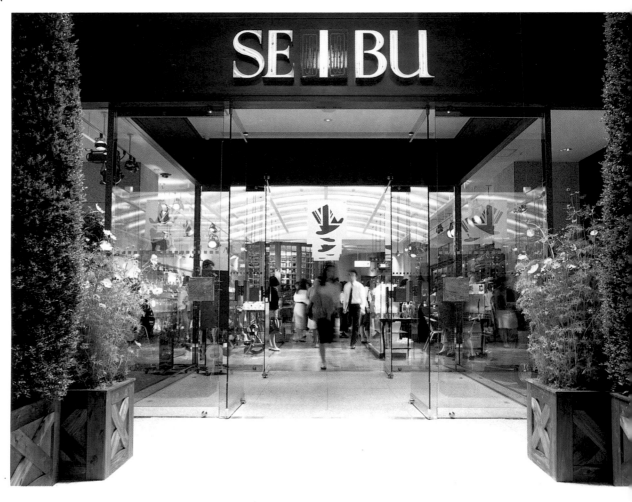

SEIBU YURAKUCHO
Tokyo, Japan

Even in Japan, where the department store has been raised to a high art in recent years, Seibu Yurakucho in Tokyo is an exception. Intended as the "show window" for the giant Seibu retailing group, Yurakucho is almost an art gallery of retailing. The original store opened in 1983 with floors of fashion designer mini-empires, each with its own interior vying for attention. In 1987, a new extension on six floors was added, providing a further 38,364 square feet (3,564 square meters), and linked to the original store by a dramatic, backlit bridge. In the new store, as with the original, complete floors have been given over to different design teams.

Floors are organized by departments. The ground floor houses groceries, flowers, and the tearoom, the first basement, food, and drink (both designed by Nomura-Kogeisha). On the second basement level is Uraku, an elaborate member's club and restaurant, designed by John Chan. The first two floors, designed by Kanome Design Office and Kyoto Design House, contain furniture and interior goods, and the third floor is an art gallery, designed by Super-Potato.

The furniture and interior goods floors demonstrate the prevailing style of the retailing areas of Yurakucho. A consistent, rectilinear grid suspended from the black painted ceiling organizes the network of lighting tracks, sprinklers, and extract ducts. Underneath this layer of essential services, displays are arranged almost freeform: furniture in room sets, with other merchandise mostly contained within "walls" that integrate shelving and display lighting. Video monitors are widespread, showing rather abstract programs devised by the store's in-house team of video artists.

Materials are used as appropriate to the character of merchandise. Hence, the Japanese furniture is shown on a raised wooden platform with tatami mats, contemporary furniture on a hardwood floor, and traditional western furniture on a patterned carpet (with the additional touches of cornices on the walls and glazing bars on the "windows").

If the departments themselves are very different and idiosyncratic, circulation between floors is fairly standard and provides a linking device. A central bank of escalators provides the main vertical circulation, supplemented by a double bank of lifts at the far end of the building from the entrance and staircases on the sides.

A Japanese "room set" (above) contrasts with a display of Western-style home furnishings (center).

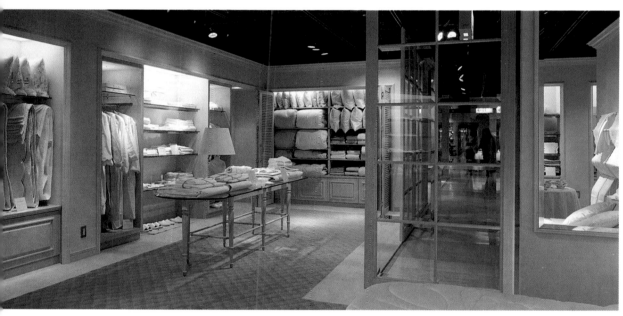

The restaurant lobby recreates a sense of *al fresco* relaxation, while displaying merchandise.

The two buildings that comprise
the Printemps department store
are linked by a glass bridge on
the first floor.

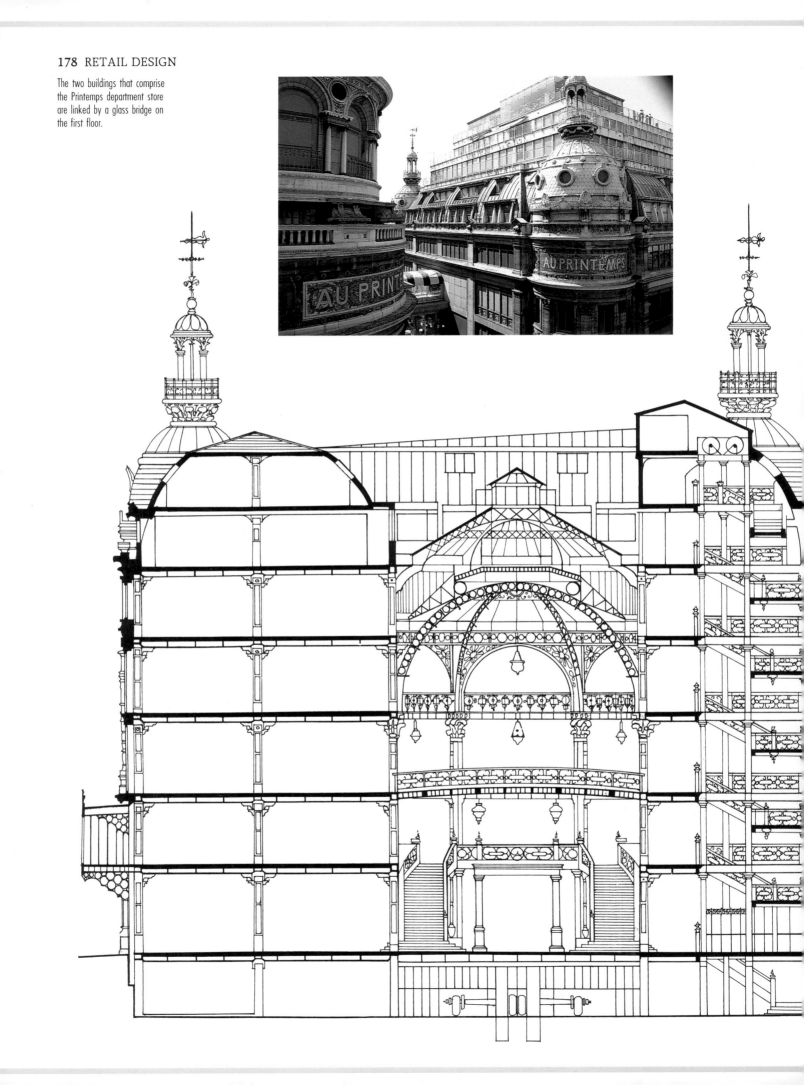

PRINTEMPS
Paris, France

In some senses, Printemps lives with the memory of a long-departed department store. The original Printemps, built in 1882 by Paul Sedille, was one of the first great flowerings of the genre, jostling in central Paris with Bon Marché, the Grand Magasin du Louvre, Belle Jardinière, and Galeries Lafayette. The iron-framed building was organized around a large central court, topped by a grand glass dome. At the turn of the century a new owner had different ideas and commissioned the architect René Binet to refurbish Sedille's store into something far grander. Using the finest French craftsmen (signs and light fixtures were by Lalique), Binet created one of the great examples of art nouveau design. In particular, the great dome was transformed into a glorious work of art in blue and green glass – a grand centerpiece for a grand retail design.

A fire in 1921 gutted Binet's masterpiece and resulted in another rebuilding and the central space was tragically filled in. Now, Printemps is in two adjoining buildings with only a hint of Binet's floriate grandeur. However, both buildings still retain echoes of Printemps' glorious past.

Printemps de la Mode (the fashion departments), fills one of the buildings. Designer fashion is concentrated on the first floor. Printemps commissioned French designer Philippe Starck to renovate this fashion floor, to give it a special identity, responding to intense competition from other Parisian department stores.

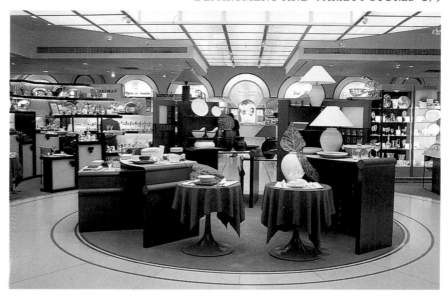

Starck's design imposes what he terms an "urbanistic" sensibility on the floor: "streets," "squares," and "buildings" provide definition and identity. This proves an effective way of creating order on a floor containing fashion designer fiefdoms, each with its own corporate style.

The manifestation of Starck's retail "urbanism" are aisles (the streets) of marble, lined by heavy square pillars and beams, some black, some gray. Behind these "façades" are the various designer areas. An echo of the Printemps architectural heritage comes from domed ceilings at key circulation junctions and, according to Starck, large chromed spheres on the floor at axes where walkways meet.

The second floor of Printemps de la Mode is geared more towards the mass market. But even here, some inventive details have been used, notably the black wire display mannequins, which serve also as directional signage: the mannequin heads have been replaced by the announcement "2ᵉ étage" ("second floor"). The basement of the building houses the lingerie department, which is distinguished by a soft colour scheme of pink and cream, with perspex display fixtures and units.

Printemps de la Maison is reached across a glass bridge. Again, the principal design device on each floor is to open up some larger space at the junction of major walkways, although the airiness of Starck's domes is not repeated. Individual designer areas have the most interest, with carefully coordinated room sets. On the fourth floor, towels, bedlinen, and rugs are displayed among bright red pillars and green bamboo.

Binet imbued the original Printemps with a character that was typically Parisian – decorative and stylish. Philippe Stark has chosen to follow in the Binet tradition and continues to give the store a characteristically French dimension.

The circulation plan is apparent around this central display of china and glass. (Photos: Printemps)

A view of the lingerie department.

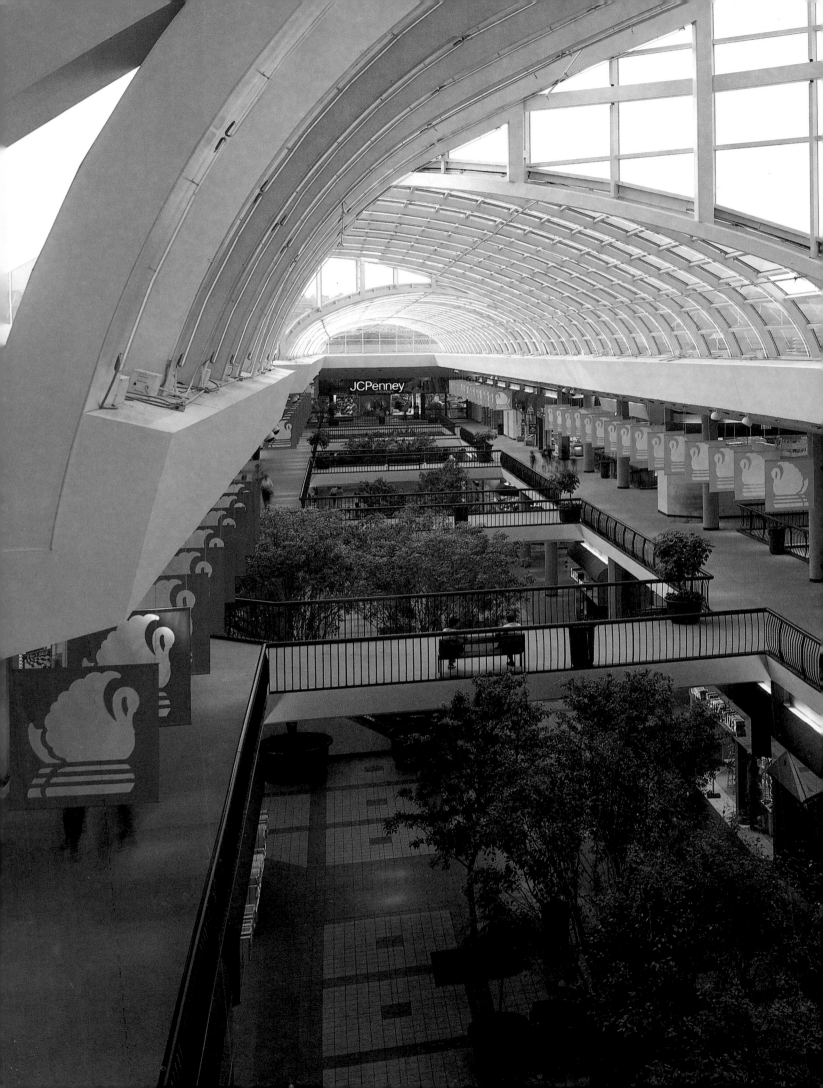

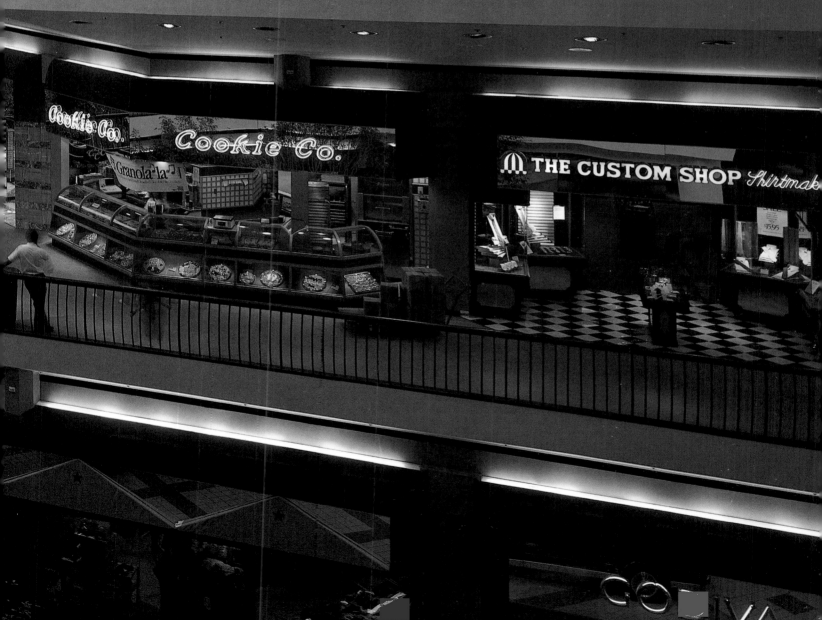

SHOPPING CENTERS AND MALLS

Europa Boulevard in West Edmonton Mall, Canada (opposite) is reputed to be the largest shopping mall in the world. The overall design incorporates a highly successful imitation of traditional European architectural styles, giving the storefronts of the exclusive fashion boutiques it houses both colourful individuality and conformity. *Trompe l'oeil* painting at the end of the mall creates the impression of high windows in another old building. (*Photo:* John Wadsworth Photography/ Inspiration Press)

The development and spread of shopping centers in the United States, Britain, and Europe in the last decade has been quite astonishing. In Britain and much of Europe, urban shopping center development sprang from the postwar rebuilding of cities. An element of civic pride, and the fact that most of Europe was not a car-oriented society until well into the 1960s, meant that in many cities traditional main streets were rebuilt as large shopping centers. It was only with the development of roadway networks and a more affluent, car-owning society that conditions provided the opportunity for out-of-town shopping developments. Hence, to this day, a lack of car parking provision is prevalent in European central city developments.

A special factor in British shopping centers is the strong position of multiple retailers, who provide a ready-made and fertile source of potential tenants – a situation unique in Europe. In the United States, shopping centers are a natural extension of "real estate development," reinforced by the flight of residents from "downtown" and the redevelopment of the United States as a suburban nation. Yet, for all the thousands of centers that have been built, and millions of dollars invested, few have a distinct identity. The very proliferation of shopping centers has made more critical the need to impart a *genius loci*, a spirit of place, to each development, so that they attract and retain shoppers in a highly competitive market.

Shopping center design is too often seen as a real-estate opportunity and a primarily architectural problem. But with the increasing numbers of centers, the skills of the retail designer – and the perceptions of how good design can promote retailing – have become more important. In the past, retail designers built their credentials by working directly for retailers. Shopping center design involves different criteria: the retailer may be only one of many tenants, and it is the project

The sweeping, vaulted glass roof of Riverchase Galleria (previous page) in Birmingham, Alabama, highlighted with red neon strips, enforces the clear circulation route through the center. (*Photo:* John Wadsworth Photography)

as a whole that requires design skill. Many design firms now have specialist shopping center teams and knowledge, with a better understanding of both retailers' and shoppers' needs. Centers are not necessarily planned as catch-all locations for shoppers these days, but are often targeted to a specific market. Good retail design can add this crucial element of differentiation and targeting to a project. To do so, the designer should be involved in plans for a shopping center at the earliest stage, before insurmountable constraints have been imposed. There are other considerations, too, such as planning rules and construction regulations, which vary from country to country. Often this affects the question of scale – a shopping center in Dallas, Texas, is quite a different matter from a center in York, in England. Scale should be thought of in terms of balance and proportion rather than simply dictated by how much can be built on a particular site.

Differentiation of character is particularly important for a shopping center, because most developers today plan to target their center for a focused market sector. By creating the right tenant mix, the developer tries to draw a certain kind of shopper; untargeted consumer groups will want to go elsewhere. The design needs to reinforce this focus: an appropriate design for a relatively high-class center, anchored by such exclusive US stores as Neiman Marcus and Lord & Taylor, for example, will seem discordant with a mass-market center anchored by such predominantly self-service low-priced stores as Sears Roebuck. The targeting of shopping centers is more direct in the United States, where there is a greater proliferation of and thus more competition between centers, but even with the less highly developed European shopping centers, some focus is needed. A shopping center that tries to be all things to all people will struggle for commercial success. This demand for distinction and

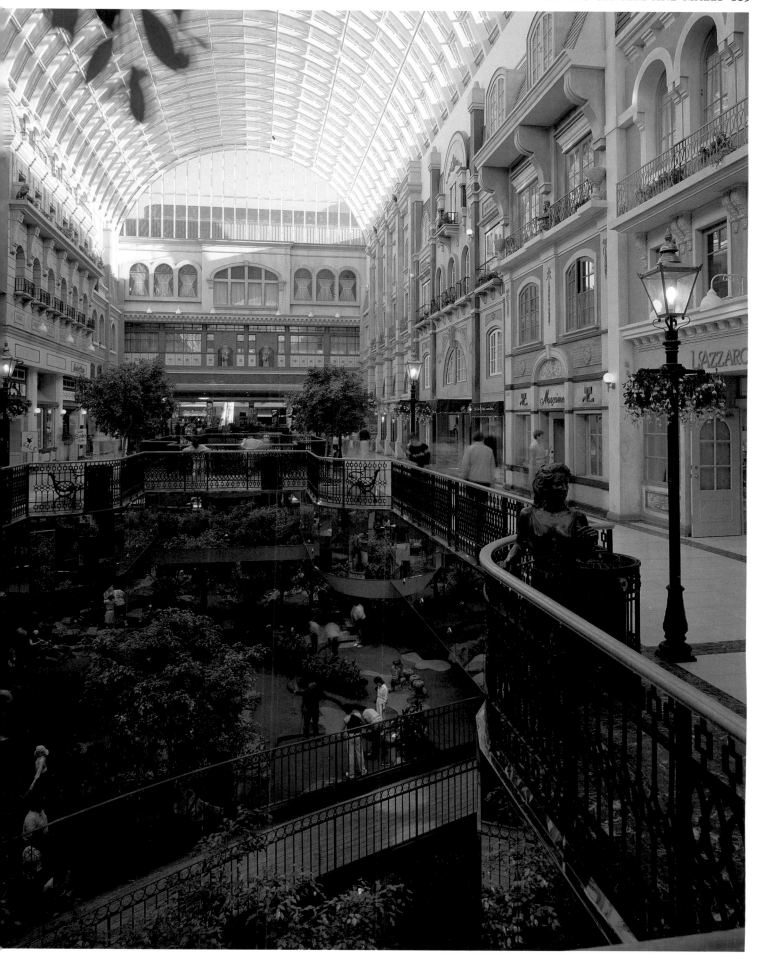

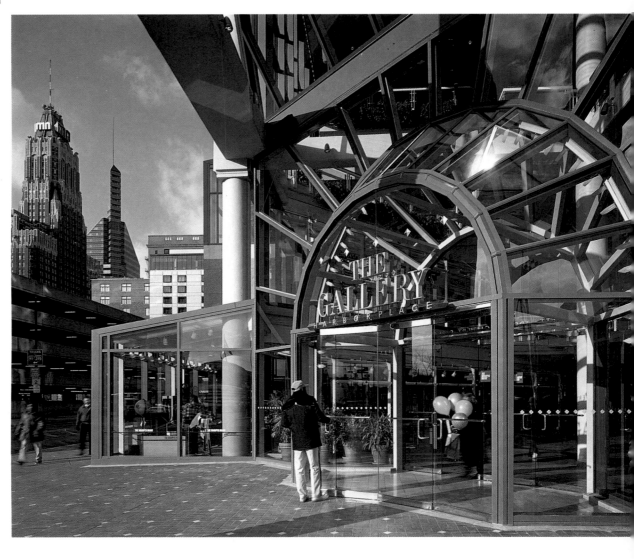

character – in effect, corporate identity – applies whether the center is out-of-town, or situated in town, which remains the dominant European type. In both cases, the aim for the designer should be to create a center where shoppers not only know where they are but also feel a sense of enjoyment and belonging. The corporate identity of a shopping center has many manifestations, and the kind of graphics used plays a significant part. But too many developers make the mistake of building an ordinary center, and then devising a name that may or may not have any local significance; attempting through some tenuous connection, expressed in trite graphics, to create an identity. Identity, however, means more than this and certainly involves a greater understanding of the potential of powerful graphics. Communication Arts, a Denver-based firm, are pioneers in the field of three-dimensional graphics. They see graphics as an integral part of the architectural detail – sometimes becoming even the architecture itself, as at Bayside, Miami. At several of their projects, signs, information, and directions, are wittily built into balustrades, canopies, light fittings and architectural details.

EXTERIORS

The first impression of a shopping center, and its prime identifer, is the exterior. In town, the design of the exterior is often a problem of how to achieve both sympathy with surroundings and "good neighbourliness" while still advertising a center's presence. Out of town, the exterior must act as a giant sign, both attracting attention from speeding automobiles and as a landmark in its own right. But exteriors need not be overly dramatic and declaratory: what the designer is striving for is a presence in the landscape. Most in town centers resolutely present their backs to the townscape, rather than play an active role. This missed opportunity is frequently justified on cost – blank walls are generally the cheapest way to build. But the alternative, which often amounts to "paper façadism" – exterior decoration that is only paper thick – is little better. Designers need to forge a careful path that combines economic construction with a firmly established, nontrivial architectural impression. One of the critical facts of shopping centers is that they are planned to be there for a long time; they

must last both physically and visually, so an exterior treatment that prevents a center from being just another box must also be easy to maintain. (This is by no means a new problem; there are plenty of historical examples of successful screen walls, such as the Parthenon in Athens.) Complex *trompe l'oeil* paintings on blank walls tend to fade rapidly (especially in areas that suffer from severe weather), and are rarely restored. More simple paintwork may be easier to reinstate, or could be painted with a new scheme. Molding a façade with brickwork, stone, or cement render, may raise the initial cost of construction, but such an effect will last far longer than cheaper decorative schema. But all these methods are devices. The objective must be to create identity through the overall quality of the architectural concept. This is the most enduring approach, especially since these shopping centers have been likened to "the cathedrals of our times."

Out of town, the impact of even good architectural ideas is usually marred by the sea of automobiles surrounding a center. Few designers get a chance to design a parking lot, which is generally dictated by pure engineering considerations: traffic flow, car-turning radii, and average car size (still very different between Europe and the United States). But if shoppers feel uncomfortable driving to a center, they will be reluctant to return. This has implications for both out-of-town and in-town developments. Out of town, some degree of landscaping can transform a parking lot, hiding the unsightly mass of cars, providing welcome shade in hot climates, and making clear the

progression to the entrance. At Union Station, St. Louis, the designers were fortunate in having the world's largest train shed to provide cover for parts of the parking. Even the simple construction of an arcade along the footpaths – to shelter from a hot sun in some climates, or the rain in others – can make the difference between a pleasant shopping experience and an endurance test, not to be repeated (see, for example, Sainsbury's, Derby, page 225). At the Stanford Shopping Center, Palo Alto, California, such arcades also prove an effective way of orientating shoppers in the parking lots. In town, where multistorey parking garages are the norm, even minimal generosity of lay-out will be appreciated. Given that the investment in an urban shopping center project will run into millions of dollars, it is well worth improving the parking garage budget and insisting on better design, remembering that the garage is both the first and last impression. Good lighting, easy access to stores, and clear circulation routes all help make a better shopping experience, while shopping cart stations and easily cleaned surfaces will help maintenance staff as well as shoppers.

One of the most important aspects of the exterior is, of course, the entrance. In general, entrances should be dramatic, though not necessarily large: drama can be created by a well-defined, jewel-like slit in a long, blank wall. The use of exquisite materials can make a striking first impression. Out of town, in particular, the dramatic impact of an entrance helps provide some sense of direction. The entrance should be a welcoming beacon for shoppers approaching from the parking lot, as with Bayside, Miami (page 92).

Attention to detail is much in evidence in the design of Water Tower Place, Chicago; the lavish use of marble and glass, despite the first impression of an open-seeming frontage, suggests exclusivity and high-priced stores inside. (*Photo:* Zeidler/Roberts Partnership)

Princes Square in Glasgow (opposite) celebrates its circulation space in grand style. The careful restoration and stylish redevelopment of the original 1840s buildings was carried out in conjunction by architects, Hugh Martin & Partners and designers, Design Solution. The architectural theme of the whole complex is the Tree of Life, which is reflected in many Art Nouveau and Viennese Secessionist details in wrought steel and etched glass. The grand staircase is in the shape of a double helix; the glass cladding of the feature lift shafts (topped with sprays of leaves) is etched with designs by Maria McClafferty on the Tree theme; and the escalators (not seen here), articulated to maximize shoppers' sense of drama, feature an old astronomical pendulum that swings between them. (*Photo:* Alastair Hunter)

INTERIORS

Inside, shopping centers, albeit in multi-occupation, should nevertheless obey the same rules of retail design as a single store. Given the scale of centers, however, circulation is of even greater importance. Clarity and visibility, which define good circulation, are therefore crucial. But shopping centers demand something more: articulation and rhythm. The long, straight lines of early shopping centers – which pleased retailers schooled in the importance of lines of vision – create monotonous, lifeless interiors. Instead, circulation can be articulated to suggest something just beyond view, just around the corner: something more reflective of city centers in older towns. Articulation can be achieved in many ways. Narrow spaces opening into larger spaces, and then decreasing again, generate a rhythm that moves shoppers through a center. Curved walls also tend to lead people on, both physically and in terms of their field of vision. Articulation can be reinforced by staircases or escalators at focal points, or designed "events," such as the boats at Rivercenter, Sante Fe, or, on a larger scale, the ice-skating rink at Peachtree Plaza, Atlanta. However, the

The Zeidler/Roberts Partnership, with Bregman and Hagmann, designed the Eaton Centre in the heart of Toronto. It consists of a glass-enclosed galleria between two office towers, giving some 484,000 square feet (45,000 square meters) of retail space for about 300 stores. The layout of the galleria and its crossings relate to the city's existing grid pattern; water fountains, a large revolving clock, a sculpture of 100 geese, benches and trees are among the features used to enhance a sense of both excitement and relaxation. The mall is an ideal width to encourage shoppers to "bounce" from side to side of the space, browsing in different stores. (*Photo:* Zeidler/Roberts Partnership)

vogue for events or features in shopping centers ha led to many well-intentioned, poorly designed pro jects. Instead of the usual banal events – a bad sculp ture or fountain – features need to be well done carefully detailed, and customer-involving. Although something of a cliché, an intricate mechanical clock for example, invariably fascinates as both children and adults watch gears spin, levers flip, and hand turn. A more educational and creative approach i suggested by the museumlike events at Union Station St. Louis: mementoes of the old railway station, panel of historical explanation, and actual trains provide meaningful focus for the center (see page 106).

Another key variable in circulation is the width o the mall. In general, narrowness is desirable, as shop pers like to "bounce" back and forth across the mall wandering from store to store. The effect can be similar to an old, characterful shopping street rathe than a cleanly efficient main road. In most shopping centers, designers will need to consider vertical a well as horizontal circulation. Here again, the same principles apply: articulation is preferable to the bland and straight, and the shoppers should always be encouraged to look beyond immediate vistas, to ex plore around the corner. Simplicity and clarity are o key importance – designers should ignore advice to hide circulation space in a nonprime position (a mis guided attempt to preserve prime space for selling areas), and should choose instead to celebrate it, with grand staircases, escalators moving dramatically through the space, and wallclimber or scenic eleva tors. Spiral escalators may be particularly effective too The San Francisco Center, for instance, has four floors of double spiral escalators, leading to a department store. However, the easy circulation cliché should be avoided. Wallclimber elevators have become so popu lar that they are sometimes used to move just between two floors: not only does use of such an elevator become unnecessarily time-consuming, but the short journey is clearly ridiculous and ultimately ignored by shoppers who soon tire of useless novelty. But par ticularly for multilevel shopping centers, the oppor tunity to create interest by exploiting the three dimensional potential of space is unparalleled in other areas of retailing. Opening up double- or triple-height vistas, for example, can make a drama, a spectacle that is enlivened by the sight of people moving up, down, and across the whole area. The vogue for scenic or wallclimber elevators and spiral escalators reflects the intrinsic appeal of visible motion through space. Spa tial interest can also be created with balconies or overhangs from upper floors or by using structural elements in a decorative fashion. In Toronto's Eaton Centre, the access points from the parking garage on many levels jut into the center from blind walls. Exploiting spatial opportunities effectively can help solve other shopping center design problems as well.

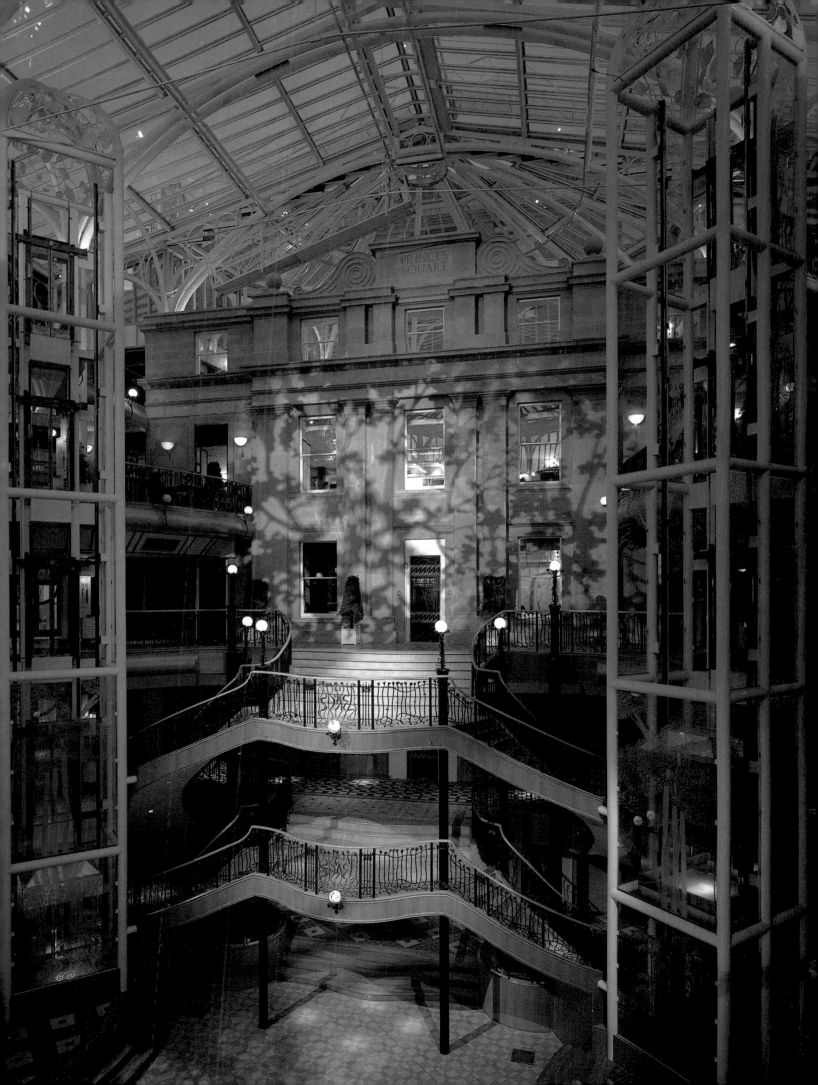

West Edmondon Mall in Canada covers some 1,125,000 square feet (104,512 square meters) and includes over 800 stores and services. Among the many attractions which provide focal points for the complex is the Santa Maria, a carved and painted replica of Columbus's ship. The curved galleries at different levels provide viewing-points close to the stores. (*Photo:* John Wadsworth Photography/Inspiration Press)

Lighting should be used to amplify the principal
oals of the design, especially in circulation areas. The
ld assumption for lighting in shopping centers was
nat it should be subdued and functional, so that the
ndividual stores could stand out. But what results is a
airly gloomy atmosphere that does neither the stores
or the center as a whole any good. Light and warmth
reate an inviting feeling, and variations in brightness
an help draw shoppers through a center: pools of
ght can be events in circulation just as surely as
onstructed elements. Natural light, once rigorously
xcluded from centers, diminishes the claustrophobia
hat a completely indoor space sometimes induces.
oof lights are the most common device for introduc-
ng natural light into centers. The advantage of this
orm of overhead lighting is that it facilitates careful
ontrol of direct sunlight. Lighting can also be used to
aise or lower lines of vision in a center. A string of
ghts climbing vertically up a space, for example, will
ccentuate the height.

The British shopping center, The Pavilions (left), in Uxbridge, designed by FitchRS, features a "Florentine" house as a focal point, drawing people nearer along the long view-lines of the mall. Once more, traditional architectural references – no matter how modern the setting – can provide a successful source of interest. The designers improved the shopping experience further by running raised, covered walkways between the center and the parking area: these start from behind the Florentine house.

Attention to materials is much in evidence in the design of Water Tower Place, Chicago – a combination of polished or mirrored surfaces and glass with starry lighting. Once more the elevator provides a centerpiece, while the surrounding offset galleries allow interesting vistas of individual stores. (*Photo:* Zeidler/Roberts Partnership)

Riverchase Galleria (opposite), in Birmingham, Alabama, makes a feature not only of the central foundation but also of the glass elevators, framed in symmetrical lift shafts and lit with Tivoli lights. The combination with natural light is as effective by day as it is by night. (*Photo:* John Wadsworth Photography)

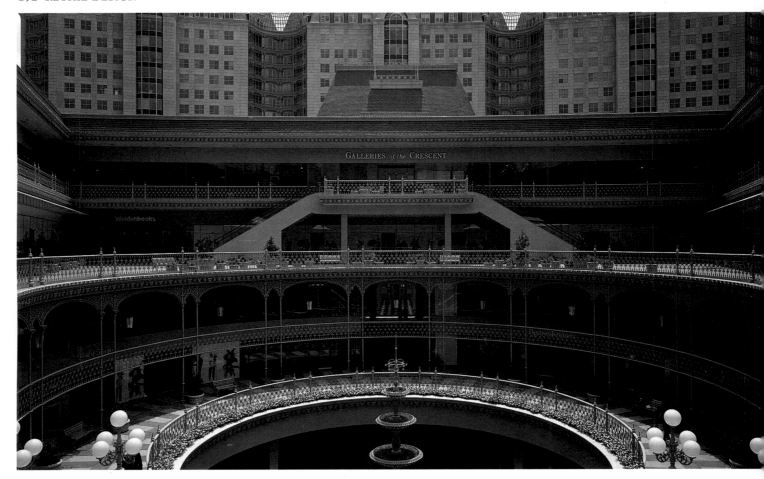

GALLERIES of the CRESCENT

CENTER IDENTITY

Center identity can be seen at its most pronounced in the case of The Crescent in Dallas, designed by John Burgee, who describes the style as a combination of French château design and Galveston Victorian ornamentation. The exterior is executed in limestone; cast aluminium is used for decorative detail, granite for the paving, and marble for the lobbies. Here, external store identity is considered much less important then the overall cohesiveness of the design. (*Photo:* John Wadsworth Photography)

One of the main design difficulties presented by shopping centers is that in most cases, the designer has little control over the many storefronts. In a successful design, a balance needs to be achieved between a center's identity and the individual character of the stores – retailers must have the opportunity to exert their own personalities. Creating this balance should be possible, whatever the scale and space of a site, provided that the brief given to the designer is reasonable in its fixed demands and generous in allowing retailer character and personality to come through. In many centers it is possible to exercise some control on the individual storefronts, but this power must be used judiciously. In London's Covent Garden, for instance, the architects designed the storefronts to retain the overall Victorian identity of the center. Another approach, far more common, is to set constraints – rules within which tenants have the freedom to do what they want – outlining, for instance, setback or projection into the circulation space, heights of fascia from the floor, and size or look of flush or projecting signs. While defining the style to be used – whether modern, traditional, New England, or prairie style – the designer will also need to establish the type of material and finishes to be used.

One characteristic of shopping centers is that the cater for many tenants (anything up to 800 individua stores), and there may well be periods when units ar not occupied. How to deal with untenanted space therefore, must be considered. Empty space can b used temporarily for promotions or charity outlets, c possibly for playrooms or child-minding facilities. Th cheapest (and least imaginative) solution is to use billboard to cover the frontage – preferably set back few feet and including some lighting, so as to give th impression of a potentially interesting store rathe than blank space. The design of a storefront for tenant will evolve from the criteria used. In som cases the design will pass through a committee c owner, agent and architect. As mentioned above, th most common problem is how to integrate stron individual retail character, emanating from powerfu retailers, into the style of the center itself. Overall, th aim for any center must be to achieve an appearance c organic development, rather than the instantaneou growth that is the reality. Most of the more successfu centers give both tenants and designers more rathe than less flexibility. If variety is the goal, people mus be allowed to create their own dramas. A shoppin center must permit change. If it is constructed to rigidly, or if constraints preclude flexibility, then it lifespan will be limited.

PRACTICAL CONSIDERATIONS

There are two other aspects of a center that must be taken into account in order to make a visit pleasant and the project successful. First, on a practical level, any materials should be easy to maintain, agreeable to the touch, and sympathetic to tenant storefronts. Floor surfaces, of course, need to be nonslip. A careful balance needs to be achieved whereby the effect is neither overpowering on the one hand nor too self-effacing on the other.

The second consideration affects the overall approach to the design of a shopping center – the special needs of disabled visitors. Legislation governs this to some extent, but only in terms of minimal requirements. Designers should serve this group better, as they should nursing mothers, people with young children, or those who are elderly or frail. All shoppers will be favourably impressed by obvious concern for the needs of this large customer base – needs that should be sympathetically studied and addressed from the beginning in the design of a center. Provision should always err on the generous rather than the statutory minimum. This can contribute positively to center identity and customer image.

Servicing of a shopping center is a "behind the scenes" aspect with several practical implications. Do the delivery trucks get in the way? Do their access routes combine and compete with visitors' cars? Rubbish bins and compacters will need to be accommodated too, and should be located out of customer areas or sight, so as to be efficient, without causing obstruction. Other services may be more public, part of the "visible" side of a shopping center: public toilets, for instance, first aid facilities, perhaps a café or children's play area, or an information office. The standards for all these should be the same as for the rest of the center. The complexity and variety of shopping centers make it particularly difficult to give absolute rules, but these factors explain the continued vitality of shopping centers, for both retailers and customers. Although the future of shopping centers may be indeterminate, the history of the phenomenon so far suggests that they will increasingly require the ideas and inspirations of designers to bring coherence, identity and a sense of place. Today, a new generation of center and center design is providing retailers and customers alike with new opportunities. Centers can be more interesting, more surprising, better researched and, certainly, better designed.

Westside Pavilion in Los Angeles, designed by the Jerde Partnership Inc., is another center to take its tone from famous European gallerias, with an eclectic use of architectural styles. Arcades on these levels are sunlit, thanks to a curved, continuous skylight. Touches of brass and chrome are used, along with a variety of colours. Designed by Sussman/Prejza & Company Inc., the graphics of both the center and store signs sustain a sense of variety and interest while being hung in uniformly along the mall. (*Photo: Jerde Partnership*)

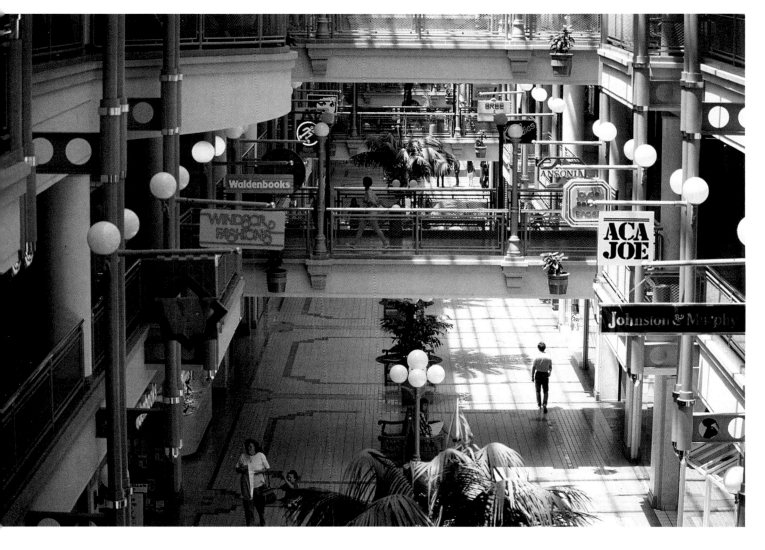

The gentle curve of the walkways leads the visitor through the middle of a mock-palazzo façade.

HORTON PLAZA
San Diego, California, USA

Horton Plaza, San Diego, marks a significant step in shopping center design in a number of ways. While most shopping centers in the United States were anti-urban or, at least, unconcerned with downtown – built as they were in the suburbs or near highway junctions where ample parking could be provided – Horton Plaza was intended from the start as the key element in reviving a moribund section of downtown San Diego as part of an urban regeneration scheme. Further, instead of the relentlessly internal nature of most shopping centers, Horton Plaza celebrates the generally benign weather of its location, with its main circulation spine, and some of its activities, open to the skies.

It did not start out like this. When the city of San Diego convinced developer Ernest Hahn to take on the unpromising site, he sketched out a two-story covered mall much like other successful centers he had completed. However, when designers The Jerde Partnership became involved in the project, the scheme changed utterly.

On the 11.5-acre site, covering six and one-half city blocks, Jerde created a structure of four staggered tiers, organized around a central

Details, such as this "ductwork", combine an artistic sense of fun with functionality.

circulation spine that cuts diagonally through the site. The central spine is, however, more than a diagonal: a gentle S-shape contrives a sense of organic discovery, encouraging visitors to wander through Horton Plaza, rather than stride purposefully along a straight path. The other crucial planning decision was to emphasize the gradual slope of the site by building the center's main level one story above grade. As a result, the center seems to cascade down the central spine, and an intriguing

and inviting complex network of staircases, ramps for the disabled, elevators, and escalators connects the retail tiers.

What sets the scheme apart is the bewilderingly varied application of architectural styles and decorative motifs: Venetian palazzo; a borrowing from San Diego's own railroad depot; a snatch from Palladio's Basilica in Vicenza; an English crescent; a native American pueblo, and an Italianate arcade are among the references that punctuate the center. And the elements that are not dressed in pastiche architectural fragments are enlivened by a palette of twenty-eight colours: thirteen different blues, four reds, seven coral/yellows, and four mauve/violets, developed by consultants Sussman/Prejza.

Within this extraordinary stage set are four large department stores that "anchor" the center, 150 other stores and restaurants, a seven-screen cinema, a theater, a 500-room hotel, and parking for 2,400 cars. The strength of Horton Plaza lies not in any individual aspects of the design, but in the coherence of the whole: the planning concept would stand even without the decoration, but the applied decoration adds the vital ingredient of enjoyment and visual delight that is essential to retail design. Horton Plaza has succeeded in giving a boost to an inner city area and demonstrates yet again how important good retail design is in any urban regeneration plan.

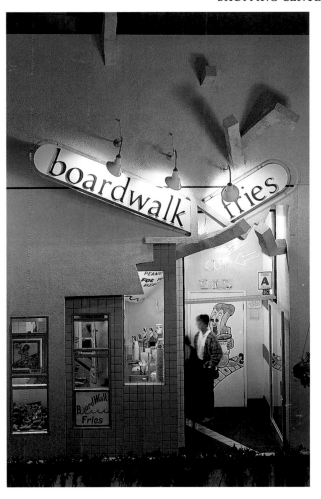

The broken-up nature of this exterior seems to anticipate a seismic disaster. (*Photos:* Peter Cook)

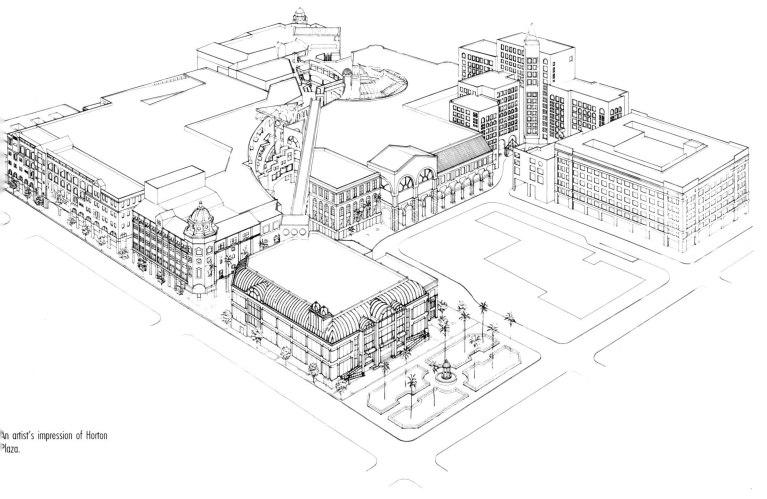

An artist's impression of Horton Plaza.

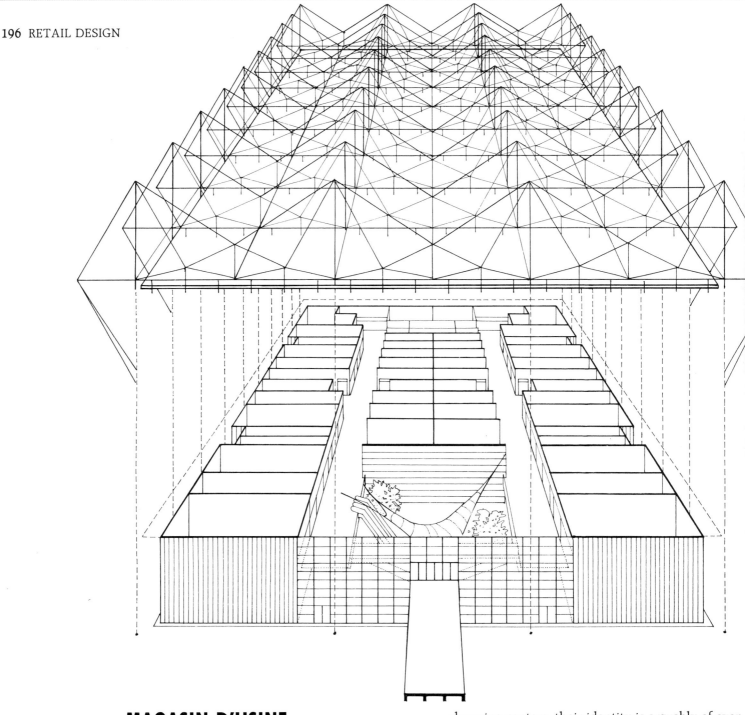

MAGASIN D'USINE

Nantes, France

Magasin d'Usine at St. Herbalin, near Nantes, France, is one of a new type of out-of-town shopping center that is growing in popularity in Europe as well as the United States. Instead of the normal mix of specialty and department stores, Magasin d'Usine – which would be called a factory outlet in the United States – has furniture and clothing stores selling merchandise direct from the manufacturer's factory. The main appeal to customers, then, is convenience and low prices.

For a factory outlet, however, a distinct, memorable identity is vital – in fact, since these outlets lack many of the amenities of typical shopping centers, their identity is arguably of even greater importance. French developers GRC have constructed a number of factory outlets, using a common approach, with utilitarian sheds and a few add-on, circus-tent constructions. But for their outlet near Nantes, they turned to the architects Richard Rogers Partnership, best known for the Pompidou Centre, Paris, and the Lloyd's building, London. Rogers, however, had also designed a factory for Fleetguard in Brittany, not far from the Nantes site.

The brief for the center demanded a sales area of 225,000 square feet (21,000 square meters) on two floors with a 21-foot (6.5-meter) floor-to-floor height, a short construction period, and a low budget. The result is a simple, blue-clad rectangle, partly concealed by rising ground on the south side. What is noticeable from a distance is the skyline of green

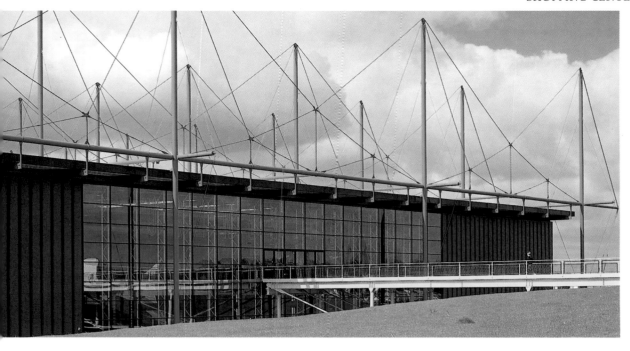

The green masts of the center make it easily identifiable from a distance, as well as being the entire structural supports.

masts and struts of the suspended structure, which allows a column-free interior. (The structure is superficially similar to the Brittany factory, which has red masts.)

The main entrance is over a bright yellow metal bridge, piercing the glazed entrance wall at first-floor level. Inside, a double-height reception and entrance space provides access to the shopping spaces within. But the flow of traffic is largely to the bank of open escalators that descend at an angle to deliver customers to the lower level. Because of the nature of the factory outlet, the developers were content to eliminate the kinds of choices that would be demanded in a typical shopping center: with no "magnet" or "anchor" stores (those large, often department, stores that attract shoppers and other retail tenants), customers are encouraged to follow a route that takes them past all of the stores before returning to the entrance. There, another set of angled escalators brings them back to the upper level.

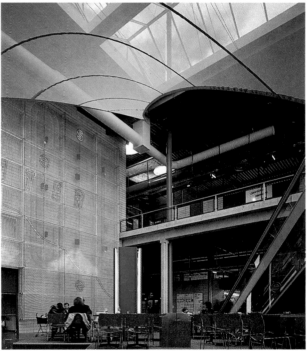

A saillike awning softens the lines of the roof structure over the cafeteria.

The circulation on both levels is in a giant U-shape, with stores on both sides of the mall. The architecture of the mall is consistent with the external "factory" image: red floors of heavy-duty, self-levelling epoxy resin, concrete block walls with steel infills, bold blue ventilation ducts running down the central service spine. Lighting is from circular skylights, and spotlights and metal halide lights mounted on the service spine.

The strongly utilitarian sense of the center is continued in the cafeteria, on the ground level of the entrance space. Metal chairs and tables cluster around the bar area and towards the enormous front glazed wall.

The engineering and service functions are celebrated here, rather than hidden. (*Photos:* Peter Cook)

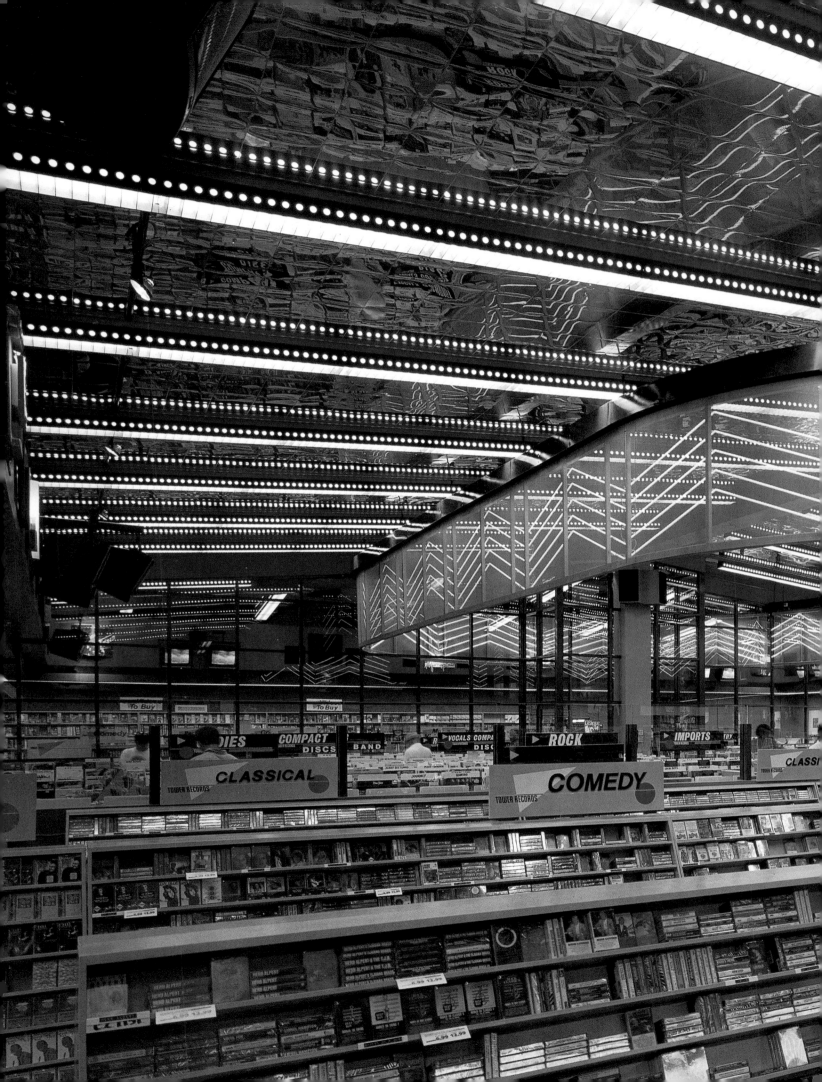

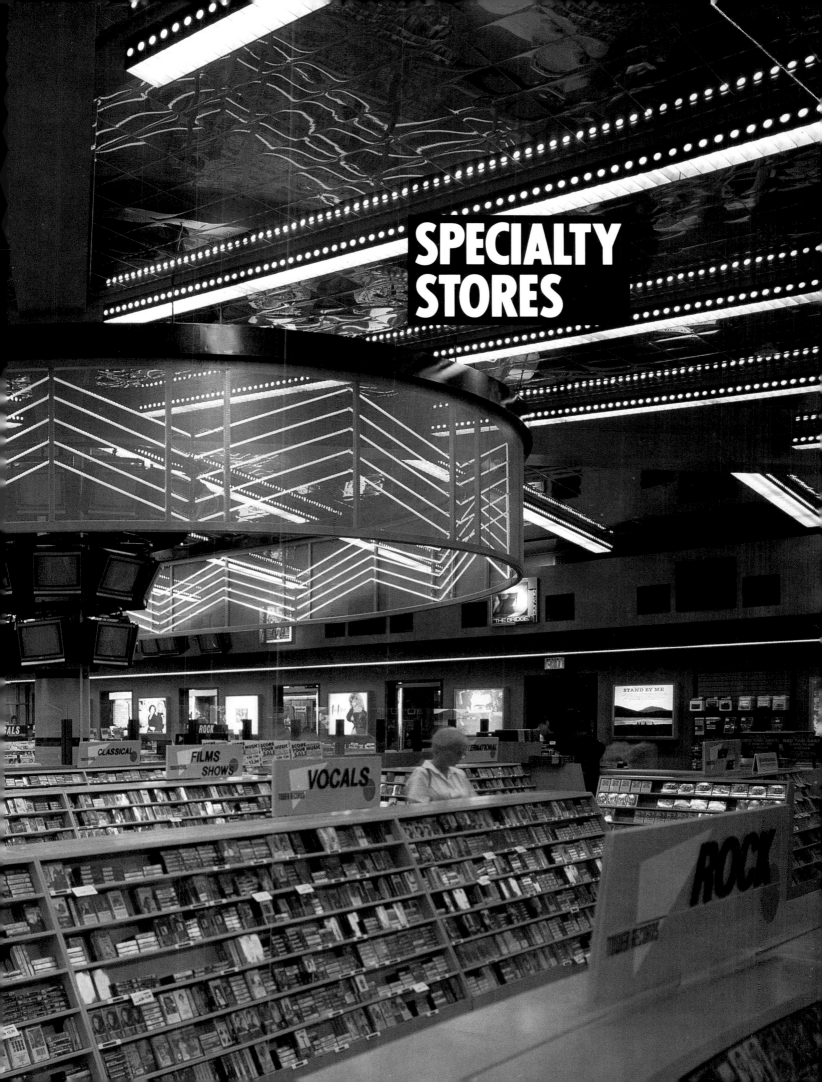

SPECIALTY STORES

The immediate impression given the customer in Tower Records (previous page) in London, is of the vast range of stock on display, doubled by the mirror tiles on the ceiling. The merchandise is arranged for easy access in functional avenues of shelving, with simple, clear signs. However, this is enlivened by the dramatic use of neon lighting, which in combination with the suspended ceiling structure adds pace and excitement. The security closed-circuit television is deliberately prominent, in a store where pilfering of small items such as cassettes can be an expensive problem.

"Specialty retailing" is a relatively new term for a form of retailing that has always existed, but in this book it means that wide constituency of stores specializing in particular product areas: books, toys, music, sporting goods, jewelry, stationery, cosmetics, flowers, and so on. What the specialty retailer is trying to achieve, and what the design needs to convey, is authority and dominance in its category. Sometimes even the name of the store can help reach this goal. The object is to create "the only place to shop for . . ." or "the first port of call . . ." Given these characteristics, the design can go on to produce the necessary excitement and clarity. A specialty store should not have a "rummaging" quality – unless it is a specialty rummaging store!

The trend towards specialty retailing is even leading to the formation of what might be termed "ultra-specialists" – one chain in the United States only sells coffee-table tops. It seems as though there is always a new specialist niche for the clever retailer, whether for entrepreneurs such as London's Sock Shop and Tie Rack, or a retailing giant such as the British variety chain Boots the Chemist (interested in, to use the management term, "intrapreneuring"), with their highly successful Childrens World and Health and Beauty stores. This growing group of specialists certainly provides a rich vein for designers. And the smaller nature of many of the specialty retailers will often make this sector a good entry point for young design firms. Since there are so many different kinds of specialist retailer, it would be impossible to discuss each type, so this chapter concentrates on some of the main categories. But the ways of thinking about a specialist retailer apply to all specialties, no matter how bizarre the niche may be.

MUSIC STORES AND BOOKSTORES

Specialty music stores and bookstores present many of the same problems for designers. Clarity in design is particularly important, because of the huge number of different items that need to be displayed – a good music store may contain many thousands of different records, tapes, and compact discs, for example. In both areas, too, there is room for specialists within the specialty: jazz, obscure rock, and classical music all have their own stores in many cities; and architectural, business, foreign-language, or travel books have their own particular outlets. For these specific specialists, the impression of authority becomes the dominant theme in the design. How then can designers achieve these ends? For all their similarities, there are still important differences between books and recorded music. The main difference is basic: books come in many different sizes, and the aspect presented must usually be the spine, rather than the cover, whereas each of the recorded music formats are standardized in size, which can solve many design problems, and generally it is the cover that is important.

The bookselling business is changing dramatically. In the near future, small general bookstores are likely to dwindle, while larger outlets, particularly those such as the British chain Waterstone's, or Barnes and Noble in the United States, are on the increase. Today there is a growing tendency for large general bookstores to have specialist or authoritative departments and at the same time to promote a "bestsellers" section. The design approach should encompass this range; as with music stores, specialisms generally

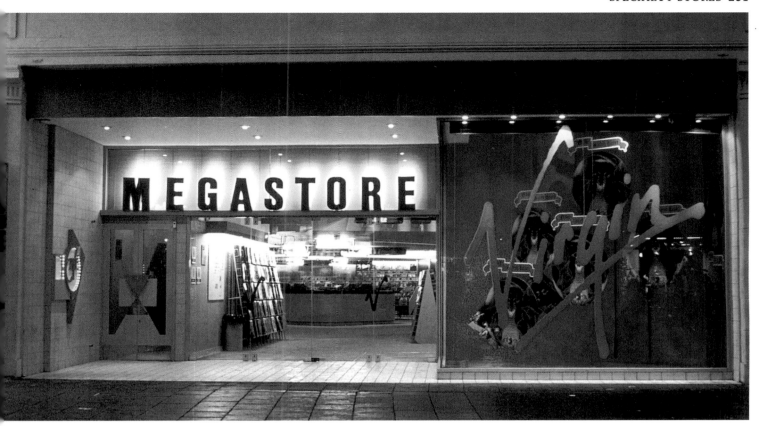

The design of the Virgin Megastore (above) in London, begins with the name. The entrance graphics, with a view of the vast interior, boldly announce that this is **the** store for music and videos. (*Photo:* Conran Design Group)

Tooth Booth in London (left) is an amusing manifestation of the marked trend towards niche retailing. The design of the store, which is devoted to dentally related products of all kinds, manages to suggest both hygiene and fun.

Bookstores increasingly stock many kinds of related merchandise, of differing shapes and sizes. Jiricna-Kerr's highly versatile metal display units at Way In, Harrods (above), can be used for greetings cards, wrapping paper, and other types of stationery. (*Photo:* Martin Charles)

At Dillons bookstore in London (right), flat surfaces combined with shelves allow for a mixture of spine and cover displays. Curved display walls add interest to the shape and lead the browser visually from one area to another.

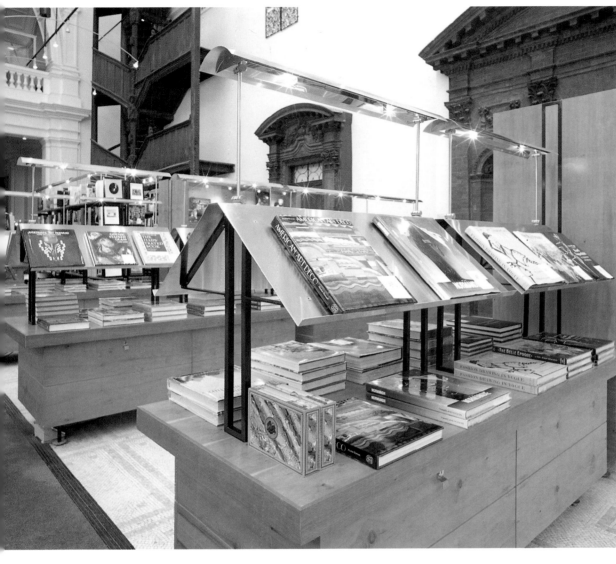

David Davies Associates were asked by the Victoria & Albert Museum in London to design their new museum store in keeping with the existing gallery space. In addition, displays had to accommodate a large number of items in widely varying sizes, from postcards to very large books. The designers have created an interchangeable plinth system, with cupboards for stock below the optional bookshelves, glass cabinets, and postcard and transparency units above. Built in yew wood with satin stainless steel, and using gunmetal finishes, it is lit by slim metal bows incorporating tungsten-halogen lights, suspended over the space. Lights are also built into the individual units. Original decorative details, including the original mosaic floor, are left untouched, except for a carpet through the space carrying flat cabling. (*Photo:* David Davies Associates)

eed calm and clarity, while popular merchandise will tolerate more activity. For the more difficult books, designers must create a combination of cover and spine display. Traditionally, best-selling books are set in cover displays, often in special promotional "dump bins" provided by the publishers. Publishers, in fact, are tending to have an increasing role in the retailing of their books: in addition to dumps, they may go to the extent of setting up "house sections" within a store; when this happens, as with publishers such as Virago or Faber in Britain, and Silhouette in the United States, they design their book jackets in a particular "house style" in order to dominate their section of the shelves, through projection of their particular corporate identity. However, designers should create those fixtures that are for a store's own use, both in wall-mounted shelving and in free-standing table or gondola units. Shelves need to be adjustable, so that small- and large-format books and stationery can be accommodated, and so that the retailer can adjust the stock periodically. Curved shelving units, such as those in Dillons, London, work wonderfully, giving customers a continuing visual interest and field of vision. Designers also need to consider the recent development among retailers of selling merchandise, such as prints, posters, graphics, and cards, which have their own display and storage requirements. Small, specialist booksellers need a different design approach, one that conveys the nature of the specialism at a glance.

Lighting must be a particular concern in book-stores, for browsing customers can often cast a shadow over shelves of books, and the small quantity of information on the spine must be easily visible. Indirect lighting, perhaps through the use of uplighters, helps eliminate strong shadows. But in many spaces indirect lighting can also create uncomfortable "hot spots" on the ceiling and a uniform impression of grayness below – even though an engineer's light meter will give a perfectly acceptable reading. Shadowless indirect lighting can be supplemented by spotlighting to pick out special displays or points of interest in the store. Lighting placed just over the shelves can prevent the dual problems of glare and shadow. Alternatively, lighting fixtures can be mounted directly on shelving units, or concealed

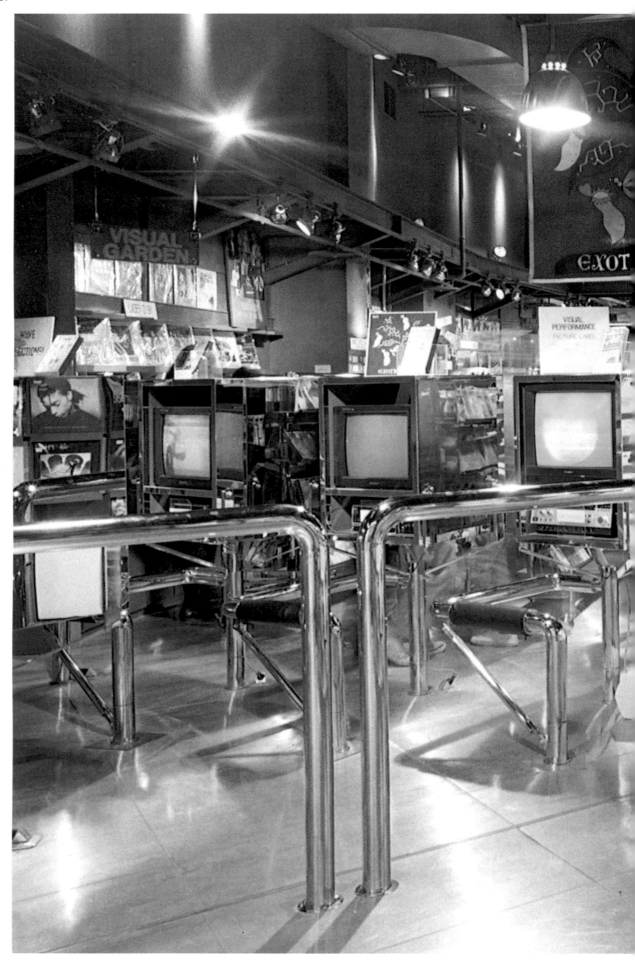

In general, specialty stores should be especially orderly and simple in layout and appearance, but – as always in retail design – exceptions prove the rule. The audio corner in the Loft store, Tokyo, designed by Axe Co., has an air of craziness and impermanence which is attractive to shoppers, but not confusing.

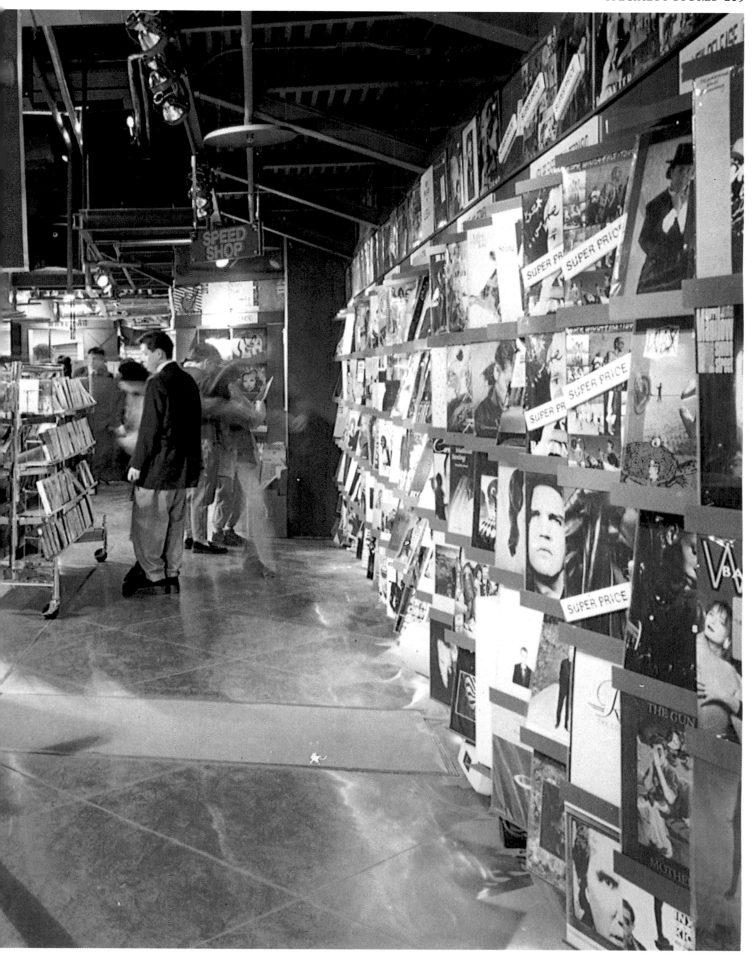

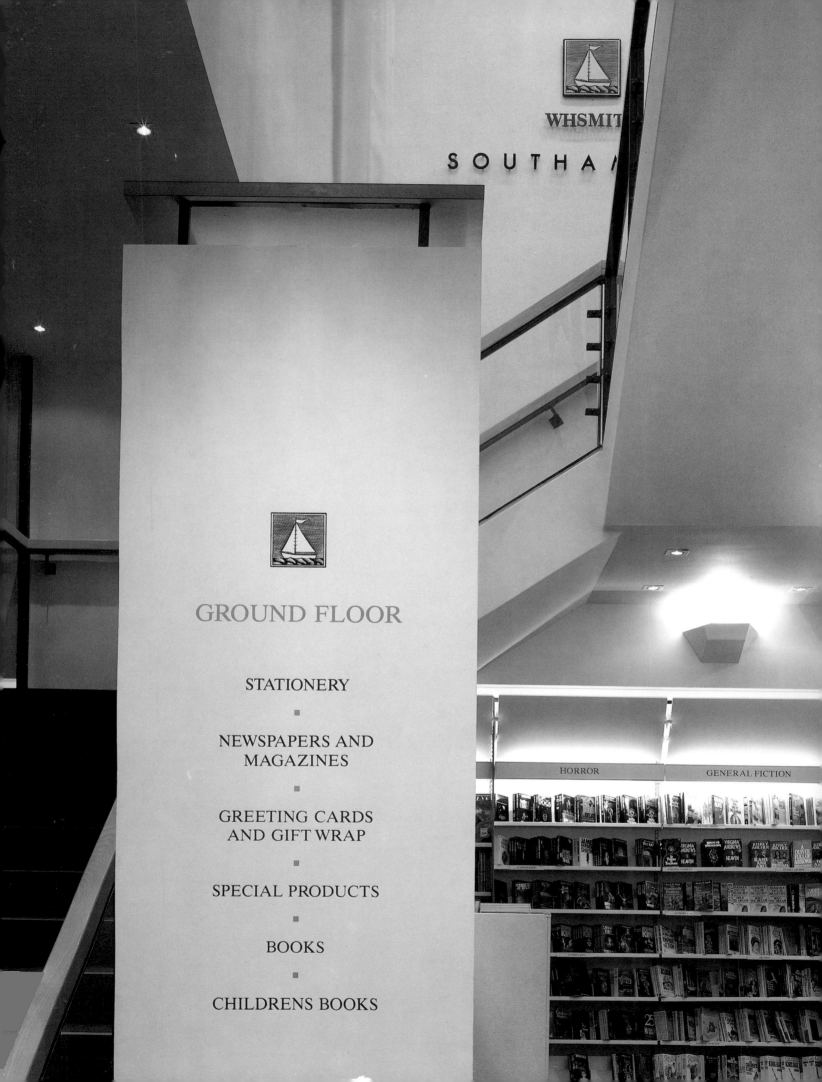

ehind vertical baffles fixed to the bookcase divisions.

Less problematic, but an intriguing area for designers, is the choice of materials and finishes within a bookstore. Many stores want to reflect the connotations of tradition and quality represented by books, with rich woods and librarylike colours, as does Rizzoli, New York (see page 62). But in some modern bookstores, particularly the large, supermarket-type chain stores, where books are considered a commodity, a more functional, less "elitist" use of materials is entirely apt: metal shelving units, and clean, light colours with a generally high overall level of brightness. The floor finish is also important: too much carpet will create an excessively solemn air, but hard floors (except in the popular section) will generate too much noise. A mixture will usually prove most successful.

Graphics play an important part in making the store intelligible and easy to use. Because of the proliferation of departments in a general bookstore, a good circulation plan and department guide are essential (Dillons, in London, is a highly successful example – see page 100). And signing and graphics can be particularly important in establishing the character of different departments within large general booksellers. The same can be said, to a lesser extent, of music stores.

In general, recorded music has an aura of modernity that makes a supermarket approach more appropriate than it would be for books. In some instances, however, aiming at a more "bookish" atmosphere may be the more intelligent design attitude, for example in the classical music section of a store. But most music stores require a display of the large range of music on offer, with clear guidance on layout. The design has to take into account one particular dilemma: the same musical recording may appear in several different formats – compact disc, cassette, and record – and the designer has to convey this without irritating duplication. Vinyl records should be in browsable bins, so that their covers can be easily seen. Compact discs are also presented by the cover, but being smaller, usually require racks or shelves rather than bins (see W H Smith, opposite). Tapes, likewise, should have cover presentation where space allows. For all three types, space and security demands often require that the publicly accessible items are dummy packages, with the actual disc, tape, or record collected at the counter. But designers must bear in mind that such a system requires a large behind-the-counter space for stock. Many of these design considerations also apply to the increasingly ubiquitous videostore.

In both book and music stores, designers should incorporate facilities for impulse purchases at the checkout counter.

Even general bookstores such as the British chain W H Smith (opposite) now have a tendency to create specialist departments, and to categorize purchases within them. In W H Smith's case, they were anxious to attract a new, younger shopper, without alienating their longstanding customers. Peter Leonard Associates opted for a light, bright image, with departments partially divided by decorated and colour-co-ordinated angled screens. Their graphics, with easy-to-read information and, in this case, a sailing-ship logo denoting Southampton's maritime connections, are particularly successful. At the same time, it is difficult, given the direction of the lighting into white angles and corners, to avoid "hot spots" and shadows. (Photo: Richard Bryant/ARCAID)

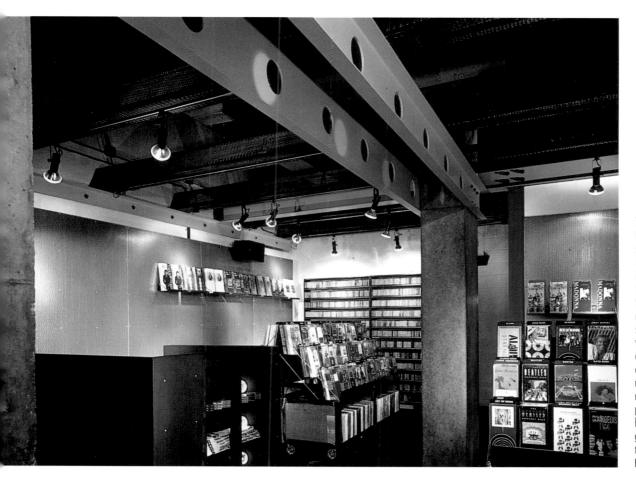

The fixtures and fittings at Digital Ticket, Chicago (left) – a store selling compact discs, records, and tapes – were designed by Robert Nevel. In this relatively small space (some 900 square feet/84 square metres), he has incorporated steel shelving which is very versatile: it can be placed anywhere. The display carts are on wheels, to allow for maximum visibility of the merchandise. The walls are of perforated stainless steel; the brightly coloured steel beams give visual unity and interest to the space. (Photo: © Jamie Padgett/Karant & Associates)

JEWELRY STORES

Lighting and presentation are everything in the design of jewelry stores. There are complex emotions to convey: preciousness, fashion, self-adornment, and the small size of much of the merchandise, with the difficulties of security, create particular problems. One principle is particularly important: jewelry stores must not intimidate. Both exterior and interior should look inviting to prospective customers. Rows of cabinets with assistants reluctant to reveal the precious items in their care is the old image of the jewelry store. The concern for security that created that pattern still exists to a certain extent, but today the design must be one that removes barriers between the merchandise and the customer. If the customer can feel that the jewelry on display is accessible – and not some forbidden object sequestered behind glass – the design will have done a large part of its work.

There are two separate kinds of jewelry that need to be treated differently: fashion and precious jewelry. Much jewelry today is fashion jewelry, which is neither exclusive nor expensive. Particularly for lower-cost fashion jewelry, the design should allow all the

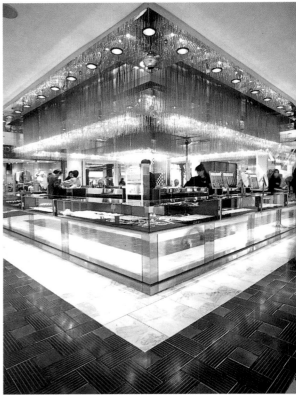

merchandise to be on open display, and the retailer must accept that this means a certain amount of "shrinkage." In Törq, London, for example, fixtures that allow bracelets to hang and necklaces to droop encourage customers to pick up the jewelry and examine it closely. The product must be touchable so that it can be tried against the customer's dress, throat, or ears. And the fittings themselves can have a fashionable approach. As in so many types of store, good adjacencies will lead the customer from one purchase to the next.

More precious jewelry does, of course, require greater security. But heavy, impenetrable glass cases are not necessary. The barriers that do exist must be largely invisible: modern glass cabinets can often seem wholly transparent. The difficulties occur inside the cabinet, where the retailer must be given the flexibility to change display, to alter the mix and size of jewelry. Lighting fixed inside the cabinet eliminates glare and reflections on the glass, and allows for highly controllable, pinpoint lighting. The aim is to create highlights to capitalize on the glitter and sizzle of jewelry. Modern low-voltage dichroic lights in particular provide clean, precise white light, and do not have many of the heat-generating problems of other forms of lighting.

In all jewelry stores, well-positioned flattering mirrors are essential. Particularly in precious jewelry stores, a private area for trying on jewelry may be a good idea.

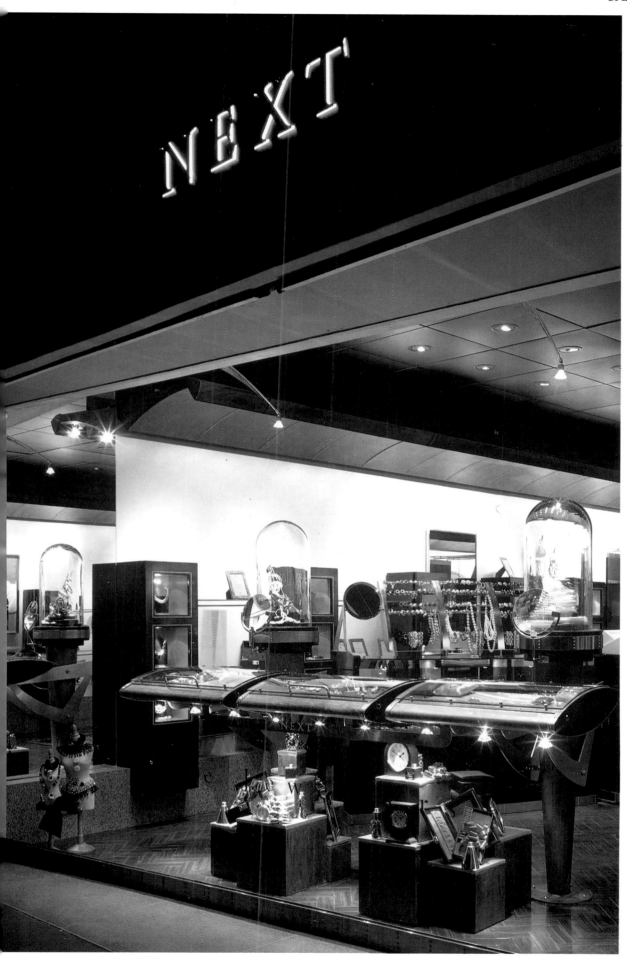

Next's jewelry department in London, designed by Din Associates, uses a combination of display under glass with starry lighting to suggest the fragility and desirability of the merchandise. The domed display pedestals, with their studded bases, themselves seem precious (the studding is repeated on the wooden display cases); the use of lights under the rims of units to highlight window displays is both effective and economical. (*Photo:* Din Associates)

An interesting specialty concept has been launched in the UK by Boots with its highly successful Childrens World stores (right). The design aims to make the experience of shopping there seem different, from the challenge and adventure of the children's entrance inwards.

Graphics are both clear and fun in this book section of the British Childrens World. A combination of the playful use of colour with hardwearing materials is ideal for a large children's store. Despite its size, the store is rendered homelike by being divided into areas whose details are undaunting and intimate.

TOY STORES

The ideal for a toy store is an Aladdin's cave of mystery and excitement, aimed both at children and parents, who usually do the buying. But this concept can be interpreted in many ways. The hugely successful Toys "Я" Us chain, in the United States and Britain, is essentially a warehouse of boxes, priced extremely competitively – an orderly Aladdin's cave, perhaps. More fun for designers, however, is the smaller toy store, or a more adventurous out-of-town retailer such as the British Childrens World. Here, "participatory retailing" takes over; activity and adventure become the touchstones of the design, with toy trains whizzing around the store, or lively games for children to play. One of the problems to overcome with toy stores is the exceedingly seasonal nature of the product. An overwhelming percentage of business will be transacted in the Christmas season, or in the school holidays, making flexibility of prime importance. What happens to the space when it is not filled with Christmas merchandise? The design must enable the retailer to increase the density of the store in the slack seasons with additional shelves, racking, and gondolas. By doing this, the space will be tightened, and made to appear more animated, while still allowing for sufficient circulation.

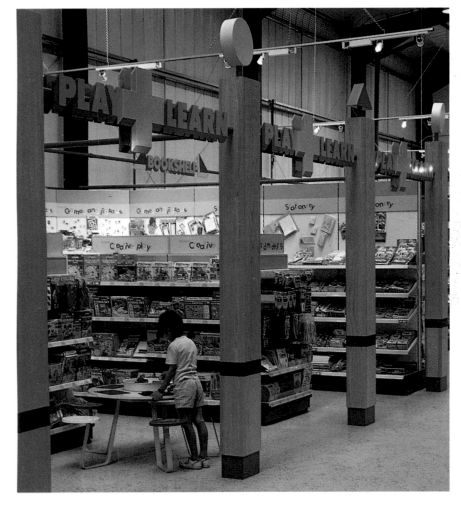

A general children's store such as Childrens World is conceived as a genuine one-stop store for the child. As such, the provision of ancillary services – including hairdressing, refreshments, public toilets, and baby changing rooms – becomes an integral part of the design. This approach, extended to less generalist children's stores, can help increase the length of the shopping trip, and will certainly allow for more enjoyment of the whole exercise, for parents and children alike. The ultimate aim is to strike a balance between the toy shop as one big playroom, pure paradise for children, and the organization of the store for its prime purpose of shifting product. It must appeal to both children and adults – in this way, it both breaks and proves the rule of specialty.

At FAO Schwartz in New York (above), the designers have created a memorable experience for any child. Mini-storefronts allow for great flexibility in both display styles and stock levels, which can vary greatly from season to season. The "road" not only creates the exciting sense of a journey of discovery, but also helps to delineate departments. Graphics designed as traffic "directions" can also help in this.

A general children's store such as the British Childrens World (below) should feature as many ancillary services as possible – hairdressing, eating facilities, restrooms, and so on – to make it a one-stop store for children and parents. Even in the hairdressing area, graphics and structural and decorative details create an enjoyable space.

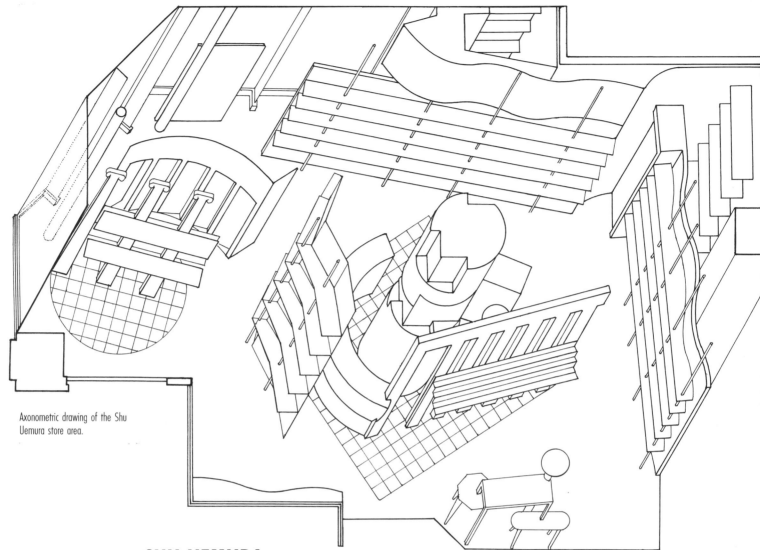

Axonometric drawing of the Shu Uemura store area.

SHU UEMURA
Tokyo, Japan

Shu Uemura is a cosmetics "store within a store" on the ground floor of the Tokyo department store Printemps (using the name under licence from the Paris store). Such concessions are a typical arrangement in Japanese stores, but the self-contained nature of the design, and its effective use of two windows to the street, allow it to function more as an independent unit. The impact of Shu Uemura comes from two main concepts in the design: the appeal of the small, intrinsically colourful merchandise, and a series of spatial devices to animate the small space and give the feeling of distinct areas within the store.

Designers Michihiko Okada and Takayuki Yanagida of JFTA had a fairly simple brief for the store which comprises 1,076 square feet (100 square meters). They were asked to renew the image of Shu Uemura, cope with the increasing quantity and types of cosmetic products, and provide for the growing demand for consultation on and

A cosmetics demonstration is conducted in privacy behind screens.

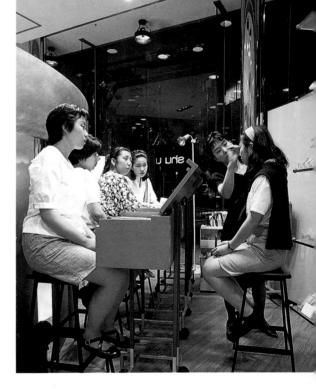

demonstration of the use of skincare cosmetics. The irregularly shaped space is organized into three areas. In the center, around a terracotta-coloured display tower, are a counter for perfumes and shelves displaying a variety of skincare products. To one side, three flattened "Ionic" columns support a table with samples and a makeup mirror. A curved wall behind the table screens a space where consultants can explain the products and show customers how to use them, in privacy. Most of the products are displayed on simple glass shelves along the two main walls of the store.

Within the tight confines of the space, the designers' skills are best displayed by the way the areas feel contained, almost private. But at the same time, the curves and angles of the fixturing encourages customers to move on to the next space. The articulation of the spaces is amplified by the change of floor surfaces: around the central display tower, the floor is white marble (1in/25mm thick), while wood-strip flooring is used elsewhere.

The visual appeal of the massed cosmetics products is allowed to do most of the work, in terms of merchandising and presentation, but simple generic signs are added on the white plasterboard walls behind the glass shelves: "For Lips," "For Eyes," paradoxically, all in English.

Lighting is provided by a mixture of high-intensity quartz (HIQ) and halogen downlights, with additional spotlighting from halogen lamps. But even in the fairly bright light levels, the cosmetic

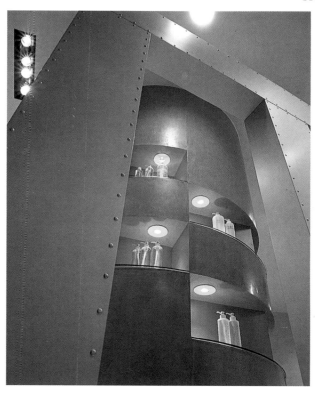

The terracotta tower is the key feature of the Shu Uemura concession.

displays stand out because of their setting: on the glass shelves, on banks of black shelves, or on the niches of the central display tower.

The success of this exemplary design for a "shop within a shop," lies in its precision and detailing, and shows that even small-scale projects can make a stylish contribution to the larger "host" store.

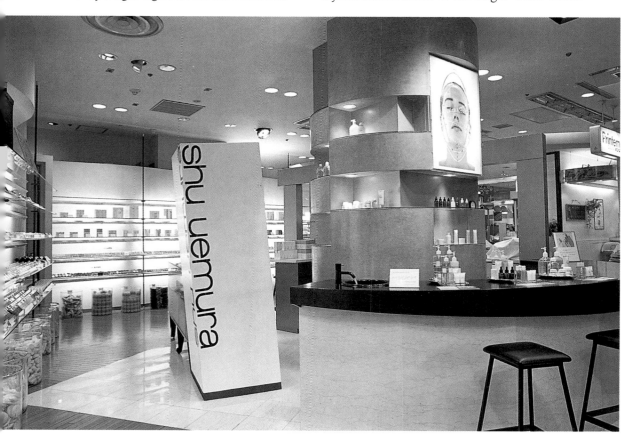

Attention is drawn to Shu Uemura by the central tower and service area and led around the store space by the gently curving lines of the plan.

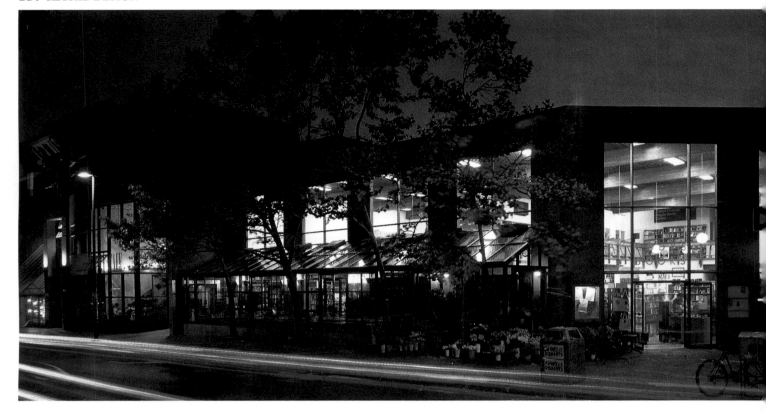

The mainly glass exterior of Cody's bookstore and café gives an inviting impression to passers-by.

CODY'S
Berkeley, California, USA

By any comparison Cody's is a large bookstore, and it describes itself as the most comprehensive bookstore in the western United States. Although it is large, Cody's has faced and resolved many of the problems confronting specialty retailers in any field, but particularly in books. Located on Telegraph Avenue in Berkeley, California, Cody's enjoys both a captive audience and a particularly demanding group of customers, with the University of California at the end of the street. There is also strong competition: Telegraph Avenue alone has a number of other bookstores.

Nevertheless, Cody's maintains its leading position in a number of ways. First, it is far larger than the other Berkeley bookstores: the sheer number of volumes it stocks gives it authority and the reputation as the store that is most likely to have the required titles. This stock position helps to create a "first port of call" attitude in its University customers. But however steady the trade in academic books may be, Cody's also stakes its claim to a substantial share of Berkeley's market for more popular books. Thus, the design of the store needs to accommodate a number of different audiences.

The main store is a double-height structure with large areas of glazing, which take advantage of the generally fine Berkeley weather to fill the store with light and dispel any "library" atmosphere. The entrance is at the sliced-off corner, with the fascia sign in simple capital lettering above the doors. Inside, the design is in the functional tradition. The large stock is held on standard banks of wooden shelves, arranged with generous aisles to allow for comfortable browsing and ease of restocking (a significant task in this store). The natural tone conveyed by the timber bookshelves is accentuated by the large wooden beams used in the ceiling and the wooden stairs and balustrade giving access to the upper level.

Popular books and magazines are concentrated near the entrance, while more academic and technical subjects are grouped upstairs or in the back sections of the store. Subject areas are announced by simple "rub down" letters on acrylic panels. The cash and service desk is also positioned near the entrance: a long counter with cash registers and ample space for the large quantities of books some customers accumulate. The area around the service desk is also the only carpeted space; linoleum tiles prevail elsewhere. Lighting is similarly utilitarian. Pendant globes (with tungsten discharge lamps) hang from the ceiling, but most of the artificial light is provided by ceiling-mounted fluorescent tubes. The flood of natural light from the large windows during the day provides most of the store's light, and combines with the natural timber interior to create an open, informal environment.

These elements alone would make Cody's a good bookstore, but perhaps nothing more than a useful destination. But the addition of a café on one side of the store in 1986 has transformed Cody's into something closer to a traditional, casual, friendly coffeehouse. The café is part of a three-story building designed by David Baker Architects, which contains offices on the upper floor. Part of the café is self-contained, with an internal entrance to the bookstore. The designers have also provided a glazed conservatory onto the sidewalk, which provides sheltered café seating, and, most important for the atmosphere within the bookstore, café tables intrude inside. This simple treatment both opens the bookstore to another street and provides that combination of indoor and outdoor interaction so appropriate to California.

As a result, customers can be lured from the café into the bookstore, or encouraged to sit, drinking coffee, while browsing through a purchase. Even for those bookstore customers who may ignore the food and drink of the café, the casual tone it creates, and the smells of fresh coffee, are conducive to longer spells in the store.

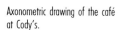

The divide between café and bookstore has been broken down in this section of Cody's – but customers are requested not to look at unpurchased books as they sit at their tables. (*Photos: Peter Cook*)

Axonometric drawing of the café at Cody's.

The light fittings give a sense of a strange combination of animal and mineral.

SILVER
London, UK

Silver defies the sterotypes of exclusive jewelry stores. The plush carpets and heavy traditional materials are replaced by hard surfaces and an aesthetic that might be described as "Industrial Gothic." Designers Branson/Coates have established a reputation for outré interiors with a series of projects in Tokyo, such as Caffé Bongo (which has an airplane wing projecting from the façade) and the Metropole restaurant (which has the feel of a garish mortuary). Silver sits on a corner site in an unprepossessing part of central London, a stone's throw from the Burlington Arcade, Bond Street, and the Royal Academy of Art. The more traditional mores of London city planners result in an exterior that only hints at the ideas jostling inside.

The original 1960s plate-glass windows could not be tampered with, because of the tenancy stipulation that the façade be consistent with the rest of the building, so the external identity is carried by the bronzed brass letters pinned to the fascia. A blue wing-like canopy juts out over the

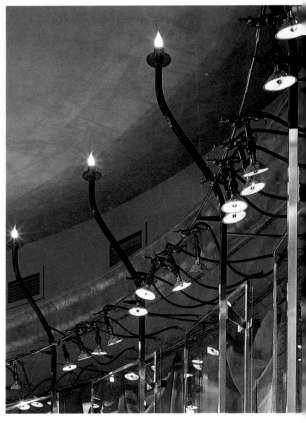

A concept sketch shows all the elements of the final plan.

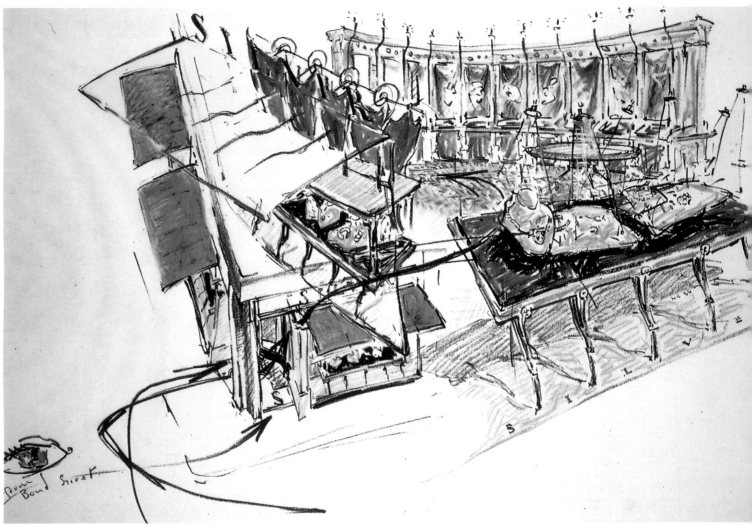

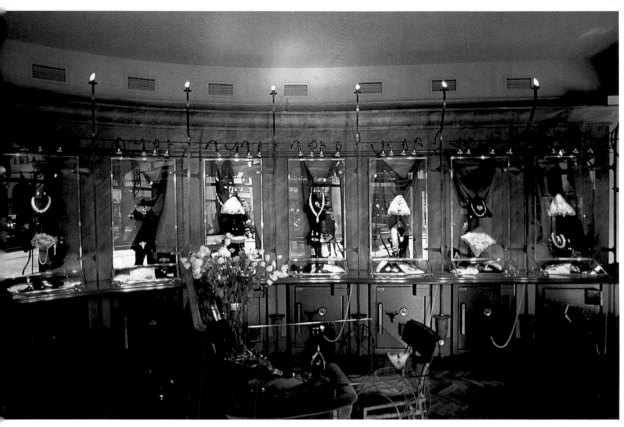

The aura of the store interior is one of drama and opulence.

window. A look inside, however, reveals something different. In place of the traditional, small artful display niche, Silver's windows are filled with large glass cases with a bronzed brass and steel structure resembling a natural history museum's specimen cases. Clusters of low-voltage lamps illuminate jewelry arranged on anthropomorphic assemblages of laboratory clamps and retort stands. Bright, electric-blue fabric acts as a backdrop.

The aesthetic, which Nigel Coates describes as "having the aura of a construction site," is extended inside. Indeed, the designed-in broken glass gives the impression less of an incomplete building and more of a recently attempted burglary. The spatial impact of the small store is heightened by a curved freestanding wall with the main row of display cases ranged along it. In addition to the low-voltage spotlights, candle-flame torch lights surmount curved brass and steel uprights, and a spindly chandelier by André Dubreuil is mounted in the center of the ceiling. Below the display cases, wall safes sit in seried ranks, mimicking the role of wood panelling in a more traditional setting. The safes, in fact, are mostly decorative: four are real, the rest are cupboards. The prominence of safes, both real and fake, is also practical – the insurers demand visible safes as a crime deterrent – and the burglars do not know which safe to rob!

The palette in the store is subdued, with the dark tones of bronze complemented by a grayish brown walnut floor and plaster gray walls. The blue fabric, and of course the jewelry, are what stand out. Branson Coates also designed the furniture for the store. The chairs have verdigris frames and gold feet.

Although the interior design creates a surreal, dramatic atmosphere, practicalities are not ignored. For example, most of the humdrum essentials are concealed by the plaster coving at the top of the curving wall, or the wood cornice that runs around the store. Ventilation ducts, security cameras, and infrared security beams hide above the cornice. Staff areas, and space for handling payments and other transactions, are behind a freestanding curved wall.

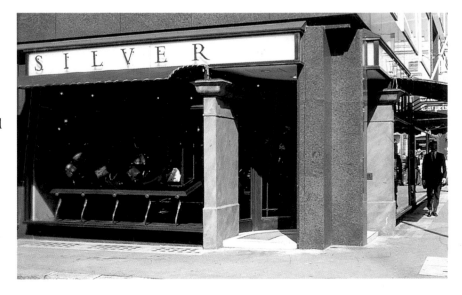

FOOD STORES

Finest
English Blue
Stilton
10 oz crock 9.99 **8.99**
5 oz crock 6.99 **5.99**

It could be argued that retailing, as such, started with food, in the street markets and stalls of ancient cities. Even today, the simple outdoor market contains some of the best lessons and precedents for a designer confronting food retailing. Above all, the design must communicate the quality, choice, and value of the food. There are certain factors that are common to the design of all food stores, from the small delicatessen or bakery to the largest supermarket. Some are practical, such as hygiene, but others are more emotive: food can be the most sensory shopping experience, involving sight, touch, taste, hearing, and, of course, smell. A good design will exploit these sensory opportunities where available. But practicalities cannot be ignored, especially in food retailing, where health is often an issue. Health requirements vary in different countries, and locally. Designers must make certain they follow stringently any relevant regulations. Health and food hygiene are paramount and a good design will be that which enables the retailer to maintain such standards without difficulty.

In food retailing the retailer's experience and knowledge of the product – how to keep fish, fruit, or meat fresh; how to avoid contamination of food – must be drawn on by the designer. With wet fish, for example, surfaces and materials must be easy to clean, must not retain smells, and should be able to remain cool, either through refrigeration or naturally. Marble is understandably traditional for fish counters, but new plastics allow for less monolithic structures, and facsimile marbles in tray form can be used on a refrigerated base. Sometimes the temperature control required for products is less obvious. Meat and cheese, for example, suffer if kept too cold: meat takes on a dark, hard, and untender look, while cheese begins to resemble plastic. Where refrigeration is required, number of design and engineering problems begin to arise, for most freezer cabinets or refrigerated units are large, chunky products, not easily handled by the designer. (Some recent designs, particularly those from Italy, are more elegant but costly.) Cabinets can often be custom-designed around standard motor and plumbing. Bolt-on facing panels can turn a refrigerator into a good semblance of a market cart, or freezer cabinet into a passable packing case. Because refrigerated cabinets need to be plumbed in, they become a prime planning consideration. Getting their position right is a matter of fundamental importance since they will often have a very prominent visual role and cannot always be easily repositioned.

Lighting, too, is important in a food store. In large stores some form of overall, ambient lighting will be necessary, for energy and cost reasons. But even in the largest stores, other lighting can be used. The Asda supermarkets in Britain (see page 232) take advantage of a particularly wide variety of lighting solutions. Again, different categories of food respond best to different lighting treatments. Filament lighting greatly enhances both meat and cheese. But at the same time, meat needs to be kept shadow free, otherwise it can look old. On the other hand, vegetables are often improved by having highlights and shadows. Lighting built into cabinets creates attendant heat buildup problems. Glass cabinets that are warm to the touch are unpleasant for shoppers, and may shorten a product's shelf life. Lighting built into shelves can warm up the product as it stands there – which is unhygienic and disconcerting for the shopper. Therefore designers should use these methods with care.

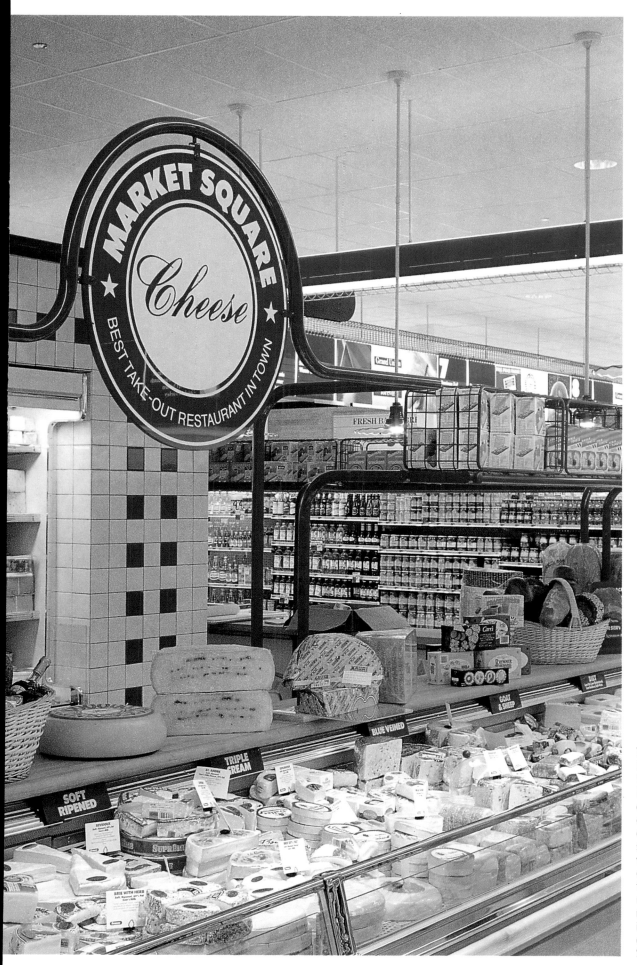

The cheese counter at the Grand Union "food market" in Paramus, New Jersey, designed by Milton Glaser, shows how even a standard refrigerated cabinet can be made to look attractive and different with some attention to materials (the wooden shelf for display), to clear and colourful graphics, and to lighting (carefully controlled not to overheat the merchandise), which is integrated into the total store design. (*Photo:* Milton Glaser Studio)

Planning and layout apart, the emotive, sensory considerations of food retailing pertain far more obviously to the designer's task. Each of the senses can be considered in turn – starting with sight. In the traditional outdoor food market, every stall-holder understands the importance of the look of the food: elaborate structures of fruit or an artful fan of fish are common sights (see the Pike Place Market, Seattle, page 99). The way fresh food is presented will affect the customer's impression of the whole store, so food retailers need to be given the opportunity to be creative. Cheese, for instance, can look very enticing on wood or even raffia, or as part of a completed display with salad and fruit. Fresh fish looks its best when wet; this can be achieved with crushed ice, or by spraying with a fine mist of water or dry ice. Merchandising fixtures for the product itself, whether for fruit, wine bottles, or even a freezer cabinet with tubs of ice cream, must allow for flexibility and inventiveness of display. Graphics can play a part here too: the instant "just-arrived" quality that market traders achieve with handwritten prices and bold signs are hard to beat (see Zabar's, New York, page 93, and the Pike Place Market, Seattle, page 99). The fresh fish and vegetable counters of the Seibu food basement in Tokyo also show very effectively this approach how food looks (see page 101).

With many kinds of food, where hygiene law permit, touch is an important part of the shopping experience, and the designer must take care not segregate the product from the customer. Taste, to can be catered to with areas for special offers, or, wine stores, a small bar for sampling. Hearing is more elusive sense to address, but for some shopper the noisy grinding of coffee beans, for example, is testimony to the quality and freshness of the produce Again, the Seibu food basement provides a goo example, where chefs vigorously chop food on hare wood blocks, creating a compelling sound. Appealing to the sense of smell applies to food retailers almos to the exclusion of all others (except the perfumers Not all designers go the extremes of Grondona Arch tects in Claudia's Bakery, Horton Plaza, San Dieg however. There, a "smell funnel" protrudes from th storefront to waft the smell of fresh baking out to th street. Bakers and delicatessens are often offere prime locations at favourable rents in shopping cen ters, in order to create the sensory experience of sme and to offer mouthwatering displays that can impar more "human" qualities to the center as a whole.

Dinah Casson and Roger Mann were the designer of Gran Gelato, a small store in London selling only ice creams. Despite the choice of synthetic, not natural, materials – evident in the details of the plastic graphics on the refrigerated cabinet and the colourful plastic spoons on their shaped container – a sense of the freshness of the produce is still conveyed, in this case by the use of handwritten labels.

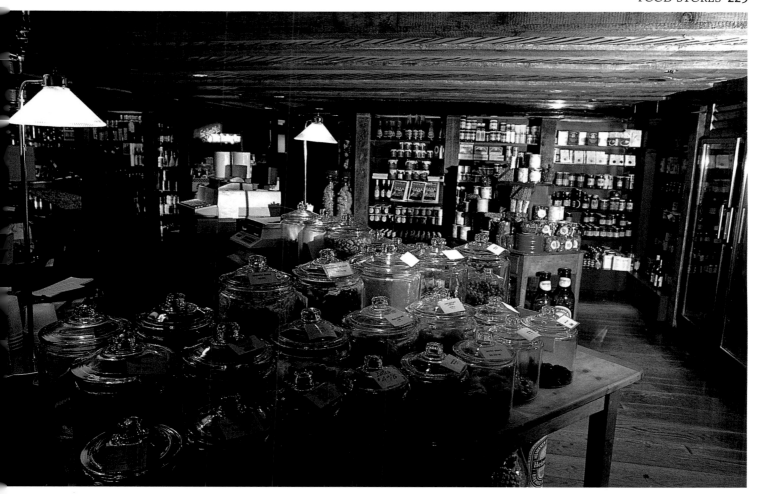

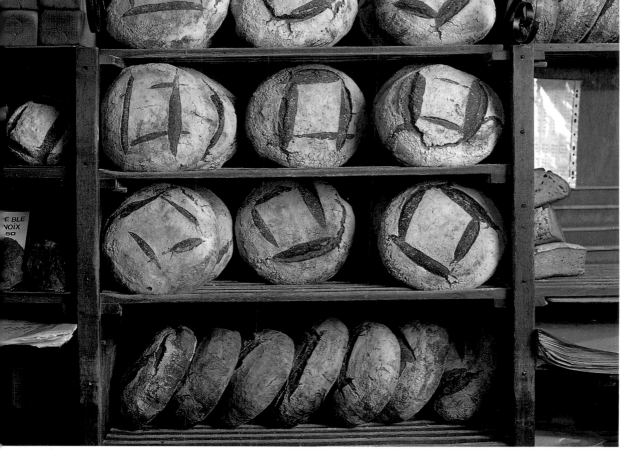

In Bloomingdale's food basement (above), in New York, a sense of ordered profusion reigns. Rough planking has been used for ceilings, floors, and the dresserlike display shelves on which merchandise is crammed. Jars and tins are stacked on homey pine tables. Materials successfully suggest the freshness of the home-bottled and home-made.

Shown left, the simplest of natural materials – in this case, a grid of rough wooden shelves – can often display foods to best advantage. At Poilâne in the rue du Cherche-Midi, Paris, the "design" just happened: Lionel Poilâne and his father installed the shelves some twenty-five years ago. (*Photo:* J. C. Martel)

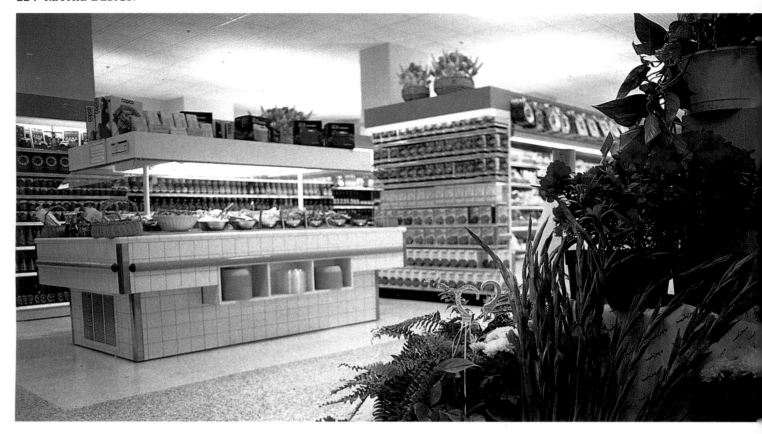

The refrigerated gondolas in America's A & P stores (above) have something of the look of market carts. With inbuilt, regulated lighting, they are carefully designed to maximize possibilities for storage and display. Given the lowness of the ceiling, the decision has been made to concentrate on the successful lighting of the product, not on overall lighting of the store – and it works.

SUPERMARKETS

Many aspects of design for food retailing depend on the scale and nature of the store. Large supermarkets face very different constraints from small delicatessens or specialist wine stores. The evolution of the supermarket has been a story of ever-increasing size. Both in and out of town, supermarket retailing has grown steadily over the decade, reflecting the change in food purchase and consumption. Customers no longer have time (or inclination) to shop daily. Supermarkets and now superstores can be from 20,000 to 180,000 square feet (1858–16,722 square meters) with a bewildering range and variety of products. But size poses particular problems for designers, especially in helping customers achieve a clear understanding of layout and circulation inside the supermarket. Although some food retailers are trying to create more interesting buildings, it is rare for the building housing a supermarket to be anything other than basic, because of the cost constraints. But particularly on out-of-town or the common edge-of-town sites, the building needs to function as a sign, an attraction to be seen from the road. Like out-of-town shopping centers, the supermarket requires a large parking lot, and the building needs to stand out from the surrounding mass of cars. One common solution is to use large-scale graphics to announce the store's presence (see page 232). Large graphic jokes and architectural tricks also attract attention.

Since the customer's first experience of supermarket shopping is often the drive from home to the store, the designer needs to consider the importance of good traffic management: clear street signs and logical off-highway access are vital. From the parking lot, the entrance should be obvious. In the standard shedlike buildings of most supermarkets, a sign may be the only way to indicate the entrance, but, occasionally, the addition of some architectural entrance feature may be possible, for example, delineating the entrance with covered ways which act both as a focal point and protect from rain and sun. Whatever the solution, external signs should be thought of as part of the building design, and not added as an afterthought. A noticeable entrance can be of particular importance when it is not in the most logical position in terms of planning. This may be forced by the difficulties of the site, the development architect, or adjacent buildings. Since any food retailer wants to impress the customer of the tidiness and hygiene of the operation from the very start, ways to eliminate exterior clutter should be considered: a well-placed wall to conceal the phalanx of shopping carts shows concern for detail. External signs should be kept to a minimum, grouped together and bold, when used. Whenever possible, shopping carts should be kept under cover – there is little worse than to start the shopping trip with wet carts.

Inside, given the scale of most modern supermarkets, the overall plan needs to be clearly comprehensible so as to enable shoppers to "read" the

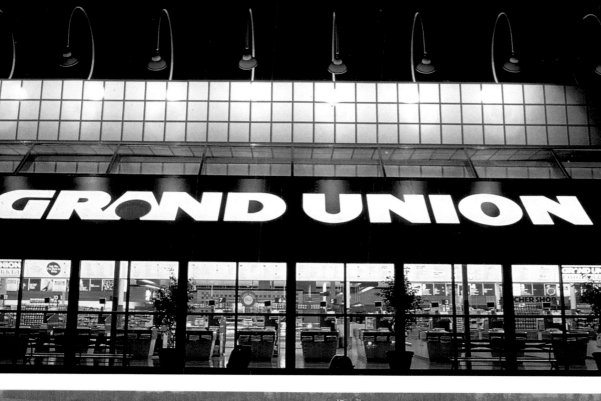

Milton Glaser's design for the façade of Grand Union (left), at Paramus, New Jersey is equally eye-catching at night. The entire frontage, once illuminated, acts as a sign; the awning recalls old-time markets. The façade concept can be applied to new or existing buildings. Sightlines from the entrance enable shoppers to orientate themselves quickly inside the store. (*Photo: Milton Glaser Studio*)

The British supermarket chain, Sainsbury's (below), signals its edge-of-town Derby store with a light, bright façade, yellow graphics and a decorative covered walkway – an attractive feature in good weather, also a practical one in bad. The building stands out successfully from the spacious parking lot which surrounds it.

Sainsbury's in Bath has been built to utilize the features of a former railway station. Approaching the supermarket from one direction via the station platform and old buildings transforms the shopper's visit into something out of the ordinary. The store itself is designed in a totally modern idiom, with ample parking and a practical covered walkway.

store at a glance. Designers are, however, helped in this task by the fact that the majority of shopping visits are repeat trips. Customers quickly become familiar with layouts. As a result, there is a danger in making the largest stores too flexible: shoppers become confused, disoriented, and irritated when the layout changes.

Particularly in large food stores, the space just inside the entrance may have many features competing for attention: special promotions or displays, perhaps an avenue of specialist stores, a service counter, a plethora of information, shopping carts, kiosks, and so on. Yet the shopper makes critical decisions at this point – whether to go into nonfoods or groceries, or whether to strike out on a general reconnaissance. Good sight lines from the entrance will enable the customer to see the scale of the operation, the likely extent of the range, the positioning of products. The main circulation channel should be clearly designated – both by making it the widest and by using easy-to-read graphics. Emotive photographs and simply stated pricing policies can be effective and give a sense of directness and value. Whatever graphic approach is chosen, the snowstorm effect of endless hanging signs should be avoided. The attitude behind this policy – if something does not sell, or needs to sell more, or has just arrived, or whatever, it needs a sign – is simply misguided. All too often, the messages of these confusing signs, such as "Easter savings," are

quite meaningless and serve no purpose other than t conceal some of the stores positive virtues.

Supermarkets often suffer from "canyons" of prod uct. How high the product is stacked may be depend ent on the retailer's "range to square footage equation For some, this technique may be an effective way c demonstrating density and value – which can be useful selling tool. But it can also be self-defeatin when overused. Generally, the higher the products g the wider the aisle should be. But the wider the aisl the less the shopper can see of the two sides at once and trying to shop laterally will lead to confusion an circulation difficulties. Field of vision along the aisl also needs to be considered: if all that shoppers ca see is dogfood or cereal, they will assume it goes o forever. As a rule of thumb, the broad product cate gory should change at least every five meters (sixtee feet) to keep people moving forward.

Key vistas and focal points – food promotions c special service counters – emphasize circulatio routes. These can be either permanent features, fc example a delicatessen counter, or temporary fixture: such as in-store special promotions, which are pa ticularly common in the United States (see Zabar' coffee section, New York, page 93). Clearly, perma nent features require a different treatment from trar sitory ones. Elaborate signing, or perhaps a: "architectural" solution, can create some variatio within the generally uniform shell of a store. Witl

The grahics are an important feature of Milton Glaser's designs for the American Grand Union stores. By clearly defining areas of merchandise and structurally integrating signs within them, he avoids the "snowstorm" effect of numerous hanging signs – often hung at irritatingly different levels – along aisles and walkways. Little graphic touches elsewhere – a "Now Baking" sign behind the bread counter that lights up when baking is in progress, for example – add interest to the shopping experience. (*Photo:* Milton Glaser Studio)

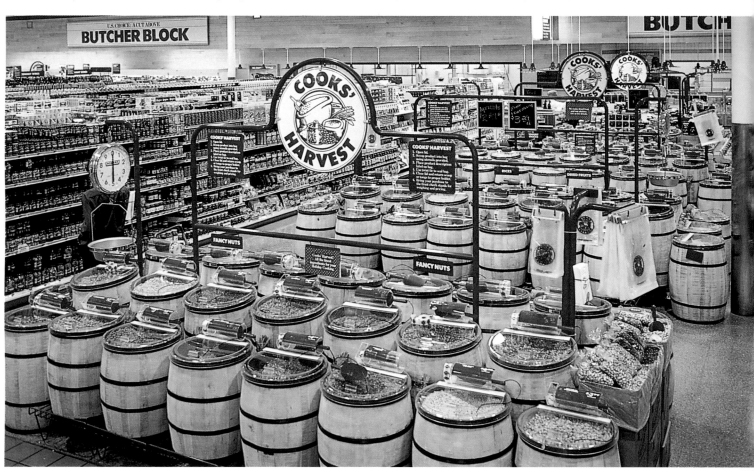

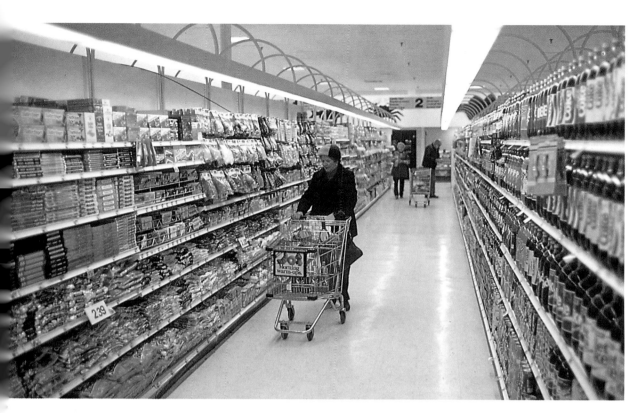

The aisles in the A & P Food Emporium, here, show the importance of planning logical adjacencies for the convenience of the shopper in ever-larger stores. The aisles are generous with space for good circulation and the lighting serves both as a source of softer, lower-level ambient lighting as well as direct lighting of the merchandise.

emporary fixtures, designers can hark back to the mobile stalls of street markets, updated where appropriate, as in the British Asda stores (see page 232). However the circulation routes are treated, they should be designed to encourage the "shopping journey" that the retailer wants the customers to make. Aisles and fixtures should be located and dimensioned in order to move the customer past the departments and promotions at the required speed and in a logical progression. The difficulty for the designer (and one not to be ignored) is that the needs of "renegade" shoppers should also be considered. Some shoppers may want to retrace their steps or take a different route, and they should not feel forced to follow one path. One further crucial point: sufficient space must be allowed behind the checkouts for lines. If this area doubles as a circulation route, at busy times the entire store's circulation may well seize up.

Circulation and planning are key issues in a supermarket, reinforcing the "selling point" of convenience. The achievement of logical adjacencies depends on common sense – the typical customer's journey through the supermarket has to be mapped out and made as convenient as possible. Crushable items should not be put first, as they will be ruined in the bottom of the shopping cart. The three major product groups – fresh food, groceries, and nonfood items – should be well defined and in a coherent sequence.

SMALLER STORES

The delicatessen or small gourmet food store presents a different design issue. In a way, it can be viewed as an enclosed and stylized market stall, where emotion is everything: noise, sight, and, above all, the sense of smell are of greatest importance. In a smaller context, the product becomes even more significant, through the effective display of range and quality. Scale and the relationship of one item to another are crucial: nothing should dominate, all aspects should be complementary. Service facilities are a major consideration in the small store. As quality of service is often part of the attraction, counters may be necessary for chopping, wrapping, and packing. Since, in order to avoid overstaffing, staff may need to perform a number of functions, these facilities must be versatile. In New York's earlier Dean & Deluca store, for example, the central service island allowed the assistant to move across from one side to the other (see page 234). Some designs make the mistake of having a wide service unit that the assistant has to walk around, nudging customers out of the way. Shoppers will appreciate shelves at the counters, on which to place bags and baskets – this is not only convenient, it will also keep bags off the products. Field of vision and adjacencies are also important in a small store. From any one point, the store should be so designed that product presentation is logical. Within the field of vision, one product should be complemented by the next, which leads on to the next, and so on. Thus one purchase may turn into several.

In the British wine merchant's store, Harvey's of Bristol, wooden shelving systems (shown right) – completely adjustable for different levels of stock and types of display – are redolent of the same traditional feel as a gentleman's outfitters. However, inbuilt lighting levels are high, to allow labels to be read easily; the effect is warm and bright, not somber.

FitchRS's ideas for Esprit du Vin in London (opposite) contradict many expectations of liquor store design – this looks neither like a traditional wine merchant's nor like a brash mass-market retailer. Metalwork artist Tom Dixon was commissioned to undertake such details as the ornamental finials on twisted reinforcing rods that serve as the shelving structure; while rough plaster wall surfaces, floorboards, and bare lightbulbs create a cellarlike feel. Although low-voltage lights make eerie shadows on the plaster walls, labels and graphics remain readable. The effect is quite uncluttered, although a mixture of end-on, upright, and 45-degree display actually allows some three to four hundred wines to be housed in the store. (*Photo:* Peter Cook)

LIQUOR AND WINE STORES

Stores specializing in drink – the United States liquor store, the British off-licence, or the specialist wine store – are in some ways easier to design than other food stores. Generally the demands of hygiene are not relevant, since the products are in bottled, canned, or packaged form. But nevertheless the designer should not ignore the emotive areas that are central to the success of any food retailer. The specialist wine store is probably the simpler design task, because of the relative uniformity of bottle size and the appeal of the bottles themselves. In some ways a wine store is more like a bookstore than a food retailer in terms of the design problems it poses: glaring or shadow-casting light, for example, will tend to reduce the customer's ability to read the labels, and back-lighting that throws standing bottles into relief is a disaster – so, too, with display. The wine store will have a mix of upright display, for featured bottles, or, where room permits, one of each type, and horizontal storage. Wine bottles are normally laid horizontally to keep the cork moist. If the bottles are lying down, the neck of the bottle must be visible as it may have vital vintage information on it. The shelf may also need additional lighting, although care must be taken to avoid heat buildup, as wine should be stored in a cool atmosphere.

Since the look of the product is likely to vary little from retailer to retailer, materials and ambience become more important. Some wine stores will opt for the warehouse look, which implies bulk purchase and good value for money and a functional "no-nonsense" approach; the warehouse feel is created by higher ceilings, white painted walls, fluorescent lighting, and cases piled high. Other stores try to promote the *cave* feeling, with curved ceilings, painted or natural brick walls, slab shelving, and distinctly low temperature. Whereas the warehouse store might have a concrete, linoleum, or other monolithic floor finish, the *cave* will use quarry-type tiles or flagstones. In both cases, finishes can be left rough, detailing can be quite legitimately crude, and lighting can be kept simple. In a store such as Esprit du Vin, London, a more sophisticated but nonetheless natural ambience is created with scrubbed wooden floors and counter facings, juxtaposed with more sophisticated metal wine-racking and architectural detail. Lighting is more selective, low-voltage, indirect, and obscured. Harvey's in London and Bristol illustrates yet another type of store – the wine store outlet of a major shipper as opposed to that of an independent retailer. The image here is of solid quality, reinforcing the 200-year reputation of the firm, with simple, functional, yet high-class display and storage shelving. In any wine store, a degree of flexibility with the shelving system may be required to expand or contract generic stock,

either for special promotions or to cope with seasonal demand. In a *cave* or warehouse, however, a sense of permanence is more important than flexibility.

Graphic information plays an important part in the design of many wine stores, particularly where the retailer wants to convey expertise in the field and to reduce the intimidatory air. The designer should follow the example of the best museum displays: concise descriptions, located conveniently near the product and plainly legible. Some retailers will want to provide more information, perhaps on regions or viticulture.

On the whole, liquor stores present the same considerations as wine stores, but with a few basic differences. Liquor sales are all about brand, price, and promotion – and do not have the same information needs as wine stores. Bottles come in many differing sizes and shapes; they will need to be displayed upright, with labels clearly shown. Cheaper beverages and those in cans should be within easy reach – more expensive bottles or spirits will probably need more restricted access and counter service, together with nearby storage facilities: most retailers will prefer extra stocks of expensive liquor to be stored separately. Some space will also need to be devoted to a refrigerated cabinet for chilled beverages. The design will probably also need to cater to impulse-buying of cigarettes, snacks and the like. Shipping boxes and cut cases often seem to have a naturalness about them as a means of presenting "bulk" product and wine by the case.

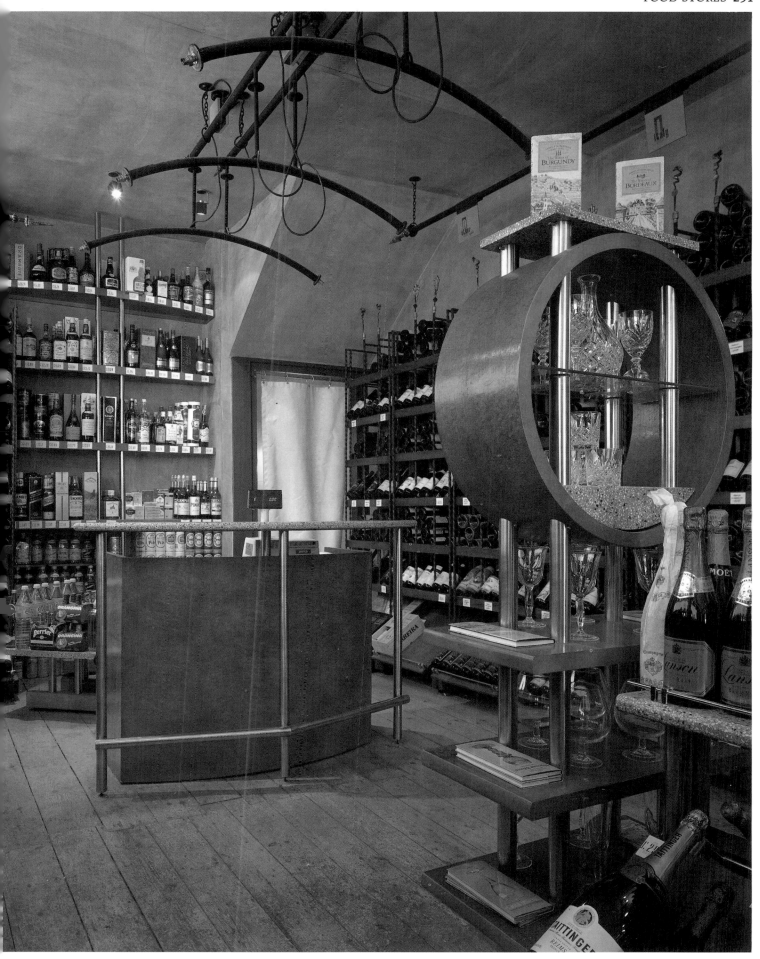

ASDA
Watford, UK

In Britain, national grocery retailing has in recent years come to be dominated by five major groups. Two chains, Sainsbury's and Tesco, are in number one and two positions. When Asda, a feisty number three with a traditionally strong market base in the north of the UK, wanted to push into new territory – the prosperous south-east and London suburban area – design was highlighted as a key part of the strategy. Supermarkets are not generally known for the quality of their design, having historically placed more emphasis on cleanliness, choice, and efficiency. Since Asda was already strong on these traditional qualities, design was able to further enhance its points of difference from the competition.

The size of an average Asda Superstore (approximately 60,000 square feet; 5,574 square meters) enables the Group to operate a one-stop shopping business with significant nonfood sections for fashion, home appliances, and electrical goods. These nonfood departments are well designed to the standards of a specialty store; this is complemented in the food sections by an emphasis on quality and freshness.

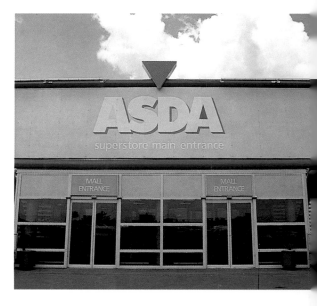

With designers FitchRS, Asda's new identity is announced by a green logo, highlighted in yellow, pink, and blue. Inside, the accent is on good departmental planning and logical adjacencies in the layout. There are three distinct zones; nonfoods are in a carpeted section, with a suspended "egg-crate" ceiling and lighting from low-voltage spotlights; the groceries, clustered on the center of the layout, are under a higher ceiling with bright clear lighting, wide aisles, and a double-deck system of signs; the fresh food section has mock store canopies and "market-stall" gondolas, to add a light, entertaining touch to this style of supermarket shopping. In this area the egg-crate ceiling is not as high and is a darker colour; the lighting is primarily tungsten and the temperature is lower.

One of the most interesting features of the design are the aerofoils mounted above the "market" gondolas. These are angled to break up the visual monotony of a large supermarket space, but they do not disrupt the sightlines. In addition, the aerofoils are used as a lighting device, with fluorescent uplighting reflected off the surface, and strings of low-voltage spotlights mounted in the aerofoil underside providing highlights on the fruits and vegetables.

Good, clear graphics play a major part in the design, to make the zoning clear and the adjacencies and promotions positive. Illustrations provide departmental ideograms to help shoppers orient themselves in the supermarket. A further orientation point is provided by promotional towers at the end of the main merchandising gondolas. Asda's design approach is also applied consistently, although flexibly, to its several thousand "own brand" product lines, once again reinforcing the point that good value and good design can go hand in hand and that this virtue can be expressed through brand imagery.

Asda store plan

A Service areas: loading, storage and staff facilities
B Fresh foods
C Groceries
D Nonfoods: leisure, fashion, home and seasonal
E Checkouts
F Glazed pyramid
G Mall areas
H Shopper's restaurant
I Retail areas leased to concessions

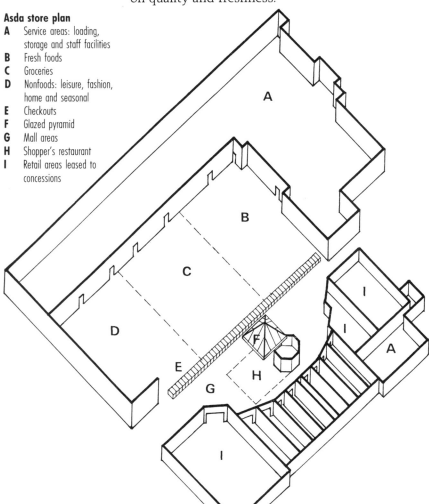

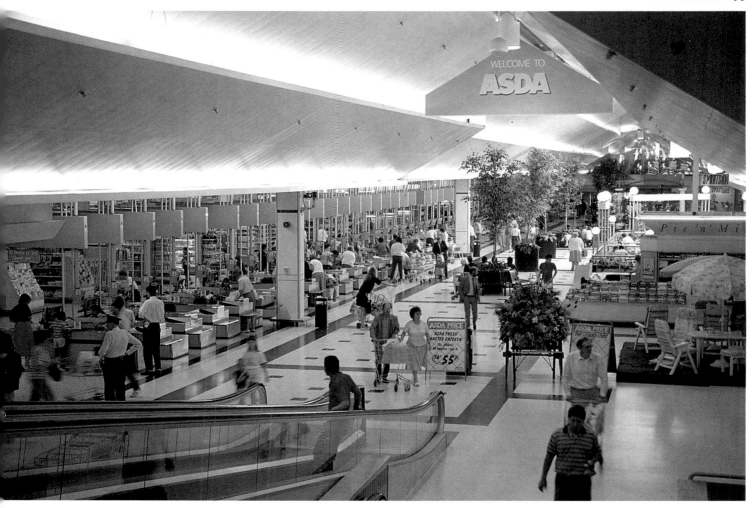

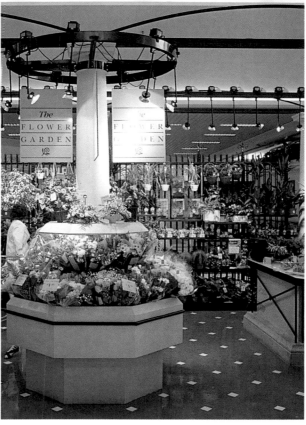

A view of the mall area, with the row of checkouts on the left.

The haircare section is marked with direct, clear graphics.

The flower shop is differentiated by strikingly coloured flooring, featuring a profusion of flowers in a central display. (*Photos:* FitchRS)

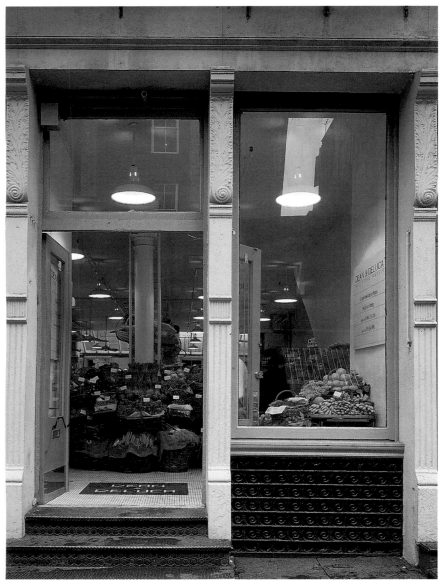

An abundant display of fresh and colourful vegetables is a feature for which Dean & Deluca is renowned, enticing customers inside.

The kitchenware section is reminiscent of a traditional ironmonger with a profusion of implements stacked and hanging.

DEAN & DELUCA
New York City, USA

If the ideal of a food store is a vibrant, vivid street market, then the Dean & Deluca store at 121 Prince Street, in the Soho section of Manhattan, New York, was an embodiment of that vision. Now located at 560 Broadway in Soho, Dean & Deluca has always been more than a food store: it offers a range of the finest items for the kitchen, including fruits and vegetables, cheeses, delicatessen food, cookware, cutlery, packaged goods, fish, and meat.

The former Dean & Deluca store, described here, will always be remembered as a classic example of a good design naturally emerging in practice rather than having been entirely planned. From the outside, the riches within are only hinted at. A tiled logo is laid into the floor at the entrance, and a glimpse of a Dean & Deluca wall-mounted sign can be seen through the tall windows. The primary appeal, however, comes from the enticing displays of fresh fruits and vegetables grouped at the entrance.

Presentation is everything at Dean & Deluca: products appeal not only as themselves but because of their visible quality and profusion. Fruits and vegetables are displayed in large wicker or stick baskets, or in the original colourful, foreign shipping crates. As in a street market, names and prices are handlettered onto simple white cards stuck on pegs, a visible reminder that everything is fresh from the wholesale market. And while the produce is the most enticing display, the same principles of quality and presentation apply throughout the store. Variety and choice are also important: cheeses, for example, are stacked in a large chilled cabinet in artful profusion; bowls of all shapes, sizes, and materials are arranged on a series of shelves; teas and coffees have their own expanse.

Shelving throughout is provided by chrome Metro units, a standard system originally created for industrial catering uses. Metro has become synonymous with "high-tech" fittings, but at Dean & Deluca its straightforward, functional virtues are foremost. The system allows the products to remain dominant, an effect reinforced by the absolutely white environment of the store: brick walls, cast-iron columns, ceiling, fans, light fittings, and tiled floor are all white.

The planning of Dean & Deluca is basic, but nonetheless effective. Foods are in the center, packaged goods along the walls, and kitchenware at the back. The advantages of this arrangement are that the food – some of which needed refrigerated display cases – form in effect a central island,

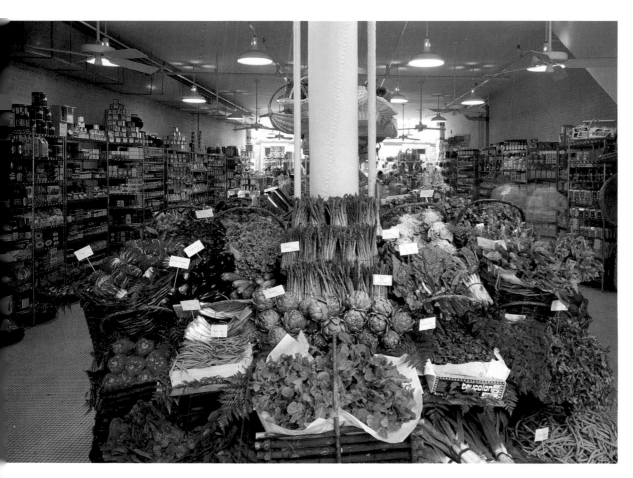

lowing staff to serve customers on either side. This low central island allows the packaged goods to be stacked fairly high along the walls, without interrupting sightlines. And the kitchenware, too can be arranged more densely and to greater height without causing circulation or sightline problems. A rooflight, running the full width of the store, at the back admits a flood of natural light, which creates a conservatory effect, attracting customers towards the kitchenware department.

The new store is in Soho, at the corner of Prince Street and Broadway, just two blocks from the old location. It is about five times the size of the old store, but uses many of the same design elements.

The interior riches are no longer "hinted at"; huge glass windows allow passersby a good look in. However, the displays of fresh fruits and vegetables that were formerly grouped at the entrance are now just inside, so they provide a similar feel. They are still in large wicker or stick baskets, but original shipping crates are no longer used. As in the old store, the handlettered white cards with names and prices are stuck on pegs and placed among the produce.

Cheese is still stacked in a large chilled cabinet, bowls and other kitchenware are displayed in the back, and teas and coffees in a separate section. As before, chrome Metro units are used, and the interior of the store is again white, although the brick walls are now either painted or tile, and the

tiled floor is now marble.

The layout of the store is somewhat different. Cheeses, delicatessen, and other foods requiring refrigeration are in chilled cabinets along the sides of the store, with staff working behind them (there is also a section where fish is displayed on crushed ice, with live lobsters and Dungeness crabs in an aquarium below the counter). There are several serving islands in the center, which allow staff to serve customers on all sides: one for breads; another for cutlery and silver; another for candy, dried fruit, coffee, and nuts; and an additional general checkout near the produce in the front, with soft drinks positioned around it.

Packaged goods are now in the center of the store, stacked fairly high on Metro units that surround columns. While there is no longer a clear sightline to the kitchenware in the back, the store now effectively has two aisles, with the serving islands alternating with the packaged goods.

While the rooflight is no more, there are still white columns, fans, and light fittings.

This new location, to which Dean & Deluca moved in 1988, uses many of the successful marketing approaches that were used in the old store. It is interesting to see how the original good design that emerged naturally, has been successfully incorporated into a larger setting. The store has kept its unique look, while expanding enormously, proving the flexibility of the original "design".

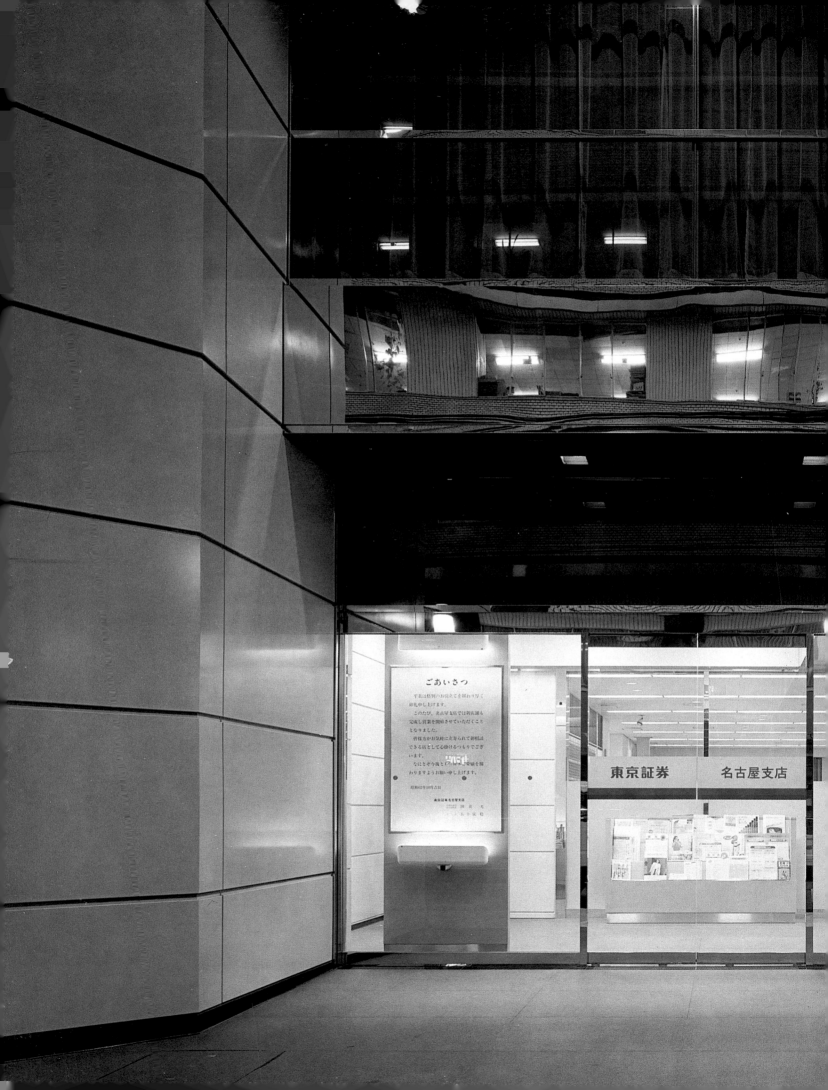

ごあいさつ

　平素は格別のお引立てを賜わり厚く
御礼申し上げます。
　このたび、名古屋支店では新店舗も
完成し営業を開始させていただくこと
となりました。
　皆様方がお気軽に立寄られて御相談
できる店として心掛けるつもりでござ
います。
　なにとぞ今後とも倍旧の御愛顧を賜
わりますようお願い申し上げます。

昭和62年10月吉日

東京証券　名古屋支店
支店長　田　吉　光
次長　八十嵐　稔

東京証券　　　　　名古屋支店

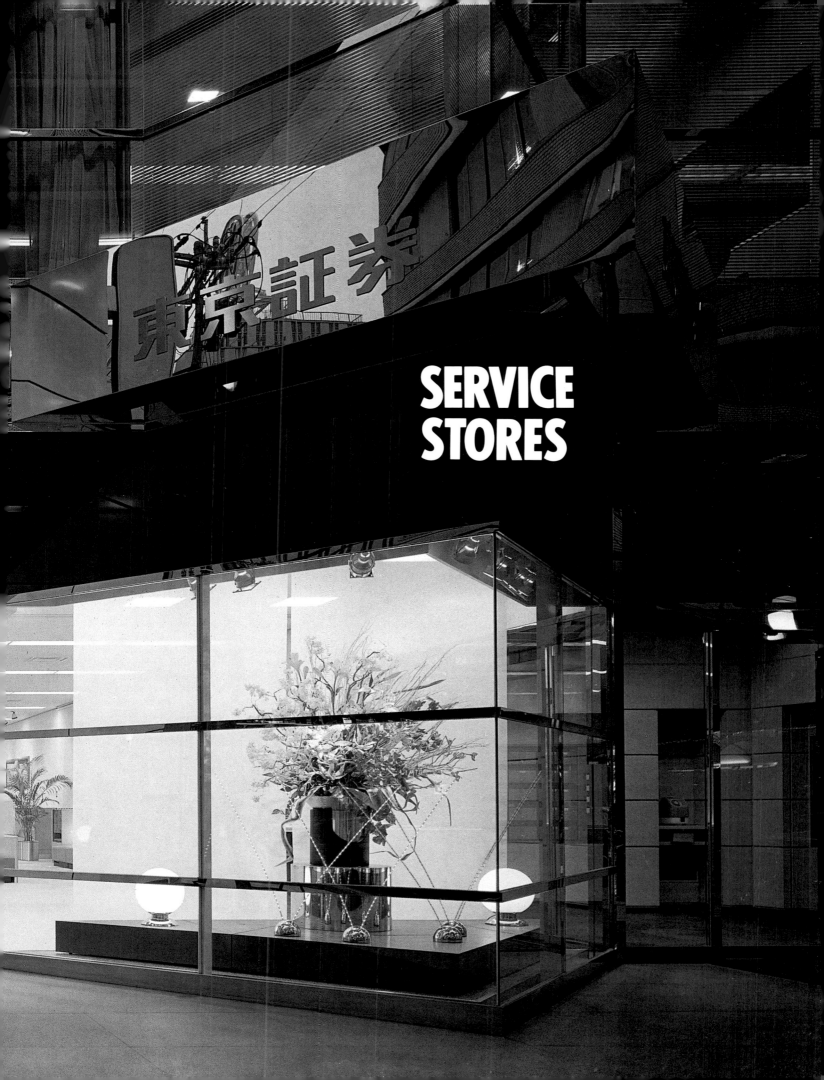

SERVICE STORES

The retailing of services is, for both the retailer and the designer, a burgeoning field – among the fastest growing of all retailing activities. New information technology, the widening of financial services, and widespread deregulation have all contributed to this expansion. While selling services over the counter has, of course, been taking place for many years, it is only recently that it has come to be considered as retailing. Service retailers include banks, building societies, travel agents, real estate agents, bookmakers, post offices, drycleaners, film services, and other related businesses.

There is one basic difference between service retailers and stores with merchandise: the service retailer deals with intangibles – an airline flight, a home loan, insurance, a betting transaction. As the name implies, these stores are providing service as a primary function, and the designer's task becomes how to present the service as a product, in the store. But the evident differences between services and mainstream retailers conceal some key similarities, which are particularly important for the design. While there may be no merchandise, there are certainly products for which principles of retailing do apply.

The product, of course, is information. And, unlike most forms of retailing, there may be minimal differentiation between the products offered by competitors – a small percentage point in interest rates, for example. But the retailer needs to be differentiated from the competitors, and the designer must effectively communicate the differentiation. The intangible nature of most services products makes the use of graphics particularly important in differentiation – and for communicating even the most basic information about the products. In a deregulated, increasingly competitive marketplace, the character of the store assumes a much more important role in services retailing: a traditional bank, for example, with tradition dark wood fittings, conveys a very different image from that of a bank with sleek, modern desks and counters. Neither are necessarily inappropriate. But is essential for the service retailer to match the physical appearance of the outlet with the cultural position of the enterprise.

EXTERNAL APPEARANCE

The tradition with some types of service retailer has been for the storefront to look visually closed and inaccessible. In banks, for example, heavy stone masonry walls and barred windows – at least in the past – denoted security and solidity, the external representation of the massive vault inside. Even travel agents tended to hide behind windows covered indiscriminately with special vacation offers or cut-price flight deals in the dubious belief, perhaps, that airline and tour operators could do a better "selling" job than the agent themselves. But as with other retailers, service retailers can use the outside of the store to communicate much of the corporate message and philosophy. The positioning and type of entrance is a key factor. An open entrance, using either automatic doors or no doors at all, is more welcoming than one where doors have to be pushed open. For banks in particular, however, a more secure arrangement may be necessary, using doors that are lockable by remote control, for example. Transparency, through large windows or full-height glass walls, indicates a more open type of store, possibly an important consideration where the retailer has to surmount a reputation of being daunting or inaccessible.

The largely transparent frontage (previous page) of the Tokyo Securities Corporation, a share-dealing bank in the financial district of Nagoya, minimizes any sense of physical or psychological barriers to entry. Designed to stand out from the rather drab and conventional surroundings, this is quite unlike the traditional blankness of old-style bank façades. There is even a window display, further evidence of the growing desire of services stores to seem as approachable as any other form of store.

The Mitsubishi Bank in Tokyo
has a dramatic, immediately
noticeable façade. Although
imposing, its large window
makes it seem accessible, too.

The effect of a frontage from
the inside should also be
considered. At the British
Worsfolds, an estate agent in
Kent, the play of light on
information hung in the large
window is attractive; the
maximum amount of light
penetrates the interior, and
passersby are encouraged by
the open view to come in. The
double-sided display of
information – a simple device –
economizes on space. (*Photo*:
Martin Charles)

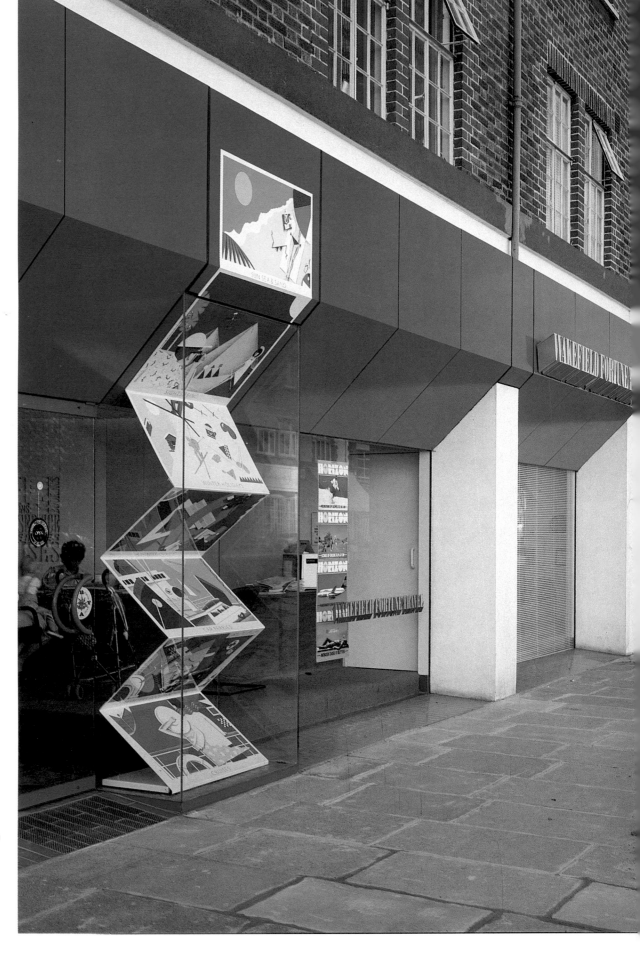

A welcoming glass frontage at the British travel agents Wakefield Fortune Travel, designed by Pentagram, is given an eye-catching focal point with a giant fold-out postcard. Images on the card suggest different types of holiday. Otherwise the window is left almost completely uncluttered. (*Photo:* Martin Charles)

In the rue de l'Echelle branch of the travel agent Nouvelles Frontières in Paris (above), designed by Gèrard Pierre, brochures are displayed on slim shelves – no posters stuck on the glass here – to maximize views of the interior. A central "dart" in the window attracts passers-by visually towards the store. (*Photo:* Stephane Couturier)

Automated services at Bank One, Columbus, Ohio (left) – cash machine and on-screen information – are a clearly visible focal point in the space. Glass is used around the perimeter of the bank to separate individual departments, giving them both privacy and a sense of accessibility.

The graphics and queuing barriers serve their purpose in this British Post Office (above) where efficiency is the priority. But lighting is white and harsh, colours are cool, and seating is scarce for the infirm or those simply waiting. There are few softening features such as plants. (*Photo:* Hodge Associates)

Warm beechwood, cozy lighting and comfortable chairs (even individual counters have fold-down seats) characterize this light, well-laid-out post office in central Stockholm (right), designed by Ahlström and Kock. The white marble floor and the Gyproc ceiling – transformed by a sponged-on painting of white clouds on blue – contribute to the airy, spacious feeling. A yellow lighting track with pale green metal supports traces the perimeter of the interior; desk and wall-mounted halogen light sources are reflected off split mirror leaves, which can be altered to redirect the light; and pendant ceiling lights consist of four glass circles and, once more, a halogen source – the whole lighting scheme creating a sense of relaxation. (*Photo:* Peter Cook)

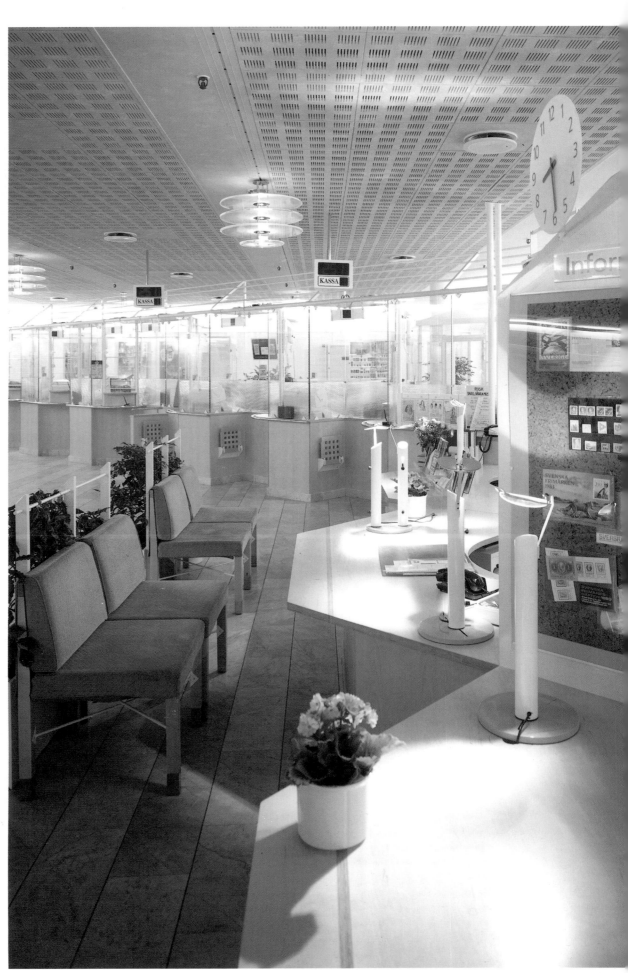

INTERIOR CHARACTER

Openness can be conveyed through other means as well. Desks rather than counters, or, better, tables instead of desks, and shared data screens or reference material help convey a sense of informality. Similarly, using low rather than desk-height seating can aid communication. In a bank, openness is best effected by reducing the apparent level of security. In countries where security screens are common, the designer may be able to restrict their use to high-value transaction counters. The transparency of the service is increased if the same technology or information is available to both customer and operator. In a travel agency, for example, both the staff and the customer should be able to see information on a common screen, or on the printed page, in order to discuss and decide on the purchase. Although it may fall outside the designer's task, any technology should, on this principle, be user-friendly."

Because more than one service may be available within one retailer, a planning hierarchy that is immediately obvious to the customer is crucial. In a bank, for example, some transactions need to be rapid and can be relatively public – withdrawing small amounts of cash, for instance. Other transactions require privacy, such as opening an account, or acquiring a large loan. Similarly, in a travel agency, obtaining basic flight information should be a quick, simple process, while deciding on details and cost of a three-week trip may require time and concentration. In many service retailers, lines present a considerable design problem. Where large lines form at peak times, some form of sifting system can help: either a seating area where customers wait until their name (or, less effectively, number) is called, or a single line that feeds into a "next available" service point. Public fast-service areas should be prominent at the front of the store and, where possible, visible from outside as a lure to passersby. Increasingly, simple transactions and information services are becoming automated. Two considerations are important in a design incorporating automated services. First, the services must be clearly visible, so that others can see them in use; there is still, for many people, a reluctance to exploit fully the efficiency and simplicity of the technology; and second, the information graphics must be coherent and clear, to prevent any confusion.

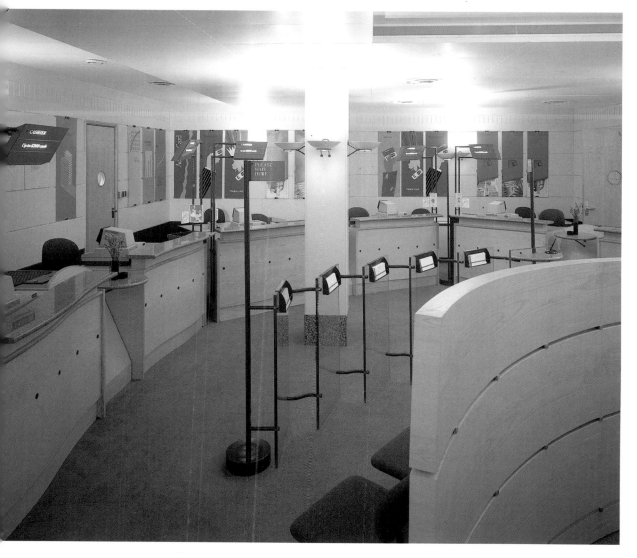

The queuing barrier in this branch of UK Lloyds bank in Swansea, and the curved seating behind it, designed by Tilney Lumsden Shane, successfully encourage a single queue formation. A line of open teller desks for small-sum cash withdrawals, designed in ash and granite, have monitors to provide instant information on customer accounts, and minimize barriers between staff and public. Bannerlike posters (the graphics were designed by Lambton Place and Tatham Pearce Ltd) can be hung at any point, thanks to the wall cladding. (*Photo:* Dennis Gilbert)

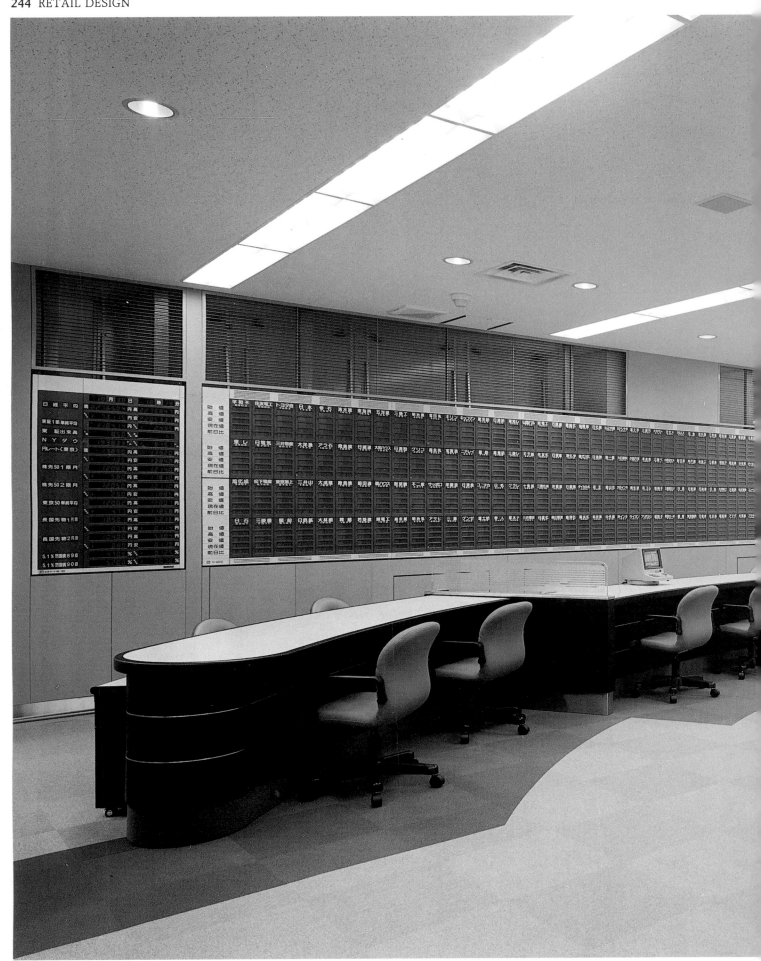

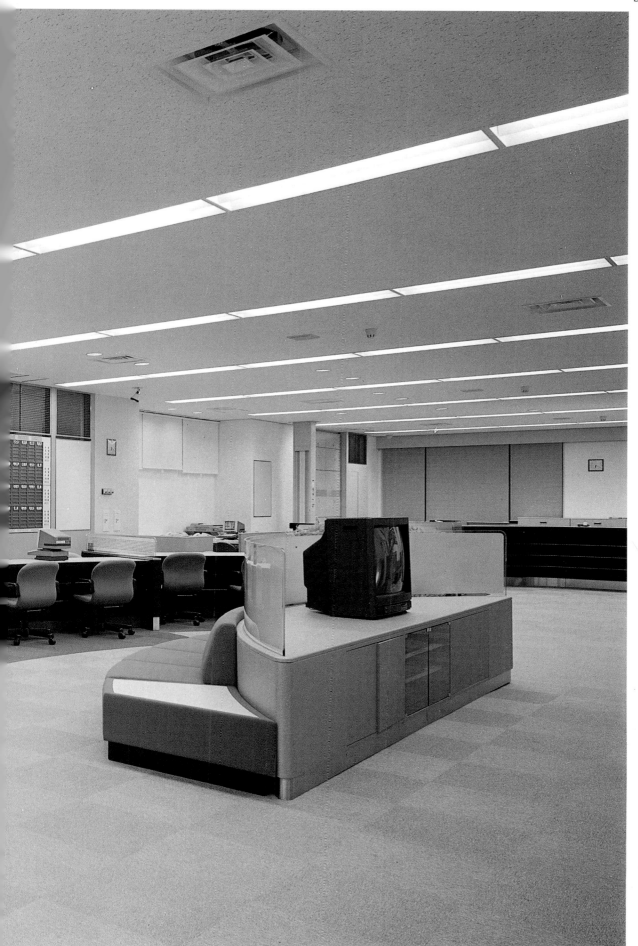

Although large, the Tokyo
Securities Corporation is designed
to set customers at their ease.
Apart from the comfortable
seating for waiting or relaxation,
the design of the chairs and
tables at which transactions take
place reassures clients by
suggesting complete equality
between staff and public.

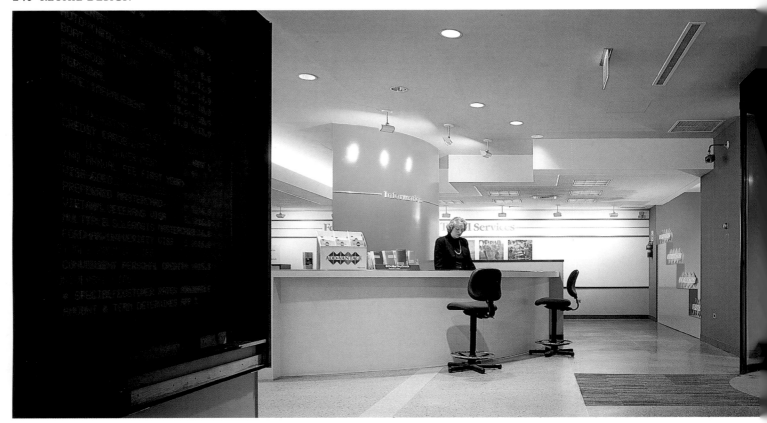

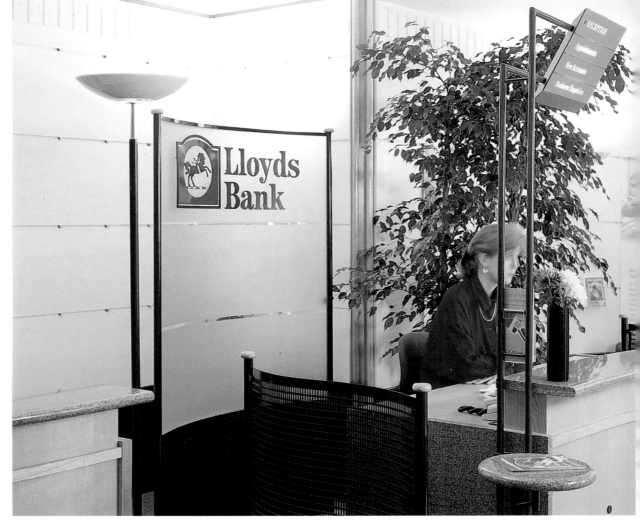

Every Dollar Drydock financial center provides the options of both fast, computerized information for help, and a more personalized service if required. At the branch on 42nd Street, New York, as elsewhere, an electronic data wall at the entry – reputedly the first of its kind – is a special talking-point, providing several "pages" of continually updated information from around the world. Nearby, a prominently placed information desk with chairs encourages more personal inquiries. Financial Concepts, Inc., Turner/Design, Inc. and B-Designed have created a relaxed, inviting "financial department store," divided into "merchandising zones" but with unified colours, graphics, and detailing. (*Photo:* Peter Cook)

Tilney Lumsden Shane designed an unintimidating reception desk at the entrance to the British Lloyd's bank in Sittingbourne. The integral descriptive header lists the help available, and has interchangeable leaflet display pockets. Polished granite and ash timber are the materials used. The graphic designers were Lambton Place and Tatham Pearce Ltd. (*Photo:* Dennis Gilbert)

GRAPHICS AND TECHNOLOGY

The intangible nature of the product in service retailing means that graphics are of particular importance to explain products on offer, or to direct customers to the appropriate area. A number of designs incorporate a clearly signposted information desk as the best initial aid for customers. New designs for Britain's Midland Bank, for example, generally have such a desk just beyond an area with automated teller machines (see page 248). The staff member serving on the desk can answer simple queries, or lead a customer to a clerk or manager to provide other services. Although a novel idea in a small bank, the information desk was a regular feature in the cavernous halls of grand, early twentieth-century city-center banks. Other ways of dispensing information can also be effective. Leaflets or posters with product information can be crucial, not only to explain details to customers but also to establish a strong corporate identity. The graphics of these printed materials should therefore be considered together with the overall store design – although this may mean the use of additional graphic design consultants for the retailer. Interior graphics can be coordinated with broadcast or press advertising to reinforce a retailer's marketing message.

Information today can also be handled electronically, through the use of video screens or simpler message boards. Some particularly forward-thinking service retailers utilize forms of interactive video, or interactive computer programs, to enable customers to answer their own questions without the need to consult staff. The use of these new technologies highlights a design concern that is particularly relevant to service retailers. Whether it is in the supply of information to customers or staff, or the operation of various automated processes, service retailers face considerable problems of wiring, data transmission, and the associated constraints that technology often creates. Designers should be conscious that hardware is frequently subject to change, particularly in fast-moving areas of financial services such as share stores or banks. As a result, routing for cables should be easily accessible: in stores with particularly intense use of new technology, some form of raised access flooring might even be considered. An alternative could be to route cables around the perimeter, again ensuring that access panels are conveniently located.

But service retailers should not forget, with all the advantages of modern technology, that the staff is the most vital part of the store. Designers, too, need to be conscious of this – both in terms of making the staff easily available to customers, and ensuring that the workplace is as well designed for the staff as it is for the customers. This book is not about office design, but, for many workers in service stores, the store is in effect their office, and they have to withstand a long day within that workplace. Thus the considerations that apply in good office design, in terms of providing a comfortable, unstressed, efficient workplace, apply in service stores. The Stockholm branch post office, for example, uses high-quality materials and has a relaxing atmosphere, providing not only an environment conducive to working but also to meeting the needs of the customer, which should be the *raison d'être* of a service store.

An entrance need not be large to be inviting. At Bank One, Columbus, Ohio, the maximum use of glass makes a welcoming doorway, while the graphic display panels on either side funnel customers into the interior.

Screens behind the central
reception desk give up-to-date
information on services.

MIDLAND BANK
Bristol, UK

Bankers have not traditionally viewed themselves as retailers. However, the growing awareness of and demand for financial services and the increasing competition for customers from other banks, financial institutions, and new retail chains, have forced many banking groups to reappraise their role. In Britain, the most extensive new approach was launched in 1986 by the Midland Bank, working with designers FitchRS.

The strategy for the redesign stems from the identification of three distinct groups of service the bank needs to offer: immediate services that do not require personal service or advice, such as money transmissions, bank statements and balance enquiries; speedy services that require a measure of personal guidance from bank staff, such as credit card enquiries, small loans, and account openings; and services that require expert advice and considered guidance from staff, such as home mortgages, insurance, and asset management. Each of these kinds of service is treated in a unified, but distinct way by the designers.

From the outside, the aura of tradition is maintained by the arched entrance. Backlit blue columns and etched, illuminated blue-and-yellow signage draw attention to the bank and its automated banking and night-safe facilities. Over the door, "Midland Bank" has been transformed to "Bank Midland," with the name "Midland" predominant. A projecting Midland "Guinea and Griffin" sign, the traditional symbol of the bank, extends out into the street.

Where branch architecture permits, large glass windows provide a clear view from outside, opening up the interior of the bank and breaking down the image of a "hidden sanctum". Inside, a polished wooden parquet floor leads to a reception desk, which, backed by electronic screens giving up-to-the-minute financial and product information, becomes the focal point of the design. The reception desk is manned by a senior staff member who oversees banking hall operations. Simple enquiries can be dealt with at the desk, while customers who require detailed advice are directed to consulting positions in a more sheltered part of the layout.

The consulting positions have a staff workstation on one side of a screen and a table with chairs for customer interviews on the other. Staff members can carry out all their duties on the banking hall floor from their desk, yet be quickly available to help a customer without the necessity of making appointments.

For customers who do not require personal service, automated cash and account information

spensers are available, as well as unscreened
ashier positions for all transactions under £200
350). Where possible, the area for the automated
eller machines has a separate entrance, screened off
ach evening from the main banking hall – giving
astomers access to use their bank card outside
ormal banking hours.

Materials used in the design are of high quality,
 stress the expected banking virtues of
ermanence and tradition. Bird's-eye maple is used
 or the screens, furniture, and wooden floor; blue
earl Italian granite for writing surfaces; stainless
eel for furniture and screens; leather for chairs. A
pecially designed Wilton carpet in the bank's
 olours of blue, gray, and coral pink is used in the
anking hall. The forms, shapes, and materials of all
 he design elements are kept within a fairly tight
 ange that helps create a positive identity yet allows
 he flexibility of application across the bank's many
 utlets. The design also includes a new staff
 niform wardrobe of coordinated separates,
 lowing a number of daily alternatives, without all
 taff appearing the same. Lighting is a combination
 f custom-designed high-frequency fluorescent
 plighters, contrasted with low-voltage lighting to
 ighlight areas.

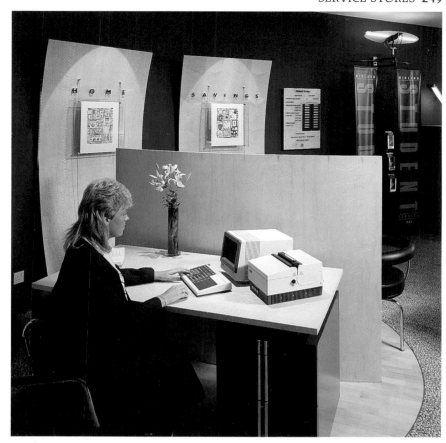

A staff workstation is separated
from the customer areas by a
wooden screen – timber being a
theme carried throughout the
design.

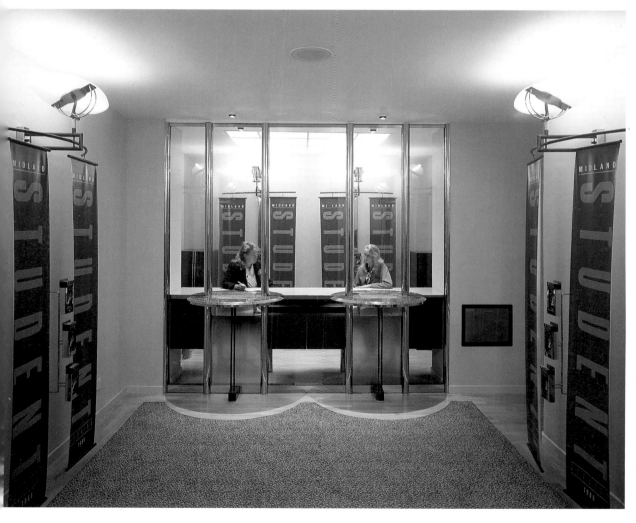

Banners with strong graphics
differentiate the customer service
areas. (*Photos:* FitchRS)

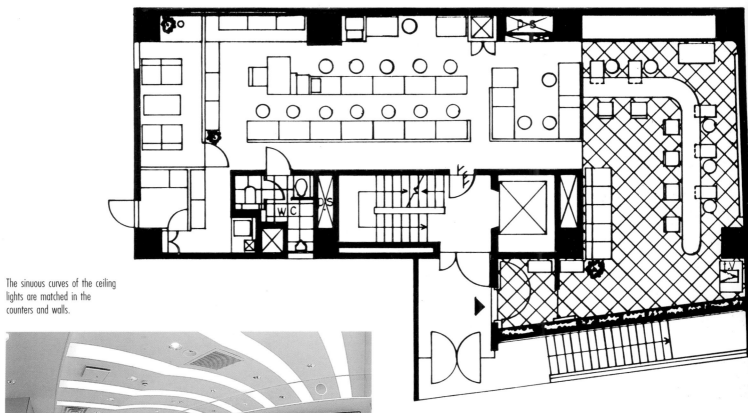

The sinuous curves of the ceiling lights are matched in the counters and walls.

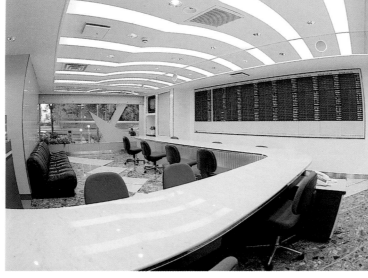

The exterior of National Shoken exposes the store to view, drawing the eye in with the lines of light along the triangular shape.

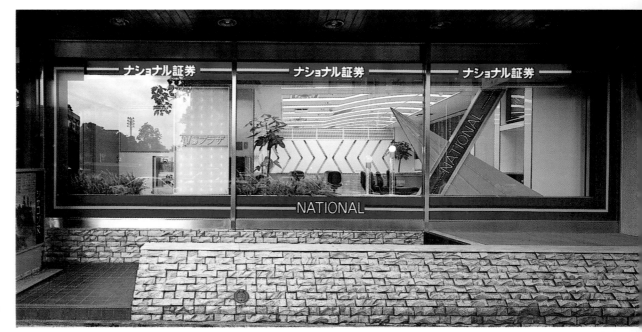

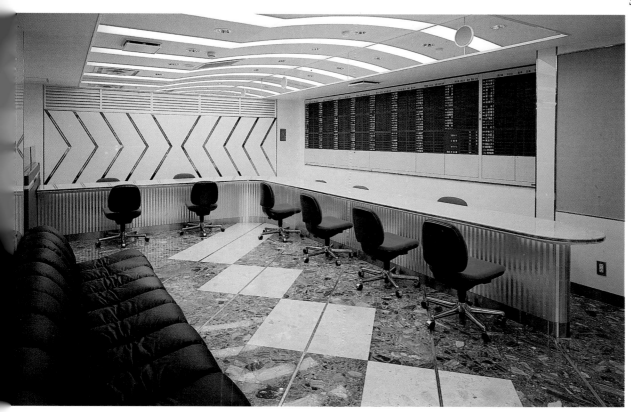

Customers can sit in comfort
while studying the latest prices.

ATIONAL SHOKEN

Tokyo, Japan

In Japan, as in the United States, it is common
practice to sell stocks and shares over the counter in
local offices. Most of these securities stores are
humdrum affairs, little different from the
standardized – and dull – Japanese office interior.
But the Aoyama branch of National Shoken in
Tokyo is, unusually, located in a busy and
extremely fashionable shopping area. Designer Yuji
Horikoshi therefore aimed to create a presence more
in keeping with the surrounding mix of retailers,
and, in doing so, has created a very different-
looking financial services interior.

From the outside, a sense of openness and
customer contact is created by a large window
giving views through to the counter service area,
where the principal feature of the design, a sinuous
series of ceiling strip lights, can be seen. "National"
is announced in both Western and Kanji lettering in
a blue strip around the windows, as well as in lights
on an angled display, which can also show a
tickertape of current share prices. The entrance,
although offset, leads directly to the main counter
area.

One of the dangers when designing innovative
financial services outlets is that the very modernity
sought by the designer can be felt by the customer
to be too fashionable and therefore transient. This
reaction has been preempted in this design by the
use of marble and other traditional materials and
details to restate National Shoken's permanence.

This culture is emphasized by the large,
swivelling office-type chairs from which customers
can transact their business in efficient comfort while
remaining alert. By contrast, the reception area has
deep leather sofas with a somewhat "clubby" air.

The service counter is L-shaped and made from
synthetic wood, with a hairline trim of stainless
steel. Behind the counter is the center of interest for
most customers – the "Big Board" detailing price
movements. But this is virtually the only sign of
new technology in the customer area at National
Shoken. Over-the-counter transactions are carried
out personally, by hand, the actual processing takes
place in the private offices, visible from the short leg
of the "L," behind a waist-high blue wall.

The ceiling is plasterboard with a paint finish.
The visual and spatial interest is created by the
gentle curve of the ceiling over the main run of the
service counter. The curve is accentuated by the
strips of fluorescent lights behind diffusers. A
warmer light is created by the downlighters
interspersed between the lines of fluorescent tubes.
The walls, too, defy the norms of Japanese offices.
In the counter service area, walls are of coloured
and clear glass, in white, pink and green.

Japan is renowned for its outstanding designs of
retail outlets. At its Aoyama branch, National
Shoken has brought a similarly innovative quality to
the financial services sector.

POSTSCRIPT: THE FUTURE FOR RETAIL DESIGN

Predicting the future is always risky, particularly so in retailing and retail design, which, as we have seen, is a business founded and thriving upon change. Recent history suggests the speed of that change is likely to increase with the changes in society, the economy, technology, and social attitudes. Equally, certain trends which will have significant impact on the design of stores in the future are already clearly visible and these perhaps form the most useful basis for informed speculation, if not bold prognostication.

Throughout its history, retailing has both mirrored and helped to shape social change. The increase in disposable income and the ready availability of credit has helped to fuel the retail boom of recent years. Intense competition has led retailers to develop consumer-led strategies, to the extent that the "customer is now King." In the fight for market share, "customer knowledge" is essential to developing marketing and retailing strategies: identifying and then supplying ever more specific needs, as shown by the rise of the "niche" retailer and mail-order shopping.

Despite many predictions of its imminent demise, mail order is a growing, vital, retail business. But the giant compendia marking the origins of mail order – the Sears Roebuck or Montgomery Ward catalogs that provided American pioneers with the necessities of life – are no longer the dominant pattern in the field. Instead, increasingly focussed catalogs, or variations such as the "magalog", allow the mail-order retailer to target a particular market and appeal to it in a highly specific way. Computer-stored mailing lists are the key element in this form of retailing, as the retailer seeks to find the right audience.

Teleshopping takes this a step further by allowing the consumer to interact with the retailer. Shopping on television is still at a fairly primitive state, with the excesses of the American Home Shopping Network as the most visible example. But HSN is really a television version of mail order: instead of seeing an object on a page, the shopper sees it on the screen. Traditional retail design skills might seem inappropriate here, but, for teleshopping to work, design perceptions must be brought to bear on the problems of this new retailing method. There is, of course, the graphic presentation, analogous to the mail-order catalog. More than that, however, a designer will need to

consider the process of teleshopping. This proce[ss] could be quite like moving through a convention[al] store. Shoppers must be guided through the offers [on] screen by clear, coherent signposting. The adjacenci[es] – the logic of any route through information – and th[e] presentation of the merchandise offer must mak[e] sense and be simple for the shopper to follow.

Teleshopping, it is generally agreed, will not repla[ce] conventional retailing, but rather supplement an[d] complement it, possibly offering the consumer a mo[re] efficient use of time. Research into the feasibility [of] teleshopping suggests that the target audience will b[e] brand-conscious children who have grown up wit[h] videos and computers and who constitute the ne[xt] generation of shoppers. However, shopping fro[m] home cannot offer the immediacy and spontaneity [of] the actual contact with merchandise and other sho[p]pers, the general ambience of the store, or the person[al] quality of customer service, which all contribute to [the] shopping experience and affect purchasing decision[s].

A recurring theme in this book has been that it is a[n] essential part of retail design to understand the cu[s]tomer. In the 1990s the customer base for man[y] sectors of retailing is likely to change, given curren[t] demographic trends towards an older population.

The customer base is also changing geographicall[y] while there is ever more differentiation between ma[r]ket segments, on the one hand, the retail market an[d] its advertising and promotional outlets are becomin[g] increasingly international. Developments such as th[e] advent of the Single European Market in 1992 and th[e] breaking down of media and broadcast barriers wit[h] satellite and cable television will inevitably effec[t] retailing practices and therefore retail design. The ol[d] maxim quoted earlier in the book will become eve[n] more relevant, to "think globally and design locally[."]

If, as broad socio-economic trends in Wester[n] Europe and America suggest, the ownership of con[sumer goods reaches more or less saturation point, [a] larger percentage of this disposable income may b[e] directed towards "experience activities," such as holi[days], courses, second homes and travel. This shoul[d] further stimulate the current trend towards shoppin[g] as a leisure experience, shown in the range o[f] activities and services now being offered by some out[-]of-town shopping centers.

Retailing will increasingly integrate with other leisure activities and embrace new, non-traditional areas. Breaking down barriers will be important – financial services, travel, motor cars, food and drink will all be part of the retail experience. The challenge for the designer will be to make it more interesting and rewarding than staying at home, teleshopping. Shopping will become a multi-media experience with more emphasis on entertainment and change, with fixtures and fittings needing to be more flexible and to be viewed as interchangeable stage props. There should be an increasing future for "ideas and solutions retailers" and for retailers who bring retailing to life – involving the customer through in-store demonstrations, shows – and who use the new technologies to dramatic effect. Retailers are now taking advantage of communicating with their customers – phoning them, or signing them up on loyalty bonus offers. Some retail groups such as Marks and Spencer in the UK are developing customer loyalty and a "club" culture through credit-card associated magazines and special deals. It is likely that specialist centers will take over from the traditional shopping center with a representative sample of every merchandise group, further developing the role of the niche retailer.

The question of service is likely to be central to retail development in the near future. If in the recent past retailers have been preoccupied with product and store design (and, in Britain, with building more and more retail space), as these avenues become exhausted it seems highly likely that many will next turn their attention to the question of service. The implications for store design are considerable, as design strategies developed for stores with minimal service become redundant. Meanwhile, outlets whose products will never support in-store service are likely to demand environments with increasingly intelligible product and store information in order to stay in tune with the general mood shift towards more "intelligent" retail environments.

The level and type of service, whether direct, personal staff service, or information provision, will also be affected by technological developments. The familiar check-out device which reads the bar code on goods represents only the tip of the iceberg when it comes to what is technologically possible in the retail environment. The techniques by which shops are stocked and controlled – and by which information is fed back to distribution centers – are likely to undergo radical change. Seibu's experimental Megatronic Store in Japan is already partially robotic, employing, for example, an electronic system for changing the price of goods on the shelves in automatic response to their rate of purchase. In that particular case an interesting by-product has been that redundant workers at back of house have been redeployed in front of house: automation has therefore brought about an increase in shopfloor staff and a corresponding rise in the quality of store service. This particular response may not prove to be universal, but it raises key questions about how stores are designed in the face of increased automation. How will exclusively robotic stores differ from those in which a high degree of personal assistance is offered? Will greater levels of explanation be necessary in high technology stores? How will the availability of personal service be expressed in terms of design?

The general message for the profession is clear. Designers must get serious about retail design, informing and educating themselves so that they understand far more than the traditionally taught "design skills." This requires art education establishments which are similarly alert to the marketplace and to what design practices really need from the students they employ. A clear distinction between artists and designers must be maintained: learning to make compromises elegantly is often what good design is all about.

It is likely that design practices themselves will become more polarized. Large multi-disciplinary practices at their best can re-invest and grow to provide services which are underpinned with many layers of research, cultural reference and peripheral expertise. At the other extreme, and equally valid, there will remain the small specialist consultancy, ideal for local clients whose needs are for discrete services and who perhaps relate better to a small-scale specialist consultancy.

Whatever other new forms of retailing are developed in the future, it is hardly probable that traditional retailing will contract. At the same time, new forms will offer more choice, more variety, but just as the invention of the department store or shopping center did not cause the extinction of the small, local shop, so new retailing forms will not wipe out the old. The balance may shift, but new challenges for the retail designer will constantly occur, to meet the demands of the everchanging world of retailing. The public on whom retailing depends for its lifeblood are increasingly design-aware. An appetite for better-designed goods and environments is now more widespread in the shopping public. This would have been hard to predict thirty years ago, but it is demonstrably true not only in the United States but in Britain and much of Europe. And whilst retailing will always remain an intuitive occupation, the design techniques which will solve its problems in the future will need to become far more scientific in order to be effective. The age of the buccaneer retailer with a good eye and some boldness perhaps is now past – retail design is and must continue to be a highly professional occupation, if only because of the sophistication of the world in which it operates.

Glossary

acoustic ceiling a ceiling of low density acoustic panels formed by a metal grid suspended from the structural slab above providing sound control.

air curtain air projected downwards at high velocity across an external doorway.

back-lighting lighting from a source placed behind the illuminated object or area, often to create a "halo" effect.

bitumen a black, sticky mixture of hydrocarbons used as a road surfacing and roofing material.

box sign a three-dimensional sign, usually made of metal with a plastic face and internally illuminated.

broadloom a carpet woven the full width of the manufacturer's loom.

"brown" goods electrical goods, such as televisions, radios and audio systems.

category dominance selling on the strength of offering the widest range of a particular product category.

ceiling track see **track lighting**.

closed back (windows) the window display area is closed off from the main body of the store.

coir the fiber prepared from the husk of the coconut, used in making rope and matting.

concealed-spline ceiling a form of suspended ceiling where the metal grid is invisible, which can be faced by a variety of materials.

concrete screed a mixture of cement, sand and water applied to a concrete slab to give a smooth surface finish, usually covered by tiles, carpet, etc..

diffusers a part of a lighting fixture usually consisting of a translucent or frosted covering or a rough reflector: used to scatter the light and prevent glare.

discharge lamp a light source produced by electricity forming an arc in a gas vapor.

downlighting lighting from specific light sources placed above the objects/area to be lit.

eggcrate or open-cell ceiling a suspended ceiling consisting of square or hexagonal sections, manufactured in panels and assembled in an open grid.

exposed-grid ceiling a suspended ceiling where the lines of the suspension grid are visible.

fascia the surface above a shop window or front.

fashion story the products are merchandised as a complete wardrobe or outfit for a consumer (see also "solution" retailing).

fiber optic the use of bundles of long transparent glass fibers in transmitting light.

fiberboard a building material made of compressed wood or other plant fibers.

fiberglass material consisting of matted fine glass fibers, used as insulation in building, in fireproof fabrics, etc.

fibrous plaster plaster containing fibers or fibrous tissues, generally used for a molded finish on decorative ceilings.

flat pack merchandise that is stored and presented folded and packed flat.

fluorescent exhibiting or having the property of fluorescence (the emission of light or other radiation from atoms or molecules that are bombarded by particles).

gondola a set of island shelves used for displaying goods, generally set out mid floor.

granite a light-coloured coarse-grained acid platonic igneous rock consisting of quartz, etc., widely used for building.

grano cement with granite chips and trowelled with a steel or wooden hand trowel to a smooth finish.

halogen a gas used in discharge lamps.

hardwood the wood of any of numerous broad-leaved trees, such as oak, beech, ash, etc.

HVAC systems systems providing heating, ventilation and air conditioning.

incandescent light a source of light that contains a heated solid, such as an electrically heated filament.

Kleigl light a form of spotlight.

louvre any of a set of parallel slats in a door or window sloping outwards.

mannequin a life-size dummy of the human body used to fit or display clothes.

marbling producing a marble-like finish, generally with paint, but increasingly an integral finish to plastic.

mercury vapour a gas used for discharge lamps.

metal halide a gas used for discharge lamps.

mezzanine an intermediate story.

mild steel strong, tough steel that contains a low quantity of carbon.

mosaic a design or decoration made up of small pieces of coloured glass, stone, etc.

neon an inert gas used in narrow glass tubes in illuminating signs and lights.

nosing the edge of a step or stair tread that projects beyond the riser.

open backed (windows) the window display area is not closed off from the main store area, allowing views in to the store.

open-cell ceiling see **eggcrate ceiling**.

parquet/Parquet Royale fixed geometric wooden tiles secured to a backing which is then glued to a concrete floor; a more expensive parquet tile laid in a herringbone pattern.

pea light a small spotlight, often used in a series.

perimeter system a wall system using fixturing units around the perimeter of the store.

ragging a textured or mottled finish to a painted surface achieved by dabbing or rolling a paint-soaked rag over it.

return-air plenum the space above the ceiling through which warm air is returned before cooling and recirculation.

scumbling a painting technique to blend or soft an outline or colour with an upper coat of opaq colour applied very thinly.

segmentation a marketing strategy, whereby selected type of customer is targeted, based market research.

shelf-life maximum period that perishable goo can be stocked (mainly food stuffs).

shrinkage loss of merchandise through store the

slatwall fixturing units with horizontal channe into which brackets can be slotted to suppo shelves, etc.

sodium, high-pressure and low-pressure gas used for discharge lamps.

soffits the underside of a part of a building or structural component, such as an arch, beam or sta

"solution" retailing the co-ordination of a me chandise display to suggest ideas and "solutions" the customer.

sprinkler system a system which automatical sprinkles water in case of fire.

stencilling a decorative finish to a painted plastered surface using a stencilled pattern.

terracotta a hard, unglazed brownish-red earthe ware made of clay; also a colour description.

terrazzo a floor or wall finish made by settir marble or other stone chips into a layer of mortar ar polishing the surface.

Tivoli lights strings of individual light sources, sim lar to pea lights.

track lighting a metal track with electric curren which permits a series of light fittings to be clippe in at random and moved at will.

triple hanging fixturing units allowing three leve of stock.

tungsten halogen an incandescent light source.

uplighting lighting from upwardly directed ligh sources.

VAV system variable-air-volume air conditionin system, which cools and recirculates warm air fror the store (or vice versa).

weathering the effect of the elements on materia and finishes.

wenge a type of hard wood.

wire management organizing the supply of a mult plicity of electricity cables within a store.

"white" goods domestic electrical appliances suc as refrigerators, washing machines, stoves, etc.

ziggurat (fittings) a freestanding fixturing unit wit shelves or hanging rails in the shape of a steppe pyramid.

ndex

Bibliography

Barr, Vilma and Broudy, Charles E. *A Complete Guide to Retail Store Planning and Design*, McGraw Hill, New York, 1986.

Barr, Vilma and Broudy, Charles E. *Designing to Sell*, McGraw Hill, New York, 1986.

Brash, Nicholas. *The Model Store 1885–1985: Grace Bros*, Kevin Weldon and Associates, 1985.

Denby, Caroline, editor. *The Best of Store Designs* and *Visual Merchandising: the best designs from leading designers*, PBC International.

Drew-Bear, Robert. *Mass Merchandising*. Fairchild, New York, 1970.

Duncliffe, Shaun. *Shopspec '88*, Pennington Press, London, 1988.

Ferry, John William. *A History of the Department Store*, Macmillan, New York, 1960.

Green, William R. *The Retail Store: Design and Construction*, Van Nostrand Reinhold, New York, 1986.

Kay, William. *The Battle for the High Street*, Piatkus, London, 1987.

Knobel, Lance. *International Interiors*, Thames & Hudson, London, 1988.

Lebhar, Godfrey M. *Chain Stores in America, 1859–1962*, Chain Store Publication Corporation, New York, 1963.

Mahoney, Tom and Sloane, Leonard. *The Great Merchants*, Harper & Row, London, 1966.

Maitland, Barry. *Shopping Malls: Planning and Design*, Construction Press, London, 1985.

Marcus, Stanley. *Minding the Store*, New American Library, New York, 1975.

McAusland, Randolph. *Supermarkets: 50 Years of Progress*, Food Distribution Institute, Washington, 1980.

Miller, Michael B. *The Bon Marché*, George Allen & Unwin, London, 1981.

Mitchell, Gordon. *Design in the High Street*, Architectural Press, London, 198

Munn, David. *Shops – a Manual of Planning and Design*, Architectural Press, London, 1986.

Novak, Adolph. *Store Planning and Design*, Lebhar-Friedman, New York, 197

Pevsner, Nikolaus. *A History of Building Types*. Thames & Hudson, London, 1976.

Sieff, Marcus. *Don't ask the price: the memoirs of the President of Marks Spencer*, Weidenfeld & Nicholson, London, 1986.

Stevens, Mark. *"Like no other store in the world": the Inside Story of Bloomingdales*, Crowell, New York, 1979.

Twyman, Robert W. *History of Marshall Field & Co.*, University of Philadelphia Press, Philadelphia, Oxford, 1954.

Weil, Gordon, *Sears, Roebuck USA: The Great American Store and How it Grew*, Stein and Day, New York, 1977.

Wohlwend, Franz (editor). *Store Design – Selection of the World's Best*, Atlanta, published annually.

Woolworth, F. W. & Company. *Woolworth's First 75 Years*, New York, 1954.

Zimmerman, M. M. *The Supermarket: a revolution in distribution*, McGraw Hill, New York, 1955.

Magazines and Journals

UK: *Designers' Journal, Blueprint*; USA: *Architectural Record, Progressive Architecture, Interiors, Interior Design, Journal of Retailing, Stores, Chain Store Age Executive, Progressive Grocer*; Italy: *Domus, Abitare, Interni*; France: *Crée Architecture d'Interieur*; Spain *De Diseño*.